AFTER EFFECTS

Apprentice

Real-World Skills for the Aspiring Motion Graphics Artist

TRISH & CHRIS MEYER

ELSEVIER

Amsterdam • Boston • Heidelberg • London
New York • Oxford • Paris • San Diego
San Francisco • Singapore • Sydney • Tokyo

Focal Press is an imprint of Elsevier

Focal Press

*DEDICATED to the After Effects team, past and present: from those hearty
pioneers at the Company of Science and Art (CoSA) who revolutionized our
industry, to the current innovators at Adobe who keep this vital program fresh.*

Focal Press is an imprint of Elsevier
30 Corporate Drive, Suite 400, Burlington, MA 01803, USA
Linacre House, Jordan Hill, Oxford OX2 8DP, UK

Recognizing the importance of preserving what has been written, Elsevier prints its books
on acid-free paper whenever possible.

Library of Congress Cataloging-in-Publication Data
Application submitted

British Library Cataloguing-in-Publication Data
A catalogue record for this book is available from the British Library.

ISBN 13: 978-0-240-80938-0
ISBN 10: 0-240-80938-6

For information on all Focal Press publications
visit our website at www.books.elsevier.com

07 08 09 10 11 5 4 3 2 1

Printed in Canada

Working together to grow
libraries in developing countries

www.elsevier.com | www.bookaid.org | www.sabre.org

ELSEVIER BOOK AID
International Sabre Foundation

is a registered trademark of
NewBay Media, L.L.C.,
810 Seventh Ave., 27th floor,
New York, NY 10019

Table of Contents

▽ Lesson 5 – Type and Music 106

Animating text and working with music are essential to motion graphics design

▽ Lesson 6 – Parenting and Nesting 134

Grouping layers to make them easier to coordinate

Introduction

In January 1993, the Company of Science and Art (CoSA) shipped the first version of After Effects – and the video and film industries haven't been the same since. Suddenly, an artist working on a personal computer could produce realistic visual effects and fanciful motion graphics that rivaled those produced on dedicated machines costing tens or hundreds of thousands of dollars. We were happy to be one of those very first users; it allowed us to start our own successful motion graphics company, CyberMotion.

"But what does After Effects do?"

After Effects is not a video editing program; it is not a DVD authoring tool; it does not create web pages. What it does is help you create graphical elements – either composites of real images, or combinations of completely original imagery – that you can cut into a video, use in a DVD menu, incorporate into a web site, play back at a trade show, upload to YouTube, download to a cell phone, or print to film for a major motion picture. Now owned by Adobe and a de facto standard in the industry, After Effects has evolved into a deep, rich program with countless features for these uses and more.

All of which leads to the next question: "How do I start?" This is a particularly daunting issue if you are completely new to motion graphics or visual effects, or if you already specialize in another area such as editing and want to learn "just enough" After Effects to help you raise the quality of your productions.

This is where *After Effects Apprentice* comes in. Our goal is to teach you the most important, core features of this wonderful program through a series of practical hands-on exercises. Every lesson is grounded in our own real-world experiences, showing you the right way to use the right feature for a given task. We start out with simple animations to help you over that first step in learning the program, eventually working up to motion tracking, keying greenscreen shots, and working with high-definition footage. By the end, you'll be creating your own 3D world and exploring it with multiple camera moves. Along the way, we encourage you to develop and use your own design sense so that you can creatively tackle a wide variety of jobs that may come your way in the future.

We hope that you find this introductory book both fun and useful and that it will help you in your current career – or perhaps inspire a new one in motion graphics.

Trish & Chris Meyer
CyberMotion

Getting Started

Learning any new piece of software can be as frustrating as it is rewarding – especially if you are unfamiliar with how it works or what a book is trying to tell you to do. Although we know you're probably anxious to jump right in, please take a few moments to read these introductions – we promise they will help reduce your stress level:

• This *Getting Started* section explains how to use this book and its associated files.

• The following *Pre-Roll* section will help familiarize you with the lay of the land inside After Effects including the user interface, plus explain how projects are structured.

In a program as broad as After Effects, there are features you will use almost every day, and those you may use only once a year or less. The exercises in this book are designed to familiarize you with the core tools and features in After Effects (plus a few important "gotchas"), preparing you for many of the real-world tasks you will encounter.

When you're ready to move to the next level, we have another book for you: *Creating Motion Graphics with After Effects* ("CMG" for short). We wrote the first edition of CMG back in 1999 to help our fellow professionals master this incredible program, and we have been updating it ever since (see the back page for details). Features covered in one or two pages here get their own sections or entire chapters in CMG – so it's definitely your next step.

Loading Up

To use this book, you need to install Adobe After Effects version 7 or CS3 (also known as version 8) on either your Macintosh or Windows computer. If you do not have a licensed copy, Adobe makes fully functional time-limited Trial versions available on its website for download at www.adobe.com/downloads/. The only shortcoming is that you will not have the additional fonts or effects that come with a full version. We rarely use them in this book; when we do, we will suggest a workaround.

Everything else you need to re-create the exercises in this book is contained on the DVD-ROM found in the back. Each lesson has its own folder; copy the entire folder intact onto your computer's hard drive. In addition to the project file and sources, many lessons also come with movies that demonstrate finished compositions or that feature guided tours of specific features. (QuickTime 7 or higher is required to view these movies.) If you are short on disk space, you can delete lesson folders once you are done with them.

After opening any lesson project for the first time, you should use Edit > Save As and give it a new name. This will ensure you can keep the original version intact for future reference. (Indeed, the original project file may be locked – especially if you are accessing it directly off the DVD-ROM.)

Adobe prints the minimum and suggested system requirements on the After Effects box. In addition to Adobe's processor and operating system restrictions, we personally suggest an extended keyboard (or that you learn the special function keys on your laptop), a three-button mouse (a scroll wheel is a nice bonus), at least a 1280×854 pixel display, and hopefully 1 gigabyte or more of RAM.

Most of the exercises have been created at the North American/Japanese DV video size of 720×480 pixels. The first two lessons use a smaller 480×360 square pixel format to ease you into working with larger sources and non-square pixels; Lesson 9 contains a high-definition exercise at its end. The bigger display you have, the more pixels you can see, while more RAM allows you to create longer previews to check your results as you work.

Virtually all of the material inside this book and on the DVD-ROM are copyright protected and are included only for your own learning and experimentation. (The United States map in Lesson 6 and the Indian Territories map in Lesson 9 are in the public domain.) Respect copyrights: Some day, it could be *you* who made that cool graphic…

By the way: Just because we provide you with all of the materials you need, this does not mean you can't use your own images and video instead! Indeed, we encourage you to use your own sources and to try your own variations on our ideas instead of just typing in the numbers we give you. There are literally gazillions of motion graphics styles out there. Although we can show only a few of them here, you will learn what you need to re-create a lot of what you see on TV – or in your own imagination.

After Effects Versions

The vast majority of the exercises in this book may be performed with After Effects 7 Standard through After Effects CS3. Only Lesson 9 – *Tracking and Keying* – requires the Professional version of the software. There are also some features in CS3 that are not included in After Effects 7; in those cases, we have created special CS3-only project files for just these exercises. They will also be noted in this book by a purple color image along the top of their pages.

With the exception of the CS3-only features, all of the screen shots in this book are from After Effects 7. The two programs look very similar. Some of the menus and dialogs have been updated in CS3; even in these cases, the core functions are almost always the same. If they *are* different, we'll warn you.

We have saved both After Effects 7 and CS3 versions of the project files on the DVD-ROM. They end with the letters "_AE7" or "_CS3" respectively. Use the project file that corresponds to your version of After Effects. *Warning:* We were finishing the first edition of the book just as Adobe was finishing CS3, which means we were using a beta version of the software at the time. There is a slim chance that After Effects will tell you the _CS3 projects were created in an earlier version and therefore will be opened as Untitled; that's okay – just save them again, giving them your own name.

Shortcuts and Phrases

After Effects runs on both Mac OS and Windows and is nearly identical on both platforms. That said, there are numerous elements in an After Effects project to keep straight, such as files, compositions, effects, and expressions. To help indicate what we're talking about, we have a handful of particular type conventions and shorthand phrases that we will be using throughout this book:

• **Words in bold** refer to the names of files, folders, layers, or compositions you are using.

• "**Words in bold and in quotes**" are text you should enter – such as the name for a new composition or solid.

• `Words in this typewriter font` indicates code inside an Expression.

• Menu items, effects, and parameter names do not get a special font.

• When there is a chain of submenus or subfolders you have to navigate, we separate links in the chain with a > symbol: For example, Effect > Color Correction > Levels.

• To help make you a faster user, we mention keyboard shortcuts throughout this book. They are indicated by a special keyboard font. The Macintosh shortcut – such as ⌘ S to save a project – is presented first, and is colored red (followed by the Windows shortcut – such as Ctrl S – in parentheses, colored blue). Keyboard shortcuts that are the same on both platforms are in gray, such as typing S to reveal a layer's Scale parameter. The icons we use mean:

⌘ Command (Mac)

⌥ Option (Mac)

Ctrl Control (Windows)

Alt Alt (Windows)

• After Effects makes extensive use of "context-clicking" on items to reveal additional menus or options. To context-click, use the right mouse button. If you are using a Macintosh single-button mouse, hold down the Ctrl key while clicking.

• After Effects makes a distinction between the normal section of the keyboard and the numeric keypad, especially when it comes to the `Enter` or `Return` key. When you see `Enter`, we mean the key on the keypad; `Return` indicates the carriage return key that is part of the normal keyboard.

• The Preferences are located under the After Effects menu on the Mac (and under the Edit menu on Windows). We'll just say "Preferences" and assume you can find them.

Speaking of preferences, we will assume you are starting out using the default preferences. Where they are saved varies depending on the operating system. If you want to save your current preferences, search for "Adobe After Effects 7.0 Prefs" or "Adobe After Effects 8.0 Prefs" (the latter is for CS3), make a note of where you found them, and copy that file to a safe place. Then, to restore the default preference settings, hold down `⌘` `⌥` `Shift` on Mac (`Ctrl` `Alt` `Shift` on Windows) while launching the program. You can always later copy your saved preferences file back to where you found it to return to your custom prefs.

Finally: Relax! Have fun! It's only software; you can't break it. And remember there is often more than one solution to any problem – especially when artistic expression is involved. Our goal here is to give you the key to unlocking your own ideas using this wonderful program.

DVD Tech Support

If your DVD becomes damaged, please contact Focal Press Customer Service at:

technical.support@elsevier.com

Their phone number is 800-692-9010 inside North America and +314-872-8370 overseas.

For Instructors

Each lesson in *After Effects Apprentice* demonstrates essential features through a series of hands-on exercises. They are supplemented with sidebars and numerous tips that cover technical issues and other features of interest. QuickTime guided tours on this book's disc also help explain more involved features and user interface elements. Additionally, we have tried to end each lesson with a series of challenges you can give your students to have them build on what they've learned. We hope that you will find this format useful and can adapt it to your specific needs.

As an instructor, you no doubt appreciate how much time and effort it takes to prepare examples and class materials that both teach and inspire. You can certainly understand that we're interested in protecting our own efforts in creating this book for you and your students. Therefore, the contents of this book and its accompanying disc are copyrighted. If a school, company, or instructor distributes copies of the sources, projects, movies, or PDFs to any person who has not purchased the book, that constitutes copyright infringement. Reproducing pages of this book, or any material included on this book's DVD (including creating derivative works), is also a copyright no-no.

As an extension of this, each student must own his or her own copy of this book. Aside from obeying copyright, this also allows them to review the material covered after class without expending valuable class time writing reams of notes!

If your school has the available disk space, students may copy contents from the DVD to their computers, or you may place the files on a classroom server, but again only as long as each student owns his or her own copy of this book. Provided each student owns the book, you are free to then modify the tutorials and adapt them to your specific teaching situation without infringing copyright.

Thank you for helping protect our copyrights, as well as those who contributed sources – your cooperation enables us to write new books and obtain great source materials for your students to learn from.

Qualified teaching professionals can acquire evaluation copies of our books directly from Focal Press: Please email textbook@elsevier.com

Pre-Roll

Exploring the After Effects landscape.

In this section, we want to give you the "lay of the land" inside After Effects and show you how to move around inside of it. You will learn what each of the major sections of the user interface are called and what they are for, as well as how to rearrange the interface to best suit the task at hand.

The After Effects Project

Before we explain the pieces of the puzzle, we should first explain the puzzle they are part of: namely, an After Effects project. A project file points at the *footage* – sources or pieces of media – you want to use to build one or more *compositions*. After Effects does not store a copy of the footage inside the project file; just a pointer to it. When you move a project to a different folder or computer, you need to move the footage it uses as well. You can use movies, SWFs, still images, sequences of stills, or audio files – all in a variety of formats – as footage items.

When you add a piece of footage to a composition (or "comp" for short), it becomes a *layer* inside that comp. Once a footage item is a layer in a comp, you can arrange it in relation to other layers, animate it, and add effects to it. Another way of thinking of a comp is as the place where your sources get composited together into the final image.

You can create virtually unlimited compositions in a project, as well as virtually unlimited layers in each comp. The same footage item can be used in more than one comp, as well as more than once in the same comp. You can even use comps as layers inside of other comps – but that's a more advanced concept we'll get to in a later lesson.

▽ **In This Lesson**

▽ tip

Help!

Pressing **F1** opens the Adobe Help Center, which includes a detailed contents menu and Search box to find specific information. The Help menu also contains a few handy shortcuts, such as going straight to the keyboard shortcuts.

User Interface Guided Tour

We have created a QuickTime movie that will give you a quick tour of managing the user interface, including how to use Workspaces. It is in the **00-Pre-Roll > Guided Tour** folder on the DVD-ROM that came with this book.

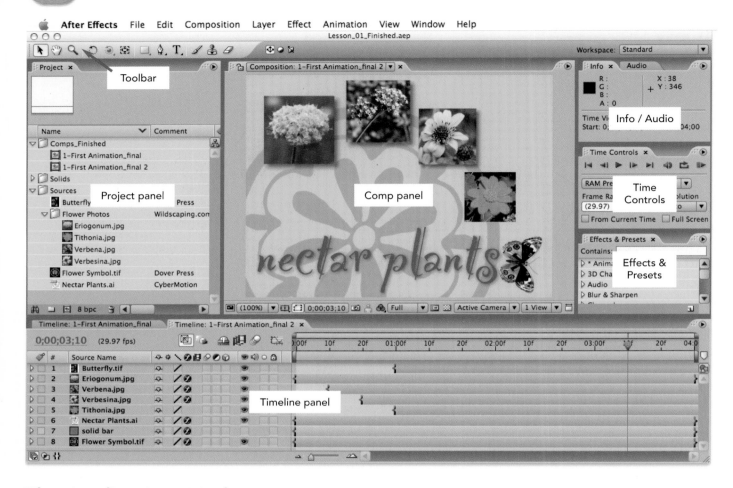

The Application Window

The box all of these puzzle pieces fit into is the After Effects *application window*. By default, this window is designed to fill your entire display, although you are able to resize it by dragging on its lower right corner, and reposition it by grabbing it along its top.

This window is split into several different sections known as *frames*. Each frame can hold one or more tabbed *panels*; a full list of available panels is included under the After Effects Window menu item.

Each panel type holds a different kind of information, such as what footage items you have already imported into your project, or which effects you have applied to a layer.

Different types of panels – or in some cases, multiple copies of the same type of panel – can share the same frame, appearing as tabs along the top of the frame. An orange outline around a panel indicates it is currently "forward" or selected.

An arrangement of panels and frames is called a *workspace*. After Effects comes with a number of pre-arranged workspace layouts; you can also save your own custom arrangements. You will learn how to do this at the end of this Pre-Roll. But first, let's become familiar with the panels you will encounter most often, what information they hold, and how you will use them while working on a project in After Effects. You won't be putting them to use quite yet; that will be your task in the following lessons!

The Tools Panel

The After Effects main window features a toolbar along its top. This provides an easy way to switch between different tools until you learn the keyboard shortcuts. The keyboard shortcuts are worth learning; they'll make you a much faster After Effects user. If a tool you want is grayed out, make sure you select a comp or a layer – it should then become active. In CS3, selecting some tools (such as Type or Paint) will also open one or more panels that go along with it.

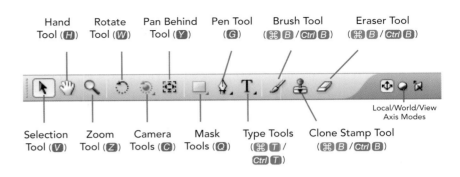

Hand Tool (H) · Rotate Tool (W) · Pan Behind Tool (Y) · Pen Tool (G) · Brush Tool (⌘ B / Ctrl B) · Eraser Tool (⌘ B / Ctrl B)

Selection Tool (V) · Zoom Tool (Z) · Camera Tools (C) · Mask Tools (Q) · Type Tools (⌘ T / Ctrl T) · Clone Stamp Tool (⌘ B / Ctrl B)

Local/World/View Axis Modes

△ **The Tools panel.** A small triangle beside the tool means that this tool has options, in which case its shortcut key will cycle between them. The Tools panel is the only one that cannot be docked into a different frame. However, you can hide and reveal it using the Window menu.

The Project Panel

The Project panel is the central hub of an After Effects project. Whenever you import a footage item or create a new composition, it appears in the Project panel.

The Project panel displays information such as file type, size, and location in a series of columns. You can drag the horizontal scroll bar at the bottom of this panel to view the different columns. Selecting a column header causes After Effects to sort the Project panel based on this column's information; look for the green bar along its top to tell which one's selected. To add or subtract a column, right-click on any column header and select or deselect it from the list that appears.

When you select a footage item in the Project panel, a thumbnail of it will appear at the top of this panel, along with its vital statistics. If you

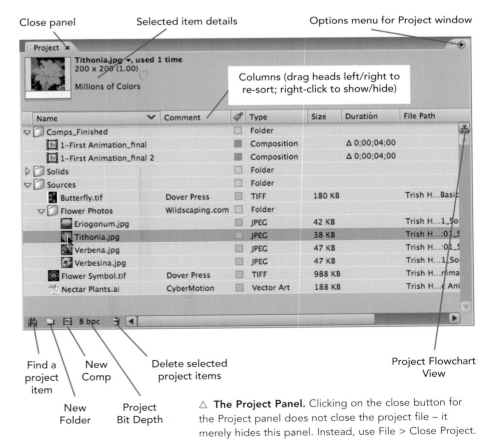

Close panel · Selected item details · Options menu for Project window

Tithonia.jpg ▾, used 1 time
200 x 200 (1.00)
Millions of Colors

Columns (drag heads left/right to re-sort; right-click to show/hide)

Name	Comment		Type	Size	Duration	File Path
▽ 📁 Comps_Finished		☐	Folder			
🖼 1–First Animation_final		☐	Composition		△ 0;00;04;00	
🖼 1–First Animation_final 2		☐	Composition		△ 0;00;04;00	
▷ 📁 Solids		☐	Folder			
▽ 📁 Sources		☐	Folder			
Butterfly.tif	Dover Press	☐	TIFF	180 KB		Trish H...Basi
▽ 📁 Flower Photos	Wildscaping.com	☐	Folder			
Eriogonum.jpg		☐	JPEG	42 KB		Trish H...1_So
Tithonia.jpg			JPEG	38 KB		Trish H...:01_S
Verbena.jpg		☐	JPEG	47 KB		Trish H...:01_S
Verbesina.jpg		☐	JPEG	47 KB		Trish H...1_So
Flower Symbol.tif	Dover Press	☐	TIFF	988 KB		Trish H...nma
Nectar Plants.ai	CyberMotion	☐	Vector Art	188 KB		Trish H...c Ani

8 bpc

Find a project item · New Comp · Delete selected project items · Project Flowchart View

New Folder · Project Bit Depth

△ **The Project Panel.** Clicking on the close button for the Project panel does not close the project file – it merely hides this panel. Instead, use File > Close Project.

Solids

When you create a Solid layer – a "blank slate" layer that After Effects can use for effects or simple shapes – they will also be automatically added to a Solids folder in the Project panel.

Multiple Views

· You can create multiple Comp panel viewers to either allow different looks at the same comp (helpful when working in 3D), or to quickly view different comps. To do this, use View > New Viewer.

are already using it in a composition, the name of the comps it appears in will be added to a popup menu to the right of its name. If you need to change some settings for a footage item – such as its frame rate, or alpha channel type – locate it in the Project panel, then open its File > Interpret Footage > Main dialog.

As projects become more complex, the Project panel can quickly become messy. Fortunately, you can create folders inside this panel to keep things organized. To do this, click on the Create a New Folder icon along the bottom of this panel or use the menu command File > New > New Folder, then drag items into and out of folders as you like. You can double-click a folder or use the arrow to its left to open and close it; to rename a folder, select its name, press **Return**, type in your name, and press **Return** again. (You'll be creating folders in Lesson 1.)

▼ Importing Footage

There are two main ways to add or "import" sources (known as *footage*) into an After Effects project. If you know where the source is, and generally what it looks like, use the File > Import menu item. This will open a dialog where you can browse to the file you want. Pay attention to the area under the file browser, as it contains important options such as whether you want to import the file as a single footage item or as a self-contained composition (handy for layered Photoshop and Illustrator files), whether you want to import a single still image or whole sequence of stills as a movie, and whether to import an entire folder in one go. You will learn how to import footage and layered files in Lesson 1.

The other approach is to use File > Browse, which launches Adobe Bridge: a handy utility standardized across Adobe applications. Using Bridge, you can sort and preview files; even search and purchase stock footage! Bridge is covered in more detail in Lesson 2.

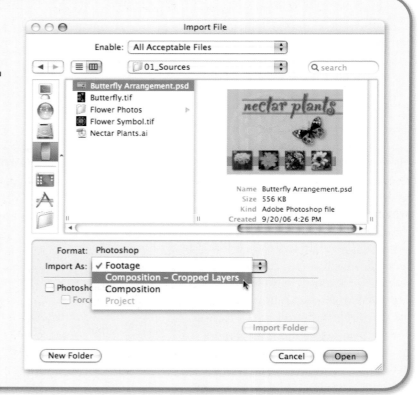

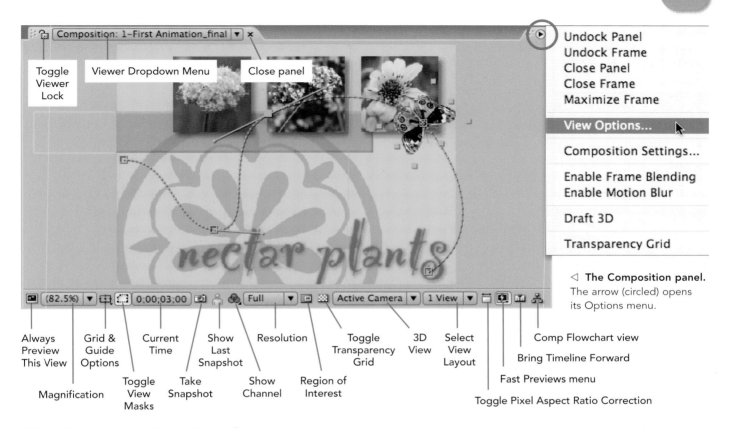

Toggle Viewer Lock

Viewer Dropdown Menu

Close panel

Undock Panel
Undock Frame
Close Panel
Close Frame
Maximize Frame

View Options...

Composition Settings...

Enable Frame Blending
Enable Motion Blur

Draft 3D

Transparency Grid

◁ **The Composition panel.**
The arrow (circled) opens its Options menu.

Always Preview This View

Grid & Guide Options

Current Time

Show Last Snapshot

Resolution

Toggle Transparency Grid

3D View

Select View Layout

Comp Flowchart view

Bring Timeline Forward

Magnification

Toggle View Masks

Take Snapshot

Show Channel

Region of Interest

Fast Previews menu

Toggle Pixel Aspect Ratio Correction

The Composition Panel

The Composition panel – or Comp, for short – is where you see your creations. It displays the current frame of your composition. You can also directly click on and drag the objects (layers) that make up your comp. After Effects renders only the pixels that fall inside the comp's image area (which we'll refer to sometimes as the Comp viewer), but you also have a pasteboard beyond this area to work with.

The buttons along the bottom of the Comp panel affect how you view the composite of your layers, such as magnification, resolution, color channels, and mask outlines. The tab along the top includes a popup menu that allows you to select which open comp to view.

Whenever you set Magnification to something other than 100%, After Effects will merely grab the nearest pixel when choosing which ones to display. This can result in the image looking very crunchy as pixels are

skipped – especially if you choose the "Fit" option in the Magnification popup. Don't panic; your final image won't look that bad when you render.

Note that magnification and resolution are two different things: magnification is the zoom level, while resolution decides how many pixels After Effects is going to process (Full means every pixel, Half is every second pixel in the width and height, and so on). For the most accurate visual results and fastest playback speeds, keep these two in sync – such as 100% magnification and Full resolution, or 50% magnification and Half resolution. And avoid the common mistake of working at less than 50% magnification while processing at Full resolution – why spend time rendering more pixels than your monitor is set to display?

The Comp panel's companion is the Timeline panel, which we'll show next.

The Timeline Panel

The Timeline panel gives you details on how the current composition is built: What layers it includes, what order they are stacked in, where they start and end, how they are animating, and what effects have been applied to them. It is the left brain to the Comp panel's right brain.

The Timeline panel is broken down into two sections: the timeline section to the right, which shows how the layers have been trimmed and any keyframes applied to them, and a series of columns to the left that display different switches, information, and options. The timeline section is also where the Graph Editor (introduced in Lesson 2) is displayed.

Like the Project panel, you may select which columns to view by right-clicking on any column header and selecting or deselecting it from the list that appears. These columns may also be dragged left and right to re-order them – we prefer placing the A/V Features column to the right near the timeline, rather than its default position of far left. Once you re-order these columns, all new compositions you create will have the same arrangement.

Unlike the Composition panel, the Timeline panel features a tab for each currently open comp, which makes it easy to see which ones are open and to quickly jump between them.

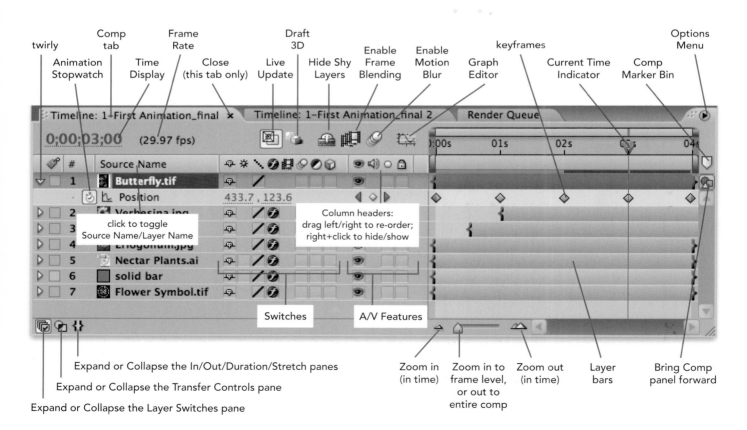

△ **The Timeline panel.** Click on a tab to bring that particular Composition and Timeline pair forward. Note that we have moved the A/V Features column (the column with the eyeball) to the right, so that the keyframe navigator arrows in this column are closer to the keyframes.

The Layer Panel

When you add a footage item to a comp, it becomes a layer in that comp, where it is combined with the other layers you've added. But there are times when it is hard to view what is going on with a particular layer in the Comp panel because it's fading out, has been effected or scaled down really small, has been dragged out of the visible area of the comp, or the view is otherwise confused by other layers. This is where the Layer panel comes in.

Double-click a layer in either the Comp or Timeline panels to open it in its own Layer panel. By default, it docks into the same frame as the Comp panel. The most interesting feature here is the View popup along the bottom right side. This gives you the option of viewing a layer before or

after a *mask* (cut-out shape) has been applied, as well as after it has been processed by any effects you have added to the layer. If you have added more than one effect, you can view it at any point in the effect chain. The Render checkbox to the right of the View popup is a quick and easy way to view the layer with or without the modifications selected in the View popup.

A layer may be slid in time in a comp's overall timeline. That means the local time in a layer – how far you are from its start – often will not match the master time in the comp. A second timeline and time marker in the Layer panel shows you where you are in the layer.

▽ **The Layer panel.** Some functions can be performed only in the Layer panel.

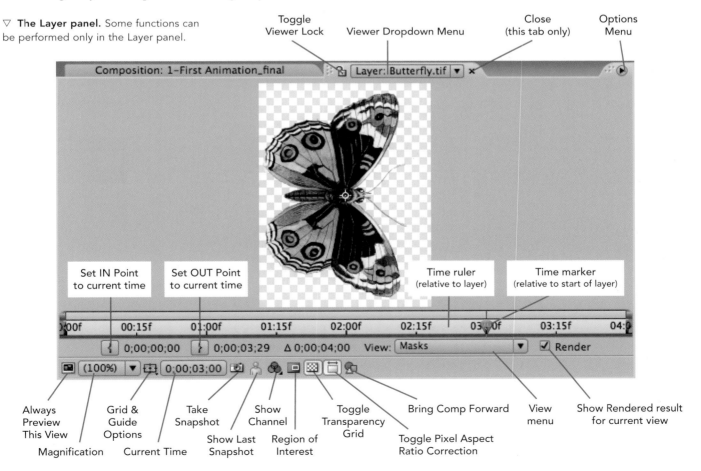

Other Panels

There are numerous other types of panels that we will be putting to work throughout this book; we will explain them in more detail as we need them. However, so they won't seem so foreign when you first encounter them, here's a quick overview of some you will use most often:

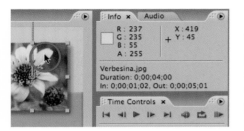

△ **The Info panel** displays information such as the color currently under the cursor.

Info

The top portion of this panel gives a numeric readout of the color value underneath the cursor in a comp, layer, or footage panel, as well as the cursor's current X/Y coordinates in those panels. Additional useful information – such as the in and out points of a selected layer – are displayed in the lower portion of this panel.

Click on the arrow in the upper right for the Options menu. Here you can change the color display to Percent, Web, and more.

△ **The Time Controls panel.**

△ Hide the RAM Preview Options to allow more room for other panels. Move your cursor over the area below Time Controls until the icon changes, then drag up.

Time Controls

Your transport controls in After Effects. Also contains options for RAM Previews (discussed in Lesson 2). Once you learn some basic keyboard shortcuts – such as the spacebar for Play – you will find you rarely, if ever, use this panel.

Audio

Volume controls for the selected layer, plus a level meter that is active while previewing a comp or layer.

When working with audio, you can also view the audio waveform in the Timeline panel; this is covered in Lesson 5.

△ **The Audio panel.**

Effects & Presets

This very handy panel provides a quick and easy way to select and apply Effects plug-ins and Animation Presets. The Contains box along the top provides a search function for your Effects and Presets, which is usually faster than searching through a menu or file dialog. It is discussed more in Lesson 3.

Effect Controls

When you add an effect to a layer, the effect's settings and user interface appear in this panel. The shortcut to open this panel is to select a layer and hit **F3**.

You can also reveal effects applied to a layer by selecting it and typing **E**, which will twirl them open in the Timeline panel. From there, you can click on the "twirly" arrow next to the effect's name to reveal its parameters.

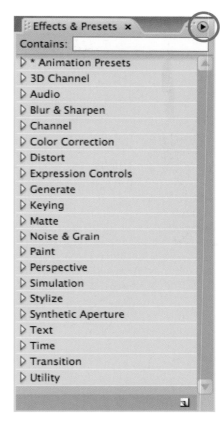

△ **The Effects & Presets panel.** In Lesson 3, a QuickTime movie will explain the different options available for searching and organizing effects and animation presets.

▽ tip

Maximizing

To temporarily view a panel full screen, select it and hit the tilde (⌐) key. Hit ⌐ again to switch back to the normal multiframe view.

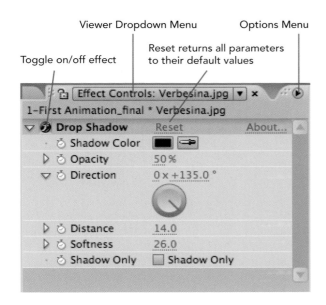

Viewer Dropdown Menu Options Menu

Reset returns all parameters to their default values

Toggle on/off effect

△ **The Effect Controls panel.**

▼ Other Panels

Character & Paragraph Panels

Covered in detail in Lesson 5 (page 108), these are the controls you need to help typeset text. Selecting Workspace > Text will open both panels.

Paint & Brush Tips Panels

After Effects contains a pretty nifty paint and clone engine, which will get a workout in Lesson 10. Selecting Workspace > Paint will open both panels.

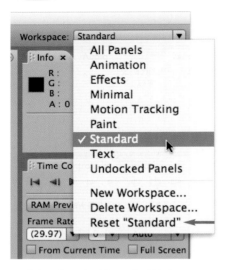

△ Select Standard from the Workspace menu. If you make a mess moving around panels, select Reset Standard. To save your new layout, select New Workspace.

△ Every frame has an arrow in its upper right corner; click on it to see its Options menu. The options at the top are universal to all panels and frames.

▽ tip

Quick Undocking

There are three ways to undock a panel and turn it into a floating window: using its Options menu (upper right corner), dragging it somewhere that a drop zone does not appear, or holding down the ⌘ key on Mac (**Ctrl** on Windows) and dragging it out of its current frame.

Managing Workspaces

After Effects comes with a number of preset workspaces, many of which open sets of panels that come in handy for doing specific tasks. You can select them by using the menu item Window > Workspace, or by clicking on the Workspace popup menu in the top right corner of the application window. Try out a few and notice how the panels and frames change. Then select the Standard workspace.

If you want to give a frame more or less room, move your cursor over the area between frames until it changes to an icon of two arrows connected to two parallel lines (see figure to the right). When you see this icon, click and drag to balance the size of adjacent frames, such as those that hold the Project and Composition panels.

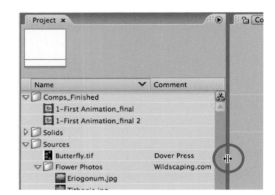

Every frame has an options arrow in its upper right corner. Click on it, and a menu will appear. The options near the top are universal to all panels and frames, such as undocking or closing panels. The options near the bottom are specific to the panel currently being shown in that frame (see page 5 for the Comp panel's Options menu).

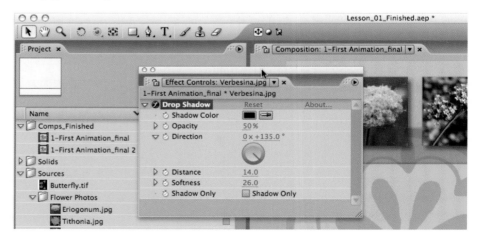

△ Here we show the Effect Controls panel after it has been undocked (in the Standard workspace, it shares the same frame as the Project panel). Once a panel is undocked, you can then dock more panels into this window, or drag this panel back into another frame.

With the Standard workspace still selected, turn your attention to the column of frames along the right side of the application window. The top frame has two panels docked into it: Info and Audio. The default in the Standard workspace is for Info to be forward; click on the tab that says Audio to bring it forward instead.

The row of dots to the left of the panel's name allow you to grab a panel to change where it is docked; the dots near the Options arrow moves the entire frame. Do this with the Audio panel: Click on its dots, then drag it until you are hovering over the middle of the Effects & Presets panel (see figure to the right). The center of the Effects & Presets panel will turn blue, indicating that if you were to release your mouse now, Audio would be docked into this frame instead. Keep the mouse depressed for now.

In addition to this central "drop zone" you will see four smaller zones around it. Drag to these and watch them highlight. If you release the mouse over one of these, you will create a brand-new frame for the Audio panel on that side of Effects & Presets. Finally, drag your cursor to the tab that says Effects & Presets until it highlights in blue: This option also means "add me to the same frame as this panel." Go ahead and release your mouse, and Audio will be tabbed into the same frame as Effects & Presets.

Now click on the Window menu, and select Character. It defaults into opening a new frame to the right of the Comp panel and frame. Drag its grab dots to dock it into the same frame as Effects & Presets and Audio. Notice that the gray bar appears above their tabs; this allows you to scroll between the tabs for the panels docked into the same frame.

Have some fun practicing rearranging the workspace. If you make a big mess, you can always select the Reset option from the bottom of the Workspace popup. If you have an arrangement you like, select New Workspace from the Workspace popup or Window > Workspace menu, and give it a name.

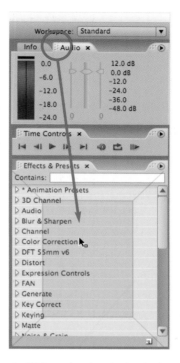 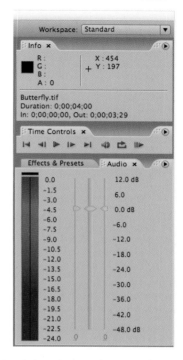

△ Click on the dots in the Audio panel and drag this panel on top of the Effects & Presets panel (left) or its tab. Once you release the mouse, the Audio panel will be docked into the same frame (right).

◁ A gray bar appears above a frame when there is not enough space to display all the panels within. This allows you to scroll left and right to view all panels.

▽ gotcha

Finding Your Way Home

After Effects remembers changes you make to a workspace, including the presets. You can't undo individual changes to a workspace. To get back to the current workspace's original layout, select the "Reset" option at the bottom of the Workspace menu, then click Discard Changes in the dialog box that pops up.

Basic Animation

Building your first animation while you learn a typical After Effects workflow.

▽ Getting Started

Make sure you have copied the **Lesson 01-Basic Animation** folder from this book's disc onto your hard drive, and make note of where it is; it contains the sources you need to execute this lesson. Our versions of these exercises are in the project file **Lesson_01_Finished.aep**.

In this lesson, you will build a typical After Effects project. You will see how to import sources while keeping your project file organized. As you add layers to a composition, you will learn how to manipulate their transform properties, as well as how to keyframe them to create animations. Along the way, you'll learn several important tricks and handy keyboard shortcuts, plus how to handle alpha channels as well as layered Photoshop and Illustrator files. Although the design itself is simple, you will learn principles you can use over and over again in the future.

Composition Basics

In the Pre-Roll section, we discussed the basic hierarchy of an After Effects project: Sources are called *footage* items; when you add a footage item to a *composition* ("comp" for short), it is then known as a *layer*. Potential sources can include captured video, Flash or 3D animations, photographs or scans, images created in programs such as Photoshop or Illustrator, music, or dialog…even film footage that has been scanned into the computer.

Layers are individual objects that can be arranged in a comp's space and animated around that space, similar to symbols in a Flash project or models in a 3D animation program. The order they are stacked in the comp's timeline determine the order in which they are drawn (unless they are in 3D space – we'll get to that in Lesson 8). Layers can start and end at different points in time.

All properties in After Effects start out static: You set them, and this is the value they have for the entire composition.

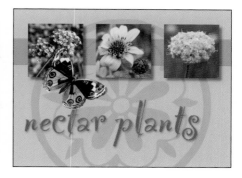

However, it is very easy to enable *keyframing* for virtually any property (including all of the *transform* properties), which means you can set what their value will be at different points in time. After Effects will then automatically interpolate or "tween" between these values over time.

You have considerable control over how After Effects moves between keyframes. In this lesson, we'll demonstrate editing the *motion path* for position keyframes, and in the next lesson we'll dive into further refining the speed at which After Effects interpolates between values.

Layers do not need to fill up the entire screen. It is quite common for a layer to be smaller than the composition, or to scale down a large layer to better frame it inside a comp. In addition to fading a layer in and out using its opacity, a footage item may also have an *alpha channel* that determines where the image is transparent and where it is opaque.

But before you start arranging and animating, you need to know how to make a new project and comp, as well as how to import sources – so let's get started!

After Effects compositions combine multiple layers together. Butterfly and flower shape courtesy Dover; flower photos courtesy Wildscaping.com.

▽ factoid

File Format Support

For a full list of file formats that may be imported in After Effects, open the program, press **F1** to open the Adobe Help Center, type "**file formats**" into the Search For box, and click on Search.

Individual layer properties may be keyframed in the Timeline panel to create an animation.

Timeline: 1-First Animation ✕		
0:00:02:00 (29.97 fps)		00:00f 00:15f 01:00f 01:15f 02:00f 02:15f 03:00f 03:15f 04:0

#	Source Name		
1	Butterfly.tif		
	Position	400.0 , 255.0	
2	Eriogonum.jpg		
	Position	390.0 , 96.0	
3	Verbena.jpg		
	Position	95.0 , 96.0	
4	Verbesina.jpg		
	Position	242.5 , 96.0	
5	Flower Symbol.tif		
	Scale	50.4 , 50.4 %	
	Rotation	0 x -96.7 °	
	Opacity	26%	
6	Nectar Plants.ai		
	Position	75.8 , 289.7	
7	Solid Bar		

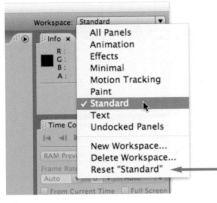

1 Set the Workspace to Standard and then reset it to make sure you are starting with the same arrangement of frames and panels as we are. That way, our instructions will make a lot more sense.

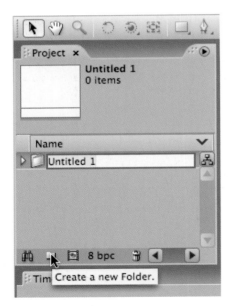

2 To create a new folder, click on the folder icon along the bottom of the Project panel. To rename it, type your new name while "Untitled 1" is highlighted, then press *Return*.

Starting a Project

In this first lesson, you'll create a colorful animation with a butterfly flying around some flowers. To see where you'll end up, locate the movie **1-First Animation_final.mov** in this lesson's folder, and play it a few times in QuickTime Player. Bring After Effects forward when you're done, and we'll guide you through building this animation from scratch.

1 When After Effects is launched, it creates a new, blank project for you. In the upper right corner of the application window, locate the Workspace popup, and select Standard. To make sure you are using the original arrangement of this workspace, from the same popup select Reset "Standard" (it's at the bottom). A Reset Workspace dialog will appear; click Discard Changes.

2 The Project panel can quickly become a confusing mess of sources and comps. To avoid this, let's create a couple of folders to help keep it organized. Click on the New Folder icon along the bottom of the Project panel. A folder called **Untitled 1** will be created. It defaults to its name being highlighted; to rename it, type "**Sources**" and hit *Return* (on a Windows keyboard, this is the main *Enter* key – not the one on the extended keypad). You can rename it at any time; just select the folder and hit *Return* to highlight the name.

3 Click in a blank area of the Project panel to deselect your **Sources** folder; the shortcut to Deselect All is *F2*. Now create a second folder, using the keyboard shortcut: ⌘ ⌥ *Shift* *N* on Mac (*Ctrl* *Alt* *Shift* *N* on Windows). Rename it "**Comps**" and press *Return*.

(If the **Sources** folder was selected when you created the **Comps** folder, **Comps** will be nested inside of **Sources**. Place it on the same level by dragging the **Comps** folder outside of the **Sources** folder.)

Saving a Project

4 Save your project by typing ⌘ *S* (*Ctrl* *S*). A file browser window will open; save your project file in this lesson's folder (**Lesson 01-Basic Animation**), and give it a name that makes sense, such as "**Basic Animation v1**".

It is a good idea to give projects version numbers so you can keep track of revisions; it also allows you to take advantage of the nifty File > Increment and Save function. Instead of just saving your project, Increment and Save will save your project under a new version number, leaving a trail of previous versions in case you ever need to go back. The shortcut is ⌘ ⌥ *Shift* *S* (*Ctrl* *Alt* *Shift* *S*). After Effects also has an Auto Save function; it's under Preferences > Auto-Save.

Creating a New Composition

5 Select the **Comps** folder you created in step 3. That way, the new comp you are about to create will automatically be sorted into it. Then either select the menu item Composition > New Composition, or use the keyboard shortcut ⌘ Ⓝ (*Ctrl* Ⓝ).

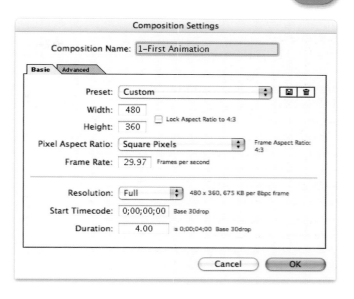

A Composition Settings dialog will open in which you can determine the size, duration, and frame rate of your new comp. At the top will be a popup menu for Preset, which includes a number of common comp sizes and frame rates. You can also enter your own settings. For this starting composition, uncheck the Lock Aspect Ratio box, then type in a Width of 480 and Height of 360. Click on the popup menu next to Pixel Aspect Ratio and select Square Pixels (we'll discuss pixels that are not square in the *Tech Corner* at the end of Lesson 3).

The last parameter in this dialog is Duration. Highlight the value currently there, and enter "**4.00**" for four seconds. Then make sure the remaining settings are at their defaults: Frame Rate of 29.97, Resolution of Full, and Start Timecode of 0;00;00;00. Don't worry too much if you miss something; you can always open the Composition Settings again later using ⌘ Ⓚ (*Ctrl* Ⓚ).

A good habit to get into with After Effects is naming your compositions as you create them. Enter "**1–First Animation**" in the Composition Name dialog, then click OK. Your new comp will open into the Comp and Timeline panels.

6 Your comp will also appear in the Project panel, inside your **Comps** folder (if it's not in there, drag it in). If you cannot read the entire name in the Project panel, just place your cursor along the right edge of the Name column and drag it wider. Finally, save your project.

Importing Footage

There are two main ways to import footage into After Effects: using the normal Import dialog, and using Adobe Bridge. We'll use the Import dialog here, and dive into Bridge in the next lesson. (You can also drag and drop from the Finder or Explorer, but that's awkward as the After Effects application window tends to take up the entire screen.)

7 It's time to import some sources into your project. First, select the **Sources** folder you created in step 2. Then use the menu item File > Import > File. Navigate to the **Lesson 01-Basic Animation** folder you copied from this book's disc, and open the folder **01_Sources**. Select the item **Butterfly.tif** and click Open.

5 These are the settings we will use for our first composition. Remember to uncheck the Lock Aspect Ratio box before typing in your new dimensions. You can always open the Composition Settings later by selecting your comp and typing ⌘ Ⓚ (*Ctrl* Ⓚ).

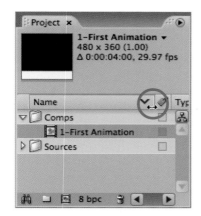

6 At this point, you should have a project with two folders and one composition. Notice the cursor to the right of the Name column in the Project panel; we just finished dragging this column wider to view our comp's entire name.

▼ Managing the Comp View

You learned in the Pre-Roll how to resize the user interface's frames. You can resize the frame that holds the Comp panel to decide how much screen real estate you can devote to it. There are several ways to control how this space is used to display the comp's image area:

• In the lower left corner of the Comp panel is a Magnification popup. A popular setting for this is Fit up to 100%, which uses as much of the Comp panel's frame as it can up to full size; that's the setting we used when creating most of these lessons and comps. A downside of the Fit option is that your image can look a bit crunchy if the result is an odd size, such as 78%. Therefore, some users prefer picking a set size such as 100% or 50% that gets close to using the space available, then resizing the frame again as needed.

• You can hold down ⌘ (*Ctrl*) and press the ◼ key to zoom in larger, or the ◼ key to zoom out smaller.

• If you have a mouse with a scroll wheel, hover its cursor over the Comp panel, and use the wheel to zoom in and out.

• For more targeted zooming, select the Zoom tool (short-cut = Ⓩ), and click to zoom in and center around where you click, or ⌥+click (*Alt*+click) to zoom out. Don't forget to press Ⓥ when done to return to the Selection tool!

• Even better, press and hold down the Ⓩ key to *temporarily* switch to the Zoom tool; add ⌥ (*Alt*) to Zoom out. When you release the Ⓩ key, the Selection tool will still be active.

• To pan around your composition, hold down the space bar to temporarily bring up the Hand tool, then click and drag in the Comp panel to reposition it. (Tapping the spacebar previews the timeline.)

8 The Import dialog will be replaced with an Interpret Footage dialog. This file has an *alpha channel*: a grayscale channel that sets the transparency of the RGB color channels. There are two main types of alpha channels: *Straight*, which means the color has been "painted beyond" the edges of the alpha channel, and *Premultiplied*, which means the color is mixed ("matted") with the background color around the edges.

If you knew what type of alpha your file has, you could select it here. Since you don't, click Guess. In this file's case, After Effects will choose the Straight option, which is correct. Click OK, and it will appear in your **Sources** folder.

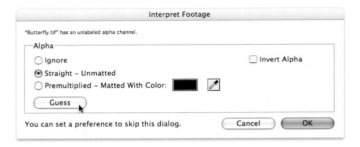

8 To get the best results out of sources with alpha channels, you want to select the correct alpha channel type. You can do this while importing a file, or any time later. After Effects has a Guess function to help.

9 Now it's time to import some more sources. Make sure the **Sources** folder (or a file inside of it) is still selected, and use the shortcut ⌘Ⓘ (*Ctrl* Ⓘ) to open the Import dialog. Select **Flower Symbol.tif**, then *Shift*+click to also select **Nectar Plants.ai**, and click Open. The Interpret Footage dialog will re-appear for the former; use Guess as you did before (After Effects will correctly guess Straight), and click OK.

10 Finally, double-click on an empty area of the Project panel – this will also open the Import dialog! Select the folder named **Flower Photos**, and click the Import Folder button. This will import all the contents of the folder for you with a single click; it will also create a folder with the same name in the Project panel. Drag the **Flower Photos** folder inside your **Sources** folder, and save your project.

Building a Comp

Now that you have your sources, you can add them to your comp, arrange them, and have some fun animating them. First, make sure the Timeline and Composition panels have the name of your comp (**1-First Animation**) in a tab along their tops. If not, double-click this comp in the Project panel to open it.

Transform Fun

11 Select the footage item **Nectar Plants.ai** in your **Sources** folder in the Project panel, and drag it over to the image area of the Composition panel. While keeping the mouse button down, drag it near the center of the comp: You will notice After Effects tries to snap it into the center for you. With the mouse button still down, drag near the four corners of the comp: After Effects will try to snap the outline of the source against these corners.

Place it in the center, and release the mouse. It will be drawn in the comp's image area, and appear as a layer in the Timeline panel as well.

After importing your sources, your Project panel should look like this.

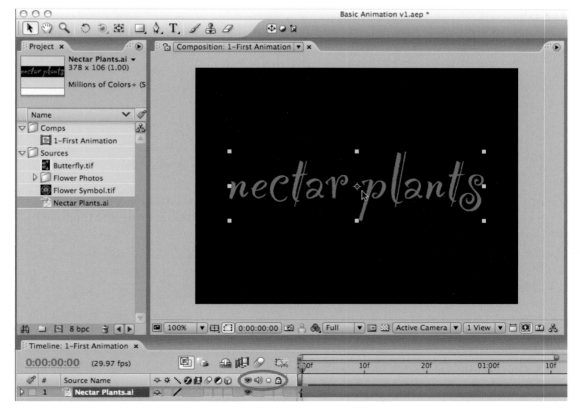

11 When you first drag a footage source into the Comp panel, it will helpfully try to snap to the center or corner of the comp's image area. (From then on, the layer will behave normally, with no snapping behavior.) The layer will appear in the Comp and Timeline panels.

By the way, we have dragged the Timeline's A/V Features column (circled in red) from its default position over to the right, to be near the timeline. You can do the same by dragging the column header to the right until it drops into place.

12 Pick a golden orange for this comp's background color.

13 To "scrub" a value in the Timeline, place the cursor over the value until a two-headed arrow appears, click, and drag. Scale has its X and Y dimensions locked together, so scrubbing one value also changes the other.

14 Highlight a layer, then use the Selection tool (shortcut **V**) to interactively scale a layer by dragging its corners in the Comp panel. The values in the Timeline will update while you drag. It is easy to distort the "aspect ratio" of a layer while doing so (as we are here); add **Shift** while dragging to constrain a layer's proportions.

12 The Comp's background color defaults to black, and the purple text is not easily readable. Let's change that:

Select the menu item Composition > Background Color. A color swatch and eyedropper will appear. Click on the color swatch; the standard Adobe Color Picker will appear. Select a golden orange to complement the purple title. Click OK, and OK again in the Background Color dialog to accept your changes.

Check to make sure the text is easily readable against your new background color; if not, change it!

13 In the Timeline panel, click on the arrow to the left of **Nectar Plants.ai**: This will reveal the word Transform. Click on the arrow to the left of Transform; this will reveal all of the Transform properties for this layer. In the future, we will refer to clicking these arrows as "twirl down" (and "twirl up" when closing a section).

Notice the numeric values next to each property: Place your cursor over one, then click and drag while watching the Comp panel to see the effect of editing these properties. This technique is referred to as *scrubbing* a value, and is a skill you'll use over and over in After Effects.

You can also type an exact value by clicking a value, which makes that field active. Press **Tab** to advance to the next value, and press **Return** when done.

Some properties – such as Scale and Position – have separate X (horizontal, or left-right) and Y (vertical, or up-down) dimensions to their values. By default, Scale's X and Y dimensions are locked together to prevent distorting the layer; you can unlock them by clicking on the chain link icon next to their value.

14 After you've experimented with scrubbing, click on the word Reset next to Transform to return these values to their defaults. Next you're going to play with directly manipulating the layer in the Comp panel to edit its Transform properties. While doing so, keep an eye on the values in the Timeline panel to get a better feel for what's going on.

• To edit Position, directly click on and drag a layer in the Comp panel. To constrain movement to one dimension, start to drag the layer, *then* hold down the **Shift** key and drag some more.

• To edit Scale, click and drag one of the eight square dots ("handles") around the outline of the layer in the Comp panel. To avoid distorting the layer and keep its original aspect ratio, start to drag the layer, *then* hold down the **Shift** key and drag some more.

• To edit Rotation, press **W** to select the Rotate tool (also known as Wotate), click on the layer, and drag around in circles. When you're done, press **V** to return to the Selection tool (➤).

As before, click on the word Reset next to Transform to return these values to their defaults.

Animating Position

Now you know how to transform a layer manually; next comes making After Effects transform a layer for you over time. This involves a process known as keyframing.

15 There are keyboard shortcuts to reveal select Transform properties. Click on the arrow to the left of **Nectar Plants.ai** to twirl up all the properties, then with the layer selected, type **P** to reveal just Position.

You're going to make this layer move onto the screen and settle into place. Decide where you want the layer to start (you can even drag it totally onto the pasteboard). Then make sure the current time marker is at the start of the time-line (the numeric time display in the Timeline panel should read 0;00;00;00). If it isn't, grab the blue head of the current time marker and drag it there, or press **Home** to quickly make it jump to the start.

To the left of the word Position is a small stopwatch icon. Click on it, and it will now be outlined and highlighted. You have now enabled Position for keyframing and animation. [The shortcut to toggle on and off the Position stop-watch for a selected layer(s) is **Opt Shift P** (**Alt Shift P**).] Enabling keyframing also places a keyframe (indicated by a yellow diamond to the right in the timeline portion of the display) at the current time, using Position's current value.

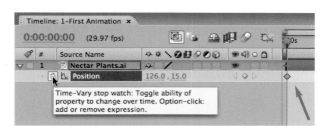

16 Press **End** to make the current time marker jump to the end of your timeline. Pick up and drag the **Nectar Plants.ai** layer where you want it to end up. A new keyframe will auto-matically be created for you with this value, at the current time.

You may have noticed that a line appeared in the Comp panel, tracing the path from where your layer started to where it is ending up. This is known as the *motion path*. It is made up of a series of dots. Each dot indicates where that layer will be at each frame in your timeline. The motion path is visible only when the layer is selected.

Drag the current time marker back and forth along the top of the timeline, and notice how your layer moves along its motion path. To see what it would look like playing back in real time, press **0** on the numeric keypad to initiate a RAM Preview. After Effects will work its way through the frames once at its own speed, then make its best attempt to play back the animation in real time. Press any key to stop the preview.

▼ Transform Shortcuts

The following shortcut keys reveal specific Transform properties for the selected layer(s):

A Anchor Point

P Position

S Scale

R Rotation

T OpaciTy

To add a property to those already being displayed, hold down **Shift** when you press these shortcuts.

15 In the Timeline panel, click on the stopwatch icon next to the word Position to enable keyframing for it; this also creates the first keyframe (the yellow diamond).

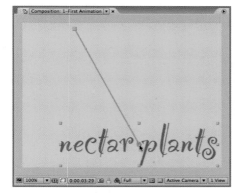

16 Move to a different time, and drag the layer to a new position; a motion path will appear in the Comp panel illustrating its travels.

▽ factoid

Space = Speed
The spacing between dots along the motion path gives a quick visual indication of how fast it is moving. The farther apart the dots, the farther that layer will travel between frames, and therefore the faster it is going.

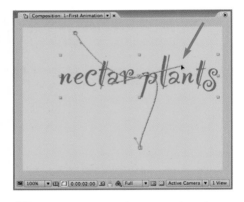

18 In the Comp panel, you can drag the handles sticking out of a keyframe to easily manipulate the motion path into and away from that keyframe.

20 Under the A/V Features column are a pair of keyframe navigation arrows, which make it easy to jump to the previous or next keyframe for a given property. If the diamond between them is yellow, the current time marker is parked on top of a keyframe.

Editing Your Moves

17 Drag the current time marker to somewhere around the middle of the timeline (about 02:00). Now pick up and drag **Nectar Plants.ai** to a new location. After Effects will automatically create a new keyframe between the existing two keyframes, and alter the motion path to travel between all three of your keyframes. Confirm this by dragging the current time marker back and forth, or do a RAM Preview by pressing **⓪** on the numeric keypad.

To change the position of a keyframe in the Comp panel, simply select one of the square keyframe icons (it will change from being hollow to being solid), and drag it to a new position. You don't have to move to that point in time to reposition a keyframe in space.

18 You will notice some handles have appeared in the Comp panel, sticking out of your keyframes. These are known as *Bezier* handles (named after the type of curve they create), and allow you to tweak the curve of the motion path. Go ahead and experiment with dragging these around, previewing the effects of your edits. You can create complex paths with few keyframes just by manipulating these handles.

19 It is easy to change the timing of keyframes: In the Timeline panel, drag the diamond keyframes to the right or left to make them occur earlier or later in time. RAM Preview to see the new timing.

20 You can also easily edit the value of a keyframe after you've created it. In the A/V Features column of the Timeline panel are a pair of gray arrows surrounding a small diamond. These are known as the *keyframe navigation* arrows. Clicking on them will jump to the next keyframe in line for that property, confirmed by the diamond changing from hollow to yellow. Once you're "parked" on a keyframe, to edit that keyframe either scrub the layer's Position values, or drag the layer around in the Comp panel.

If you don't jump to the exact time of a previously existing keyframe, you will instead create a new keyframe. If you create one by accident, you can delete it by selecting it in the timeline and pressing Delete. Or, use the keyframe navigation arrows to jump to it, then click on the yellow diamond between the arrows to remove it.

Save your project. Indeed, now would be a good time to use the File > Increment and Save option, so your work to date will be saved under a new version number.

Adding a Second Layer

Now that you know how to animate Position, you pretty much have all the skills you need to animate virtually any other property in After Effects. But first, let's learn a few more tricks for adding footage to a comp:

21 In your **Sources** folder in the Project panel, select the footage item **Flower Symbol.tif**:

• Drag **Flower Symbol.tif** down to the *left side* of the Timeline panel, near the name of your other layer (**Nectar Plants.ai**). Hover your cursor above your existing layer, and you will see a thick black horizontal line, which indicates you're about to place it above this layer. Drag it downward until this line disappears and release the mouse. The new layer is placed below the existing layer. Note that no matter where the current time marker was parked, the new layer starts at the beginning of the comp (00:00).

• Press ⌘ Z (Ctrl Z) to Undo this addition, and try another method. This time, drag **Flower Symbol.tif** to the *right side* of the Timeline panel until your cursor is hovering over the timeline area. You should see a second blue time marker head appear. This indicates where it would start in time if you were to release your mouse now, and provides an interactive way to decide your initial starting time.

You can also move it up and down in the layer stack. Pick some location in the middle of the timeline, and release the mouse. The new layer will be added at the time you've picked. Note that with both methods, the layer is added to the center of the comp.

22 Drag the current time marker back and forth, and notice how the flower symbol does not appear in the Comp viewer until after the time marker crosses the start of the layer in the timeline. You can click and drag the center of the layer bar for **Flower Symbol.tif** to make it start sooner or later in time. Finally, with **Flower Symbol.tif** selected, press ⌥ Home (Alt Home) to make it start at the beginning of the comp.

While you're having fun, practice dragging each layer above and below the other in the timeline stack, noticing the impact this has on how they are drawn in the comp's image area. For now, place **Flower Symbol.tif** on top of **Nectar Plants.ai**.

▽ tip

Quick Location

To make a layer start where the current time marker is, select it and press (left square bracket). To have it start at the beginning of the comp, select it and press ⌥ Home (Alt Home).

21 When you drag a new source from the Project panel to the Timeline panel, you can decide when and where to drop it in the layer stack. Notice the ghosted outline and second current time marker before we let go of the mouse (top), and how it corresponds to the layer's placement after we let go (above).

▽ tip

Multiple Undos

You have 32 levels of Undo in After Effects. If that's not enough, you can set it as high as 99 in Preferences > General.

▽ key concept

Anchor Point

Notice how the flower symbol scaled and rotated around its center? That's because we centered it when we made it. You won't be so lucky with other sources; they may appear to wobble when they rotate. The cure for this is setting the Anchor Point, which you'll learn in Lesson 2.

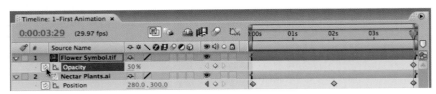

24 At the end of the comp, set **Flower Symbol**'s Opacity value to 50% and then turn on the stopwatch for Opacity.

▽ tip

Slow Scrubbing

To scrub a value by smaller increments for precise control, hold down the ⌘ (*Ctrl*) key while scrubbing. To jump by larger increments, hold down *Shift* while scrubbing.

Animating Opacity, Scale, and Rotation

When animating your first layer, you picked its starting location, then its end location. It's also fine to work in reverse: Arrange your layer where you want it to end up, then keyframe where it came from.

23 Press *End* to jump to the last frame in your comp (03:29). In the Comp panel, drag **Flower Symbol.tif** to a nice place in relation to your title layer. Don't worry about covering up some of the letters; we're about to fix that…

24 With **Flower Symbol.tif** selected, press **T** to reveal its Opacity. Scrub this value, and notice how the purple title starts to become visible through the white flower graphic. Pick a nice intermediate value, like 50%.

Click on the stopwatch icon to the left of the word Opacity. This will set a keyframe for this value at this point in time.

25 With the flower layer still selected, hold down the *Shift* key and press **S**. This will add Scale to the Opacity value you are already displaying. You can scrub the Scale value to pick a new ending size for this layer, or leave it at 100%.

Click on Scale's stopwatch to enable keyframing for this property as well.

26 Now type *Shift* **R** to also reveal Rotation.

With Rotation at 0 degrees, click on Rotation's stopwatch to enable keyframing for it, too.

27 Press *Home* to jump to the start of the comp. Scrub the *second* Rotation value (degrees) to pick a starting pose for the flower; notice that if you scrub the degrees past 359, the first value (revolutions) will change to a 1. Because your second keyframe has a value of 0, a negative value for the first keyframe will cause the flower to rotate clockwise to 0, while a positive value will cause it to rotate counterclockwise to 0. The larger the value, the more it will rotate over time. Set a value to taste, and a new keyframe will automatically be added for you.

Go ahead and preview your animation; if you aren't happy with the rotation, return to the first keyframe (use the navigation arrows, or press *Home*) and try a different value.

28 At 00:00, play with the Scale and Opacity values to create starting keyframes for them also. This is the type of animation where it may be interesting to have both start out with a value of 0. To do this, click on their current value to select it, enter 0, and hit *Return*.

Preview your results, and tweak to taste. This is the point where you might want to start trying out some different ideas for the timing of your animation. For example, try moving the second and last Position keyframes for **Nectar Plants.ai** earlier in time, so the title finishes its move before the flower does.

Another idea is to set the first Scale and Opacity keyframes for **Flower Symbol.tif** to something larger than 0 (such as 25), and drag them to start later than the first Rotation keyframe: This will cause a small, transparent version of the flower to spin in place before it zooms up. Oh – and save your project!

28 After animating Scale, Rotation, and Opacity for **Flower Symbol.tif** (top), it zooms, spins, and fades up into position (above).

▽ try it

Smooth Moves

By default, After Effects creates linear keyframes in the timeline. These result in sudden starts and stops. Keyframe interpolation and velocity are covered in the next lesson. But until then, to add a more elegant touch, select a keyframe and hit **F9** to apply the Easy Ease keyframe assistant to give it smooth starts and stops.

(Mac users will have to change Exposé in System Preferences to free up the shortcuts **F9** – **F12**.)

▼ Nudging Position, Rotation, and Scale

Sometimes it's easier to use the keyboard to nudge the transform values for a layer. Here are the magic keys:

Position: cursor keys ⬆ ➡ ⬅ ⬇

Rotation: numeric keypad's ➕ and ➖

Scale: ⌥ (*Ctrl*) plus numeric keypad's ➕ and ➖

If you hold down the *Shift* key while doing any of these, the transform values will jump in increments of 10 rather than 1.

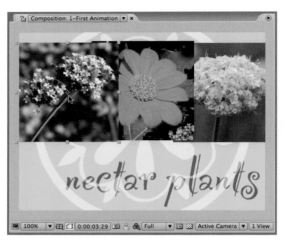

29 Drag in three of the flower photos, and arrange them roughly in a line along the top.

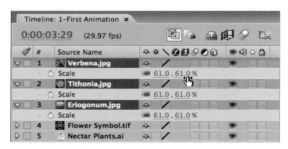

30 Scale down all three flower photos together by *Shift*-clicking all of them and scrubbing the Scale value for one (above). All three change size (below).

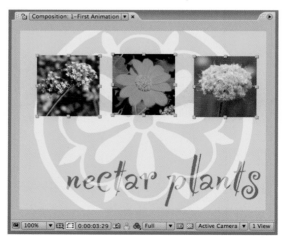

Arranging and Animating Multiple Layers

Next, you will see how to manipulate more than one layer at the same time. In general, if you select multiple layers and edit a parameter for one of them, all of the other selected layers will get the same change, making your work go much faster.

29 Inside your **Sources** folder in the Project panel, double-click on the **Flower Photos** folder to twirl it open. There are four to choose from; pick three and drag them into the Comp view, then arrange them roughly in a line along the top.

30 They're a bit large, so you will need to reduce their scale. To adjust all of their sizes together, do this:

• *Shift*+click on the three images to select them all. You can do this in the Comp or Timeline panels; it's easier in the Timeline.

• Press **S** to reveal the Scale parameter for all three.

• Scrub the Scale value for one of them; all three will scale together as you scrub. Pick a size where all three will fit across the top of your comp with enough space between them to look nice.

31 Now that you've scaled down these three photos, it's time to get them into a line. You can do this by eye, or by numerically editing their Position values. However, there's a feature in After Effects that makes it even easier:

Press **F2** to Deselect All, then drag the left and right photos where you'd like them to be horizontally in the comp; don't worry about lining them up perfectly. Then open Window > Align & Distribute. It will open in a new frame in the user interface, which takes up more screen space than needed; dock it into the frame that currently has the Effects & Presets panel, and resize the Comp panel if needed to still see its entire image area.

Select all three of your photos, and type **P** to reveal their Position and note their values. In the Align & Distribute panel, click on the Horizontal Center Distribution icon (lower row, second from the right) to space the middle photo evenly between the two end photos. Then click the Vertical Center Alignment icon (upper row, second from right) to place them all on the same line; you can verify the result by looking at their new Position values.

With the three photo layers still selected, you can continue to nudge them into place one pixel at a time by using the cursor keys, or by dragging one of them – the other two will follow.

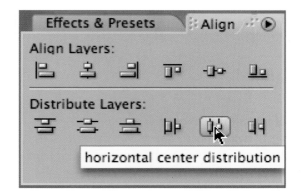

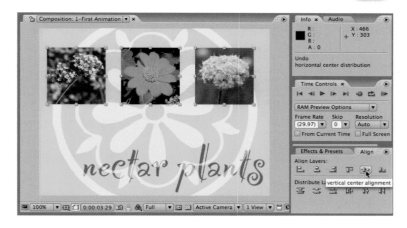

32 Now that you have your end placement, you will animate the photos to come from somewhere else to this location. Move the current time marker to around two seconds into your timeline. To do this numerically, click on the time display in the Timeline panel, type "**200**" and click OK or hit *Enter*.

With all three photos still selected, click on the Position stopwatch for one. Keyframing will be enabled for all three (very handy!). Press *Home* to send the time marker to 00:00. Then use the up cursor to move all three photos off the top of the screen; keyframes will be set for all three. If you hold down the *Shift* key while doing this, they will jump 10 pixels at a time, instead of just 1. Preview your work, edit to taste, and save your project!

31 Select the three photos, open Window > Align & Distribute, and click on Horizontal Center Distribution to evenly distribute their X positions (left). Click on Vertical Center Alignment to line up their Y positions (right).

▽ try it

Swapping Layers

It's easy to replace the source for a layer you've already animated. After step 33, select the flower photo you did not use from the Project panel. Next, select a flower layer you would like to replace in the comp (make sure the other two are not selected). Then press ⌥ (*Alt*) and drag in the replacement layer. RAM Preview; your new source will have the same transforms and animation as the original!

32 You can keyframe all three flower photos as a group to make them drop in together from the top.

▼ Spatial Keyframe Types

The position keyframes in the Comp viewer are referred to as spatial keyframes, as they define where the layer is supposed to be in space at a given time. How the motion path flows into and out of a spatial keyframe is also important, and can be deciphered both by looking at the path itself, and by looking at a selected spatial keyframe:

• The default spatial keyframe type is Auto Bezier. It is indicated by two dots in a straight line on either side of the keyframe (A). This means After Effects will automatically create a smooth bend through this keyframe.

• Dragging one of these dots results in the keyframe being converted into a Continuous Bezier type, indicated by the straight line ("handle") that connects the dots (B). You can drag this handle to explicitly control how the motion path flows through the keyframe.

• If you want to create a sudden change in direction at the keyframe, hold down **G** and drag one of the handle's dots to "break" their continuous nature. You can then drag the handles of this Bezier keyframe independently (C).

• To create a hard corner without a curve or handles, hold down **G** and click the keyframe's vertex itself to convert it to a Linear keyframe (D).

• To return a Linear keyframe to an Auto Bezier keyframe, hold down **G** and click on the keyframe again. Press **V** to return to the Selection Tool when done.

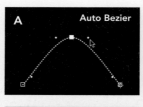
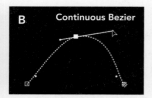
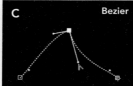
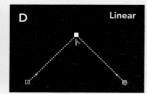

Adding a Flying Flower

Building on skills you've already learned in this lesson, add one more touch: A butterfly flitting across the screen. Then we'll show you a twist…

33 With your comp selected, press **Home** to return to 00:00. Select **Butterfly.tif** from your **Sources** folder in the Project panel, and drag and drop it somewhere near the left edge of your comp, so it's on top of all the other layers. Scale it down to an appropriate size compared with the flower photos.

34 With the **Butterfly.tif** layer selected, press **⌥ Shift P** (**Alt Shift P**): This will enable keyframing for Position, and reveal it in the timeline. Move a little later in time, and move the butterfly to a new position, perhaps flying around the flower photos. Do this a few more times until you reach the end of the timeline, then edit the keyframes as needed:

• To move a keyframe's position in the Comp panel, select it (it will change from a hollow square icon to a solid square), then drag it to a new position. **Shift**+click to select multiple keyframes to move.

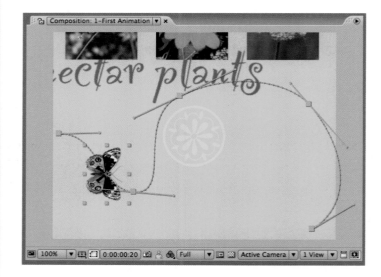

34 Create several Position keyframes over time for the butterfly, and edit the motion path's Bezier handles in the Comp panel to bend its path. One problem: the butterfly is always facing to the right, not where it's flying…

• When you select a keyframe, you may see a pair of dots with no line connecting them. This means After Effects is using the default "Auto Bezier" keyframe type, which creates a smooth curve automatically. Drag one of the dots and the regular Bezier handles will appear. Remember that a keyframe must be selected to see its handles, and a layer must be selected to see its motion path!

Edit the motion path's Bezier handles to create a fun, looping path (but don't worry about the rotation just yet). There's a good chance that when you do a RAM Preview, your butterfly will speed up and slow down as it moves between keyframes; you can also verify this by looking at the spacing of the dots in the motion path. We'll get into editing the speed of a layer in more detail in the next lesson, but for now, try sliding the Position keyframes earlier or later in the Timeline panel to roughly even out the spacing of the motion path dots.

▼ Backgrounds, Solids, and Transparency

The Background Color is not really a layer in your composition. You can see it in the image area, and if you render to a file format that does not have an alpha channel (such as a DV movie or sequence of JPEG stills), it will appear – but inside After Effects, it's actually transparent. This means if you placed (or *nested*) this comp into another comp, or if you rendered to a file format that also included an alpha channel, the background color would disappear. If you want to fill in the background of your composition with a color that will always be there, use a solid (Layer > New > Solid) instead.

When you view the RGB channels of your comp, the Background Color is evident. However, if you were to view the alpha channel of the comp (right), you would see that it is actually transparent, represented by the black areas in the image (black = transparent, white = fully opaque, and gray means the underlying RGB pixels are partially transparent). You can use the Show Channel popup along the bottom of the Comp panel to switch between these views.

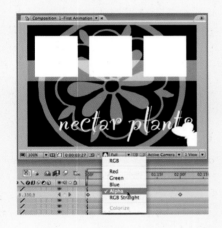

The Toggle Transparency Grid button (the checkerboard icon a little over to the right of this popup) is another way to check transparency in a comp.

35 You might have noticed that your butterfly remains stubbornly pointed to the right, no matter how you loop around its animation path. You could try animating its rotation to match, but there's an easier way.

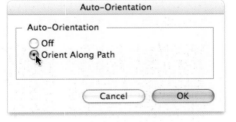

With **Butterfly.tif** selected, select Layer > Transform > Auto-Orient. In the dialog that pops up, select the option Orient Along Path. Click OK, and preview your animation: Your butterfly will now always look where it's going!

35 After setting the butterfly's Auto-Orientation to Orient Along Path (top), it always faces where it is going (above sequence). Note that if the butterfly ends up pointing in the wrong direction, you could edit its Rotation value to fix it without affecting the auto-orientation behavior.

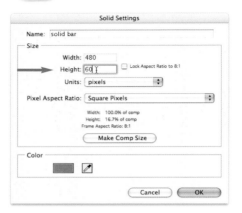

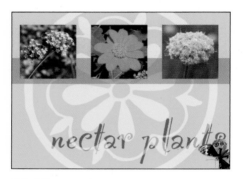

36–38 Create a Solid layer, color it red, and use it as a graphical element to tie together the three flower photos.

Solid Design

Footage items are not the only things that can be layers in a comp. For example, After Effects can create *solids*, which are simple graphical elements of a solid color.

36 Select Layer > New > Solid; the keyboard shortcut is ⌘ Y (*Ctrl* Y). To create a full-width bar, click on the Make Comp Size button; this will create a solid that fills the entire comp. Then enter a smaller value for Height, such as 60.

Next, click on the color swatch along the bottom of the dialog, and select a color you think would nicely complement your other elements (say, red), and click OK. Give it a name such as "**Solid Bar**" and click OK.

37 In the Timeline panel, drag and drop **Solid Bar** up and down the layer stack, seeing where it looks best interwoven with the other layers (the comp's image area will not redraw until you release the mouse, so this will involve some trial and error). If you like, type **T** and reduce its Opacity as well.

38 Finally, nudge the position of your solid up or down to nicely balance the frame. There is no right or wrong answer; you could try the middle, centered behind the photos or title, or acting as an underscore to anchor the photos. Save your project at this point.

Quick Effects

You've created a nice little animated composition here, but it looks a touch flat. Let's apply a few effects to give a sense of depth and help colorize some layers. (We'll cover effects more thoroughly in upcoming lessons; we just wanted to give you an early taste…)

39 Add Effect > Perspective > Drop Shadow to one of the flower photos. Tweak the effect's Distance and Softness to taste.

39 To see things in context, move the current time marker to some point where all of your layers are visible. Then select one of the flower photo layers you added in step 30, and select the menu item Effect > Perspective > Drop Shadow. An Effect Controls panel will open, docked into the same frame as the Project panel (assuming you are using the Standard workspace).

Scrub the Distance and Softness parameters in Drop Shadow's Effect Controls until the flower photo appears to float nicely off the background.

40 Once you have a look you like, add it to the other photos. Fortunately, you don't have to reinvent the wheel every time you want to reuse an effect: Click on the effect name Drop Shadow in the Effect Controls panel, and copy it by typing ⌘ C (*Ctrl* C). Then click on one of the other flower photo layers in

the Timeline panel, and ⌘+click (*Ctrl*+click) on the third to select it as well. Type ⌘ V (*Ctrl* V), and your shadow will be pasted onto the other two photos.

41 Select **Nectar Plants.ai**, and paste again: You will get a shadow, but it will appear much larger and more diffuse. This is because you scaled down the photos compared with the title, and After Effects calculates effects first, followed by transforms such as scale. No problem: Reduce the Distance and Softness values for **Nectar Plants.ai** to make it look more appropriate.

42 Let's change the color of the graphical flower to better match the flower photos. Select **Flower Symbol.tif**, and apply Effect > Generate > Fill, which will fill the image with a new color – initially, a pure red.

42 The Fill effect.

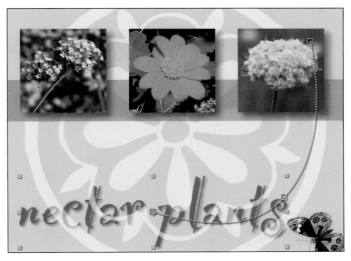

41 Copying and pasting the Drop Shadow effect to the title results in a big, soft shadow, as its Scale value is larger than the flower photos. Reduce the title's Distance and Softness until it looks appropriate compared with the other layers.

To better harmonize your elements, pick a color from one of the flower photos. Click on the eyedropper icon next to the Color swatch in Fill's controls, then click on the green background in one of the photos. Feel free to tweak your initial selection using the color picker.

If the flower is now too prominent in the final composite, move to its last Opacity keyframe and alter the final opacity to taste.

43 For a final touch of dimension, select **Solid Bar** and apply Effect > Perspective > Bevel Alpha to add an edge to it. You can scrub the Edge Thickness value to change its size.

Save your project!

43 The final composition. Of course, yours does not have to look exactly like ours; feel free to exercise your own design judgment to arrange and animate the layers the way you see fit!

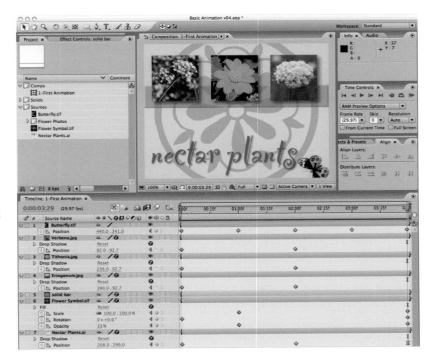

▼ Importing Layered Photoshop and Illustrator Files

In this lesson, you learned how to build a composition from scratch in After Effects by importing sources, dragging them into a comp, arranging them to taste, and animating them. Indeed, this is our preferred way of working.

However, some of you may be more familiar working in Photoshop or Illustrator, and may want to start your project there. Perhaps you work for a company with a separate print department where they use Photoshop or Illustrator, and they want to hand you their files to now animate for video or the web. After Effects also accommodates this type of workflow.

After Effects can import Photoshop and Illustrator files several different ways: flattened into a single image, selecting just a single layer to bring in, or as a composition where all of the layers exist as their own footage items which you can then animate and re-arrange. Let's try all three options in that order:

1 Select your **Sources** folder in the Project panel, and type ⌘ I (Ctrl I) to import a file. Navigate to the **Lesson 01** folder you copied from this book's disc, open it, then open the **01_Sources** folder inside that. Locate the file named **Butterfly Arrangement.psd** and select it.

Turn your attention to the bottom of this dialog, and click on the Import As popup. Here you see options of whether to treat this file as a single source or as a composition. These options are presented again later, so the best choice here is to just accept the default (Footage) and click Open.

2 A second import dialog will open. The top popup – Import Kind – is similar to the Import As dialog; for this first exercise, make sure it

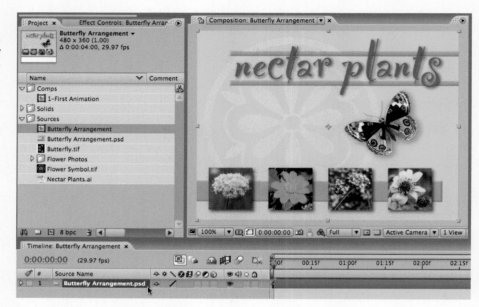

2–3 You can import a layered file as a single footage item (and either merge all the layers, or select a single layer), or a composition (includes all layers). If you choose to import as Footage (above), you will get a single layer in After Effects (top).

says Footage as well. Then look under Layer Options: You have a choice of whether to bring in the entire layered file merged into a final image, or to choose just a single layer. For now, choose Merged Layers, and click OK.

3 A single footage item will be added to your project. Select it, and select File > New Comp From Selection (you can also drag it to the Create a New Composition button at the bottom of the Project panel). After Effects will create and open a comp that is the same size as your file, flattened to a full-frame single layer without access to the individual elements.

4 Repeat step 1, but this time in step 2 select Choose Layer under the Layer Options in the second dialog. Pick a layer from this popup, such as **Butterfly**. Underneath it, the Footage Dimensions popup will become active. If you select Document Size, After Effects will create a footage item the size of the entire layered file, with this one layer placed where it was in the original file.

We prefer the option Layer Size, which auto-trims the layer to just the pixels needed. Select it, and click OK.

6 In After Effects 7, import as Composition with the Footage Dimensions set to Layer Size. (In CS3, the Import Kind and Footage Dimensions popups have been combined; choose Composition – Cropped Layers.)

7 If you import a layered file as a composition, all of the layers in the original Photoshop file (above) will appear as individual elements in the Project panel and a composition in After Effects (right).

5 Notice that just the butterfly appeared as a footage item in the Project panel. Drag it into the comp you created in the previous step. You can move this single element freely around your comp.

6 Delete what you've imported so far in this exercise. Repeat step 1 again, but this time in step 2 select Composition from the Import Kind dialog. The Layer Options will be grayed out, but Footage Dimensions will be active; again, we suggest you select the Layer Size option. (In CS3, the Import Kind and Footage Dimensions popups have been rolled into one; choose Composition – Cropped Layers.) Click OK.

7 You will now have two new items in the Project panel: a comp and a folder, both named **Butterfly Arrangement**. Double-click the comp to open it; you will see a stack of layers representing the individual layers in the Photoshop file. Back in the Project panel, double-click the **Butterfly Arrangement Layers** folder to twirl it open; each layer will be there as a footage item.

We're sure you can quickly see how flexible this option can be. However, there are some limitations: The individual layers have already been scaled down, and in some cases treated by effects. That's why we prefer to build things from scratch in After Effects – so we can change our minds later about what we want to do with each layer.

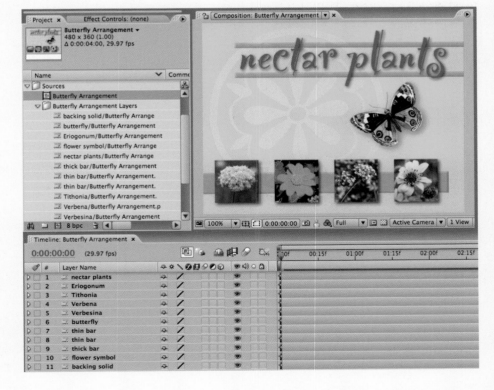

Rendering

Time for the final payoff: Rendering your animation to a movie file. Save first; it's always a good idea to save your file before you render, just in case the render crashes.

45 To choose where to save and what to name your render, in the Render Queue panel click on the name to the right of Output To.

46 The Render Queue keeps you apprised of what frame it is working on, and how much longer it thinks the render will take. If the composition being rendered is open and the Comp panel is visible, you can watch the frames while they're rendering.

44 Click the tab for **1-First Animation** if this comp is not already forward. Select Composition > Make Movie; the shortcut is ⌘ M (*Ctrl* M). This will open the Render Queue panel. By default, it will appear in the same frame as the Timeline panel. If you have a cramped screen, you may need to drag this frame larger to see your comp's full entry in the queue.

45 The default Render Settings and Output Module are fine for our first effort (we'll show how to modify them in the Appendix).

Click on the name to the right of Output To. This will open up a standard file dialog. Pick a place on your drive where it will be easy to retrieve the movie later. The default movie name is the same as the comp's name (that's one of the reasons to give comps names that make sense when you create them); you can change it at this stage if you like. Click Save.

46 Click on the Render button, or hit *Return*. Your composition will start to render. The Render Queue panel will tell you what frame it is currently working on, and when it thinks it will finish. If the Comp panel is visible, you will get visual feedback of what each frame looks like after it is rendered.

47 When the render is done, go to the location where you saved it on your drive, and double-click it to open it in QuickTime Player. Hit the spacebar to play back your work. Nice job!

You may think you're done at this point…but in reality, motion graphics jobs are rarely done at the first render. This is the stage where you will analyze your work, decide how to improve it, make changes, and render another version. Indeed, we will end this lesson by giving you a series of ideas to try out to improve or create variations of your creation.

Idea Corner

In addition to teaching you After Effects, the goal of this book is also to teach you the art of motion graphics – which includes creative thinking and being able to craft variations on a theme. We will even include some "Try This" tips sprinkled throughout the lessons. Below are some ideas to try for this lesson. Some of our results are included in the project file **Lesson_01_Finished.aep** inside the **Comps_Finished** folder; don't peek until after you've tried your own solutions.

• Stagger the timing of the flower photos: Select one of the flower photo layers, and drag its layer bar in the Timeline panel until its head starts around 15 frames in. Then drag another until its head starts around 1 second in, and preview this alternate animation.

• Animate the three photos to come in from different locations, such as from the left and right sides.

• Animate the solid bar onto (or off!) the screen.

• Try some alternate uses for solids, such as using a thin bar to underscore the title, or thick bar to anchor the top or bottom third of the entire frame. Try creating vertical bars: In step 36, reduce the solid's width instead of its height.

• Create an alternate layout that doesn't rely on layers being in straight lines – for example, arrange all four flower photos in an arc that follows the outline of the flower symbol.

• Finally, import the layered Photoshop file **Butterfly Arrangement.psd**, and animate its elements to end up with this final design.

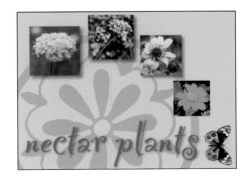

You've learned quite a bit in this lesson – skills you will use in virtually every After Effects project you tackle. In the next lesson, we'll show you several ways to fine-tune your animations.

Try alternate timings and animations, such as sliding in the red solid bar and staggering the timing of the photos that drop down.

▽ tip
Solid Tips

When you create a solid, After Effects automatically creates a **Solids** folder in the Project panel. Solids may be re-used in a project, just like other footage items. To change the size of a solid after you've created it, select it and type ⌘ Shift Y (Ctrl Shift Y). This opens the same Solid Settings dialog you saw when you created it.

▽ future vision
Drawing a Path

In the next lesson, we will demonstrate the Motion Sketch Keyframe Assistant, which gives you a fun, interactive way to create a motion path.

Advanced Animation

Manipulating keyframes to create more refined animations.

Getting Started

Make sure you have copied the **Lesson 02-Advanced Animation** folder from this book's disc onto your hard drive, and make note of where it is; it contains the project file and sources you need to execute this lesson.

In this lesson, you will work through a number of easy exercises to help build your animation skills. Along the way, you will become familiar with working in the After Effects Graph Editor, applying Keyframe Assistants, and taking maximum advantage of a layer's Anchor Point. We'll also show you advanced tricks such as using Motion Sketch to hand-draw your animation path, using Roving Keyframes to maintain smooth speed changes over complex paths, the best approach for "motion control" style movements, and the crucial component needed to create "slam down" animations.

Keyframe Basics

When animating in After Effects, the center of your universe is the *keyframe*. Keyframes provide two main functions: They define what a parameter's value is at a specific point in time, and they contain information about how those values behave before and after that point in time.

This behavior is referred to as a keyframe's *interpolation*. It consists of two components: the *velocity*, or how fast a value is changing over time, and the keyframe's *influence*, which boils down to how abruptly speed changes occur around the keyframe. A keyframe may have both incoming and outgoing velocity and influence. For example, if you are animating position, and a keyframe has an incoming velocity of zero (which means it will come to a stop) with a very high influence, the object would seem to slowly glide into its new position. If its velocity was zero but the influence was very low, the object would instead seem to abruptly stop when it reached that keyframe.

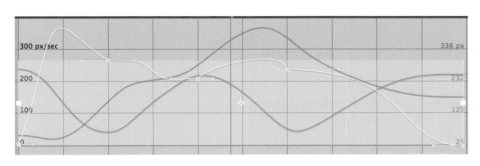

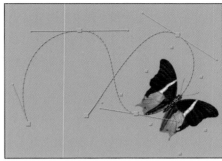

Most keyframes are *temporal*, meaning they describe how values change over time, and these changes can be viewed and edited in the Graph Editor. However, keyframes that describe changes in position also have a *spatial* component. Remember the motion paths with Bezier handles that you played with in the previous lesson? Those were spatial keyframes. The length and direction of their Bezier handles define the path the layer travels along in space. The skills you learned while editing spatial paths will also come in handy in editing temporal keyframes, as the Graph Editor gives you Bezier handles to edit velocity and influence.

Most of this chapter will be devoted to working with keyframes and interpolation. But first, we're going to take a detour through an alternate way to import your sources into an After Effects project: using the helper program Adobe Bridge to browse and select your files.

Spatial keyframes define where a layer is in the composition's space at a given time (right). *Temporal* keyframes numerically define a parameter's value at a given time, and also show how fast that value changes (the white graph, left). Butterfly courtesy Dover.

▽ insider knowledge

Temporal + Spatial

After Effects is unusual in that it gives you separate temporal and spatial control over keyframes. This is good, because you can split your work into first deciding how an object moves through space, then concentrating on how quickly it moves. Many other programs change the path as you change the speed, which can be more difficult to control.

▽ tip

Editing by Percent

To edit the value for a transform property using various criteria, right-click a value or keyframe and select Edit Value. In the dialog that opens, you can position a layer as a % of Composition, or reset the anchor point to the center of a layer (enter X = 50 and Y = 50 as a % of Source).

▼ The "Ken Burns" Technique

Ken Burns is famous for making documentaries of historical events such as the U.S. Civil War. There often is no film from those events, but sometimes there are photographs. Rather than rely on re-enactments, Burns pioneered a technique of panning and zooming a camera around these authentic images, creating something much more compelling than a stationary shot.

It is easy to mimic this technique in a program such as After Effects by animating a layer's anchor point. Indeed, when someone asks you to "do a Ken Burns effect" on a still image, this is what they're talking about.

This technique is also referred to as "motion control." We cover animating the anchor point in the Faux Motion Control section on page 52.

After Effects artists can take this technique to the next level by using a 3D camera, even separating individual elements onto different 3D layers. Animating a 3D camera is covered in Lesson 8.

Adobe Bridge

Adobe Bridge provides several useful functions: previewing the Template Projects and Animation Presets that come with After Effects, searching Adobe Stock Photos to purchase content, and as an advanced file browser to select your own content. Let's become more familiar with Bridge, then use it to open a Template Project that we will use to learn more about keyframe animation.

1 Adobe Bridge is a central file organization and preview program that works across many of their products. Bridge's Preview panel has the ability to show still images as well as play movies. Footage courtesy Artbeats/Timelapse Cityscapes 1.

1 Open After Effects. Then select the menu item File > Browse, which will launch Adobe Bridge. You will notice that it is similar to After Effects in that it has a single application window, divided into several frames that contain tabbed panels. You can resize the frames by dragging the bars between them; you can also re-dock some of the panels.

2 Under the Window menu select Workspace > Reset to Default Workspace. One of the first things you will notice is a tab in the upper left corner called Favorites which includes several preset locations, including Adobe Stock Photos and your computer's desktop.

3 Click on the tab in the upper left named Folders. Use this to navigate your computer's drive. As you click on a drive or folder, its contents will appear in the large area to the right. Double-clicking on a folder in either place will open it.

Use these to navigate to where you copied the **Lesson 02** folder from this book's disc to your drive, then open the **02_Sources** folder inside.

4 Click on the still image file **Auto Race.jpg**. Notice how its image appears in the Preview panel, and its file info appears in the Metadata panel.

Then click on the QuickTime movie **Cityscape.mov**. A set of transport controls will appear along the bottom of the Preview panel. Click on the Play arrow to start playback, and Pause to stop it. (In Bridge CS3, click on Play again to Pause.) Experiment with the other buttons – including Loop – and the location scrubber along the bottom.

5 Along the bottom right of the main Bridge window are tools for deciding how your files are displayed. For example, drag the slider to change the thumbnail size. Then click on the View icons to the right of this slider.

6 Pick one of the files in the **02_Sources** folder, then click on the Label menu: This allows you to rate your preference for each file, as well as give it colored labels. Go ahead and give star ratings and colored labels to a few of the files.

7 Along the top right of the Bridge window, click and hold on the word Unfiltered. This gives you a way to quickly sort through your labeled files. For example, say you gave 4 or 5 starts to at least one file in this folder: Select Show 4 or More Stars, and only those files will shown. (In CS3, filtering is even more powerful; click on the "Sort by" header to explore your choices.)

To import a file into After Effects 7, either double-click it, or type ⌘ **O** on Mac (*Ctrl* **O** on Windows) for Open. (In CS3, use File > Open With.) To import multiple files at once, simply preselect them first. Bridge will return you to After Effects, with these files imported into your project.

As you can see, Bridge can be very helpful when you have to sort through and select a large number of files, or files you are not familiar with. In future lessons when we prompt you to import a source, feel free to use File > Browse to launch Bridge instead of using File > Import.

▽ tip

Bridge Help

Adobe Bridge is used by all the applications in Adobe's Creative Suite and Production Studio. It has far more features than we have room to discuss here. Open Bridge, then press 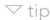 to open the Adobe Help Center to learn more about what Bridge has to offer.

▽ tip

My Favorite Place

If you have a folder you expect to return to often – such as where you keep your photos – select the folder in Bridge, and use File > Add to Favorites. You can also right-click on a folder and get this option.

7 Bridge allows you to rate and color-code your files, and then filter which ones you see based on these tags. Note the shortcut keys in the Label menu: These are well worth learning so you can do "selects" on a large number of files quickly. Holding on Mac (*Ctrl* on Windows) while typing a number directly corresponds to the star rating a selected file or files receive. (Bridge CS3 has an entire panel dedicated to filtering your choices.)

The Graph Editor

Time to learn how to view and edit keyframe interpolations in detail. To let you get straight to the meat of the matter, let's open an Adobe-supplied Template Project that already has some animated objects.

1 In After Effects, select File > Browse Template Projects. Bridge will open, displaying thumbnails of the templates that ship with After Effects.

2 You can also browse Template Projects in Bridge. Opening one starts a new After Effects project.

2 Single-click on a few different thumbnails. The Preview window will play a preview movie of that project's animation.

3 Double-click the project **Bright Idea.aet**; Bridge will return you to After Effects. If you had another unsaved project open, After Effects will ask you if you want to save your current project, then open this template.

4 Select the Timeline panel, and type ⌘ A (Ctrl A) to select all the layers in it. Then type U: This reveals just the animating properties of selected layers.

Study the keyframed properties in the Timeline panel, slowly dragging the current time marker back and forth in the timeline to get an idea of how each layer is animating. Then RAM Preview (press 0 on the numeric keypad) to buffer up the animation and see it at normal speed. All of the movements have sudden speed changes, which correspond to the default linear keyframe interpolation method. You can also tell they are linear because all the keyframe icons in the timeline are diamond shaped.

▽ tip

Do U See What I See?

A great keyboard shortcut is U: It reveals all of the animated properties for the selected layer(s). If you type U twice quickly (U U), you will see all of the edited properties whether they are animating or not. This is a great way to quickly get an idea of who's doing what.

5 With all of the layers still selected, click on the Graph Editor icon along the top of the Timeline panel. The keyframes and layer bars will be replaced with a graph, and a new set of icons will appear along the bottom right of the Timeline panel. Click on the eyeball icon, and select Show Animated Properties from the popup menu. Now you will see a series of colored lines, which correspond to how each animated property in this project is changing over time.

Type F2 to deselect all of the layers, then select them one at a time: Just that layer's animated properties will be displayed. Notice how the numeric values in the Switches column have colored boxes around them – these match the color of their respective lines (graphs) in the Graph Editor.

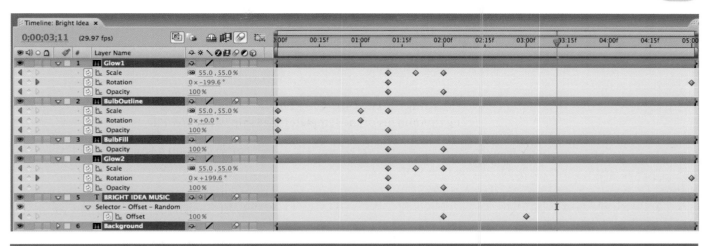

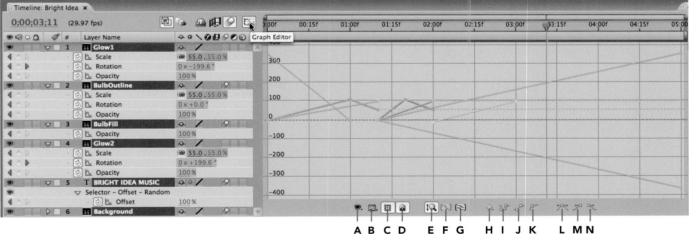

A B C D E F G H I J K L M N

5 The normal keyframe view displays keyframes for each property underneath each layer's bar in the timeline (top). The Graph Editor allows you to see multiple layers and properties overlaid in a single, larger display (above).

6 First, let's focus on refining the movement of layer 2: **BulbOutline**. You can see from the Graph Editor that its last animation keyframe is at 01;10 in the timeline. Click on a time display, enter "**1.10**" in the Go To Time dialog that opens, and click OK. Then type **N**: This ends the Work Area at this time. RAM Preview; only this portion of the timeline is previewed. Get a feel for the way it spins up and then scales down, with sudden shifts in speed.

Feel free to also zoom in the work area to make better use of the available space. Drag the end handle of the Time Navigator bar that runs along the top of the timeline to the left until the area from 00;00 – 01;10 is filling up the timeline. (Zooming is covered in the *Panning and Zooming Time* sidebar.)

Legend Key

A Choose which properties are shown in Graph Editor

B Choose graph type and options

C Show Transform Box when multiple keys are selected

D Toggle Snap on/off

E Auto-zoom graph height

F Fit selection to view

G Fit all graphs to view

H Edit selected keyframes

I Convert selected keyframes to Hold

J Convert selected keyframes to Linear

K Convert selected keyframes to Auto Bezier

L Easy Ease

M Easy Ease In

N Easy Ease Out

▼ Panning and Zooming Time

You can zoom in and out in the Graph Editor and the normal time-line keyframe display in a variety of ways:

Fit Selection to View

Zoom slider Auto-zoom Fit All Graphs
 graph height to View

- Drag the end handles of the Time Navigator bar that runs along the top of the timeline area
- Drag the Zoom slider along the bottom of the timeline area
- Use the normal magnification shortcut keys ⊟ and ⊜

 Once zoomed in, you can slide the Time Navigator bar or hold down the spacebar and drag to pan earlier or later in time.

 The Graph Editor has an Auto-Zoom button; this defaults to On and is handy for making sure you see the full value range of your graphs. You can also use the normal Zoom tool: Press **Z** to engage, then drag a region to auto-fit it to the Graph Editor display.

 When the Auto-Zoom button is disabled (not highlighted), you can use a mouse scroll wheel: The normal wheel movement is up and down; **Shift**+scroll moves horizontally.

If you have zoomed in on a graph and want to quickly get back to viewing your entire curves, click the Fit All Graphs to View button along the bottom of the Graph Editor. To zoom in on selected keyframes, first select the keyframes you want to focus on, then click on the adjacent Fit Selection to View button.

 Remember that the eyeball icon offers a Show Animated Properties option. When enabled, simply selecting a layer will show a graph for every animated property. To view just one property at a time, disable this option and select individual properties, or **Shift**+click to view multiple properties.

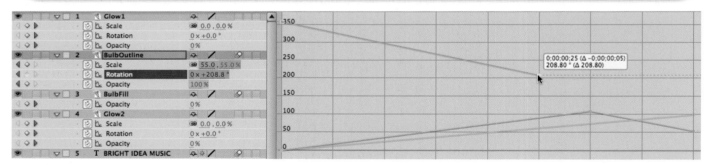

7 As you drag a keyframe in the Graph Editor, an info display helps you figure out how much you are moving it, and to where.

▽ tip

Graph Editor Keyboard Shortcuts

For a full list of keyboard shortcuts when working with the Graph Editor, select Help > Keyboard Shortcuts from inside After Effects to open the Adobe Help Center, then select the entry "Keys for working with the Graph Editor."

7 The descending turquoise line is this layer's Rotation. Hover the cursor over it, and an info box will appear. Select the yellow square at the end of this line: That's its second keyframe. Drag it earlier or later in time (such as to 01;10), and RAM Preview. Then try dragging it up or down; this will affect the end Rotation value. Hold down the **Shift** key while dragging to constrain yourself to just horizontal or vertical movements. After you're done playing, return it to its original position: a value of 0.00° at 01;00 in the timeline.

8 Time to make the end of the rotation less sudden. With the second keyframe still selected, click on the Easy Ease In icon (second from the right along the bottom of the Graph Editor). The keyboard shortcut is **Shift** **F9**. This does not create a special type of keyframe; it just edits the influence and velocity of the keyframe you already have.

The turquoise Rotation curve will change shape to taper into the second keyframe, and a Bezier handle will appear sticking out of the keyframe. RAM Preview to get a feel for this default Easy Ease keyframe interpolation. Then experiment with dragging the handle longer (a more gradual ease) or shorter (a more sudden stop). Again, holding down the **Shift** key will constrain your dragging to just horizontal moves.

Next, experiment with rotating where this Bezier handle is pointing. This affects how the value approaches the last keyframe. Try a few different angles, then RAM Preview; this will help you build up a visual correspondence for how its graph relates to its speed. For example, dragging the second keyframe handle upward results in a slow rotation that suddenly snaps into its final value.

When done, apply Easy Ease In to this keyframe again.

9 The red line is **BulbOutline**'s Scale value. You can "read" its graph to guess what it is doing: The line goes up, meaning this layer scales up, then the line goes down, which means the layer scales back down.

Double-click the word Scale. All of its keyframes will be selected. You can now:

• Move the set of keyframes in time by sliding the bounding box left and right. Add **Shift** to constrain your dragging to horizontal or vertical moves.

• Edit the size of the bounding box by dragging the handles at its corners and sides. Pressing ⌘ (**Ctrl**) then dragging resizes it equally in both directions.

When you're done getting a feel for editing the bounding box, type ⌘ **Z** (**Ctrl Z**) to undo back to where you started. Then click outside the bounding box to deselect it.

8 You can drag the yellow influence handles to determine how a value approaches or animates away from a keyframe.

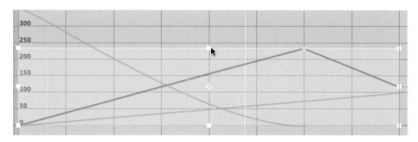

9 If you select multiple keyframes, they will be surrounded by a bounding box. Dragging the corners of this box scales and time shifts the selected keyframes. (Make sure the Show Transform Box switch under the Graph Editor is enabled!)

▽ key concept

The Work Area

The gray bar just above the layer bars in the timeline defines the length of the current work area. RAM Previews – and in some cases, renders and Keyframe Assistants – are restricted to the duration of this bar. You can grab and move its start and end of the work area, as well as slide the bar along the timeline. The keyboard shortcuts are worth learning too:

• **B** sets the beginning of the work area to the current time
• **N** sets the end of the work area to the current time
• Double-clicking the bar returns the work area to the full length of the comp

▼ Speed versus Value Graphs

The Graph Editor can display two types of graphs: the Value Graph, and the Speed Graph. In the Value Graph (which you have been using so far), the higher the curve, the higher that value at that point in time. In the Speed Graph (which is good for editing Position animation), the higher the curve is, the faster the underlying value is changing. After a while, you will develop a feel for how changes in value curves affect changes in speed, but you can also edit the Speed Graph directly to ensure you're getting the changes you want.

You can select which graph to view with the Choose Graph Type popup at the bottom of the Graph Editor (it's the icon to the right of the eyeball); After Effects defaults to Auto-Select Graph Type.

The Show Reference Graph option (in the Choose Graph Type menu) shows a non-editable outline of the graph type you don't have selected. For example, you can edit the Value Graph, and immediately see its effects on the Speed Graph.

△ The Value Graph (left) shows you how a parameter's value changes over time – in this case, X and Y Position coordinates. The Speed Graph (right) shows how fast a value is changing over time. In this case, the speed is constant between keyframes, and therefore the graph is flat, with different heights indicating different speeds. You can select between these views using the Choose Graph Type button (circled in red).

▽ tip

Diamonds and Circles

You don't need to be in the Graph Editor to toggle between Linear and Auto-Bezier (smooth) keyframes. In the regular keyframe display, ⌘ (*Ctrl*) + click the Linear (diamond) keyframe icon to toggle to Auto-Bezier (circle icon).

10 The Scale keyframes for BulbOutline are linear keyframes, and they could benefit from some "ease" style animations.

• A simple way to change a linear keyframe to a basic "smooth" keyframe is to hold down the ⌥ (*Alt*) key to get the Change Direction tool, then click on a keyframe. Try this with the middle Scale keyframe. This type of keyframe is called Auto-Bezier because the handles that pop out are set automatically to add a little rounding. Revert back to a linear keyframe by ⌥ (*Alt*) + clicking the keyframe again.

• You can "pull" handles out of any keyframe by pressing ⌥ (*Alt*) and dragging out from a keyframe with the regular Selection tool. Again, ⌥ (*Alt*) + click will retract the handles again.

• Select the middle keyframe and click the Easy Ease button at the bottom of the Graph Editor. This adds easy ease to both the incoming and outgoing handles. The shortcut is *F9*.

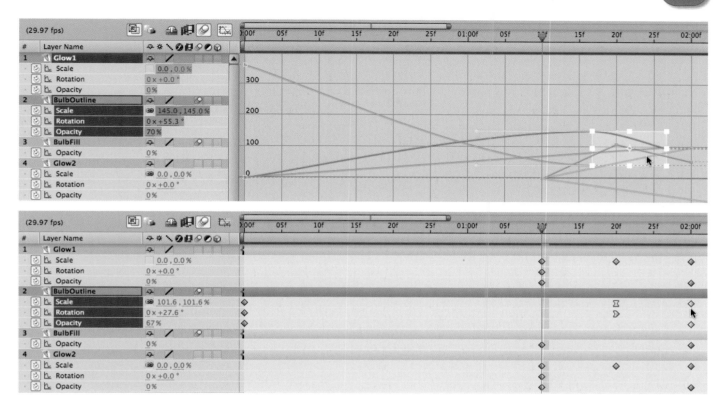

11 Double-click the Work Area bar to extend it to the full length of the comp again (if you zoomed in on the timeline, press the minus key on the regular keyboard a few times to zoom out all the way).

Creating refined animation is a signature of a good motion graphics artist. So feel free to gain some more practice by tweaking the **Glow1** and **Glow2** layers before moving on.

Remember that keyframes selected in the keyframe view will also be selected when you go into the Graph Editor, and vice versa. While you can use the Graph Editor to synchronize the timing of keyframes from one layer to another, you may find it easier to move keyframes in the regular timeline. When synchronizing keyframes, press **Shift** to make the current time marker snap to keyframes, and add **Shift** after you start moving keyframes to make them snap to existing keyframes and the time marker.

11 You can select multiple layers and see their values overlaid in the Graph Editor, which may help when editing their timing or values (top). However, many actions – such as lining up the timing of keyframes – are just as easy or even easier in the normal view (above). (Hold down **Shift** while dragging keyframes, and they will "snap" to the current time marker and other keyframes.)

When two values - such as X and Y Scale - are the same, you see just the color of the one on top (here, red for X Scale). If you disable Constrain Proportions, you can then set their dimensions to different values, and the other dimension's curve will be visible as a different color.

Float Like a Butterfly

Remember that butterfly you animated back in Lesson 1? Next we're going to show you a different way to animate its cousin by literally drawing its flight path. Then we'll employ some Keyframe Assistants and a few other tricks to refine its animation, while also working with the Graph Editor.

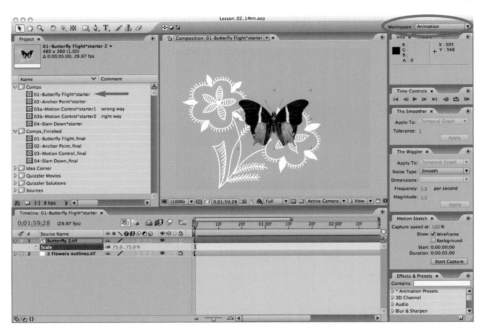

3 Selecting the Animation workspace opens a variety of Keyframe Assistant panels down the right side of the application window. Flower outline courtesy Dover.

4 In the Motion Sketch panel, enable the Background checkbox so you can see the other layers while you sketch.

1 Open the folder **Lesson 02** that you copied from this book's disc to your computer, locate the file named **Lesson_02.aep**, and double-click it to open it. In the Project panel, open the **Comps** folder, locate the comp **01-Butterfly Flight*starter**, and double-click it to open it.

2 The butterfly is a bit large. Select **Butterfly 2.tif**, type **S** to reveal its Scale parameter, and reduce it to around 75%.

3 Click on the Workspace popup in the upper right corner of the main window, and select Animation, which will open a few new panels. If necessary, re-size the Comp panel to see its entire image area, and press **⊟** (minus key) to zoom out the timeline to view the full duration again.

4 Turn your attention to the Motion Sketch panel along the right. This captures your mouse movements in the comp's image area and converts them into Position keyframes. Its Start and Duration are determined by the work area.

To see a box indicating the size of your layer while you're sketching, keep the Wireframe checkbox enabled; to see the other layers (which we do here, to determine the butterfly's path), enable the Background checkbox.

5 The plan is to draw a path of the butterfly starting on one of the flower heads, have it fly about the other flower in the picture, then settle back on the same flower, all during the duration of this comp (five seconds). Practice this by dragging the butterfly around while counting to five to get a feel for what you want to do, and how fast.

• Make sure that Background is checked, then click the Start Capture button in the Motion Sketch panel. After Effects will wait until you click and start dragging the mouse in the Comp panel. Click on your "hero" flower to start, then draw

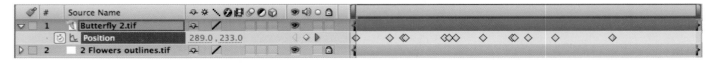

your path, keeping the mouse key pressed. It's okay if you finish early; just release the mouse. Your new motion path will be drawn in the Comp panel.

- Press **P** to reveal your new Position keyframes in the timeline.
- RAM Preview your movement. If you're not happy with it, or if time ran out before you were finished, type **⌘ Z** (**Ctrl Z**) to undo until your new path and keyframes disappear, then try again! You can also toggle off the stopwatch for Position to delete all keyframes. When you're happy, save your project.

The Smoother

After you use Motion Sketch, you'll probably have a large number of Position keyframes. This makes it really difficult to edit your path. So let's simplify things.

6 Click on the word Position for the layer **Butterfly 2.tif** to make sure all of its keyframes are selected; they will turn yellow. Then turn your attention to The Smoother panel (if its text and buttons are grayed out, deselect then reselect your keyframes).

This assistant plots what would be a theoretically perfectly smooth curve for the selected keyframes, then looks at the actual keyframes to see how far they deviate from the ideal case. How much deviation you allow is set by the Tolerance parameter. You can scrub the Tolerance value or click it and type an absolute value. Try a value of, say, 10 for Tolerance and click Apply (its Apply To popup is set automatically depending on the keyframes selected).

Press **F2** to Deselect All. Notice how you have fewer keyframes, and your path has been simplified. RAM Preview; the movement should be an idealized version of your original sketch. You can always undo and try another Tolerance value. The goal is to avoid leftover clusters of keyframes that are too close to one another. Feel free to also remove keyframes manually if they are unnecessary. It should be relatively easy to tweak your motion path now that you have fewer keyframes to rearrange.

After Effects CS3 adds a Smoothing option in the Motion Sketch panel. It has the same effect as automatically applying The Smoother right after a sketch. It defaults to Smoothing = 0.

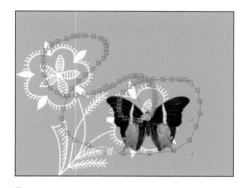

5 Select the butterfly, click Start Capture in Motion Sketch, and trace a flight path for the butterfly by moving your mouse. After you are done, you will see the motion path in the Comp panel (above); press **P** to reveal the Position keyframes in the Timeline panel (top).

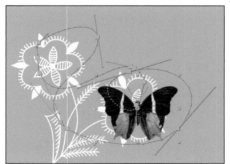

6 After applying The Smoother (left), you will have considerably fewer keyframes to deal with in the Comp (above) and Timeline (below) panels, even though the path is very similar to your original sketch.

Auto-Orient and Motion Blur

Let's clean up a few details before further refining our motion.

7 Currently, the butterfly stays pointed toward the top of the frame, regardless of how it's flying. You learned how to fix this in Lesson 1: Select **Butterfly 2.tif**, and type ⌘ ⌥ O (*Ctrl* *Alt* O) to open the Auto-Orientation dialog (or go Layer > Transform > Auto-Orient). Select Orient Along Path, and click OK.

A B C D E F

7 Normally, layers keep the same orientation as they move around a comp (A–C). By setting Layer > Transform Auto-Orient to Orient Along Path and adjusting their initial rotation, they will now appear to automatically rotate to follow their path (D–F).

• At this point, your butterfly will rotate to follow its path...but it's skidding sideways! No problem: Type *Shift* *R* to reveal its Rotation parameter in addition to Position, and scrub the degrees value (the rightmost value with the ° symbol, not × next to it) to point her the right way.

When using auto-orientation, pay close attention to the handles for the beginning and ending spatial keyframes in the Comp panel. Zoom in, and you'll often find that the default dots (the Auto-Bezier handles) are pointing a little off to the side, causing the layer to do a little twist as it exits the first keyframe and enters the last keyframe. To fix this, drag the dots to create Bezier handles and edit them so that they are exactly in line with the motion path.

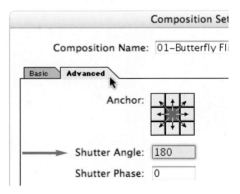

8 When you enable the Motion Blur switch for the butterfly layer and the comp (right), you will notice the butterfly's wings get blurry as it moves – especially as it turns a corner (far right). You can adjust the overall amount of motion blur by setting the Shutter Angle under the Composition Settings > Advanced tab (above).

8 In the sidebar on the following page, we discuss Motion Blur. Let's enable it for our butterfly:

• In the switches panel for **Butterfly 2.tif**, toggle on the Motion Blur switch (the hollow box underneath the switch that looks like a circle with an echo).

• To see the effect in the Comp panel, also toggle on the large Enable Motion Blur button along the top of the Timeline panel. RAM Preview and enjoy the motion blur effect.

• To render more or less blur, open Composition > Composition Settings, click on the Advanced tab, and change the Shutter Angle. Try various values between 90 and 720 and compare the effect.

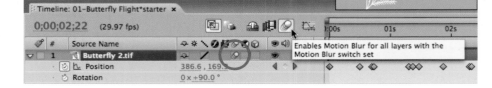

▼ Motion Blur

When moving objects are captured by a normal camera, they might appear blurry, depending on how far they have moved while the camera's shutter was open during the course of capturing a frame. After Effects can mimic this through the use of Motion Blur.

To add this to a layer, the layer's Motion Blur switch must be enabled. To preview what the blur looks like in the Comp panel, you also need to turn on the master Enable Motion Blur switch along the top of the Timeline panel. There is a separate Motion Blur popup in the Render Settings to determine whether this blur is rendered for "checked layers" (layers with their Motion Blur switch on).

When enabled, After Effects will automatically add blur to layers where the Transform properties are animating; some effects also can calculate motion blur.

To control the amount of blur, open Composition > Composition Settings and click on the Advanced tab. The Shutter Angle controls how much blur is calculated. There are 360° of possible blur per frame. Real cameras typically have 180° of blur; the maximum in After Effects is 720°. The length of the blur is also affected by the frame rate: The slower the rate, the longer the shutter is open, and therefore the longer the blur streaks.

Motion blur helps prevent fast-moving objects from appearing to strobe or stutter across the frame. However, motion blur takes longer to render, and large blur values can reduce the clarity of objects. In extreme cases, it will produce visible "echoes" of the image.

If it is taking too long to render previews, simply turn off the master Enable Motion Blur switch in the Timeline to temporarily disable motion blur. Don't turn off the motion blur switch for the layers themselves!

△ The Motion Blur switch looks like an echoed hollow circle. It can be enabled (layer 1) or disabled (layer 2) per layer. To preview it while working, you must also enable the master Motion Blur switch along the top of the Timeline panel.

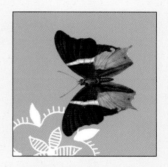

◁ Butterfly (top) with no motion blur, and (bottom) with motion blur enabled. Remember, you must enable the comp's master Enable Motion Blur switch to see the blur rendered in the Comp panel, and also enable it in Render Settings when you render to disk.

• When you've settled on a shutter angle you like, RAM Preview again. Notice how the outside of the wings are more blurred whenever the butterfly turns a corner quickly because the pixels are traveling faster than the butterfly's body. Later in this exercise you'll add ease controls to its motion; take note how motion blur automatically ramps up and down as the speed of the layer changes.

Save your project before moving on.

▽ try it

Keyframe Strrrreettcchh

To stretch or compress the amount of time that a group of keyframes is spread across, select them, hold down ⌥ (*Alt*), and then drag the first or last keyframe (not the middle ones).

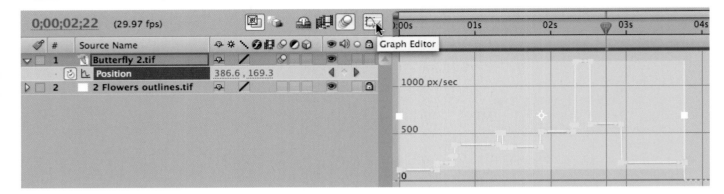

9 The butterfly's initial speed graph. The flat lines between keyframes reflect the constant speeds which result from the default linear temporal keyframes.

▽ **tip**

Right-click to Rove

You can right-click a keyframe in the Graph Editor or timeline view to toggle on and off Rove Across Time. If this option is grayed out, make sure the first or last keyframe is not also selected.

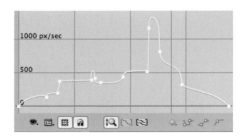

10 Before trying to smooth out the speed graph by hand, apply Easy Ease to the first and last keyframes, and then ⌥+click (*Alt*+click) on the keyframes in-between to convert them to Auto Bezier. Even though your overall speed is still inconsistent, the changes will be smoother.

Roving Keyframes

Next, we want to show you how to create smooth speed changes over time even when you have a bunch of position keyframes in space. Make some room for the timeline by selecting Workspace > Standard, and resize the Comp panel if needed.

9 Click on the word Position for **Butterfly 2.tif** in the timeline to make sure this property is selected. Then click on the Graph Editor button along the top of the Timeline panel to open this display.

 You should see a squared-off white graph. If not, click on the Choose Graph Type popup underneath the Graph Editor (the one to the right of the eyeball), and select Edit Speed Graph. In this graph, higher values mean faster motion. You can "read" this graph to tell that speed changes at keyframes are sudden, not smooth, because the butterfly enters the keyframes at one speed and exits at a different speed. It is also cruising at a speed higher than 0 at the start and end, which makes for sudden starts and stops. Remember that the dots in the motion path also indicate speed – the closer the dots are together, the more slowly the butterfly is traveling.

10 The sudden changes in speed are the result of using linear interpolation. Take a stab at trying to smooth out this speed graph by hand:

• Drag the first keyframe all of the way down to the horizontal line at zero, or select it and press the Easy Ease Out button.

• Do the same for the last keyframe, or select it and press the Easy Ease In button.

• Marquee around all the keyframes in the middle (excluding the first and last); the selected keyframes will have a bounding box around them. Change these linear keyframes to smooth keyframes by pressing ⌥ (*Alt*) to temporarily switch to the Change Direction tool, then click on any one of the selected keyframes: All the keyframes will convert to Auto Bezier (smooth) keyframes with short Bezier influence handles sticking out. Click outside the selection box to deselect the keyframes.

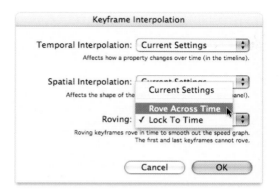

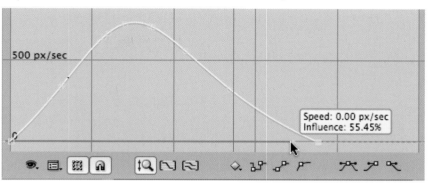

• Now try dragging individual keyframes up and down and left and right to smooth out bumps in the curve; dragging the handles longer will also help.

RAM Preview; even though the butterfly's flight should have smoother speed changes, there is an easier way to achieve this goal using one of the best-kept secrets in After Effects: Roving Keyframes. This trick leaves your motion path alone (in other words, it doesn't touch the spatial keyframes in the Comp panel), but simplifies your temporal keyframes (where they are in time in the Timeline panel) so that you have to edit only the starting and ending keyframe. After Effects will then automatically move ("rove") all of the keyframes in-between to work out the required timing.

11 Still in the Graph Editor, double-click Position to make sure all of the Position keyframes are selected. Then open Animation > Keyframe Interpolation. Click on the Roving popup, and select Rove Across Time. Click OK. All of the keyframes between the first and last automatically adjust to maintain a smooth speed curve between these two keyframes; RAM Preview to verify this.

The first and last keyframes cannot Rove Across Time. Drag the handles on the first and last keyframes to alter their influence; namely, how the butterfly speeds up out of the first keyframe, and slows down in the last. Notice how the ease controls now apply across the entire animation as if the keyframes in the middle didn't exist in the timeline.

12 Last trick, and then you can break for tea:

• Double-click Position again to make sure all keyframes are selected, then select the menu item Animation > Keyframe Assistant. These are a series of utilities that automatically edit keyframe values for you.

• Select Time-Reverse Keyframes. It does just what it says: It reverses all of your keyframes in time. RAM Preview, and now you'll see your butterfly travel in the opposite direction along your path. For comparison, our version is in **Comps_Finished > 01-Butterfly Flight_final**.

11 Select all the Position keyframes, then select Animation > Keyframe Interpolation and set Roving to Rove Across Time (left). Afterwards, you only need to adjust the interpolation of the first and last keyframes (right), and the ones in the middle will slide ("rove") in time to ensure smooth speed changes in-between.

▽ tip

Rove in Either View

The Keyframe Interpolation dialog may be opened while in either the Graph Editor or the normal keyframe view.

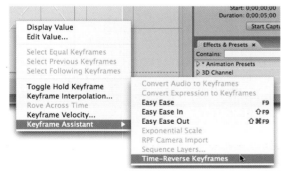

12 Select all of the keyframes, and right-click on one of them to bring up a version of the Animation menu – including the handy Keyframe Assistant.

Anchor Point 101

The Anchor Point is the center of a layer's universe around which it scales, rotates, and moves. Although it defaults to the center of a layer, it may be moved anywhere, including outside the layer's boundaries.

1 Open **Lesson_02.aep** (if it isn't open already). In the Project panel, locate and double-click on the empty comp **02-Anchor Point*starter**.

Back in the Project panel, open the folder **Sources**, and select **2 Flowers outlines.tif**. Use the keyboard shortcut ⌘ / (*Ctrl* /) to add it to the center of the current comp. In the Timeline panel, twirl open all of its parameters by ⌘ (*Alt*) + clicking on the arrow to the left of the layer's name.

2 Whenever you add a layer to a comp, think: What should this layer logically rotate or scale around? In this case, the base of the flower stem.

Scrub the layer's Rotation parameter: Notice the flower symbol rotates from its center, not its base. Scrub its Scale; again, that's not the behavior we would want, say, to simulate the flower growing.

2 Double-click **2 Flowers outlines.tif** to open its Layer panel, undock this panel, and arrange it so that you can see it, the Comp panel, and the Transform properties in the Timeline panel all at the same time.

Double-click **2 Flowers outlines.tif**: It will open in a viewer known as the Layer panel. This allows you to see a layer without distraction from the rest of the layers in your comp. (If you have trouble keeping these two panels straight, look at the top of the panel for the word "Composition:" or "Layer:" before its name. The Layer panel also has its own timeline and a different set of switches.)

Click on the arrow in the upper right corner of the Layer panel to open its Options, and select Undock Panel. Drag this panel somewhere where you can see it as well as the Comp panel and the Transform properties in the Timeline panel.

3 Set the View popup to Anchor Point Path. This allows you to directly manipulate the Anchor Point: the crosshair icon that starts out in the middle of the layer.

3 In the Layer panel, click on the View popup, and select Anchor Point Path. The small crosshair in the middle of the panel is the layer's Anchor Point.

• Drag the Anchor Point while carefully watching the Comp and Timeline panels. You will notice that as you drag down, the flower moves up in the Comp panel. As you drag left, the flower moves right. Does this mean you're editing the layer's Position?

• Drag the anchor point again in the Layer panel, but this time watch what happens to the anchor point in the Comp panel. The position of the anchor point in the Comp panel stays the same, as does the Position value in the Timeline. So why does the layer appear to change position? Because you are changing where the anchor point is in relation to the layer. This in turn changes

where the layer's pixels are drawn in relation to this position coordinate – a subtle but important difference.

• When you're done playing, drag the anchor point in the Layer panel to the base of the flower's stem. Any rotation or scale will now occur around this point.

4 In the Comp panel, drag the flower down so that its stem rests on the bottom of the comp's image area.

Now play with Rotation and Scale: They behave more appropriately. But only after you set a layer's Anchor Point to where *you* – not After Effects – think it should be.

Pan Behind Tool

Close the floating Layer panel, and we'll show you a great shortcut for moving the Anchor Point.

5 In the Timeline, click Transform > Reset to reset the layer to how it was when you first added it to the center of the comp.

• Type **Y** to select the Pan Behind tool (which we also call the Anchor Point tool). Drag the Anchor Point while carefully watching the Comp panel and the transform values: The Position and Anchor Point values change in opposite directions, resulting in the layer remaining stationary.

6 Here's how to move the layer to the bottom of the comp more precisely: Right-click on the Position value and select Edit Value. In the Position dialog that opens, set the Units popup to % of Composition, then set X = 50, Y = 100. Click OK and the layer's position will be centered at the bottom of the comp.

Type **V** to return to the Selection tool.

3–4 In the Layer panel, move the anchor point to the base of the stem of the flower. Then in the Comp panel, move the flower so its stem touches the bottom of the comp.

4 When the Anchor Point is relocated to the bottom of the flower, animating Scale and Rotation will look more natural.

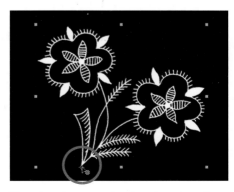 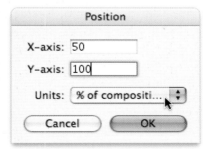

5 Select the Pan Behind Tool (top), and in the Comp panel move the Anchor Point to the bottom of the stem (above). When done, press **V** to return to the Selection tool.

6 The Position dialog allows you to place a layer based on a percentage of the composition.

3 The Problem with Position: After you've moved the layer into place (A), when you edit its Scale, it will appear to slide out of place (or even out of frame!) (B), requiring you to reposition it (C). This is because layers scale around their Anchor Point, not the center of the comp. Photo courtesy CyberMotion.

▽ tip

Nudging Scale

To edit the Scale value in 1% increments, press ⌥ (*Ctrl*) and use the ➕ and ➖ keys on the numeric keypad. To nudge in 10% increments, add *Shift*.

Faux Motion Control

You can add a layer larger than your comp size to a composition, then pan and zoom around that image. However, if you animate using Position and Scale, it can quickly become an exercise in frustration, because scaling happens around the anchor. The secret is to animate the Anchor Point instead of Position. To compare both approaches, try these exercises:

1 In the Project panel, locate and double-click on the comp **03a-Motion Control*starter1**.

This comp already has a layer in it – **Auto Race.jpg** – that is considerably larger than the comp's size. Drag it around in the Comp panel to get a feel for how it looks (you can view the entire image in the Footage panel by double-clicking **Auto Race.jpg** in the Sources folder in the Project panel).

2 Select this layer in the Timeline and type ❿ to reveal its Position, followed by *Shift* ❺ to also reveal its Scale. Press *Home*, and enable keyframing for Position and Scale at 00;00.

3 Drag the layer to focus on some cars you like, and reduce the Scale to get more of them in the picture. Notice that as you alter Scale, the image is no longer framed the same. This happens because the layer is scaling around its Anchor Point – not the portion of it you were viewing in the comp. Drag the layer back to where you like it.

4 Press *End*, and drag the layer to focus on a different set of cars, then set a different "zoom" level (Scale value). Again, you'll have to re-tweak the position as the scale edit made them move. Hmm…there's got to be an easier way…

5 Back in the Project panel, double-click **03b-Motion Control*starter2**. This is a blank comp. In the Sources folder in the Project panel, select **Auto Race.jpg** and press ⌘ ⁄ (*Ctrl* ⁄) to add this to the center of your comp, starting at 00;00. Resist the urge to reposition the layer; you want the anchor point to stay centered in the comp.

Type ❺ to reveal Scale, but this time type *Shift* ❹ to also reveal the Anchor Point. Press *Home*, and enable keyframing for these two properties. *Throughout the remainder of this exercise, do not reposition the layer in the Comp panel.*

6 Now double-click **Auto Race.jpg** to open its Layer panel. This panel should already be floating in its own window from an earlier exercise; if it's not, click on its options arrow and select Undock Panel. Reduce its Magnification (zoom it down) to see all the cars comfortably, and position it so that you can still see the full Comp image area as well as the left side of the Timeline panel.

In the Layer panel, set the View popup to Anchor Point Path. Drag the crosshairs *in the Layer panel* to the center of the group of cars you want to see. Then edit the layer's scale to get the zoom amount you want. Notice how you smoothly zoom in and out of the center of your framed image – it doesn't slide off the screen.

7 Hit **End**. In the Layer panel, drag the Anchor Point to a different car or cars to focus on. *Again, resist the temptation to drag the layer in the Comp panel!* Then edit Scale to change your zoom amount. Notice how the layer stays "centered" as you scale – that's because Position (where the anchor point is in relation to the comp) is always in the center of the comp.

8 If you remembered to enable keyframing in step 5, you will now see a motion path in the Layer panel (not the Comp panel). It has Bezier handles, just like a position motion path. Tug on those handles and create a nice arc for your motion control camera move.

(If you can't see the handles clearly, press ⌘ (**Ctrl**) and drag out a handle from the keyframe icon.)

To RAM Preview, bring the Comp panel forward – otherwise, you'll preview the Layer panel (which is not very exciting). Feel free to enable motion blur and add ease controls to taste.

If you'd like to compare, our version is **Comps_Finished > 03-Motion Control_final**.

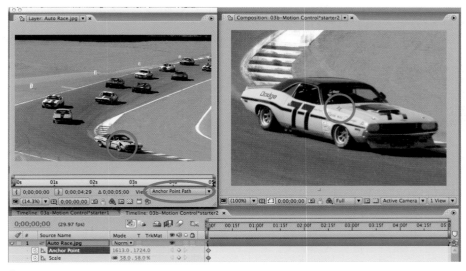

6 By moving the Anchor Point in the Layer panel (top left), you can easily set the center of what your virtual camera is looking at in the Comp panel (top right).

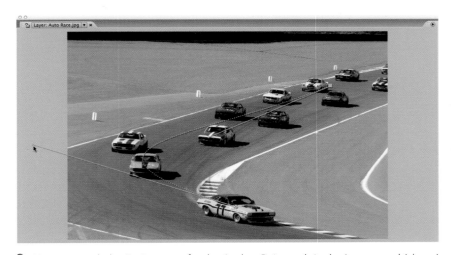

8 You can tweak the Bezier curve for the Anchor Point path in the Layer panel (above) to create a "motion control" move that sweeps around your photo (below).

Hold Keyframes

Sometimes an animation requires sudden, jerky movements. The perfect tool for this job is the Hold keyframe. Hold is another type of interpolation – like linear – except this one says "hold my value until you encounter another keyframe." Let's put it to work on a common animation style known as the "slam down." If you'd like to see where you're going with this exercise, take a peek at our finished version in comp **04-Slam Down_final** and RAM Preview it.

1 In the Project panel, locate and double-click the comp **04-Slam Down*starter**. This comp already has two layers in it: **REJECT**, which is the word in the middle of the comp, and **frame**, which is the rounded rectangle bordering it. The goal here is to have the word stagger and slam into position by 02;00 in the timeline, then to slowly drift as the frame around it blinks.

2 Click on a time display in the Timeline or Comp panels, type "1." to jump to 1;00, and click OK. Select the **REJECT** layer, type **P** to reveal Position, then **Shift S** to reveal Scale and **Shift R** to reveal Rotation. Press the stopwatch for Position and drag down across the stopwatches for Scale and Rotation to enable keyframing for all three parameters in one smooth move; After Effects will remember the current values at this point in time.

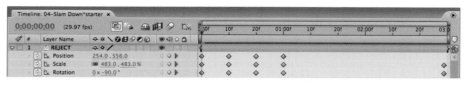

3 Keyframe the **REJECT** layer to strike a few poses as it falls into position, then to drift away.

3 Move the current time marker 10 frames earlier in time to 00;20. The shortcut is **Shift PageUp**. Choose a new pose for your word: Try something larger (increase Scale), offset a bit (edit Position), and perhaps rotated (Rotation). After Effects will automatically create the new keyframes for you.

• Press **Shift PageUp** again, and create a new pose at 00;10 in the same fashion. Then press **Home** to jump to 00;00 and create your beginning pose.

• Finally, press **End** and set up a final pose that's slightly smaller and perhaps slightly rotated from the main pose you set up at 01;00.

4 Preview your animation: The word REJECT slides around between keyframes then drifts away as After Effects interpolates between your keyframes. Hmm… we had something harder-edged in mind.

Click on the word Position in the Timeline panel, then **Shift** +click on Scale and Rotation – this will select all of their keyframes. Now, select the menu item Animation > Toggle Hold Keyframe. Notice how the shapes of the keyframes

changed to have squares on the outgoing side. Also, in the Comp panel, all the handles retracted so that the motion path moves only in straight lines.

RAM Preview again: Now we have sudden movements…but we lost our drift! That's because we also converted the keyframes at 01;00 to Hold, which means they can't change their value until the next keyframe.

5 Select just the three keyframes at 01;00 by dragging a marquee selection around them. Press the ⌘ (*Ctrl*) key, and click on one of them: All selected keyframes will change back to linear keyframes (diamond shape). RAM Preview; now you have your desired animation.

6 If you know you want a parameter to use Hold keyframes, you just have to set up the first one; subsequent keyframes will then get the same interpolation.

Let's say we want the border around the title to blink on and off, starting when the word lands:

• First, move to 01;00, select **frame** (layer 2) and press ◖ (left square bracket) to make it start at this point in time.

• Press ⌥ T (*Alt* T) to enable keyframing for Opacity; it defaults to 100% and a linear keyframe. Toggle it to a Hold keyframe using this shortcut: Press ⌘ ⌥ (*Ctrl* *Alt*) and click on it.

• Press *Shift* *Page Down* to jump 10 frames to 01;10 in the timeline, and set **frame**'s Opacity to 0%. It automatically gets the squared-off keyframe shape on the right side, indicating it also will "hold" its value and not interpolate.

Finish off this animation using copy and paste to save time. Select the Opacity keyframes at 01;00 and 01;10 and copy. Press *Shift* *Page Down* to move to 01;20 and paste: Both keyframes, with the copied values and spacing, will be created for you. Move to 02;10 and Paste again. RAM Preview; the **frame** layer will blink on and off. Our finished version is shown in comp **04-Slam Down_final.**

4 Select all of the keyframes, and either right-click on them or use the Animation menu to select Toggle Hold Keyframes. The square shape on the right (outgoing) sides of the keyframes indicates "hold."

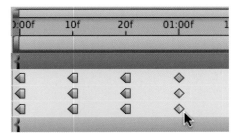

5 Select just the keyframes at 01;00, and ⌘+click (*Ctrl* +click) on them to convert them to normal linear keyframes. You need this interpolation to get the drifting motion at the end.

6 Our final timeline, including hold keyframes for **frame**'s Opacity so that it blinks on and off. (If the keyframes are not visible, select both layers and press ◖ U ◗ to reveal animated properties.)

▼ Tech Corner: Time Display and Timecode

After Effects features three different ways to count time: SMPTE Timecode, Frames, and Feet+Frames. The counting method used can be changed in File > Project Settings. You can also ⌘+click (*Ctrl*+click) on the frame number in the top left of the Timeline panel to toggle between the choices. Regardless of the counting system chosen, the starting number can be set for each comp inside its Composition > Composition Settings dialog.

△ Open Edit > Project Settings for more control over how time is displayed. We will be using SMPTE timecode Non-Drop Frame for the remainder of this book.

SMPTE

This is the most common frame counting format – and the most confusing. SMPTE displays the number of hours (HR), minutes (MN), seconds (SC), and frames (FR) in the format HR:MN:SC:FR.

△ SMPTE timecode*

△ Frames

△ Feet+Frames

After Effects supports three different ways to represent time: SMPTE timecode, Frames, and Feet+Frames.

* The semicolons in the SMPTE timecode indicate Drop Frame counting; normal colons would indicate Non-Drop counting.

There are three standard frame rates: 24 frames per second (fps) for film, 25 fps for PAL video, and 29.97 fps for NTSC video. It's harder to count to 29.97 instead of a simple number like 30. Therefore, SMPTE has two different ways of counting this rate: *Drop Frame* and *Non-Drop Frame*.

Non-Drop Frame assumes the frame rate is 30 fps, *just for the sake of counting*. It counts neatly from 00 to 29, then rolls over to 01:00. Most people in NTSC-land working on shorter programs (say, under a half hour) use Non-Drop. After this lesson, we will use Non-Drop Frame counting as our project default for the rest of this book.

If the actual frame rate is 29.97 fps (the NTSC standard) instead of 30, the Non-Drop frame number displayed will eventually drift compared with real time. Therefore, Drop Frame counting was created. To even things back up, Drop Frame skips the frame numbers 00 and 01 (just the numbers, *not* the actual frames) every minute, except for

10s of minutes. You can tell Drop Frame counting is being used by the semicolons between the numbers.

Drop Frame is the timecode system used by NTSC DV, so you will see these semicolons while working with DV projects in non-linear editing systems. It is fine to insert DV renders from After Effects projects that used Non-Drop counting into Drop Frame sequences.

Frames

This simple format just displays the frame number, starting from the beginning of the timeline. It is preferred by some animators.

Feet + Frames

This is the way film editors count time – they actually measure the amount of film that has gone past. Different film sizes have different numbers of frames per foot; 35mm film has 16 frames per foot. Therefore, time in this format is displayed as FEET + FR.

Idea Corner

The following will help you build on the animation skills learned in this lesson:

• Create an animation in **03b-Motion Control** that explores multiple areas of the image. You could pause at some areas by using Hold keyframes, or "whip pan" quickly from one area to another, using motion blur for added effect. Our version is **Idea1 – Motion Control**. Also feel free to use your own image!

Use Hold keyframes whenever you "pause" Position or Anchor Point paths to ensure that Bezier handles are retracted (this avoids odd behavior in the motion path). If you have trouble moving the anchor point when keyframes are stacked on top of each other, scrub the Anchor Point value in the timeline to move them apart, and drag from there.

In **Idea1 – Motion Control**, we used a combination of different keyframe types and motion blur.

• Near the end of Lesson 1, we showed you how to import a layered Photoshop or Illustrator file as a composition. Import the file **Reject_split.ai** from this lesson's **02_Sources** folder as a comp – it contains each character on a separate layer. Animate a slam down (as you did in **04-Slam Down**) for each character, this time using more steps and animating faster. Our version is **Idea2 – REJECT on 3s**, where we animated the slam down every 3 frames (known as "animating on 3s").

Idea2: By giving each character its own layer, you can create even more interesting slam-down effects.

Quizzler

A large part of becoming a motion graphics artist is looking at another animation, and "reverse engineering" it. Play the movies inside the **Quizzler Movies** folder, and try to figure out how they were done:

• The animation in **Quiz_Butterfly Orbit.mov** can be done a couple of different ways. Try it using Position keyframes; it's hard to get that perfectly circular path. What other two transform properties could you combine to get a perfect rotation like this?

• Overshooting animations are a staple of character-style animation. You can do it using three keyframes, including one for the peak of the overshoot, or with just two keyframes: start and end. Play **Quiz_Overshoot.mov** and see if you can re-create this. (Hint: This will require a trip into the Graph Editor…)

▽ solutions

No Peeking!

Our versions of the Idea Corner and Quizzler animations are contained in folders with the same name in the **Lesson 02.aep** project file. Don't peek at the Quizzler Solution comps until you've tried them yourself first! There is no "right" answer to the Idea Corner challenges, so feel free to take a different path and use your own sources instead.

Layer Control

Learning how to trim layers and enhance them using Blending Modes and effects.

▽ Getting Started

Make sure you have copied the **Lesson 03-Layer Control** folder from this book's disc onto your hard drive, and make note of where it is; it contains the project file and sources you need for this lesson. Open the file **Lesson_03.aep** to work through the exercises in this lesson.

In the first two lessons, we focused on animating the properties of layers. However, your sources may have built-in animation of their own – namely, the frame-to-frame movement inside a video clip. Therefore, we're going to spend a good portion of this lesson showing how to move a clip in time, edit its in and out points, and work with its frame rate and ability to loop. From there, we'll move onto combining clips using Blending Modes – the "secret sauce" that creates rich, deeply layered looks. We'll end by showing alternate ways to work with effects, including using Adjustment Layers and taking advantage of Animation Presets.

Working with Layers

Before we get into trimming and editing, first let's take a refresher course on the significance behind how layers are stacked in the Timeline panel.

1 Open this lesson's project file **Lesson_03.aep** – you will be using it for the exercises in this lesson. In the Project panel, open the **Comps** folder, then double-click the comp **01-Layer Practice*starter** to open it.

2 In a typical two-dimensional comp such as this one, layers closer to the top in the timeline stack also appear closer to the top in the comp viewer. This is particularly an issue with full-frame footage, as a layer can completely obscure the layer behind it.

Note that this timeline has three layers, none of which are as long as the comp – their colored layer bars have "open air" before and after them.

2 Studying the timeline (above) allows you to easily "read" which layer will play when. Layers on top are drawn on top of layers they overlap underneath, such as here where the NYC footage overlaps the jet landing. "Ghosted" areas of layer bars indicate there are additional frames of footage that are currently trimmed away. Selected layers are drawn darker than deselected ones.

With an eye on the Comp panel, scrub the current time marker between 00:00 and 10:00, and notice how the image switches as the first layer bar ends.

3 In the Timeline panel, grab the first layer and drag it just below the second layer. Now scrub the current time marker, and note the change: Even though it is not the top layer in the comp, the second layer plays first, because the layer above it doesn't start until later.

Practice swapping layers while scrubbing the time marker until you have a solid grasp on the interaction between layer stacking order, and when they start and stop in the comp.

Moving Layers in Time

With layers, there are two sets of times we are interested in: the layer's internal in and out points which determine what portion of the clip we use, and its external in and out points which determine when a trimmed layer starts and stops in the comp. You can edit these separately or together. We'll continue working in **01-Layer Practice** to demonstrate this; **Jet Landing.mov** should be the top layer at this point.

4 Along the bottom left of the Timeline panel is an icon of a pair of brackets. Click on this icon to expose the In, Out, Duration, and Stretch columns in the Timeline panel. Then right-click on the top of the Stretch column and select Hide This; you won't need it here.

3 Dragging **NYC Pandown** below the **Jet Landing** layer in the timeline (above) results in the jet being drawn on top in the Comp panel (below). Footage courtesy Artbeats/Transportation.

4 Click on the Expand or Collapse In/Out/Stretch/Duration button in the lower left corner of the Timeline panel to reveal these parameters. Then right-click on the Stretch column header to hide it.

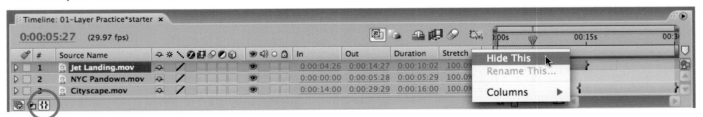

▽ insider knowledge

The Quality Switch

After Effects defaults to using Best Quality when rendering layers. This means animated layers are positioned with 16 bits of precision within each pixel of a comp to create exceptionally smooth movement, and transformations and effects are anti-aliased to produce smooth rather than jaggy edges. Draft Quality renders pixels with just "nearest neighbor" resolution, which is faster, but looks a bit rough. Click the Quality switch to toggle a layer to Draft Quality (dotted line); click again to toggle back to Best Quality (solid line).

▽ tip

Ins and Outs

To quickly locate the current time marker to a layer's in point, select it and type **I**. To locate to its out point, type **O**.

▽ tip

Splitting Layers

To split (divide) a layer into two at the current time, select Edit > Split Layer. This will duplicate the layer and automatically trim both copies so that they meet up at the split. Any keyframes and effects will appear on both layers after splitting.

5 Place the current time marker where it overlaps the first layer. In the timeline, click in the middle (not the ends) of the layer bar and drag it left and right along the timeline while watching the Comp panel; note that the frame being displayed changes. As a result, the layer will play earlier or later in the comp. Notice how the In and Out times in the Timeline panel change, but the duration doesn't – this is confirmation that you're not trimming the layer, just sliding it.

• A good shortcut to slide a layer is to place the current time marker where you want a layer to start, make sure the layer is selected, and press **[** (the left square bracket) – the layer will move so that its In point matches the current time.

• To move a selected layer so that it ends at the current time marker, press **]** (the right square bracket). Note that these shortcuts also work when multiple layers are selected. When you're done experimenting, drag layer 1 so that you can see both its In and Out points in the timeline.

Trimming Layers

Oftentimes you don't want to use all the frames in a movie clip. There are several ways to non-destructively trim a layer:

6 Place the current time marker where it overlaps the first layer. Click and drag the start of the layer bar: Its In and Duration times change, but the frame being displayed in the comp does not change (unless you trim it so much that you reveal the layer underneath). You can do the same to its Out point. This is referred to as trimming a layer "in place" because you are *not* sliding which frame of the footage will play at a given point in time. Note the "ghosted" area of the layer bar that shows how much you have trimmed off the front.

7 Time for more shortcuts, this time for trimming layers:

• Place your current time marker where you want the layer to start, such as when the plane's tires first touch the runway. Select this layer, and type **⌥[** on Mac (**Alt [** on Windows) – the layer will be trimmed in place to start at this time. The out point stays the same, and the duration changes.

• To trim the out point to the current time without moving the layer, select it and type **⌥]** (**Alt]**). The in point stays the same, and the duration changes. Note that these shortcuts also work when multiple layers are selected.

▼ Trimming in Other Panels

Those with an editing background might be used to trimming a clip in a separate clip window. You can work like this in After Effects as well:

• In the timeline, double-click any layer to open its Layer panel. To see the original layer before any masks or effects are applied, set the View popup to None or turn off the Render button. Trim the clip's in and out points by dragging the ends of the layer bar in this panel's timeline, or press the In button (the { icon below the ruler) to set the in point to the current frame. Either way, when you change the in point in the Layer panel, *the layer will slide in time to maintain the same start point in the composition.* Trimming in the Timeline panel doesn't offer this feature.

• You can trim a clip before you even add it to your comp. In the Project panel, select one of the movies in the **Sources** folder, press ⌥ (*Alt*) and double-click it to open its Footage panel. The trimming controls are identical to the Layer panel.

To add the trimmed clip to your comp, make sure the comp you want it to appear in

is the forward comp; the Footage panel will verify this with its "Edit Target" in its lower right corner. Click on the Overlay Edit button to add this clip into a new top track in the comp beginning at the current time without

disturbing the other layers. The Ripple Edit button has the added function of splitting any underlying clips at the insertion point and moving all of the later clips after the new clip is done.

△ Opening a source from the Project panel into its own Footage panel allows you to trim the source before overlay- or ripple-inserting it into the currently forward composition. Footage courtesy Artbeats/Timelapse Cityscapes.

△ Double-click a layer to open it in its Layer panel, where you can focus on its internal in and out points – how it has been trimmed, regardless of how it is being used in a comp.

△ Trimming in the Layer panel affects the In and Out points relative to the source clip, but does not change its In point in the comp's timeline (notice the two "In" times are different here). You can also click the { button (circled in red) to set the in point to the current frame.

8 Place the cursor over the ghosted area of a layer bar, and the Slip Edit tool will appear. This allows you to edit the frames of the source that will be played back without moving its In and Out points in the comp's overall timeline.

9 By selecting the Pan Behind tool (above), you can slip edit a layer by dragging its layer bar. This is especially handy if you can't see the start or end of the layer in the Timeline panel (below). When you're done, type **V** to return to the Selection tool.

10 If you slip edit with keyframes deselected, the keyframes will not move relative to the comp, meaning they keep their same relationship to other layers.

If keyframes are related to specific frames in the layer (such as with masking and "rotoscoping" keyframes) then they should be preselected before you slip edit so that they keep the same relationship to the layer.

Slip Edit

We'll finish our editing tour with the Slip Edit tool. This is a great way to change the portion of a clip that plays without disturbing its overall timing in a comp.

8 Trim the in and out points of the layer you've been working with so that you see some "ghost" layer bar at its head and tail. Place the current time marker in the middle of the layer, and hover the cursor over the ghost areas until you see a two-headed arrow bracketed by two lines: This is the Slip Edit tool. Click and drag while this tool is visible; note that the In, Out, and Duration values do not change, but the frame visible in the Comp panel does. How far you can slip a layer is determined by how much trimmed space exists at its head or tail. This is a lot faster than sliding a layer, then re-trimming its ends!

9 Sometimes, you will not be able to see the ghosted portions of the layer bar – maybe you are zoomed into the middle of the clip in the timeline, or it extends beyond the end of the comp. You can still use the Slip Edit tool.

Type **Y** to switch to the Pan Behind tool we introduced in the previous lesson. Now you will get the Slip Edit tool when you hover over the layer bar itself; drag the layer and try it out! Don't forget to type **V** to return to the normal Selection tool when you're done.

10 Life gets more interesting when the layers you are sliding or trimming have keyframes as well. For example, open comp **02-Layers & Keyframes*starter**. Type **⌘ A** (**Ctrl A**) to Select All, then **T** to reveal their Opacity keyframes. These perform crossfades between the layers.

Note that because we were working with full-frame sources, we animated Opacity only for the topmost layer; if we also animated the lower layer, both layers would be semi-transparent and the background color would show through.

• Keyframes are attached to frames in the source, not frames in the comp. Move layer 2 in time by dragging its layer bar, and notice that its keyframes go along for the ride. Undo to return layer 2 to its original location.

• Place the current time marker at around 10:00 so it's over layer 2, and use the Slip Edit tool to slide the layer. In this case, the keyframes remain in the same place in the comp. This is really useful for occasions when the keyframes need to keep the same timing relationship to the rest of the composition.

• Now select the Opacity keyframes near the out point of layer 2, and perform a slip edit. As you drag, selected keyframes should remain selected and move along with the movie; keyframes that are not selected won't move. (Note that this behavior is broken in version 7.0; instead, all keyframes are deselected as soon as you start to slip edit!) If keyframes are timed to the overall composition – such as fades – deselect them to leave them in place. If keyframes are timed to a clip – such as a rotoscoping mask – select them to have them move with the clip.

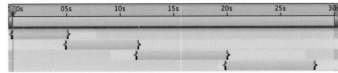

Sequence Layers

After Effects can automate some common editing tasks. Let's start with a group of layers that are supposed to play back end to end:

1 Open the comp **03a-Sequence – Full Frame*start**. It contains four already trimmed layers that are placed at the start of the comp.

2 Type ⌘ **A** (*Ctrl* **A**) to Select All, then choose the menu item Animation > Keyframe Assistant > Sequence Layers. For now, turn the Overlap option off, and click OK. The layers are automatically placed end to end.

3 Undo to get back to your initial timing. With the layers still selected, type **T** to reveal their Opacity, and let's talk about that Overlap option.

• Right-click on one of the layer bars and select Keyframe Assistant > Sequence Layers again. When the dialog opens, enable the Overlap button. This automatically creates crossfades determined by the Duration value. For now, use the default Duration of 01:00, and set Transition to Dissolve Front Layer.

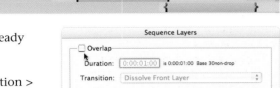

2 Selecting layers and applying Sequence Layers with Overlap disabled (above) results in the layers being placed end to end (top).

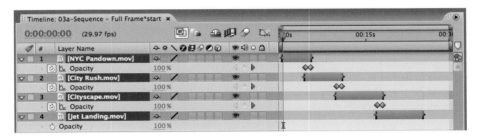

• Click OK, and preview. The layers have been arranged to have one second of overlap, and the layer on top fades out to reveal the layer underneath.

4 When you have layers that cover the entire frame – or otherwise perfectly line up and cover each other – you want to use the Dissolve Front Layer option. To verify why, undo and try step 3 again using the Cross Dissolve option instead, then scrub the time marker around where layers overlap: There will be a dip in opacity as the layer on top fades out while the layer underneath is fading up.

5 The Cross Dissolve option comes in handy if you have layers of different sizes, or layers with interesting alpha channels:

• Open the comp **03b-Sequence – Alpha*starter** that contains a number of 3D wireframe renders.

• Select All, and press **T** to reveal Opacity.

• Apply Sequence Layers, using the Dissolve Front Layer option. Notice how the layer underneath "pops" on through the transparent areas of the layer on top?

• Undo, and try again using the Cross Dissolve Front and Back Layers option. Opacity keyframes are created for both the outgoing and incoming layer. Much nicer, yes?

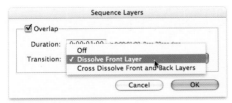

3 Enabling the Overlap option in Sequence Layers (above) both overlaps the layers by the specified duration, and creates Opacity keyframes so that they will crossfade (top).

▽ tip

Sequence and Slip

After performing Sequence Layers, you can then slip edit moving footage to adjust the frames you see without disrupting the overall timing.

▼ Solo Switches

When layers are stacked on top of each other, it can be difficult to see what each one looks like. Use the Solo switches (the hollow circle to the left of the padlock) to preview them individually:

• For instance, turn on the Solo switch for layer 4 to see it in isolation; layers 1–3 will temporarily be disabled and their eyeballs will be grayed out.

• Then turn on the Solo switch for layer 3 to preview it; notice that layer 4 remains solo'd.

• ⌥ (*Alt*) + click on the Solo switch for layer 2. Only layer 2 will be solo'd. All other layers are disabled.

When you're done, and you want to see all the layers again, *turn off the Solo switch for all layers*. If you turn them all on, any layers you add to the comp in the future won't be displayed unless you solo them also!

6 Time to put a few tricks together. Open the comp **03c-Sequence – trim*starter**. Say you want to crossfade between its photographs at a nice, orderly pace:

• Select layer 4, then **Shift**+click to select layer 1. This will select all layers, but from the bottom up (layer 4 will then be sequenced first in time).

• Type ⌥ **Home** (**Alt Home**) to make them all begin at the start of the comp.

• If you want a layer to play for four seconds and then crossfade for one, each layer needs to have a total duration of five seconds. Since After Effects starts counting at 0, move the time marker to 04:29 for a five second duration, and type ⌥ **]** (**Alt]**) to trim their out points.

• Right-click on one of the layer bars and select Keyframe Assistant > Sequence Layers. Set the Overlap > Duration to 01:00 crossfade time. (Which Transition option should you use for full-frame sources?) Click OK.

• Press **T** to show the Opacity keyframes, and RAM Preview. Our version is in the **Comps_Finished** folder. Save your project at this point.

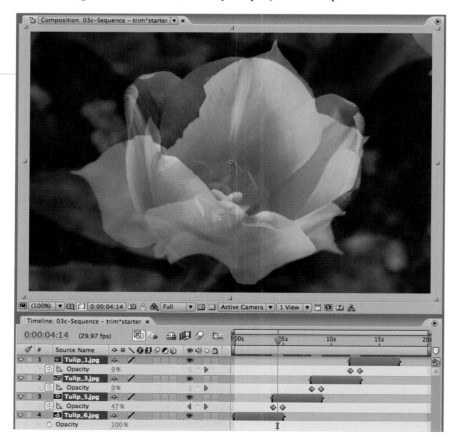

6 To quickly trim layers to have the same duration, line them up to start together, and trim their ends as a group (above). Then use Sequence layers to automatically spread them across time, with crossfades (right). Photos courtesy Wildscaping.com.

Looping Footage

You now know how to shorten footage; how can you make it longer? You could increase the Time Stretch value, but that also slows down the playback speed. Fortunately, some clips have been designed to be seamlessly "looped" or repeated. After Effects can make them look like one long clip:

1 In this lesson's Project panel, locate and open **Comps > 04-Looping Footage*starter**. It should be empty.

2 Back in the Project panel, select the folder **My Sources** so that the file you're about to import will automatically sort into it. Type ⌘ I (Ctrl I) to open the Import File dialog.

 Navigate to where you copied this lesson's files onto your computer and open the **Lesson 03 > 03_Sources > Movies** folder. Select the file **Clock+Skyline.mov**, and click Open.

 Double-click this movie in the Project panel to open its QuickTime player. Play it, and watch what happens when the movie reaches the end: It looks the same as it did at its beginning, indicating this footage file is a candidate for looping. Close the player.

3 Type ⌘ / (Ctrl /) to add it to the already open comp **04_Looping Footage**. This clip is 10 seconds long, but the comp is 30 seconds long – you can see it doesn't reach the end.

 Select **Clock+Skyline.mov** in the Project panel (not the Timeline), and type ⌘ F (Ctrl F) to open its Interpret Footage dialog. Near the bottom in the Other Options section is a parameter called Loop. Enter 3 here (3 × 10 = 30), and click OK.

4 Back in the comp, you will now see the "ghost" layer bar after the layer's Out Point, indicating it can be longer. Press End to jump to the end of the comp, select **Clock+Skyline.mov**, and type ⌥] (Alt]) to re-trim its Out Point to this time.

 Practice importing, looping, and extending the other files you find in the **Lesson 03 > 03_Sources > Movies** or **> Wireframes** folders on your drive. Normal footage files of people and places don't loop cleanly, but other items – such as the wireframe 3D renders – do.

1 Play the **Clock+Skyline.mov** in the Quicktime Player and it will seamlessly loop. However, it won't automatically loop when After Effects uses it as footage. Footage courtesy Artbeats/Digital Biz.

3 The movie is initially not long enough to play for the entire comp (above). However, it was designed to be looped. Open it in the Interpret Footage dialog (below) and Loop it 3 times.

4 After you loop the movie, you will see that the ghosted (trimmed) duration of its layer bar now reaches to the end of the comp (above). Re-trim its Out Point to reach the end (below).

1 Set Preferences > Import > Sequence
Footage to the frame rate you expect to be
working at, such as 29.97 fps for NTSC video.

Image Sequences

Sometimes, you will receive a set of still image files that are intended to be played back as if they were a continuous movie. You don't need to use the Sequence Layers assistant to make this happen; you can do it during import, setting the spacing between frames by "conforming" the resulting file's frame rate.

1 Open Preferences > Import. Because sequences of images have no inherent frame rate, After Effects defaults to setting them to 30 fps. In the Sequence Footage field, enter the correct NTSC frame rate of 29.97 (or 25 fps for PAL). Click OK. This preference will be retained for future projects on this computer.

• In the Project panel, select the folder **My Sources** so that the file you're about to import will automatically sort into it. Type ⌘ I (*Ctrl* I) to open the Import File dialog.

• Navigate to this lesson's files on your computer, and open the **Lesson 03 > 03_Sources > Muybridge Sequence** folder. It contains 10 similarly named TIFF format files. Select the first one. Along the bottom of the Import File dialog will be a checkbox for TIFF Sequence; make sure it is checked, then click Open.

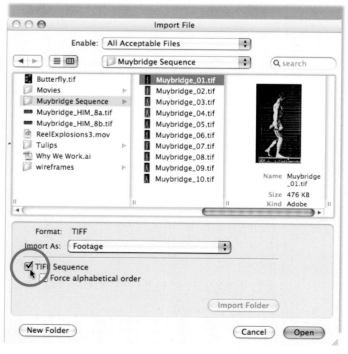

1 *continued* Navigate to the folder that holds your file sequence, select the first frame, and make sure the Sequence option is checked before clicking Open. Footage courtesy Dover.

2 After importing, a footage item named **Muybridge_[1-10].tif** will be selected in the **My Sources** folder in

the Project panel. Along the top it says it is 10 frames long at 29.97 fps (or 25 fps for PAL).

Ten frames is rather short for a movie; fortunately, this sequence was designed as a seamless loop – so let's loop it. With this file selected, type ⌘ F (*Ctrl* F) to open its Interpret Footage dialog. Enter a large number such as 100 for its Loop Times value, and click OK. The duration should now read 33:10 at the top of the Project panel.

3 Back in the Project panel, drag the image sequence (**Muybridge_[1-10].tif**) to the Create a New Composition icon at the bottom of the

Project panel. A new comp will be created with the same width and height, frame rate, and duration as the footage. Press ⌘ K (*Ctrl* K) to open Composition Settings, and change the duration to something shorter, such as 05:00.

The new comp – **Muybridge 2** – will be created in the same folder as the footage; move it to the **My Comps** folder.

RAM Preview and check out the speed this sequence plays at (remember that the preview speed is not accurate while it's caching, only when it plays back). Does it seem a bit too fast to be realistic? Let's conform just this layer's frame rate without affecting the global Import Preference.

4 Bring the Project panel forward, select **Muybridge_[1-10]** in your **My Sources** folder, and open its Interpret Footage dialog again. Look for the section named Frame Rate; enter a new number for Assume this Frame Rate (such as 10), and click OK. Bring your comp forward, and RAM Preview again. The footage will play back at this rate in your comp, independent of the comp's frame rate, skipping or repeating frames as needed. Try out different rates until you find one you like the feel of.

4 You can conform your sequence to an alternate frame rate in the Interpret Footage dialog to slow it down (or speed it up!).

Frame Rate versus Time Stretch

There is another way to change the playback speed of a source: Time Stretch. But it has an important difference compared with "conforming" the frame rate…

5 Add a fade-up to your Muybridge sequence: Press Home, select the layer, type **T** to reveal Opacity, set it to 0%, and enable keyframing. Then move to 01:00 and set Opacity to 100%.

• Change Interpret Footage > Assume this Frame Rate again as you did in step 4; the timing of the keyframes stays the same. This is because settings in the Interpret Footage dialog affect source files *before* they are processed in a comp.

• Reveal the Stretch column in the timeline by right-clicking on any column head and selecting Columns > Stretch. Enter a value of 200%, which means the layer will take twice as long to play back. RAM Preview, and note that not only does the layer slow down, the timing of its Opacity keyframes is stretched as well: Your second keyframe now appears at 02:00. Scrub the value for Stretch and watch this keyframe move. Time stretching affects the speed of a layer *after* the keyframes are applied.

▽ insider knowledge

Stretching Keyframes

Time Stretch is a good way to give multiple copies of the same footage item different playback speeds. However, unlike adjusting a source's Frame Rate, Time Stretch also changes the spacing of any keyframes already applied to the layer.

5 If you place keyframes (top), then use Stretch to retime your footage, the timing of the keyframes will change as well (above).

1 At 100% opacity with its Blend Mode set to Normal, the Muybridge sequence completely blocks out the background behind it.

Blending Modes

We're going to move on from ways to edit layers to ways of making layers look cool. The secret to this is Blending Modes.

When you place one layer on top of another, its pixels normally replace the pixels of any image underneath. As you fade the top layer, its pixels are mixed with those underneath. Blending Modes provide alternate ways to mix (blend) these pixels together, such as adding together their color values. Let's try out a few to get a feel for them.

1 Open comp **06_Blending Modes*starter**. Select layer 1, **Muybridge_[1-10].tif**, and type **T** to reveal Opacity. Scrub its Opacity value and note the result of fading it in and out over the layer behind it. Set it back to 100% for now.

2 Open the Mode column. You can press **F4** to toggle between it and the normal Switches column. If you have a fairly wide monitor, right-click on any column header in the Timeline panel and select Columns > Modes from the popup: Now you can see both Switches and Modes at the same time (re-order them to taste by dragging the column heads left and right).

In the Modes column, note that each layer has a Mode popup, which decides how it blends with the layer below. It defaults to Normal. Different types of modes are roughly grouped in this popup – for example, the second group tends to make the results darker; the third group tends to make the results brighter; and the fourth group creates interesting, colorful blends of layers.

2 F4 toggles the Switches/Modes columns. If you forget the shortcut, the two buttons in the bottom left corner of the Timeline panel also toggle between Switches and Modes (above). You can open both panels at once by right-clicking on any column header and selecting them; re-order them by dragging the column heads left and right.

✓	Normal
	Dissolve
	Dancing Dissolve
	Darken
	Multiply
	Linear Burn
	Color Burn
	Classic Color Burn
	Add
	Lighten
	Screen
	Linear Dodge
	Color Dodge
	Classic Color Dodge
	Overlay
	Soft Light
	Hard Light
	Linear Light
	Vivid Light
	Pin Light
	Hard Mix
	Difference
	Classic Difference
	Exclusion
	Hue
	Saturation
	Color
	Luminosity
	Stencil Alpha
	Stencil Luma
	Silhouette Alpha
	Silhouette Luma
	Alpha Add
	Luminescent Premul

2 *continued* The Mode popup has a long list of choices. They tend to be grouped: Modes that brighten the result, for example, are in the same section.

To move up and down the Mode menu without using the popup, select a layer and press **Shift** **+** (the plus key on the regular keyboard) to move down, and **Shift** **−** (the minus key) to move up.

3 Click on the Mode popup for the **Muybridge** layer, and pick Multiply. This says "take my brightness, and multiply it by the brightness of the pixels underneath." You can think of black pixels as having a value of 0, meaning the result will be 0 (black); think of white pixels having the value of 1 or 100%, which means the result will keep the color of the underlying pixel.

Try other modes in this first group, and notice they have similar but different results.

4 Now select Add mode – this adds the color values of pixels together. If the pixel on top is black (0), it will have no effect on the pixel underneath. If it is white, it will cause the result to be white. Try other modes in this group such as Screen, which is a less intense version of Add.

5 Staying with the **Muybridge** layer, select Overlay from the third group. This is a more complex mode, providing colorful, richly saturated results. Black pixels on top darken underlying pixels, but do not cause them to go completely black; white pixels lighten and tint rather than go to white. Again, try other modes in this group.

The next level is applying effects to the layer that is being "moded" onto the layers underneath:

6 Select the **Muybridge** layer, and apply Effect > Color Correction > Levels; it will appear in the Effect Controls panel. The Levels effect is the pre-ferred way to alter the brightness and contrast of a layer. Take a look at the Histogram in the Effect Controls: This gives you a visual representation of the darks and brights that exist in the image.

Try scrubbing the Gamma value, which sets the gray midpoint of a layer; you can also drag its pointer under the middle of the Histogram. Note how it changes the contrast of the image sequence. Try this with the different modes. Remember that you can temporarily Solo the layer to see the results of the effect without the blending mode.

7 Turn off Levels by clicking on the stylized "f" (or "fx" in CS3) next to its name in the Effect Controls panel. Then apply Effect > Color Correction > CC Toner* to the **Muybridge** layer. Click on the Midtones color swatch, and pick a color such as yellow, or use the eyedropper to pick a color from the background movie. Notice how the result is richer again and more colorful. Try different colors and modes, and reduce Opacity to tone down intensity.

Save your project, and close all unnecessary comp panels.

* Cycore Effects is a separate installer on the After Effects 7 disc. (If you are using the demo version of After Effects, use Color Correction > Tint effect and change the Map White To color.)

3-5 Choosing different modes for **Muybridge_[1-10].tif** creates different "looks" in the way it blends with the underlying layer. Here we compare Normal (A), Multiply (B), Add (C), and Overlay (D).

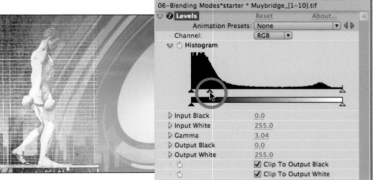

6 You can use effects to further alter the blend. Here we're using Levels to adjust the image's Gamma (right) to alter the midpoint values in the composite using Overlay mode (left).

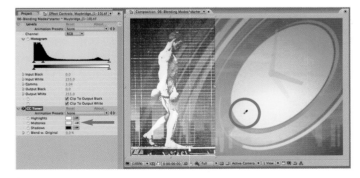

7 We disabled Levels, added CC Toner, and used its Midtones eyedropper to select a color from the background to tint the Muybridge image. The result (with Overlay mode) is an even richer composite compared with using the original grayscale source.

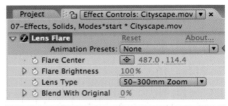

2 If the Lens Flare effect is selected (top), you can see and drag around its Flare Center in the Comp panel (above) to interactively place the flare.

3 Many effects – such as flares – work best if applied to a black comp-size solid.

Effects, Solids, and Modes

Now that you have a working knowledge of modes, let's employ them to give us more control over how we apply effects. While we're here, we'll also show you how to edit the motion path for an effect point.

1 Click on the Project panel tab to bring it forward; if you can't see it, drag the scroll bar along the top of its frame to the left or press ⌘ **O** (*Ctrl* **O**). Then double-click the comp **Comps > 07_Effects Solids Modes*starter** to open it.

2 This comp has a single layer in it: **Cityscape.mov**. Select this layer and apply Effect > Generate > Lens Flare.

While Lens Flare is selected in the Effect Controls panel, you will see a crosshair at the center of the flare's brightest point in the Comp panel – this is its *effect point*. Drag it around the comp and note how the flare changes.

Let's say you generally like this flare, but want to tweak it a bit. You can explore its parameters in the Effect Controls panel, but unfortunately this effect has no way to directly change its color. You could try applying Effect > Color Correction > Hue/Saturation, but this will change the color of the underlying footage as well as the flare. So let's explore a better approach:

3 To gain more control over an effect, we need to give it its own layer.

• Start by removing the effect from the movie, but rather than deleting it, select it in the Effect Controls panel and Edit > Cut.

• Select Layer > New > Solid; the shortcut is ⌘ **Y** (*Ctrl* **Y**). Click on the Make Comp Size button. Then click on the Color swatch and set it to pure black. Click OK in the Color Picker, then OK in the Solid Settings.

• With your new **Black Solid** layer selected, select Edit > Paste. The Lens Flare should now appear on the solid layer, using exactly the same settings.

4 If the Mode column is not visible, type **F4** to reveal it. Set the Mode for **Black Solid** to Add – the black solid will disappear, leaving just the bright flare.

4 Apply the Lens Flare to the solid, and place it above the layer to be treated (left). Try different modes such as Add (A), Screen (B), and Color Dodge (C) to get different looks.

Now press **Shift** **+** (the plus symbol on the regular keyboard) to move down the Modes list without using the popup. Screen will give you the same look as when you applied it directly to your footage layer. Linear Dodge looks identical to Add in this mix, while Color Dodge creates a tight single flare. Use whichever mode you like best.

Note that pressing **Shift** **–** (the minus key) moves back up the modes list.

5 Apply Effect > Color Correction/Hue Saturation to your **Black Solid** layer; it will be added to the Effect Controls panel below Lens Flare. Scrub the Master Hue value to change the color of the flare; notice that your underlying footage remains unaffected.

Effect Motion Path

Remember in step 2 where you played with the location of the flare's center? This gives us a good excuse to take a brief detour and show you another important skill: animating the motion path for an effect point path.

6 Make sure the current time marker is at 00:00. In the Effect Controls panel, click on the stopwatch to the left of the Flare Center parameter to enable keyframing. This should also select the Lens Flare effect, which will cause its Flare Center crosshair to be visible in the Comp panel.

• Drag it to a good starting location, such as near the upper left corner. (If you can't see its crosshair, click on the crosshair in the Effect Controls panel, then click where you want it to be in the Comp viewer.)

• Press **End**, then drag the Flare Center to a good ending location. RAM Preview, and your flare will trek in a straight line across the sky.

The effect point creates *spatial* keyframes (they have an X and Y value), but these values are in relation to the layer, not the comp. That's why you won't see its motion path in the Comp viewer. But all is not lost…

• Double-click the **Black Solid** layer to open its Layer panel. In the bottom right corner, check that the View popup is set to Lens Flare and that the Render button is on.

You should now see the Flare Center's motion path.

5 Apply other effects such as Hue/Saturation to the solid layer to alter the lens flare without affecting the underlying footage.

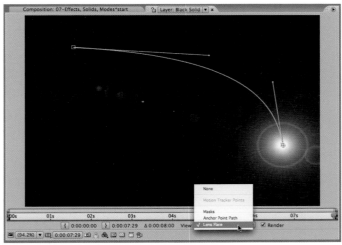

6 Effect Point paths are not visible in the Comp panel (top). Double-click the layer to open its Layer panel (above) where you can edit the effect point path. (If the motion path is not visible, select Lens Flare from the View popup.)

7 We suggest you set Preferences > Display > Motion Path to All Keyframes so that you see the entire motion path. (This preference will be retained for all future projects on this computer.)

7 We are assuming that you are using the default After Effects preferences. If this is the case in After Effects 7, you will see only the keyframe icons for 10:00 worth of time (5 seconds on each side of the current time marker). So at the end of the comp (07:29) you won't see the first keyframe's icon. To fix this, open Preferences > Display, set the Motion Path option to All Keyframes, and click OK. This preference will be retained for future projects on this computer.

Go ahead and edit the Flare Center's motion path, perhaps making a nice arc going across the frame. If you have trouble spotting the two dots that you pull to create Bezier handles (they are in line with the motion path), hold down ⌘ (*Ctrl*) and drag handles out from the keyframes. Preview the comp to try out your new path, and close the Layer panel when you're done. Our version in the **Comps_Finished** folder is **07-Effects Solids Modes_final1**, where we also animated Flare Brightness and the color.

Lens Flare pivots around the center of the layer it is applied to. By applying it to a solid larger than the comp (as we did in **07-Effects Solids Modes_final2**), you can reposition it as desired.

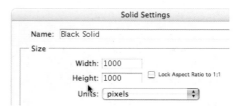

Big Solids

You may have noticed that a lens flare always pivots around the center of the layer it is applied to. Another reason to apply effects to a solid is that you can increase the size of the solid, then reposition or otherwise transform the solid in the comp to change how the effect appears.

In this exercise, select **Black Solid**, type ⌘ *Shift* Y (*Ctrl* *Shift* Y) to open its Solid Settings, enter a larger number such as 1000 for its Width and Height, and click OK. The flare is no longer required to pivot around the center of the comp, giving you more flexibility in deciding its path. Have fun scaling, rotating, and moving this layer. We provide one alternative idea in **Comps_Finished** > **07-Effects Solids Modes_final2**. Save your project when you're done playing.

Deeper into Effects

Next we're going to show you a few more ways to work with effects, including finding them in a hurry, and alternate ways to animate them. Then we'll reveal how to save and use Animation Presets, which can recall not only what effects you have applied to a layer but any keyframes you have applied as well.

Finding and Animating Effects

It can be a challenge to remember which Effect submenu a particular effect resides in (for example, is Invert in Color Correction or Channel?). Fortunately, After Effects has a panel that makes it much easier to find effects: Effects & Presets.

2 Click on the Options arrow in the upper right corner of the Effects & Presets panel, and temporarily disable Show Animation Presets so only actual effects are searched (left). Then type "**radial**" into the Contains box to search for these characters in any effect name (below).

Effects & Presets is one of the default panels that appear in the Standard workspace. However, it's a bit cramped along the bottom of the right side. To make more room for it, close the Time Controls panel; its frame will close too, making more room for Effects & Presets. (Don't worry; you can always get Time Controls back by selecting it in the Window menu, or by using Workspace > Reset "Standard".)

1 If the Comp or Timeline panel is forward, you can close all of the old comps you are finished with by typing ⌘ ⌥ W (Ctrl Alt W). Next, click on the Project panel tab to bring it forward; if you can't see it, type ⌘ 0 (Ctrl 0) to reveal the Project panel. Then double-click **Comps > 08_Save Preset*starter** to open it. It has one layer in it; select it.

2 Turn your attention to the Effects & Presets panel. Click on its options arrow in its upper right corner: This is where you determine what this panel will show you, and how it will show it. For now, disable the option Show Animation Presets so that you see only the names of actual effects.

Along the top of this panel is a search box named Contains. Type "**radial**" into it. As you type, the area underneath will sort through all of the effects that contain the characters you are typing.

Double-click the effect named Radial Blur, and it will be applied to the layer you had selected. If you forgot to select a layer, you can also drag and drop it to the desired layer.

3 The Effect Controls panel will open, showing the effect you applied. In addition to some of the normal user interface elements you have seen so far, Radial Blur contains a custom element in the form of the blur graphic. To change the

Effects & Presets Guided Tour

The Effects & Presets panel offers many different options for searching through effects and animation presets. There is a QuickTime movie in this lesson's **Guided Tour** folder that walks you through these options, as well as advice on searching and organizing animation presets.

3 The Radial Blur effect has a custom user interface to adjust the center and amount of blur. Drag inside the graph to change the center of the blur.

center of the blur, either drag around inside the graph in the Effect Controls, or drag the effect point directly in the Comp panel. The slider directly below the graphic changes the Amount of blur. Change the Type popup from Spin to Zoom for a different effect.

• Come up with a look you like, and at 00:00, enable keyframing for the Amount property by clicking on the stopwatch to the left of its name in the Effect Controls panel. Type **U**, and this animated property will be revealed in the Timeline panel as well.

• Move the current time marker a few seconds later to 02:00, and set the Amount to 0. Type **N** to end the work area here, and hit **0** on the numeric keypad to RAM Preview. Your blur effect will animate from your initial setting to unprocessed video over this time. (This is a slow effect, so feel free to drop the comp's Resolution popup from Full to Half to speed up previews.)

4 Let's apply another effect to help create a sort of flashback look. In the Effect & Presets panel, delete "radial" and instead type "**tint**" to reveal the Tint effect. Double-click it, and it too will be applied to your layer.

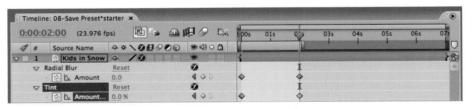

3–5 Animate Radial Blur and Tint (top) to resolve from a blurry black-and-white image to a sharp, full-color one (above). Footage courtesy Artbeats.com.

5 Press **Home** to return to the start of the comp (and where you placed your first Radial Blur keyframe).

• In the Effect Controls panel, enable keyframing for the Amount parameter at its default value of 100%, which gives a black and white treatment to this color image. Press **U** until both this and the Radial Blur keyframes are revealed in the Timeline panel.

• Press **Shift End** to jump to the end of the work area at 02:00. In the Effect Controls window, set the Amount to Tint value to 0%, restoring the original color in the image.

Save your project, and RAM Preview. If you'd like to compare results, we saved our version as **Comps_Finished > 08-Save Preset_final**.

Saving Animation Presets

Let's say you like that treatment, and decide you'd like to apply it to other layers. You could copy and paste the effects and their keyframes, but that's cumbersome – especially if that layer was in a new project, started sometime in the future!

You should know by now that whenever we present you with a problem, we're about to show you a better way:

6 In your **08-Save Preset*starter** comp, select the **Kids in Snow** layer and press **F3** to bring the Effect Controls panel forward (if it isn't already). Click on the effect name Radial Blur to select it, then **Shift**+click on Tint to select it as well.

There are various ways to save your effects as an animation preset, including:

• Choose the menu item Animation > Save Animation Preset.

• Click on the Create New Animation Preset icon at the bottom right of the Effects & Presets panel.

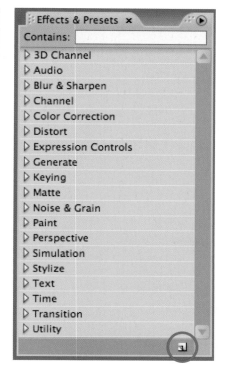

A file browser dialog will open. It should default to the **Presets** folder in the After Effects applications folder. You want to save your new preset somewhere in this **Presets** folder, so it will automatically appear in the Effects & Presets panel later. It's a good idea to start your own subfolders inside **Presets** to keep track of the presets you create. So create a New Folder, give it your name, then give your new preset a name you'll remember it by – say, "**radial flashback.ffx**" (keep the .ffx suffix). Then click Save. After a slight pause, the Effects & Presets panel will refresh.

6 Select both effects (above left), then use either the Animation menu item or the button in the lower right corner of the Effect & Presets panel (above) to Save Preset.

7 To see how easy it is to apply your new preset to a different layer, bring the Project panel forward and open a different comp, **09_Apply Preset*starter**. Preview; it currently has an untreated video layer in it called **City Rush.mov**. Select that layer.

Animation presets apply their keyframes starting at the location of the current time marker. If you want to make sure that your keyframes start when the layer starts, select the layer, and type **I** to jump to its in point.

7 There are several ways to search for saved Animation Presets; if you've just saved it or used it, it will appear in the Animation > Recent Animation Presets menu (above). You can then apply the preset to any other layer (left). Footage courtesy Artbeats/City Rush.

Effects & Presets ×

Contains:

▽ * Animation Presets
 ▷ 🗀 Backgrounds
 ▷ 🗀 Behaviors
 ▷ 🗀 Chris
 ▷ 🗀 Image – Creative
 ▷ 🗀 Image – Special Effects
 ▷ 🗀 Image – Utilities
 ▷ 🗀 Shapes
 ▷ 🗀 Sound Effects
 ▷ 🗀 Synthetics
 ▷ 🗀 Text
 ▷ 🗀 Transform
 ▷ 🗀 Transitions – Dissolves
 ▷ 🗀 Transitions – Movement
 ▷ 🗀 Transitions – Wipes

2 Twirl open the *** Animation Presets** folder. It contains hundreds of presets supplied by Adobe, broken down by category into folders; it also contains any folders you created (such as the one you made in the previous exercise).

Remember that you won't see Animation Presets unless the Show Animation Presets option is selected from the Effects & Presets options menu (click arrow in top right).

3 Many of the **Image – Creative** presets include color treatments, such as Colorize – Sepia (below left) and Bloom – brights+darks (below right).

Just like you have options on how to save a preset, you have options for applying presets. With the layer selected, either:

• Open the Animation menu. If you hover over the Recent Animation Presets submenu, your new preset will appear there.

• You could use the handy Effects & Presets panel and its search function! For this to work though, you will need to include presets in the search. Click on the Effects & Presets options arrow, and re-select the choice Show Animation Presets. Then start typing "**flashback**", or whatever name you gave your preset, until it appears. Double-click it or drag it onto your layer.

• If it exists outside your After Effects application folder, you can use Animation > Apply Animation Preset and navigate to the preset on disk.

Whichever method you use, the Effect Controls panel will come forward to show which effects are part of the preset. Type **U** to reveal animated properties in the Timeline; you should see your two effects as well as your keyframes. Preview, and you will see your entire treatment has been re-created on this new layer in this new comp.

Adobe's Animation Presets

In addition to creating and saving your own animation presets, Adobe ships After Effects hundreds of presets that they've developed for you to use. Let's take a quick trip through applying them, and a category you should particularly explore: Behaviors.

1 Save your project, and open the comp **10_Adobe's Presets*starter**. It has two layers in it; currently, the first layer (**Butterfly.tif**) has its Video switch turned off. Select the second layer: **Kids in Snow.mov**.

2 Delete any text left over in the Contains box of the Effects & Presets panel. Twirl open the top folder – *** Animation Presets**. (If you can't see it, enable Show Animation Presets from Effects & Presets Options menu.) This contains Adobe's presets, and if you saved your own presets as we instructed above, your own folder will show up here as well.

3 Twirl open the **Image – Creative** subfolder (resize the panel wider if the names are truncated). It contains a number of interesting image treatments. For example, double-click **Colorize – sepia**; you'll see an old-fashioned photo treatment. Undo to remove this preset, then try another, such as **Bloom – brights+dark**.

Now the video will look much richer. (By the way, this particularl preset is a version of our "Instant Sex" trick covered later in this lesson.)

4 In the Timeline panel, turn on the Video switch (the eyeball icon) for the layer **Butterfly.tif** and select it.

Twirl up the **Image – Creative** folder, and instead twirl down the subfolder **Behaviors**. These use a combination of effects and "expressions" (a user programming language for After Effects) that creates animation moves without the need for keyframes.

For example, double-click the preset **Rotate Over Time**, then preview: The butterfly will slowly rotate clockwise over the course of the comp. Look at the Effect Controls panel, and scrub the Rotation parameter in the top effect – this controls how fast the layer rotates, and in what direction.

Undo until the Rotate Over Time preset is removed, and apply the **Wiggle – position** preset. Preview; the butterfly will now wander about the comp – without you having to keyframe a motion path! Edit the two parameters in the Wiggle parameters at the top of the Effect Controls panel to change how nervous or sedate the butterfly is.

Note that there are separate Behavior presets for wiggling position, rotation, scale, and skew, but the funnest to play with has to be **Wigglerama**, which throws them all into one mondo preset! Try it on some of your own footage items, or a text or logo layer.

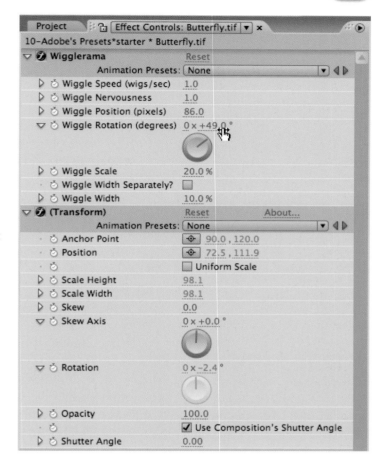

4 Some presets – such as Wigglerama – add a specialized "controller" effect, followed by one or more effects that it actually controls.

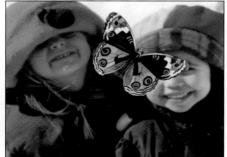
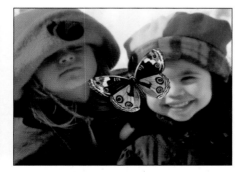

4 *continued:* The Behaviors presets create automated animation, such as Wigglerama's random movement. Butterfly courtesy Dover.

▽ future vision

Adjustment Ideas

Anything you do to effect the shape or opacity of an adjustment layer is fair game; see *Idea Corner* at the end of this lesson for one suggestion. In later lessons you'll learn about masks and track mattes; you can also apply these techniques to adjustment layers to create interesting shapes for the effected area.

2 The half-moon icon in the Timeline panel indicates that a layer is an Adjustment Layer.

5–6 Scaling down the adustment layer (below) results in just an inset portion of the composite being affected by the effects applied to the adjustment layer (above).

Adjustment Layers

Another great tool to use with effects is an Adjustment Layer. These allow you to apply effects to just one layer, and have them affect all of the layers underneath. Then we'll wrap this lesson by showing you one of our favorite tricks: Instant Sex.

1 Bring the Project panel forward by clicking on its tab; if you can't see it, type ⌘ **O** (*Ctrl* **O**). Then open **Comps > 11_Adjustment Layers*starter**. How would you go about blurring all three layers in it? Happily, you don't have to apply a blur effect three times!

2 Select Layer > New > Adjustment Layer. This creates a solid that is the same size as the comp and places it at the top of the layer stack, with one difference: Its Adjustment Layer switch (the half-moon icon in the Timeline panel's Switches column) is on. You can't "see" adjustment layers; you need to apply effects to them and observe their results.

3 With your **Adjustment Layer** selected, add Effect > Blur & Sharpen > Fast Blur. The Effect Controls panel will come forward. Increase the Blurriness value; the entire composite image gets blurrier.

4 Adjustment layers treat only those layers underneath them in the layer stack. In the Timeline panel, grab **Adjustment Layer** and drag it down a level, just above the **Muybridge_[1-10].tif** layer: The title is no longer blurred, but the layers underneath still are.

Drag **Adjustment Layer** down one more level, to just above the layer **Clock+Skyline.mov**. Now just the background image of the clock and skyline are blurred, and the other two layers above it are sharp.

5 If adjustment layers don't cover the entire comp image area, then only the area underneath them will get treated.

Select **Adjustment Layer**, and type **S** to reveal its Scale. Reduce the scale to around 80% while keeping an eye on the comp: You will see that only the areas below the adjustment layer are blurred. Drag it to reside just below **Why We Work.ai** so the text remains sharp, while part of the background is blurred.

6 Try out some other effects. For example, replace Fast Blur with Hue/Saturation, and scrub its Master Hue and Saturation values to colorize the underlying layers.

7 With **Adjustment Layer** still selected, type *Shift* **T** to reveal its Opacity. Scrub this value, and note how much of the adjustment layer's effect is blended into the final composite.

Instant Sex

Adjustment layers are handy for adding effects to a number of layers that have been stacked to create a composite image. They are equally useful for quickly treating a number of layers that have been arranged in time, such as a video montage.

1–4 The original image is sharp and literal (A). Adding an adjustment layer with some blur results in the entire image becoming blurry (B). Choosing a mode such as Overlay (left) results in a much more interesting treatment (C). Footage courtesy Artbeats/ New York City Scenes.

1 Re-open one of the comps from this lesson's earlier exercises where you were playing with editing layers, such as **03a_Sequence Layers – Full Frame**.

2 Add a Layer > New > Adjustment Layer to this comp – a new layer will appear above your edit.

3 Apply Effect > Blur & Sharpen > Fast Blur to your new adjustment layer, increase its Blurriness parameter, and toggle on the Repeat Edge Pixels option. Drag the current time marker through the timeline, and note how all of your layers – including any crossfades between them – get the same amount of blur.

Believe it or not, there is a master plan behind teaching you so many seemingly disparate concepts in the same lesson…and here's the payoff:

4 Type **F4** to reveal the Modes panel, and select a Blending Mode such as Screen or Overlay for the adjustment layer. The result will be that a blurred composite of your layers will be blended back on top, creating an intense, dreamy, sort of filmic look that is very popular. You can even duplicate your adjustment layer and use a different mode for each.

We call this technique Instant Sex; one version of it is saved in **Comps_Finished > 03a-Sequence – Full Frame_final**. In our version, we duplicated the Adjustment Layer then set one to Overlay and the other to Screen. You don't have to blur both layers, but you must apply an effect in order for the mode to actually work.

▽ tip

Universal Tint

A great way to help unify a group of disparate clips is to give them all the same color treatment. For example, apply CC Toner (or Tint) to an adjustment layer above an edited group of clips, and tweak its Opacity to get the amount of tint you want.

We often apply two adjustment layers to create the Instant Sex look. See example: **Comps_Finished > 03a-Sequence – Full Frame_final**.

▼ Tech Corner: Non-Square Pixels

Most of the exercises in this lesson use compositions that have a size of 720×480 pixels. This is the standard size for an NTSC (North American Television Standards Committee) DV video frame. Another common size is the NTSC D1 (professional digital video) size of 720×486 pixels; in Europe and some other parts of the world, the common size is 720×576 pixels.

All of these sizes describe an image area that has an aspect ratio of 4:3 – four units wide for every three units tall. But if you dragged out a calculator, you would find that none of these frame dimensions work out to a 4:3 ratio. What's going on?

Computers assume that every pixel (picture element) will be drawn as wide as it is tall – in other words, as a square. However, many digital video standards are designed using *non-square pixels*. This means they expect to be "projected" upon playback in a slightly distorted manner. The amount of this distortion is referred to as the *pixel aspect ratio* (PAR for short).

In the case of NTSC DV, images will be drawn wider on the computer screen compared with how they will look when corrected for the television screen; in the case of PAL, they will be drawn narrower on the computer than they'll appear on television. So remember, if a D1/DV comp looks correct on the computer screen, it'll probably look wrong on a television screen where the pixels are rectangular.

Some widescreen formats (such as HDV) have a more extreme distortion. If looking at this distortion drives you crazy, the Footage, Composition, and Layer panels have Toggle Pixel Aspect Ratio Correction buttons to compensate for this in the way they are dis-

△ Objects that are supposed to appear perfectly round (A) may appear on the computer to be too fat (B) or skinny (C). This is the natural result of non-square pixels. Footage courtesy Artbeats/Digidelic.

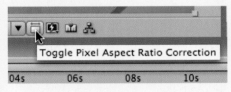

△ Along the bottom of the Comp panel is a Pixel Aspect Ratio Correction switch that will re-scale the Comp view to make non-square pixels appear correct on a square pixel computer screen.

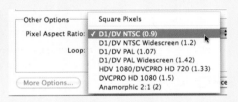

△ For After Effects to properly manage pixel aspect ratios, it is absolutely essential that you set this ratio correctly and truthfully for all footage in the Interpret Footage dialog (above), and when creating compositions (below).

played on your computer screen. This is for preview purposes only; it does not affect the Make Movie or Export functions.

After Effects does an excellent job of managing PARs, automatically stretching and squashing layers as needed to line things up – as long as everything is tagged correctly! For footage items, this is done in the Interpret Footage dialog: Video should have the Pixel Aspect Ratio popup set to match its format (this happens automatically in most cases); photographs and the such should be set for square pixels.

In Composition > Composition Settings, D1 or DV size comps should also have their Pixel Aspect Ratio popup set to match their video format. Selecting from the Preset popup will also set the PAR popup appropriately.

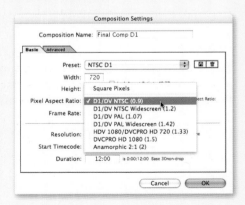

Idea Corner

• Do you have access to a still-image camera? Use it to create a time lapse or stop motion "video" of a scene. Import them as an image sequence, or import them individually and use Sequence Layers to add crossfades.

• In the **Idea Corner** folder in the Project panel, open the **Idea-Adjustment Layer Alpha** comp. Layer 1 is an animated butterfly created with motion sketch (Lesson 2). It has the Hue/Saturation effect applied. Turn on the Adjustment Layer switch (the black/white split circle) for this layer. The butterfly becomes an adjustment layer, and any effects are now applied to the layer below using the butterfly's alpha channel! Try this with your own sources; text or logo layers work well, too.

Idea-Adjustment Layer Alpha: We used the butterfly layer as an adjustment layer and animated it with Motion Sketch.

• Also in the **Idea Corner** folder, open the **Idea-Animated Bars** comp. Layer 1 (**bar 1**) is a full frame adjustment layer. Select it and open Layer > Solid Settings, and change the width to 100 pixels. Press **F3** to open the Effect Controls, and edit the effects to taste. Animate this bar moving left or right across the frame. Create additional bars for a more complex look. Note that we used the Transform effect to Scale the layers below, as the regular Scale property scales only the size of the adjustment layer solid.

• The Muybridge frames in our image sequence were originally part of a "film-strip" that contained five images in a row – see the **Idea Corner > Muybridge > Sources** folder. We used Hold keyframes to line up and pose these individual images inside the **barbell walk sequence** comp and then rendered them out as a sequence that we could then import and loop. If you have one of the Muybridge books* (from Dover Publications), scan a different image and create another sequence using the same technique.

Idea-Animated Bars: Animated adjustment layers can create looks reminiscent of some television show opening titles...

Quizzler

• Inside this lesson's **Quizzler** folder is a movie called **Quiz_pyro.mov**; play it. The explosion was originally shot against black, with no alpha channel. Open **Quiz-Pyro*starter** – how you would composite it on top of the night traffic scene?

• In the Quizzler folder, play the movie **Quiz-Build on Layers.mov**; four objects build on over time, two seconds apart, each one fading up for one second. We used Sequence Layers to help create this effect. Open the **Quiz-Build*starter** comp and see if you can re-create this look. It's a brain teaser! (The answer is in the **Quizzler Solutions** folder.)

Our versions of some of the Idea Corner and Quizzler animations are contained in a folder of the same name inside this project file. Don't peek until you've given them a try!

* Muybridge was a photographer who in the 1870–'80s devised ways of taking timelapse photographs of humans and animals in motion. Muybridge released two books of his plates – *Animals in Motion* and *The Human Figure in Motion* – which Dover publishes to this day.

Quiz-Pyro: Composite an explosion shot on black on top of the **Cityscape** footage. Pyro footage courtesy Artbeats/Reel Explosions 3.

Creating Transparency

Using masks, mattes, and stencils to cut out portions of a layer.

▽ In This Lesson

▽ Getting Started

Copy the **Lesson 04-Transparency** folder from this book's disc onto your hard drive, and make note of where it is; it contains the project file and sources you need to execute this lesson.

In this lesson, we will be focusing on different ways to create transparency. One of the keys to creating an interesting composite of multiple images is to make portions of those images transparent, so that you can see other images behind or through them. This is one of the main techniques that set motion graphic design and visual effects compositing apart from video editing.

Masks, Mattes, and Stencils

In previous lessons, we introduced two basic forms of managing transparency: altering the Opacity property of a layer, and taking advantage of a layer's built-in alpha channel that defines which parts of it are supposed to be transparent. In this lesson, you will go beyond these by adding your own transparent areas to an image using *masks*, *track mattes*, and *stencils*.

Masking is a way to cut out sections of a specific layer. At its default, a mask shape says "I want to see only the area inside this shape; make the area outside transparent." You can draw your own shapes and paths directly on the layer, or copy paths from the Adobe companion programs Photoshop and Illustrator and paste them onto an After Effects layer to create a mask shape. You may have multiple masks per layer, and combine them in a variety of ways such as adding together their shapes or using only the area where they overlap. You can also control the opacity of a mask (making its cutout semitransparent), define its feather (how soft its edges are), and invert it so areas inside of its shape – rather than outside – are transparent. As an added bonus, some effects can use mask shapes to draw lines, and you

Masks take a layer (A), and allow you to cut out portions to make them transparent or opaque (B). Mattes use either the alpha channel or luminance of one layer (C) to define the transparency of a second layer (D) to create a final composite image (E). Images courtesy Wildscaping.com, Artbeats/Virtual Insanity.

can have text follow a mask (which we'll show in the next lesson). You can even create a mask shape that is just a line or path rather than an enclosed area; these are particularly handy when used in conjunction with effects or text.

In After Effects CS3, the same tools are used to create masks and Shape Layers. If you are using CS3 to create masks, be sure to select the layer first (see page 104).

Track mattes, by contrast, involve the combination of two layers. One layer – the matte – is used just to define transparency; you don't directly see the image it contains. This matte is then used to decide what portions of the layer immediately below it are visible. There are two types of mattes: *alpha matte*s, which use the matte's alpha channel to define the transparency of the second layer, and *luminance* (or *luma*) *mattes*, which use the luminance – grayscale values, or brightness – of the matte layer to define the transparency of the second layer.

Stencils take the concept of track mattes further: Rather than define the transparency of the next layer below, a stencil layer defines the transparency of *all* the layers below, cutting a hole through the entire layer stack. Just like mattes, stencils can also be based around alpha channels or luminance.

It's easy to confuse these methods of creating transparency, so just remember: Masks involve one layer, mattes involve two layers (the fill and the matte), and stencils are basically mattes that can affect multiple layers below them. In this lesson, you'll learn how to put all three to work.

▽ future vision

Keying

Keying – the art of making certain colors in a layer transparent – is another way of creating transparency. Unlike the techniques demonstrated in this lesson, keying relies on an effect to create transparency. Keying is covered in Lesson 10.

▽ tip

Help with Shortcuts

For a full list of pen tool and mask editing shortcuts, see Help > Keyboard Shortcuts (or Help > After Effects Help, and search for "keys for using masks").

2 Select the layer to mask, then select the Mask tool (above). Click and drag in the Comp panel to define the mask shape you want (below). Foreground courtesy Artbeats/Timelapse Cityscapes; background 12 Inch Design ProductionBlox Unit 02.

▽ tip

Constrained Masks

Press **Shift** while dragging a mask shape to create a perfect square or circle; add **⌘** on Mac (**Ctrl** on Windows) after you start dragging to draw the mask outward from a center point.

3 Double-click the mask outline to enable its Free Transform Points; the shortcut is **⌘ T** (**Ctrl T**). Here we are grabbing the top point to change the height of the shape.

Masking

There are several ways to create masks, and several ways to use them. In this first exercise, we will focus on using the Mask tool to create windows on footage, to reveal a title, and to create a vignette.

1 We assume you've already opened the project **Lesson_04.aep**. If you'd like to preview what you'll be creating in this exercise, open its **Comps_Finished** folder and RAM Preview the comp **01-Masking_final**. Close it when you're done by pressing **⌘ W** on Mac (**Ctrl W** on Windows).

2 In the Project panel, open the **Comps** folder and double-click the comp **01-Masking*starter** to open it.

Select the foreground layer **Cityscape.mov**. Then select the Rectangular Mask tool from the toolbar along the top of the application window; its shortcut is **Q**. Click and drag in the Comp panel to surround a few of the major buildings on the right, plus some of the freeway. As you draw this outline, the areas of **Cityscape.mov** beyond the outline will disappear, revealing the background.

After you release the mouse, with **Cityscape.mov** still selected, press **M** to reveal the new Mask and its Mask Shape (Mask Path in CS3) property in the Timeline panel (see right).

In the Comp panel, you should see a yellow outline around the mask shape. If you don't, click the Toggle View Masks button along the bottom of the Comp panel to turn it on.

3 Press **V** for the Selection tool. Then double-click on the yellow mask outline; this will enable its Free Transform Points, which means you can edit its shape. Note the eight small boxes ("handles") around its shape: As you hover your cursor over these, the cursor will change to icons that indicate you can click and drag to resize or rotate the shape. Dragging anywhere else moves the entire shape.

Tweak the size and position of the mask to taste, then hit **Enter** to accept your edits and turn Free Transform off.

4 Next, you want to reveal a different section of **Cityscape.mov** – but you can't see the rest of the image as it's already been masked out. No problem: You can also create masks in the Layer panel where you can view the entire image.

Double-click **Cityscape.mov** to open its Layer panel. If it opens docked into the same frame as the Comp panel, right-click on its tab, select Undock Panel, then drag it side by side with the Comp panel.

Along the bottom of the Layer panel is a View popup; check that it is set to Masks. Uncheck the Render button (to the right of View): This will reveal the entire layer without the effect of masking.

Select the Rectangular Mask tool again. This time, hold down the **Shift** key while dragging out a new mask shape along the left side of the layer; this will constrain it to draw a perfect square. (Actually, it will look slightly wide, as this layer has non-square pixels – refer to the *Tech Corner* at the end of the previous lesson.) The result of your masking will instantly appear in the Comp panel as you draw; when you're done, Mask 2 will appear in the Timeline panel.

5 After you are done drawing a mask shape in the Layer panel, you will see the individual mask points or "vertices" that define it; by default, all vertices are selected. Press **V** to return to the Selection tool. While all points are selected, you can drag any one point to move the entire mask, or use the arrow keys to nudge it by one screen pixel. You can **Shift**+click or drag a marquee around individual vertices to select or deselect them, and edit the position of these directly. You can also double-click the mask to use the Free Transform Points as you did in the Comp panel.

Tweak your second mask shape to taste, and close the Layer panel when you're done.

6 By default, masks have sharp, crisp edges. However, it is possible to soften these. With **Cityscape.mov** still selected, type **Shift F** to reveal the Mask Feather parameter in addition to Mask Shape. Turn the Toggle View Masks button (at the bottom of the Comp panel) off to more clearly see the outlines, and scrub Mask Feather to soften the masks. Set Feather for both masks to taste.

7 After Effects calculates effects for a layer *after* masks have been taken into account. Apply Effect > Perspective > Drop Shadow to **Cityscape.mov**; notice that both masks get the same shadow. Slightly increase the Distance and Softness of the shadow to taste, and save your project.

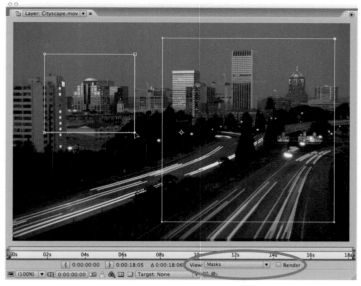

4 Double-click a layer to open its Layer panel. Set the View popup to Masks and turn off the Render switch. You can then draw and edit masks undistracted by other layers or the results of previous mask shapes.

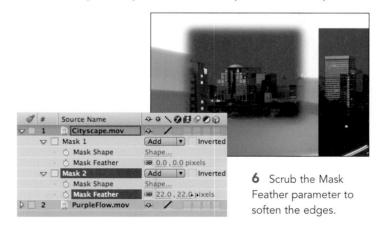

6 Scrub the Mask Feather parameter to soften the edges.

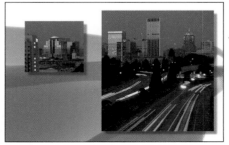

7 Effects are applied after mask shapes. That means the single Drop Shadow effect applied to this layer affects both masks.

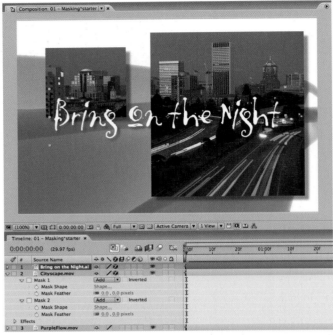

9 Add a title, use the Fill effect to color it white, and add the Drop Shadow effect.

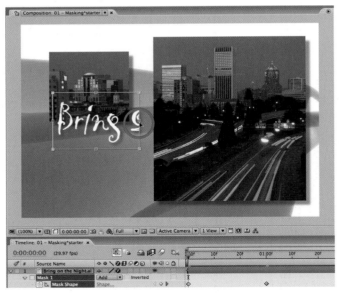

11 To wipe on the title, animate a mask to reveal it. Here we are dragging one of its Free Transform Points to edit the mask shape.

Animating a Mask Shape (Mask Path)

Masks do not need to be fixed windows onto another layer – their shapes can also animate. This is particularly useful for revealing the content of layers.

8 Press **Home** to make sure you are at the start of the composition. Bring the Project panel forward, and open the **Sources** folder. Select the footage item **Bring on the Night.ai**, and type **⌘ /** (**Ctrl /**) to add it to your comp.

9 This black title is hard to read against your video. With it selected, add Effect > Generate > Fill. Click on its Color swatch, and change it to white.

That's better, but it still looks a bit flat on top of your composite. Add Effect > Perspective > Drop Shadow, and adjust the Distance and Softness to taste.

10 As we mentioned in a previous lesson, sometimes it's easier to start where you want to end up, and work backward. With **Bring on the Night.ai** selected, double-click on the Rectangular Mask tool. This will add a mask to it that is the same size as the layer – a perfect ending point for a reveal. Enable the Toggle View Masks switch to see its outline in the Comp panel.

11 Type **M** to reveal the Mask Shape parameter in the Timeline panel. Move the current time marker to 01:00, and click on the stopwatch next to Mask Shape to enable keyframing and create the first keyframe.

Hit **Home** to return to 00:00. Then double-click on the mask outline in the Comp panel to bring up the Free Transform Points; the shortcut is **⌘ T** (**Ctrl T**). Drag the handle on the right edge all the way to the left until the title is completely hidden. A new Mask Shape keyframe will be created automatically at 00:00.

To soften the leading edge of your wipe, increase the Mask Feather for the title's mask. You need to increase only the first value, which is in the X (horizontal) direction.

12 Press **0** on the numeric keypad to RAM Preview your animation. Add a dramatic pause by moving **Bring on the Night.ai**'s layer bar to start later in the timeline, such as at 01:00 – its keyframes will move with it. Save your project!

Creating a Vignette

Masks can also be used to create subtle effects, such as adding a "vignette" where the edges of an image are darkened, focusing the viewer more toward the center of the screen.

13 Press **Home** to return to 00:00. Create a Layer > New > Solid; the shortcut is ⌘ Y (*Ctrl* Y). In the Solid Settings dialog that opens, click the Make Comp Size button, and set the Color to be something complementary to your scene such as a dark purple or blue. Give it a name that makes sense such as "**vignette**" and click OK.

14 Click and hold on the Mask tool; a popup will appear. You want a rounded mask for this task, so select the Elliptical Mask Tool option, and release the mouse. (You can also toggle between the two by pressing **Q**.) Then, with the **vignette** layer selected, double-click this tool in the toolbar to create a full-size oval mask.

15 Now you have a big dark oval obscuring the center of your image – probably not what you had in mind. But that's easy to change.

With **vignette** still selected, type **M M** (two **M**s in quick succession) to reveal all of the mask properties, and make the following edits:

• Click on the checkbox next to Inverted: Now the mask solid will be transparent inside and opaque outside.

• Scrub the Mask Feather until you get a nice, soft falloff around the edges.

• Scrub the Mask Expansion property: This offsets a mask to draw inside or outside of the original Mask Shape. (To better see its effect, temporarily turn Mask Feather down to zero.) Increase Mask Expansion to push the vignette off into the corners.

• If the corners are too dark, reduce the Mask Opacity value (or use the regular Transform > Opacity property). Then feel free to balance the Mask Feather, Opacity, and Expansions values off of each other to get the look you want.

14 Select the Elliptical Mask Tool (inset), then double-click in the toolbar to create a full-size oval mask on your new solid (above).

▽ tip

Numeric Shapes

Clicking the word Shape… in the switches column of the Timeline panel opens the Mask Shape dialog, where you can enter values numerically.

Congratulations – you've created a tasteful little animation, plus now have a handle on creating masks. Go ahead and tweak your animation to taste. If you like, compare your results with ours – see comp **01-Masking_final** in the Project panel's **Comps_Finished** folder.

15 To finish off the vignette, invert the mask (A), increase its feather (B), increase its expansion (C), and reduce its opacity (D). Our version is in **Comps_Finished > 01-Masking_final**.

▽ tip

Select All Points

To select all the points on a mask, with the Selection tool active hold down ⌥ (*Alt*) and select any one of the mask's points.

2 Select the Pen tool, and turn off the RotoBezier option for now.

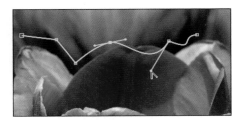

3 The Convert Vertex Point tool is used to toggle between smooth and hard corners, and to break or unbreak the continuity of the Bezier handles. Image courtesy Wildscaping.com.

Masking with the Pen Tool

Next up is practicing using the Pen tool to create more detailed mask shapes. It has two basic modes: One that creates common Bezier curves with handles (which we'll do first), and a RotoBezier mode which automatically determines the curve of the path. As with the Mask tool, you can create shapes in either the Comp or Layer panels, plus keyframe their shapes.

Drawing a Path

1 In the Project panel for this lesson's file, locate **02a-Bezier*starter** in the **Comps** folder and double-click it to open it. Select **PinkTulips.psd**.

2 Select the Pen tool (the shortcut is **G**). When you do, a RotoBezier option will appear on the right end of the Toolbar; turn it off for now.

3 Drawing with the Pen tool is similar to drawing paths in programs such as Photoshop and Illustrator, although the shortcuts can differ slightly. To practice, start by just making a random shape:

• To create straight line segments, click with the mouse to create a series of points.

• To create curved segments, click and drag to pull out Bezier handles for the point you are creating.

While drawing with the Pen tool, you can edit the points you've just placed:

• To reposition any point or handle before you're finished drawing a mask, temporarily toggle to the Selection tool by pressing the ⌘ (*Ctrl*) key.

• To toggle between a sharp corner point and a smooth point, press ⌥ *Shift* (*Alt Shift*) and click on a point. The cursor will automatically change to the Convert Vertex Point cursor, which looks like an upside-down V. To toggle the last point you drew, just click on it without holding down these extra keys.

• To break the continuous handles of a smooth point, click and drag one handle. In version 7, repeat to switch back to a smooth point. In CS3, hold ⌥ (*Alt*), click on the vertex and drag to make them continuous again.

• Click any point other than one you just drew to delete it (the cursor will automatically change to the Delete Vertex tool). To delete the most recent point, Undo.

• To add a new point between points you've already drawn, click on the line joining them – the cursor will automatically change to the Add Vertex tool while doing so.

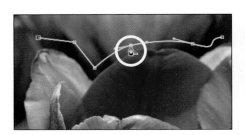
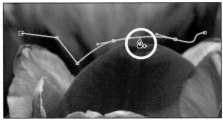

3 *continued* To delete a vertex, place the cursor over a point; it will automatically change to the Delete Vertex tool (left). To add a vertex, place the cursor between points (right).

• To pick up drawing a mask shape where you left off, make sure only the last point is selected, then continue creating points with the Pen tool.

• To close a mask shape, click back on the first point. Only closed masks create transparency. If you want to create an open path, simply change to the Selection tool (shortcut = **V**) when you're done creating the path.

Editing the Path

You can switch back to the Selection tool for editing a mask. However, some of the shortcuts will then change. Because closing the mask creates transparency, if you need to see the entire image, we suggest you edit the mask shape in the Layer window with the Render switch off. Feel free to zoom in as well.

4 Press **V** to change to the Selection tool, and practice the following:

• To add or delete points, hold down **G** (to temporarily switch to the Pen tool) and click. The cursor will automatically change to a Delete Vertex tool when you are near a mask point, and an Add Vertex tool when you are between points.

• To toggle a point between a smooth and sharp corner point, press **⌘** **⌥** (**Ctrl** **Alt**) and click on the point.

• To break or rejoin Bezier handles in version 7, press **⌘** (**Ctrl**) and drag on a handle. In CS3, hold **G** to break handles, and **⌘** **⌥** (**Ctrl** **Alt**) and drag out from the vertex to create a smooth point again.

5 After you've had some fun, delete your experimental mask, and practice drawing a mask around the foreground tulip. It will require a combination of smooth shapes and sudden direction changes where some of the petals overlap or meet the stem. It's fairly challenging, but a good example of a task you will often need to perform in the real world. Our version is in the **Comps_Finished** folder (**02a-Bezier_final**), pictured to the right.

▼ Applying an Effect to a Masked Area

To apply an effect to an area of a layer in Photoshop, you would create a selection first. In After Effects, you need to duplicate the layer, create a Mask Shape on the top layer, then apply the effect to the top or bottom layer depending on whether you want the area inside or outside the mask to be effected.

For instance, let's say you wanted the foreground flower in the **PinkTulips.psd** layer to be in color, and the rest of the image to be in black and white. Open the comp **02b-Masked Effects*starter**, and follow these steps:

• Select the **PinkTulips.psd** layer, and select Edit > Duplicate – the shortcut is **⌘** **D** (**Ctrl** **D**).

• Select the bottom layer, and select Layer > Masks > Remove All Masks.

• With the bottom layer still selected, apply Effect > Color Correction > Tint to make it

black and white. Our version is in **Comps_Finished > 02b-Masked Effects_final**.

You also could have started by duplicating your original layer and masking just the top one. The end result is the same: Two layers, the top one has the mask, and effects are applied as needed to one or both layers.

Which Point Is First?

The First Vertex Point (FVP) is the point where you started drawing a shape with the Pen tool; it is the top point if you used the Elliptical Mask tool, and top right if you used the Rectangular Mask tool. It appears slightly larger than the other points.

2 The maple leaf (left) and oak leaf (right) mask shapes unfortunately do not interpolate smoothly (center).

 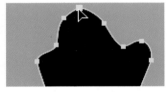

2 *continued* The maple leaf's First Vertex Point (FVP) is at its bottom (left); the oak's FVP it at its top (right). This misalignment is what causes the funky interpolation.

3 Select the top mask point of the maple and set it to be the First Vertex Point.

How Mask Shapes Interpolate

In the first exercise, you animated a mask shape to wipe on a layer. You can also animate shapes made with the Pen tool. However, the more complex the mask, the harder it is to get smooth interpolation from one shape to another. Here are some ways to make it smoother.

1 Open the comp **03-Interpolation*starter**. It contains a solid that has an animated mask. If the Mask Shape property and its keyframes are not visible, select the layer **leaf shapes** and press **U**.

2 RAM Preview; the maple leaf shape interpolates to an oak leaf shape. Unfortunately, it twists inside-out on its way.

When you see mask interpolation problems such as this, the most likely culprit is the little-known First Vertex Point (FVP). The FVP of one mask shape always interpolates to the FVP of the next mask shape, and the rest of the points do what's necessary to follow.

Click on the words Mask 1 in the Timeline to select the mask shape, and make sure Toggle Mask Views is on. Move the current time marker to the first keyframe at 00:00, and carefully look around the shape until you see one mask point that is larger than the others (hint: it is at the bottom left of the maple leaf stem). This larger point is its FVP. Type **K** to jump to the second keyframe, and look for the FVP; it is at the top of the oak leaf.

Changing the First Vertex

Interpolation works best if all of the FVPs are at the same relative point of a shape, such as the top or bottom.

3 Type **J** (or press **Home**) to jump to the earlier maple leaf shape keyframe. Drag a marquee around the top mask point so just this one keyframe is selected. Then select Layer > Mask > Set First Vertex (in CS3, it's under Layer > Mask and Shape Path); you can also right-click on the point and choose the same option. (If it's grayed out, you have more than one point selected.) RAM Preview, and note how the interpolation is much smoother – not perfect, but a lot better!

Another reason mask shapes don't interpolate smoothly is when there are different numbers of points in each shape. Watch the mask points move as you scrub the time marker; they will "crawl" around the leaf stems, causing the shape to twist. You can often fix this by adding extra points to one side of one shape to balance them out. We added extra points to the bottom left of the maple leaf; our results are in **Comps_Finished > 03-Interpolation_final**.

Mask Paths and Effects

You now know how to create and animate interesting mask shapes. You can make them even more interesting by employing effects that can use their shapes.

1 Open the comp **04-Effects*starter**. It contains the leaf shape animation from the previous exercise.

2 Select the **leaf shapes** layer, and apply Effect > Generate > Stroke. The mask will be outlined in white. (Turn off Toggle View Masks to make it easier to see.) Preview, and note how the white stroke follows the changing outline of the leaf.

In the Effect Controls panel, you will see that Stroke has a Path popup. This allows you to select the mask it uses, in the event you have multiple masks on the same layer. It defaults to the first mask shape it finds. If there are no masks, the stroke will not be drawn.

2 The Stroke effect renders an outline around the mask shape (starting and ending at the First Vertex Point).

3 Scrub the Start and End values, and note how they control the portion of the stroke that is drawn. Press **Home**, and set both Start and End to 0%; the stroke will disappear. Click on the stopwatch to enable keyframing for End, which will set a keyframe at this value.

Move the current time marker to 02:00, and set End to 100%, which means fully stroked. A keyframe will be created for you. Preview, and enjoy the stroke animation.

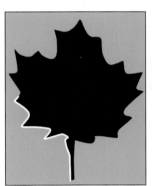

3 By animating Stroke's End value from 0% to 100%, it will draw on the outline over time.

4 The whole point of this lesson is to create transparency – so let's place something behind this masked-out solid.

Bring the Project panel forward, and open the **Sources** folder. Select **Wildflowers.mov**, and drag it to the left side of the Timeline panel below the **leaf shapes** layer. It will appear where leaf shape is transparent, starting at 00:00.

What if you want to see just the stroke, and not the masked portion of the original image? Select **leaf shapes** and press **F3** to bring the Effect Controls panel forward. In the Stroke effect, change the Paint Style popup for Stroke from On Original Image to On Transparent. Now you will see just the stroke.

Feel free to play with the other Stroke parameters. Our version (with some additional enhancements) is in **Comps_Finished > 04-Effects_Final**.

Our final **04-Effects_Final** comp, which includes rendering just the Stroke effect as well as adding a Drop Shadow. Footage courtesy Artbeats/Timelapse Landscapes 2.

1 For your first mask shape, add a full-frame elliptical mask to **Wildflowers.mov**.

3 For your second mask shape, paste in the animated mask from an earlier exercise. Rename the masks to keep track of them.

Advanced Modes

The Lighten and Darken modes are useful when Mask Opacity is set to less than 100%: Lighten affects how the alpha channel value is calculated when Add mode is used for overlapping mask shapes; Darken affects the alpha value when Intersect is used.

Multiple Mask Madness

You've probably noticed that every mask has a popup next to it in the Timeline panel, which defaults to Add. This is the Mask Mode, which determines how multiple masks on the same layer interact. By default, they add together – but great fun can be had with the other possible combinations.

1 Open **Comps > 05-Mask Modes*starter**, and select the **Wildflowers.mov** layer. Type **Q** until you see the Elliptical Mask tool appear in the Toolbar. Then double-click this icon to add a full-frame oval mask. The wildflowers will appear inside an oval; the color around the outside is the comp's Background Color.

Type **M** to reveal Mask 1; its Mask Modes popup is set to Add. Rename Mask 1 by selecting it, hitting **Return**, typing "**oval mask**", and hitting **Return** again.

2 Open **Comps_Finished > 03-Interpolation_final**. It contains the finished version of the leaf shape animation you worked with earlier. Copy it by clicking on the word Mask Shape to select its keyframes, and type **⌘ C** (**Ctrl C**).

3 Click on the tab **05-Mask Modes*starter** along the top of the Timeline panel to bring it back forward. Make sure **Wildflowers.mov** is still selected, then type **Shift F2** to deselect your first mask shape but leave the layer selected – otherwise, you may paste over the first mask by accident!

Hit **Home** to position the current time marker at 00:00, and type **⌘ V** (**Ctrl V**) to paste the leaf mask and its keyframes. It will default to Add mode, which was its setting in its original comp. Make sure Toggle View Masks is enabled; you should now see the leaf mask inset inside the oval mask. Rename this new mask "**leaf shapes**" to help remember which mask is which.

4 Change the Mask Mode popup for leaf shapes to Subtract: You will now see the wildflowers inside the oval, but not inside the leaf shapes. Continue to experiment with the Mask Modes to get a better feel for them – for example, set the oval mask to Subtract and leaf shapes to Add. Your result should then look the same as our version in **Comps_Finished > 05-Mask Modes_final**.

4 You can get different results from the same masks by changing their Mask Mode settings.

There's no need to stop with just two! Experiment with drawing a third mask shape that overlaps both existing masks (we drew a simple rectangular mask along the bottom), then playing with the Intersect and Difference modes. Keep in mind that masks are rendered from the top down (similar to how effects are rendered), so the third mask would be combined with the result of the first two.

To make a mask inactive while experimenting without having to delete it, set its mode to None. We also suggest you avoid Inverting a mask unless you cannot achieve the result you are looking for with the Mask Modes popup – inverting masks makes the logic doubly confusing!

Our "going further" comp is **Comps_Finished > 05-Mask Modes_final2**, where we resized the first leaf shape, added a third mask, and applied a Drop Shadow effect with Distance set to 0. Just for fun, we also placed a blurred version of the original movie in the background, offset in time.

You can create some interesting looks by combining multiple masks, placing the masked layer on top of an unmasked copy, and giving each different effects such as drop shadows and blurs.

▼ Mask Opacity

Another fun way to work with multiple masks is to use their Mask Opacity to fade on individual shapes. Open **Comps_Finished > 05-Transition_final**, select **Cityscape.mov**, and make sure Toggle View Masks is enabled to see the mask shapes. If the Mask Opacity keyframes are not visible, type **U** to reveal them.

Scrub the current time marker through the timeline, and note how the mask shapes inside the Comp panel are filled in as you go between Mask Opacity keyframes. This is a very useful transition, as it gives precise control over what part of the image comes on in what order.

Once you feel you understand how we created this look, try it yourself! Open **Comps > 06-Transition*starter**, and follow these general steps to create your own version:

• To view the entire, unmasked video while creating your mask shapes, double-click **Cityscape.mov** to open its Layer panel. Set the View popup to Masks, and uncheck Render.

• Draw a series of mask shapes, focusing on different parts of the video. If your shapes do not add together to cover the entire video, draw one more mask shape that includes the entire video image.

• Close the Layer panel, and type **T T** (two **T**s in quick succession) to reveal the Mask Opacity properties for your masks. Keyframe them fading up from 0 to 100% to bring on the masks. Offset the timing of the keyframes to create a staggered fade.

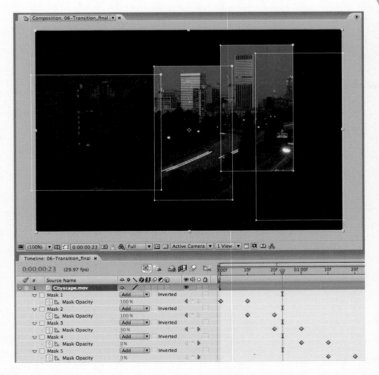

The combination of multiple masks and animating their Mask Opacity creates interesting transitions.

RotoBezier Mask Shapes

The final step in your path to mask enlightenment is working with RotoBezier mask shapes. You just click where you feel mask points should be, and After Effects will automatically create a curve to smoothly join them. You can tweak the "tension" at each point to influence this curve. RotoBezier is great for organic shapes; they also generally animate more smoothly.

To get an idea of where you are headed with this exercise, close all open comps and open **Comps_Finished > 07-RotoBezier_final2**. Press **O** to RAM Preview. Notice how the audio spectrum line along the top bops along with the music – that's what you're going to create.

1 Open **Comps > 07-RotoBezier*starter**. Select **PurpleFlow.mov**; that's the layer you're going to draw on.

2 Select the Pen tool; the shortcut is **G**. Along the right side of the Toolbar, a checkbox for RotoBezier will appear. Check it.

Get a feel for RotoBezier masks by clicking around in the Comp panel. You don't need to drag any handles to create a Bezier curve; After Effects will create curves automatically.

To form a hard corner at a RotoBezier point, with the Pen tool still active hold down the **⌥** (**Alt**) key and click on a point. To change its tension, hold down **⌥** (**Alt**) and click-and-drag left and right to select from a range between a sharp corner to a generous curve.

Once you feel you've got the hang of this behavior, select Layer > Mask > Remove All Masks.

In this exercise, you will animate a path above the purple ribbons and add an Audio Spectrum effect that will draw along it.

2 Select the Pen tool, and enable the RotoBezier option (top). Practice clicking around the comp; RotoBezier automatically creates curves between your points, with no visible Bezier handles (above).

Trace the Flow

3 Press **Home**, and using the same technique, create an open path that runs just above the flowing purple shape. This will be your first mask path. Press **M** to reveal its Mask Shape in the Timeline panel, and enable keyframing by clicking on its stopwatch.

The yellow mask path can be hard to see against the white background, so click on the yellow swatch for Mask 1 and choose a more visible color, such as red.

4 Next, you will edit this starting mask shape to animate along with the undulations of the flowing purple ribbon.

Move the current time marker forward 15 frames, and press **V** to return to the Selection tool. By default, all of the mask points are selected. Drag a marquee around just one to select that point, and move it into a new position that better follows the purple shape. Tweak the rest of the points to follow the purple shape as needed, remembering these tips:

▽ tip

To Mask or not to Mask

To create a closed mask but not have it create transparency, or to temporarily turn off a mask, change its Mask Mode popup to None. You can still apply effects to it.

- If you want to add or delete a point, hold ⌘ (*Ctrl*) and click on a point or along the shape. Note that adding or deleting a point will affect existing and future keyframes as well.

- If you want to tweak tension of a point when the Selection tool is active, press ⌘ ⌥ (*Ctrl* *Alt*), and drag left and right through a point.

Continue this for the duration of the comp. You can scrub the current time marker back and forth to check your progress. If you are short of time (or are easily bored), open our comp **07-RotoBezier_final** where we've animated the mask shape and changed the temporal keyframes to Auto Bezier. Continue with the rest of this exercise using our comp.

Audio Spectrum Effect

Audio Waveform and Audio Spectrum are two examples of effects that draw along a mask shape. Although they must be driven by an audio layer in the comp, you don't apply them to the audio layer – you apply them to a layer with pixels!

5 Select **PurpleFlow.mov**, and apply Effect > Generate > Audio Spectrum effect. The Effect Controls panel will open. Make the following changes to the default settings:

- Set the Audio Layer popup **CoolGroove.mov** (the audio track in this comp).

- Set the Path popup to Mask 1; otherwise, Audio Spectrum will draw along a straight line defined by its Start and End Point.

- Enable the Composite On Original option at the bottom of its settings.

RAM Preview, and feel the groove. Disable the Toggle View Masks option to see the effect more clearly in the Comp panel. You can tweak the other Audio Spectrum settings to taste. For our version, we eyedroppered colors from the **PurpleFlow.mov** for Audio Spectrum's Inside and Outside Colors. We also increased the Thickness, reduced the Softness, and set Hue Interpolation to 90 degrees. Play with increasing the Maximum Height, and check out the different styles in the Display Options popup. Save your project when you're done.

▽ try it

Smoother Interpolation

All temporal keyframes – Mask Shape included – default to Linear interpolation, which can result in a jerky animation. For a quick improvement, click Mask Shape to select all of your keyframes, and ⌘ +click (*Ctrl* +click) on any one to change them all to Auto Bezier. We've already done this with our final versions.

5 By default, Audio Spectrum just draws a straight line. You need to edit a few of its Effect Controls (left) to get it to render your audio along your mask path (above). Tweak the effect controls to taste (below)

▽ tip

All Keyframes

When you add or delete a point on an animated mask, points are added or deleted for each keyframe.

▽ tip

Masks and Mattes

You can combine masks and mattes. For example, you can use masks to define the transparency of a layer, and use the result as a matte for the layer underneath.

▽ factoid

Honoring the Alpha

Masks, mattes, and stencils work in addition to a layer's alpha channel; they don't replace it. If you add a mask to a layer that already has its own alpha, the mask will only further reduce the area visible through its alpha channel.

▽ tip

Take Any Matte

You can take almost any layer and use its luminance as a luma matte. To better "see" a layer's luminance, apply the Color Correction > Tint effect to make it grayscale. Use other effects such as Levels to increase the contrast between the black and white values.

Using Track Mattes

Masks create transparency directly on the layer they are applied to. But what if you want to borrow transparency from another layer? That's where Track Mattes come in.

The most common use of Track Mattes is to play video from one layer inside a window defined by either the transparency (alpha) or grayscale values (luminance) of a second layer. In this exercise, you will learn how to set up an Alpha Track Matte.

1 Still in **Lesson_04.aep**, click on the Comp Viewer drop-down menu (along the top of the Comp panel) and select Close All to close all open comps.

Bring the Project panel forward, and open **Comps > 08a-Alpha Matte*starter**. It is currently empty, with its Background Color set to white.

2 Track mattes require two layers, and the stacking order of these layers in the Timeline panel is important: The matte layer must be on top of the "fill" layer.

• In the Project panel, open the Sources folder and select **VirtualInsanity.mov** – this will be the fill. Type ⌘ **/** (*Ctrl* **/**) to add it to your comp.

• Then select **Sources > Night Vision.ai**, and either drag it into the Comp panel and position it, or type ⌘ **/** (*Ctrl* **/**) to add it centered in your comp. This text will be your matte. Remember that the matte *must* be on top of the image that will fill the matte, so reorder the layers if that's not the case.

3 Make sure the Modes column is visible in the Timeline panel – if not, press **F4** to reveal it.

For the **VirtualInsanity.mov** layer, click on the popup menu under the "TrkMat" heading: It will give you four choices for the type of matte, all of which should mention **Night Vision.ai** (the name of the layer above). Select Alpha Matte, which says use the alpha channel of the layer above for the matte.

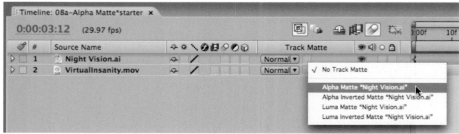

3 Start with the matte layer – the text – on top of the fill layer (left). Set the Track Matte popup for the fill layer to Alpha Matte (above). When you release the mouse, the fill will be seen only inside the matte.

Once you release the mouse, the movie will now appear only inside the text, and you will see the white Background Color outside the text. If you want to verify that these areas are transparent, click on the Toggle Transparency Grid button along the bottom of the Comp panel (it's the one with the checkerboard pattern); the checkerboard indicates transparency.

You will also notice a few changes in the Timeline panel. For one, the Video switch (eyeball icon) for **Night Vision.ai** will be turned off. This is because you no longer want to directly see the content of the matte layer; you just want to borrow its alpha channel. You will also notice that some additional icons appear to the left of the layer names, representing the matte (top layer) and fill (bottom layer).

If your results don't match the figures, compare your comp with our version: **Comps_Finished > 08a-Alpha Matte_final**.

4 To understand the difference between Alpha and Alpha Inverted, go ahead and set the Track Matte (TrkMat) popup to Alpha Inverted Matte: Now the area inside the text will be transparent, and the area outside will be filled with the **VirtualInsanity.mov** layer. Set the popup back to Alpha Matte when you're done.

Nesting with Track Mattes

The two-layer combination required to create a track matte gives you a lot of flexibility in combining layers, plus the freedom to animate them independently from each other. However, there are a couple of downsides to this combination:

• You can't directly add an effect to the composite (the result of the track matte). This is particularly a problem when adding drop shadow or glow effects.

• It is trickier to move the pair as a group and keep them in sync.

The best way to work around this is to leave the track matte layers in their own composition, then "nest" this comp as a second comp where it will appear as a single layer. We'll discuss nesting in greater detail in Lesson 6, but for now all you need to know is that you can treat a nested layer just like a normal layer

3 *continued* The result of selecting Alpha Matte when the background is white (left) and after the transparency grid is toggled on (right).

3 *continued* After setting the Track Matte popup, the matte layer on top will have its Video switch (the eyeball) turned off, and new icons will appear to the left of the layer names indicating that one is being used as a matte for the other. Notice there is no track matte popup for layer 1 because there is no layer above it. If there were additional layers above **Night Vision.ai**, the track matte popup would appear for the matte layer as well, which can be a source of confusion.

4 The result of using Alpha Inverted Matte. The white areas are the Background Color, showing through where the result is transparent.

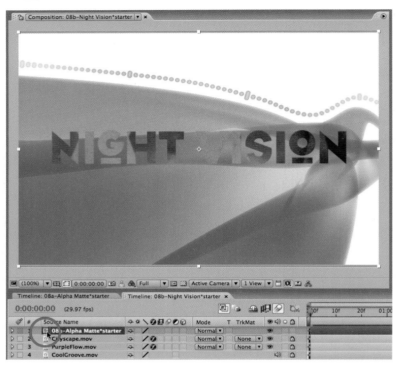

6 Nest the comp with your track matte pair into a new comp that already has a set of video and audio layers. Note the icon for **08a-Alpha Matte*starter** layer: It looks like the comp icons you see in the Project panel, which helps you identify it as a nested comp.

(with the added perk that you can go back and edit the contents of the first comp, and have the results automatically show up in the second comp).

5 Open **Comps > 08b-NightVision*starter**. This is a background we've built for you, using elements you've already worked with in the earlier exercises.

6 To nest your track matte pair into this new comp, locate **08a-Alpha Matte*starter** in the Project panel, and either drag it on top of **08b-NightVision*starter** in the Project panel, or press ⌘ **/** (*Ctrl* **/**) to add it to **08b-NightVision-*starter**. Using either of these techniques will ensure it is on top of the layer stack in the Timeline, and centered in the Comp panel.

After you've "nested" the comp, you will see the name of your first comp **08a-Alpha Matte*starter** appear as a layer in the second comp, with a special "comp" icon to reinforce this.

7 RAM Preview your composite: Fun, but a bit too much may be happening all at once. In the Timeline, slide the **08a-AlphaMatte*starter** layer bar to the right to start around 00:28, which happens to line up with a good beat in the music. This allows the masks in **Cityscape.mov** to build on and be the hero before the title comes up. Preview and see if you like that better.

8 The fill movie in **08a-AlphaMatte*starter** contains flashy red-orange colors against black. Go to 03:16 in time; the black doesn't read very well against the dark city footage. To quickly fix that, apply Effect > Channel > Invert to this nested comp layer. Now the black areas become white, and the red-orange areas become blue (the opposite color on the RGB color wheel).

8–9 To increase the readability of the text (A), add an Invert effect to make the black areas white (B), use Hue/Saturation to alter its color (C), and add Bevel Alpha plus Drop Shadow to give it some perspective (D).

That cured the problem with the black text, but what about the colors? Go to 01:13 in time; the turquoise text needs some color coordination help! With layer still selected, apply Effect > Color Correction > Hue/Saturation, and dial the Master Hue to somewhere between 50 and 90 degrees. This will shift the cool blue color to the warmer purple range.

9 The masked city footage has drop shadows to set it off from the purple background; you can do the same to your title here. Apply both Effect > Perspective > Bevel Alpha and Perspective > Drop Shadow to the nested **08a-Alpha Matte*starter** layer, and tweak the effect controls to taste.

10 As we mentioned, an advantage of nesting a composition is that you can treat its results as one layer, making animation easier. Go ahead and animate the **08a-Alpha Matte*starter** layer to come on in an interesting fashion.

If the layer is moving quickly, turning on the Motion Blur switch for the layer plus the Timeline's Enable Motion Blur switch will give a nice look.

If you're curious, our version of these steps is in **Comps_Finished > 10b-Night Vision_final**. Compare it to make sure you followed the steps correctly, but feel free to deviate from its precise settings to create your own look.

10 The final animation. Since the track matte is created in a precomp, you needed to animate only one layer.

▼ Effects and Track Mattes

Track Mattes involve the combination of two layers. Effects are applied to a single layer. So in the comp where you applied the track matte, you can apply effects to the fill layer or the matte layer, but this applies them to the layer *before* the track matte is composited together. Edge effects (like drop shadow, glow, bevel alpha) need to be applied to the track matte *result*.

If you need to see this problem for yourself, in the Project panel, select **Comps_Finished > 08a-Alpha Matte_final**, duplicate it (Edit > Duplicate), and then open the duplicate comp.

• Try adding Effect > Perspective > Drop Shadow to **VirtualInsanity.mov**: You won't see any change. This is because the effect is being applied to the rectangular movie layer *before* the track matte is composited.

• Now try adding Drop Shadow to the **Night Vision.ai** layer and increase the Distance parameter. You may think you're seeing a normal shadow, but RAM Preview and you will realize that the fill movie is playing inside the shadow.

This is because a black drop shadow at 50% opacity is being applied to the matte layer *before* the track matte is composited. Since the fill layer is using the alpha channel of the layer above as a matte, it plays at 50% opacity inside the shadow.

To apply edge effects, you will need to composite the track matte in one comp, then nest this comp in another comp where you can apply the effects. (After you complete Lesson 6, you will also be able to use precomposing to achieve the same result.)

NIGHT VISION

If you add a drop shadow to individual layers of a track matte pair, you either won't see the result, or the shadow will become part of the matte that the fill plays inside of.

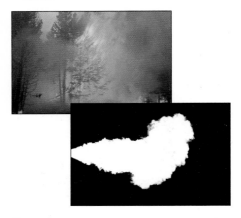

2 The fire (top) will be your fill; the clouds (above) will be your matte. Footage courtesy Artbeats/Nature's Fury and Cloud Chamber.

Luma Track Matte

In the previous exercise, you used an Illustrator layer – which inherently has an alpha channel around its shapes – as an Alpha Track Matte. This time, you will use a high-contrast grayscale layer as a Luma Track Matte.

1 Bring the Project panel forward, and open **Comps > 09-Luma Matte*starter**. It is currently empty, with its Background Color set to black.

2 As you learned in the previous exercise, track mattes require two layers, with the matte on top and the "fill" underneath:

• In the Project panel's **Sources** folder, select **Firestorm.mov** and add this to your comp. This will be your fill layer.

• In the same folder is **Cloud matte.mov**; this will be your matte. Add it to your comp on top of **Firestorm.mov**. Scrub the current time marker; you will see the **Cloud matte.mov** spew out a white cloudy stream over a black background.

3 When you set **Firestorm.mov** to Luma Matte (above), it plays through the bright areas of **Cloud matte.mov** (below).

▽ tip

Hicon

Layers that have high contrast between white and black levels make good luma mattes. Indeed, you will often hear them referred to as "hicons" or as a hicon matte.

3 If the Modes column is not visible, press **F4** to reveal it. Set the TrkMat popup for **Firestorm.mov** (remember – always the bottom layer of the two!) to Luma Matte. The matte layer will turn off, track matte icons will appear in the Timeline panel next to the layer names, and the fire will now play inside the cloudy stream. If you like, click on the Toggle Transparency Grid button to confirm that the black area outside the clouds is transparent.

As we noted earlier, you can edit the two components of a track matte independently from each other. For example, press **Home**: You won't see the fire, because the luma matte layer is all black at its first frame. Slide the luma matte layer **Cloud matte.mov** to start earlier in time (before 00:00), and you will see some of the fire from the first frame of your comp. This is what we did in our version **Comps_Finished > 09-Luma Matte_final**.

4 To help confirm what the different matte modes do, select Luma Inverted Matte; now the fire plays outside the clouds.

Then select Alpha Matte: The fire plays full frame, ignoring the clouds. This is because **Firestorm.mov** is using the alpha channel of the full-frame movie **Cloud matte.mov** above it, and its alpha channel is all white.

4 Using Luma Inverted Matte.

Animated Track Matte

You're not stuck with the original content of a still image or movie to use as a track matte. You can also animate and add effects to it to create more interesting matte shapes.

1 Open **Comps > 10-Animated Matte*starter**. It is currently empty, with its Background Color set to black. In the Project panel's **Sources** folder, locate the still image **inkblot matte.psd** and add it to your comp. (To create this image, we dropped some India ink on a piece of paper, squished another one on top, pulled them apart, scanned it once it had dried, and inverted it.)

2 We created **inkblot matte.psd** larger than the comp so you would have some room to animate it:

- Type **P** to reveal Position, and click on its stopwatch to enable keyframing.

- Slide it downward until the top of **inkblot matte.psd** just reaches the top of the comp. Remember you can hold **Shift** while dragging to constrain your movement in the Comp view, or scrub just the Y Position value (the second one) in the Timeline.

- Press **End**, and slide the blot upward until its bottom just touches the bottom of the comp view.

 Press **0** to RAM Preview. Hmm…not all that exciting. But all is not lost; we know of an effect that can add some interesting movement…

3 With **inkblot matte.psd** selected, apply Effect > Distort > Turbulent Displace. In the Effect Controls panel that opens, scrub its value for Evolution: The blot will now undulate in an organic manner.

 This effect does not self-animate, but it's easy enough to keyframe:

- Press **Home** to return to 00:00. Reset Evolution to 0x +0.0° and click on the stopwatch for Evolution to enable keyframing.

- Press **End**, and set Evolution to a different value, such as 1x +0.0° (one full revolution).

 RAM Preview again. Now that's more interesting!

4 Bring the Project panel back forward, locate **Firestorm.mov** (your fill layer) in the Sources folder, and add it to the Timeline *below* **inkblot matte.psd**. Check that **Firestorm.mov** starts at the beginning of your comp; if not, press **⌥ Home** (**Ctrl Home**).

5 Make sure the Modes column is visible, and set the TrkMat popup for **Firestorm.mov** to Luma Matte. The fire will now play inside the animated track matte. Note that just the shape of the matte – not the fire footage – is distorted by Turbulent Displace.

2 The file **inkblot matte.psd** is larger than the comp, so you have room to animate it moving up over time.

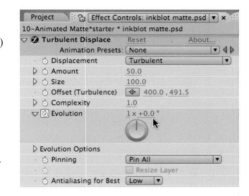

3 Effect > Distort > Turbulent Displace is handy for adding organic movement to layers. You need to animate the Evolution parameter to have the distortion change over time.

5 The displaced ink blot is used as a matte for **Firestorm.mov**. The black areas are where the image is transparent; you could put another image behind this if you wished.

▼ Stencils

The third and final method of creating transparency that we'll explore in this lesson is stencils. Stencils can be thought of as mattes on steroids: Rather than define transparency for just one layer, they define the transparency of the stack of all the layers underneath, cutting all the way through to the bottom of the layer stack in the Timeline (stencils don't affect layers that sit above them). Like mattes, they come in alpha and luma flavors.

Stencil Luma

1 Bring the Project panel forward, and open **Comps > 11-Stencil Luma*starter**. It contains a pair of movies we've used earlier in this lesson, with a twist: **Cityscape.mov** has been inverted to make it look more graphical, and **VirtualInsanity.mov** has been applied on top of it in Overlay mode (you played with Blending Modes in the previous lesson).

2 In the Project panel's **Sources** folder, select **Cloud matte.mov** and add it to the top of the layer stack. Move the current time marker a bit later to where the cloud stream emerges, or drag **Cloud matte.mov** to start a second or two earlier so you see some action at the beginning of the comp.

3 In the Modes column, set the Mode popup for **Cloud matte.mov** to Stencil Luma – it's near the bottom of the list. Just as in a previous exercise, the image will appear only inside the clouds. (If your version doesn't look like our figures here, compare it with **Comps_Finished > 11-Stencil Luma_final**.) Note that unlike mattes, the Video switch for the stencil layer must stay on.

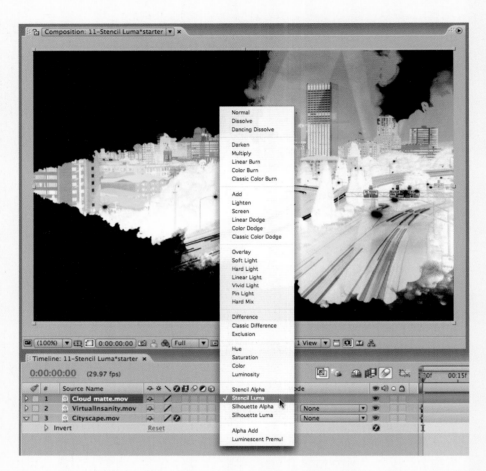

Just for fun, also try the Silhouette Luma option; the area outside the cloud stream will now be visible. Continuing the matte analogies, you can think of Silhouette as being "Stencil Inverted."

4 Remember that stencils affect only the layers below them. Drag **Cloud matte.mov** down one space in the layer stack so that it sits between **VirtualInsanity.mov** and **Cityscape.mov**. The layer below – **Cityscape** – will be cut out by the cloud stream, but the layer above – **VirtualInsanity** – will now play full frame.

3 Placing **Cloud matte.mov** on top of the other two layers and setting its Mode to Stencil Luma causes it to cut out both layers below (above). Silhouette Luma gives the inverted result (below).

Stencil Alpha

As with track mattes, stencils can also be based on a layer's alpha channel. Effects can be used on the stencil layer, just as we treated the matte layer earlier in this lesson.

1 Open **Comps > 12-Stencil Alpha*starter.** The background layers are the same as in the previous exercise. Layer 1 – **Night Lites.ai** – is an Illustrator layer that you will use as a stencil. Because it is black, it won't work as a Stencil Luma (black pixels = zero opacity), but it will work as a Stencil Alpha.

2 Set the Mode popup for **Night Lites.ai** to Stencil Alpha. The background layers will now be contained inside the stencil's alpha channel. (Silhouette Alpha is akin to "Inverted Stencil Alpha" and will yield the opposite result; stick with Stencil Alpha.)

3 Make sure **Night Lites.ai** is selected, and apply Effect > Distort > Turbulent Displace. Animate the Evolution property from 0 at time 00:00 to a value of 1 revolution at the end of the comp. RAM Preview. If the title isn't "oozing," verify that you animated one whole revolution and not just one degree!

Just to make life more interesting, make the amount of ooze change over time: Animate Turbulent Displace's Amount to increase from 0 to, say, 25. While you're at it, have fun experimenting with the options under the Displacement popup too.

4 Finish off your animation by animating the stencil to make it come on in a more interesting fashion. When you're done, check out our version in **Comps_Finished > 12-Stencil Alpha_final.** You applied Turbulent Displace to the stencil layer, but we applied it to an adjustment layer (Lesson 3) so it would affect layers below. Move it below the stencil layer and it will distort the movies only, and not the stencil. Choices, choices!

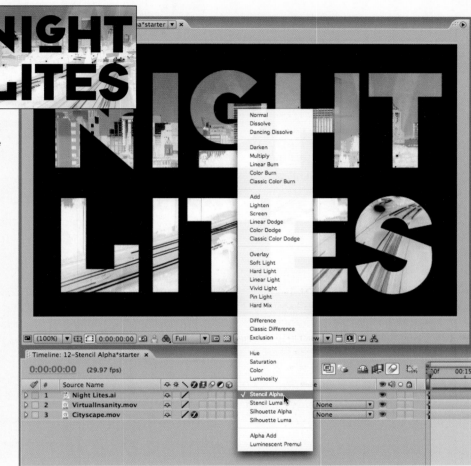

1 + 2 The comp **12-Stencil Alpha*starter** initially has black type on top of a composite of two background layers (inset). Setting the type to Stencil Alpha results in it cutting out the underlying layers (above).

4 Add and animate Turbulent Displace to the type to make it ooze over time. You can also animate the scale and rotation of the type to create additional movement.

Masks in After Effects CS3

A major new feature in After Effects CS3 is the addition of vector-based Shape layers (explored in Lesson 11). Both Shape Layers and Masks are created using the same Shape and Pen tools. So, how do you know which you are creating?

- If no layer is selected, you will create a new Shape layer.
- If any layer other than a Shape is selected, you will draw a Mask.
- If a Shape layer is selected, a pair of buttons to the right determine whether you are creating a new Shape Path or a Mask for the Shape layer.

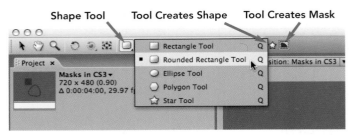

The Shape tool menu has been expanded to include more basic shapes, such as the useful Rounded Rectangle. Both this and the Pen tool are used to draw Masks or Shape layers, depending on what type of layer is selected. If there is a choice, an additional pair of "creates…" icons will become active in the Toolbar.

New Mask Shapes

After Effects 7 included Rectangular and Elliptical Mask tools. In CS3, the same popup menu contains five shape choices: Rectangle, Rounded Rectangle, Ellipse, Polygon, and Star. In both versions, **Q** selects this tool and toggles between the choices.

Rounded Rectangles, Polygons, and Stars have additional parameters: how rounded the corners are, how many sides there are to the polygon, and how many points there are on the star. You can use the cursor keys to change these while dragging before you release the mouse:

	up/down cursor	*left/right cursor*
rounded rectangle	corner roundness	toggle rectangle/ellipse
polygon	number of sides	corner roundness
star	number of points	point roundness

The scroll wheel on a mouse will have the same effect as using the up/down cursor keys. Pressing ⌘ (*Ctrl*) while dragging out a Star shape alters the distance between the inner and outer points of the star.

The Rectangle, Rounded Rectangle, and Ellipse are drawn from corner to corner as you drag; add ⌘ (*Ctrl*) while dragging to draw them from their centers. The Polygon and Star are always drawn from their centers outward. A new feature in CS3 is that you can add the spacebar while dragging to reposition the mask shape before you release the mouse.

Once you are done dragging out the mask shape (called a Mask Path in CS3), it will immediately be converted into Bezier paths with normal handles and mask vertices. There is no easy way to uniformly edit the corners or number of points after the fact.

While dragging a Rounded Rectangle, Polygon, or Star shape, the cursor keys can alter parameters such as how many points the star has and how rounded its points are.

Idea Corner

If you want to practice the techniques you've learned in this lesson, try out the following variations on the exercises you've already performed. Some of our versions are included in the Project panel's **Idea Corner** folder.

• Animating a mask shape is one way to wipe on a title; another approach is to use a transition-style effect. For example, in **01-Masking** delete the mask used to wipe on **Bring on the Night.ai**, and instead apply Effect > Transition > Linear Wipe. Re-create the same animation using this effect. Also experiment with the other effects in this category; the CC effects installed with the Cycore FX plug-in set (free on the After Effects 7 installer disc) can create a lot of interesting looks.

• Effects applied to mattes or stencils treat only the shape of the matte or stencil – they don't affect the image being cut out. For example, in the comps **10-Animated Matte** or **12-Stencil Alpha** where we used Turbulent Displace to alter the matte and stencil, you might have noticed that the background cut out by the matte or stencil didn't ooze as well. If you want to ooze the entire composite, delete the effect from the matte or stencil, and instead apply it to an Adjustment Layer (introduced in the previous lesson) sitting above all the other layers. Our version is shown in **Idea Corner > Adjustment Layer**. You could also nest your track matte or stencil comp into a second comp where you can apply effects to the nested layer. (Nesting is covered in detail in Lesson 6.)

• You can stack stencils on top of stencils. In **12-Stencil Alpha**, try adding **Cloud matte.mov** or **inkblot matte.psd** as a Stencil Luma layer to the top of this comp!

• Create a series of high-contrast grayscale images using whatever means take your fancy (digital images, India ink, Photoshop). Number them sequentially and import the series as a sequence, then loop and set the frame rate in Interpret Footage. Use this sequence as a luma matte or stencil for another layer.

Quizzler

And finally, a few mask-related challenges to make you think:

• Inside the Project panel's **Quizzler** folder, play back the movie **Pop on by word.mov**. Note that the title pops on a word at a time, rather than wipes on. How did we do that using an animated mask? To test your theory, try re-creating it yourself using **Pop on*starter** as a starting point.

• In **Quizzler > Stroke play**, we made a Stroke animate clockwise around the leaf shape. How would you make it animate in the opposite direction?

Once you figure that out, how would you make it start at the top of the leaf shapes and go all the way around, instead of start at the bottom?

The solutions to all of these are in the **Quizzler Solutions** folder. No peeking!!!

The Transition effects provide an alternative to using masks to wipe layers on and off. The Venetian Blinds effect is shown above.

▽ gotcha

Overeager Stencils

The disadvantage of using stencils is that you can't put a background layer in the same comp, as the stencil will cut through that as well. To add a background, nest the stencil comp into a second comp (as you did earlier with the Alpha Matte exercise).

We rotated the **inkblot matte.psd** layer 90 degrees, and used it as a Stencil Luma layer in **12-Stencil Alpha_final** comp to erode the edges of the title.

▽ tip

Effects and Masks

For a list of which effects can take advantage of mask shapes, open Help > After Effects Help and search for "Effects that you can apply to a mask."

Type and Music

Animating text and working with music are essential to motion graphics design.

▽ In This Lesson

▽ Getting Started

Copy the **Lesson 05-Type and Music** folder from this book's disc onto your hard drive, and make note of where it is; it contains the project file and sources you need to execute this lesson.

From opening titles to closing credits, bullet points to lower thirds, and conveying information to creating abstract backgrounds, one of the most common elements in motion graphics is the use of text. Fortunately, After Effects has a very powerful text engine – but it's hardly the most intuitive tool in the world. In this lesson, we'll show you how to professionally typeset text, then animate it in interesting ways.

Another important – but often overlooked – element in motion graphics is the use of sound. By tying your animations to music and dialog, you can greatly increase the impact of your designs. Later in this lesson, we will show you how to add audio layers to compositions, preview audio, view the audio waveform, and place layer markers that will help you time your animation to events in the audio.

Text Tools

In the old days, if you wanted to add text to an After Effects project, you either needed to create it in a program such as Adobe Illustrator, or use a plug-in effect. After Effects version 6 saw the introduction of a new Text tool, which borrows heavily from other Adobe applications such as Photoshop and Illustrator. If you are familiar with creating text in those applications, you already have a good head start. You can still create type in these programs and import them into After Effects, but whenever we have the choice, we prefer to start from scratch in After Effects.

After Effects allows you to create individual characters, words or lines of text (sometimes referred to as *point text*), or paragraphs that are auto-wrapped to fit inside a box that

you define (referred to as *paragraph text*). Text can be created horizontally or vertically as well as set along a curve. Paragraphs can be left justified, right justified, or centered, with additional control over how the first and last lines are treated. You have a lot of control over *tracking* (the space between characters over an entire block of text), *kerning* (the space between individual pairs of characters), *leading* (space between lines), and *baseline shift* (the upward or downward offset of characters in superscripts and ordinals such as the "st" in 1st). You can also freely mix and match fonts, styles (bold, italic, et cetera), sizes, and colors in each word, line, or sentence – not that you necessarily should! Quite often, less is more when it comes to elegant text design.

Beyond creating text is animating it. In After Effects, the most important concept is that of the *selection*. Typically, selected characters are treated or offset in some way (such as by position, scale, rotation, color, opacity, and so forth), while characters outside the selection retain their normal appearance. The selected characters also show a transition from the ordinary appearance of the text to their treated appearance – for example, gradually growing in size. The fun comes in animating this selection zone so that characters will appear to fly in, zoom down, and do all sorts of other tricks as they move between their treated and ordinary states. And if that's not enough excitement, don't forget that many effects from the Effects menu work well with text layers!

Text Basics

To get you quickly up to speed, we've included a movie tour of the Character and Paragraph panels in this lesson's folder: **05a-Text Basics.mov**. We suggest you watch it now so you'll know how to create and edit basic text. It also covers typesetting concepts such as kerning and tracking, smart quotes, paragraph text, and more. The rest of the exercises in this lesson will assume you've been through this and know how to create starting text on your own.

As you view the movie, try your hand at creating some type if this is all new to you. Open this lesson's project file: **Lesson_05.aep**. Select Window > Workspace > Text and then Workspace > Reset "Text", or create your own

After Effects can create animated text by manipulating properties such as position, scale, rotation, opacity, and more. Here, text is blurred per character and animates along a mask path.

▽ factoid

Size Doesn't Matter

Normally, increasing the scale of a layer above 100% will make the image appear soft. But no matter what size you make your text layer, it will always render with sharp edges because it is vector-based. This is technically known as *continuous rasterization*, meaning After Effects creates pixels for the text layer only after it knows what size they should be. The only word *you* have to remember is "cool!"

 Text Basics Guided Tour

We've created a QuickTime movie walking you through the basics of creating and editing type with After Effects' Type tool. It's located in this lesson's **Guided Tour** folder.

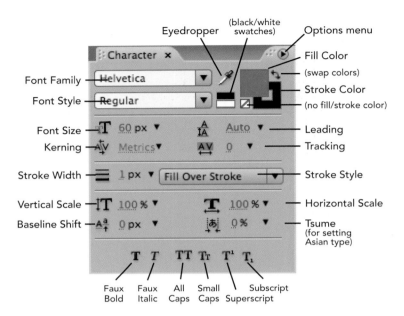

Eyedropper

(black/white swatches)

Options menu

Fill Color

(swap colors)

Stroke Color

(no fill/stroke color)

Font Family — Helvetica

Font Style — Regular

Font Size — 60 px

Kerning — Metrics

Leading — Auto

Tracking — 0

Stroke Width — 1 px

Stroke Style — Fill Over Stroke

Vertical Scale — 100 %

Horizontal Scale — 100 %

Baseline Shift — 0 px

Tsume (for setting Asian type) — 0 %

Faux Bold | Faux Italic | All Caps | Small Caps | Subscript Superscript

△ **The Character panel.**

Options menu

Alignment

Indent Left Margin — 0 px

Indent Right Margin — 0 px

Indent First Line — 0 px

Add Space Before Paragraph — 0 px

Add Space After Paragraph — 0 px

△ **The Paragraph panel.**

When the cursor is visible, you are in *editing mode* (left). After you press the **Enter** key, handles will appear around the text block; this is *layer mode*, where changes you make in the Character and Paragraph panels apply to the entire title. Double-click an existing text layer in the Timeline to enter layer mode.

custom workspace where the Character and Paragraph panels are both visible.

In the Project panel, open the folder **Comps**, then double-click the composition **01 Basic Text*starter** to open it – it will initially be blank. Then select the Type tool in the toolbar; the shortcut is ⌘ **T** on Mac (**Ctrl T** on Windows).

Select the Text tool from the application window's Toolbar to create some text. To switch between the Horizontal and Vertical Type tools, click and hold on this icon. The shortcut to select the Type tool and toggle between Horizontal and Vertical modes is ⌘ **T** on Mac (**Ctrl T** on Windows).

Here are some key points to remember when creating basic text:

• Click anywhere in the Comp panel with the Type tool to start a Text layer, or select Layer > New > Text Layer to start with the cursor in the center of the Comp panel.

• When the cursor is visible, you are in editing mode, and the style of the title you type will be determined by the Character and Paragraph panels. To change how existing text looks, you must select the text first before you change the settings in these panels.

• When you are done typing, hit the **Enter** key to exit editing mode. The layer's name will update to reflect what you typed. The cursor will disappear and handles will appear around the text block to indicate that you are in *layer mode*. Any changes you make in the Character and Paragraph panels will now apply to the entire title.

Once you've created a text layer, you can animate its regular Transform properties and apply effects to it, just like any other layer.

Text Animators

Many effective titles consist of just good typesetting and simple transform animations. However, the real fun begins when you add Text Animators. These enable you to animate individual characters, words, or lines, virtually telling the viewer a story (or at least grabbing their attention) in the way that you bring words on and off the screen! But before you get animating, we need to cover a few basic concepts:

• Nothing in the Character and Paragraph panels can be animated directly – there are no stopwatches to turn on for font size, color, tracking, and so on. All animation beyond changing the text and its typesetting is created by applying Text Animators.

• When animating a title on or off, start by creating the title the way it should finish. If you want the title to "resolve" to a certain color or size, or be in a certain position in the frame when the animation is over, start out with the text looking that way, *then* add Text Animators to transition the text on or off.

Setting the Text

In this exercise, you will create a title and use Text Animators to make it drop down into position one character at a time while fading up.

1 If you haven't already, open this lesson's project file **Lesson_05.aep**. In the Project panel, locate and open **Comp > 02-Dropping In*starter** – it will be blank to start with. Make sure the Character and Paragraph panels are visible; if they aren't, you can select Window > Workspace > Text to pick a preset arrangement that has them open.

2 To start with a clean slate, click on the arrow in the upper right corner of the Paragraph panel to open its Options menu, and select Reset Paragraph to clear previous settings. Then select the Center text option.

Likewise, click on the arrow in the upper right corner of the Character panel, and select Reset Character. Assuming your Composition > Background Color is black or some other dark color, click on the small white swatch underneath the eyedropper to set the character Fill Color to white.

3 Bring the Composition panel forward, and select Layer > New > Text. The cursor will be centered in the comp. Type your title – something that fits on one line, like "**Just Dropping In**" – and press **Enter** on the numeric keypad. The layer will be named automatically to match what you typed.

The default character style on Mac is Helvetica 36 px ("px" = pixels), but feel free to change the font style and color to taste – for example, we changed the Font Style to Bold and increased the size to 60 px. For this exercise, we suggest you stick with one style for the entire text layer to make things more clear.

Typesetting Tips

In the **Lesson 05** folder is a PDF file named **Typesetting Tips.pdf** that includes information on using smart quotes, symbols, and dashes for creating professional-looking titles.

2–3 Reset the Character and Paragraph panels using their Options menu, accessed via the arrows in their upper right corners (circled). Select the Center text option in the Paragraph panel, and set the Fill Color in the Character panel to white. We set the font style to Helvetica Bold at a size of 60 px (above) and created a single line of text to animate (below).

Just Dropping In

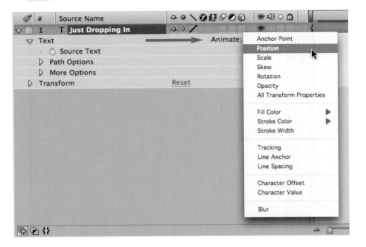

4 Clicking the Animate button to the right of the word Text reveals the properties you can animate on a per character basis. Selecting Position creates Animator 1.

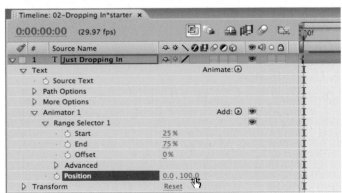

6 The characters "selected" by the Start and End values in Range Selector 1 are bracketed by the vertical lines with the arrows in their middle. As you scrub the values for Animator 1's Position, the selected characters will be offset by this amount.

Range Selectors

To animate text, you need to select it, then apply some form of transformation to it.

4 In the Timeline, click on the arrow next to the text layer to twirl it down, revealing its Text and Transform sections. Then twirl down the Text section.

To the right of the word Text will be the word Animate, followed by an arrow. Click on this arrow, and select Position from the popup menu that appears. Animator 1 will be created; nested inside will be Range Selector 1, and inside that, a Position value.

5 Twirl down Range Selector 1, and turn your attention to the Comp panel. As long as Animator 1 or Range Selector 1 is highlighted, you will see vertical lines with triangles at the start and end of the title. These indicate where the Start and End values of the Range Selector are: 0% means the beginning, and 100% means the end. Scrub the Start and End values, and note how these indicators move along the text. Then set Start to 25% and End to 75%.

6 Animator 1's Position value indicates how much the selected text should be *offset* from its original position. It starts at 0,0, which means no offset.

• Scrub the X Position value (the first of the pair); the selected characters will move left and right.

• Scrub the Y Position value, and the selected characters will move up and down.

Important concept: By default, only the selected characters – those inside the Start and End bars – are affected by the Text Animator properties. Any characters outside the selection are unaffected, and appear in their original style as created.

To reinforce what is going on, leave Position at a value such as X = 0, Y = 100 and scrub the values for Start and End to change the characters that are included in the selection. This will result in characters switching between their original and offset position.

Just Dropping In

By scrubbing the Start and End values, light bulbs should be going off about how you might create an animation: By keyframing the Start and End values to animate the characters that are selected, you can make the title, say, fall down from the top of the frame:

7 Start over with a clean slate: Select Animator 1, and press [Delete]. The text should return to being centered in the comp.

Then select Animate > Position again from the text layer's popup menu to create a fresh Text Animator, just as you did in step 4.

8 Press [Home] to ensure you are at the start of the comp.

Twirl down Range Selector 1, and click on the stopwatch icon next to Start to enable keyframing for it. The first keyframe will be created for you, using Start's default value of 0%.

Then scrub the Y Position value to around –200 so that the text is hanging from the top of the comp (keep it visible for now).

9 Go to time 01:00, and set the Start value to 100%. This will create a second keyframe at this value.

Press [0] on the numeric keypad to RAM Preview your animation, and watch the text drop into place. Save your project at this point.

Adding More Properties

Once you have created this basic "dropping in" move, it is easy to add more properties to your animation.

10 Press [Home] to return to the start of the comp where the text is at the top of your frame. In the Timeline panel, look along the line that Animator 1 sits on: You will see the word Add followed by an arrow. Like Animate, this will reveal a list of properties, but in this case a new animator will *not* be created – the selected property will just be added to the existing animator.

▽ try it

Motion Blur

Animating text often looks great with motion blur (Lesson 2). Enable the Motion Blur switch for your text layer, then turn on the master Enable Motion Blur switch along the top of the Timeline panel. Remember that motion blur takes longer to calculate, so your previews will be slower.

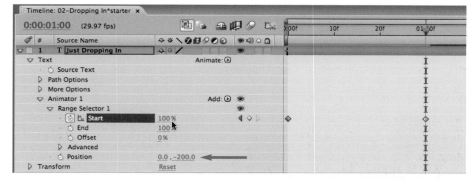

8–9 Set Animator 1's Y Position to –200 and animate the Start value from 0% to 100% (top). The result will be the text dropping from its offset position to its original position, a character at a time.

Text Animator Guided Tour

We freely admit that Text Animators are not particularly intuitive the first time you use them! If you have trouble following these steps, we've created a QuickTime movie introducing Text Animators and walking you through this *Just Dropping In* exercise. It's located in this lesson's **Guided Tour** folder.

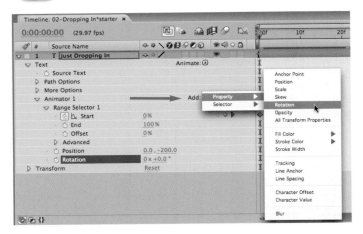

10 Once you have created the initial Animator, you can animate additional properties by clicking on its Add arrow (not the Animate arrow).

Click the Add arrow, and select Property > Rotation. The Rotation property will be added to the existing Animator 1. (If you created Animator 2 instead, you clicked on the Animate button by mistake! Undo and try again.)

11 Scrub the Rotation value to about 45 degrees. Now all characters included in the Start/End selection will be affected by the rotation offset.

RAM Preview again. As the title drops into place, the characters will fall outside the selection and are no longer rotated. You did not need to animate the Rotation value itself; the animation happens automatically as characters are transferred from inside the selection (where they get the position and rotation offset) to outside the selection.

 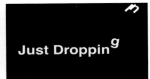

11 By adding Rotation as a property included in Text Animator 1, and setting Rotation to 45°, the characters will drop in and rotate back to 0° while doing so.

12 So far, so good. But at the start of the animation, you have a row of silly-looking characters sitting along the top of your comp. How can you make them invisible before they drop in? You could offset their position further so they started above the frame, but there's an even better way: Make them invisible!

Return to 00:00. Click the Add button arrow again, and select Property > Opacity. Scrub the Opacity down to 0%; the selected text will disappear. RAM Preview again: The characters return to their normal opacity value as they fall outside the selection.

If you want to make sure you followed the steps correctly, compare your result with our version: It's in the Project panel's **Comps_Finished** folder, and is named **02-Dropping In_final**. And don't forget to save your project!

Now that you have the basic idea, feel free to experiment by adding other properties to Animator 1. Try Scale (the characters will appear to zoom up or slam down), or Fill Color > RGB (their color will change as they fall into place). Obviously, thousands of variations are possible! Just remember that you don't have to animate these properties individually; you need to animate only the Range Selector, then let these properties decide how the characters will look different when they're inside the selection.

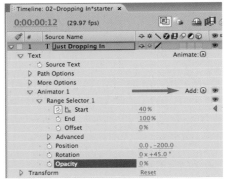

12 Adding Opacity will cause the characters to also fade in as they fall into place. (By the way, if you return Animator 1's Position and Rotation values to zero, your characters will appear to type on in place!)

▼ Randomize Order

To have the characters fall down in a random order, twirl down the Advanced section of Range Selector 1, and set Randomize Order to On (click the Off value to toggle). The characters will now drop down in a random order rather than from left to right. The Random Seed value allows you to jiggle the order and find a more pleasing pattern.

To see this result, check out our version in **Comps_Finished > 02-Dropping In_final2**.

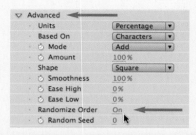

Creating Cascading Text

In the previous exercise, you learned how to make characters fly in one at a time. Sometimes it is nice to spread this movement across several adjacent characters. This creates what we refer to as a "cascading" animation, and is the subject of this next exercise. To get a peek at where you are heading, preview **Comps_Finished > 03-Cascade_final**.

1 Clean up by closing any old comps. In the Project panel, locate and open **Comps > 03-Cascade*starter**. We've already created a title for you to start with, but feel free to change the text or font style to taste.

2 In the Timeline panel, twirl down the text layer, and select Animate > Scale. This will create Animator 1 and Range Selector 1, with a Scale property. Change Scale to 400% (for now, don't worry about how the letters overlap).

3 Click on the Add arrow on the same line as Animator 1, and select Property > Fill Color > RGB. Fill Color will be added below Scale, using a default color of red. Change the Fill Color to taste by clicking on its swatch in the Timeline.

4 Twirl down the Range Selector, then twirl down the Advanced section inside Range Selector 1. Try the different options for the Shape option by selecting them from its popup, then experimenting with the Range Selector's Start and End values.

• The default Shape is Square, which means that characters inside the range selector are fully affected by the Scale and Fill Color properties. Scrub the Start value, and note how characters outside the selector are immediately returned to their original settings, with little to no transition to speak of.

A "cascading" animation is when multiple characters slide into place, like a wave. This requires a slightly different technique, which you will learn in this exercise.

2 Select Animate > Scale, and set the Scale value to 400%. The characters will swell to a size where they overlap; don't worry about that right now, as they will eventually fade up as they cascade in from this size.

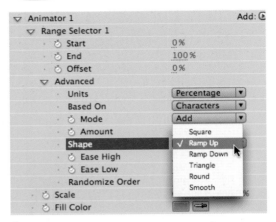

4 Twirl down Range Selector's Advanced section and explore the different Shape options. Then select the Ramp Up shape.

4 *continued* The Ramp Up shape allows cascading animations by creating a smooth transition from the unselected (white, normal size) to the selected (red, 400% scale) states.

7 Using the Ramp Up shape in combination with animating Offset from left to right results in our characters transitioning from being large and red to their original appearance.

• Try the Triangle, Round, and Smooth Shapes. You will notice that they have a wider transition zone. Also note that the characters in the center of the selection are fully affected, but the effect of your Scale and Fill Color offsets fall off the closer the selected characters are to the Start and End points. Characters outside the range selection are not affected, just as is the case with the Square shape.

• Next, select Ramp Up, which behaves differently: It uses the Start and End values to create a *transition* from the original text (white color, normal size) at the Start of the selection, to the fully affected text (red/400% size) at the End of the selection. Any characters after End are also fully affected (red/400%), as if they were inside the selection; any characters before the Start are not affected, as if they are outside the selection. Ramp Down does the same, but in reverse.

In short, the Ramp Up and Ramp Down Shapes transition between selected and not selected, and the size of this transition is determined by the number of characters between the Start and End points. These are the Shapes that you need to create cascading text animations.

When you're done experimenting, select Ramp Up from the Shape popup, and twirl up the Advanced section.

5 In Range Selector 1, set the Start to 0%, and scrub the End parameter to about 33%. All the characters after the End parameters will be fully affected (red/400%).

Offset is added to the values for Start and End. As a result, Offset is a handy way to animate both Start and End at the same time, keeping the same relationship between them so that the width of the selection remains the same.

Scrub the Offset parameter while watching the Comp viewer, and note how the transition area moves back and forth along the line of text.

6 To create the cascading effect, make sure the current time marker is at 00:00, and enable the stopwatch for Offset. Set its value to –33%. This will move the transition completely to the left of the title. Why did we pick this particular number? It's simply the negative of the End value, which ensures the selection has been offset to just before the Start.

7 Move to 02:00, and set Offset to 100%. This adds 100% to both Start and End, resulting in Start and End both being 100% (the maximum); the transition will be pushed off to the right. Scrub the current time marker back and forth along the timeline to get a feel for this animation.

Leave the current time marker around 01:00 to better see what is about to happen in the next step.

8 The finishing touch is to make the characters fade up as they cascade on. To do this, click on Animator 1's Add arrow, and select Property > Opacity. Then set Opacity to 0%. Because you're using the Ramp Up shape, the characters will transition from 100% opacity at the Range Selector's Start, to 0% opacity at its End. Characters after the End will be fully transparent. RAM Preview to see this in motion – a nice cascading effect! You can compare your results with our version in **Comps_Finished > 03-Cascade_final**.

Again, remember: You didn't need to animate Opacity! It is merely another property that is being used to treat the text as you transition from being inside the selection (in Ramp Up's case, after the End point) to outside the selection (before the Start point).

Adjusting the Anchor Point

If you watch closely, you'll notice that the scaling occurs around the *baseline* (bottom) of the text. What if you want the characters to scale from their centers?

9 Move to 01:00 to catch the animation mid-cascade, and temporarily increase the Animator's Opacity value to 50% to better see what's about to happen:

• Click the Add (not Animate) arrow and select Property > Anchor Point. This will add the Anchor Point property to Animator 1.

• Scrub the Anchor Point's Y value slowly to the left while watching the Comp panel; add the ⌘ (*Ctrl*) key to scrub in finer increments. A small negative Y value should center the characters vertically. Experiment with different X and Y values of Anchor Point and RAM preview to see the results.

• Change Opacity back to 0% when you're done.

Our experiments with Anchor Point are demonstrated in **Comps_Finished > 03-Cascade_final2**. Layer 1's anchor point is offset in X and Y. Layer 2 serves as a reminder: Randomize Order and Motion Blur are two enhancements that you can add too!

8 Adding Opacity to Animator 1 and setting it to 0% will make characters fade from 100% to 0% within the transition zone.

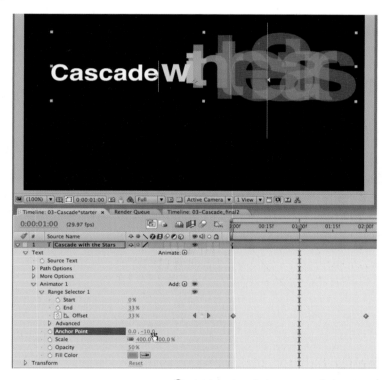

9 Add Anchor Point to your Animator and Range Selector, and offset its Anchor Point Y value slightly negative to center the expanded text vertically.

◁ We created a pair of alternate versions in **Comps_Finished > 03-Cascade_final2** that include both X and Y Anchor Point offset (both lines), as well as Randomize Order plus motion blur (bottom line).

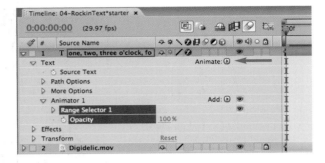

2 Reveal the Text property for layer 1, click on the Animate button, and select Opacity. An Animator and Range Selector will be created.

4 By default, when you set the Range Selector's Opacity to 0% and animate its Start, the text will type on one character at a time. Footage courtesy Artbeats/Digidelic.

(Range Selector 1 panel detail:)

#	Source Name			
	Animator 1		Add:	
	Range Selector 1			
	Start	59%		
	End	100%		
	Offset	0%		
	Advanced			
	Units		Characters	
	Based On		Characters Excluding Spaces	
	Mode		✓ Words	
	Amount	100%	Lines	
	Shape	Square		
	Smoothness	0%		
	Ease High	0%		
	Ease Low	0%		
	Randomize Order	Off		

5 In Range Selector 1's Advanced section, set Based On to Words to have entire words be selected or unselected. To cause the words to "pop" rather than fade on, set Smoothness to 0%.

One Word at a Time

So far, you've been animating text a character at a time. However, After Effects also makes it easy to animate entire words as units.

1 Close your previous comps and open the composition **04-RockinText*starter**. It includes some basic text that we've already created for you, with a drop shadow applied. We chose the font Adobe Birch, which comes free with After Effects 7. (If you don't have this font, pick another condensed font and adjust it so that it fits nicely inside the comp.)

2 Twirl down the text layer (layer 1), and select Animate > Opacity. Animator 1 and Range Selector 1 will be created, with the Opacity property already added. Set Animator 1's Opacity value to 0%. Because all of the text is selected by default, the entire line will become transparent.

3 Twirl down Range Selector 1. At 00:00, turn on the animation stopwatch for Start. This will create a keyframe with a value of 0% at the beginning of the animation.

4 Move to 03:00, and set the Start value to 100%. Preview your animation. Because the text is using the default Square shape, it will type on from left to right, one character at a time.

5 Here's the trick to make the text appear one *word* at a time: Twirl down the Range Selector's Advanced section, and set the Based On popup to Words. Preview again; the title now fades on one word at a time.

Below the Shape popup is the Smoothness parameter. For now, set Smoothness to 0% so the letters pop on with no fade up.

6 Let's add some rotation to the mix, while also learning an important gotcha. Click Animator 1's Add button, and select Property > Rotation.

Set Animator 1's Rotation value to –1 revolution (meaning it should read –1 x 0.0°). As the title types on, you might expect the characters to rotate into position. But nothing happens!

Remember the Smoothness parameter? The combination of the Square shape and no Smoothness results in no transition time, meaning no chance to see the Rotation. Set Smoothness back to 100%, and now you will see your Rotation animation (as well as the Opacity fade).

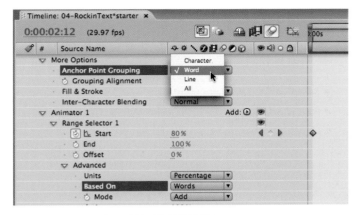

7 To have each word rotate as a unit as well (left), set More Options > Anchor Point Grouping popup to Word (above).

7 Although the Range Selector is set to animate word by word, the characters themselves are rotating around their own individual anchor points. To have them rotate word by word as well, twirl down the Text > More Options section and set the Anchor Point Group popup to Word also. RAM Preview to see the difference this makes.

8 The text is rotating around its baseline. To have it spin from a different location, play with the More Options > Grouping Alignment parameter. For example, change the Y value to –200%, and the text will rotate in from above.

8 More Options > Grouping Alignment allows text to travel in interesting ways. You can also animate this parameter.

Our version is in **Comps_Finished > 04-RockinText_ final**. We had a bit of fun by also adding Scale to Animator 1 and setting it to 200%, so that the text scales down as it rotates. And remember: Save your project.

▼ Safe Areas

If you are creating video to be played back on a television set, you need to know about *safe areas*. While you are working, After Effects shows you the entire video frame. However, the viewer doesn't get to see part of this frame – it gets cut off by the bezel around a TV's screen. Also, part of the frame might be too distorted to allow text to be read clearly.

To avoid the bezel problem, you need to keep any imagery you expect the viewer to see inside the *action safe* area. This margin is 10%, cutting 5% off the top, bottom, left, and right. As bezels vary from TV to TV, you need to put some imagery out there to prevent the viewer from seeing only black; just don't put anything important out there. To avoid the distortion problem, you need to keep text inside the *title safe* area. This margin is 20%, or 10% on all four sides.

To check your work, you can toggle a Title/Action Safe grid on and off in After Effects. The shortcut is ❔ (the apostrophe key); you can also select it from the Grid and Guide button along the bottom of the Comp, Layer, and Footage panels. 🔧+click (*Alt*+click) this button to toggle it directly.

Yes, many break these rules by putting news, sports, and stock price tickers between the action and title safe areas. And there are far fewer problems with flat-panel TVs. But regardless, if you are creating commercial video, you will be expected to respect these safe areas.

1 Open **05-Path*starter**, which contains a basic title over a cool background. Footage courtesy Artbeats/Light Alchemy.

3–4 Turn off the Constrain Proportions switch for Blur, and set the Blur Y value to around 80. This turns the characters into vertical rays of light. Then change the Shape to Ramp Up to get a transition from sharp to blurry characters. Toggle Randomize Order to On scrambles the order of which characters are sharp and which are blurry.

Flowing Text

In this exercise, you'll create some elegant, cool-looking type by animating character spacing and blur, plus flow text along a mask shape.

Animating Blur

1 Close your previous comps and open **05-Path*starter**. We've already created the basic title using the font Trajan Pro (free with the commercial version of After Effects; pick another if you like) and placed it over a cool background. Indeed, we're going to use this background to inspire our animation…

2 In the Timeline panel, twirl down the text layer (layer 1) to reveal the Text properties and the Animate button. Select Animate > Blur. This creates Animator 1 and Range Selector 1, with the Blur property added.

3 We want our characters to start out as vertical rays. To do this, click on the chain link icon next to Blur to disable its constrain proportions feature, and set the Blur Y value to around 80.

4 We also would like some variation in how blurry each character is. Variation usually means randomization, so we need to seek out a parameter that lets us introduce this.

• Twirl down Range Selector 1, then twirl down its Advanced section. Change the Shape popup from Square to Ramp Up. Note that now the characters transition from being sharp near the Start of the range to being blurry near the End.

• Then toggle Randomize Order to On. This will scramble which characters appear sharp and which appear blurry.

5 Now create a cascading-type animation:

• At 00:00, enable keyframing for Offset, and set its initial value to –100% (the negative of the End value). All the characters will be blurred.

• At 02:00, set Offset to 100%. Now all of the characters will be sharp, as Offset has moved through the entire range. Preview to see the effect.

Animated Tracking

Characters coming together is a popular look. This requires animating the tracking of the text:

6 Select Add > Tracking; this will add Tracking Type and Tracking Amount parameters to Animator 1. Return to 00:00 where the text is fully selected. Scrub the Tracking Amount, and observe how the blurred characters spread out. Set it to about 6.

RAM Preview: The text will come together as the animation resolves (see right). This is because the amount of tracking applied is controlled by Range Selector 1's animating Offset.

Text on a Curve

The text looks cool, but it's a bit rigid compared with the flowing background – so let's create a curved path for the text to follow, using the masking skills you learned in Lesson 4.

7 With the text layer selected, select the Pen tool, and enable the RotoBezier option in the toolbar.

Create an open curved path by clicking a few points from left to right across the Comp panel, using the curves in the background for inspiration. When done, press **V** to return to the Selection tool.

8 In the Timeline panel twirl down the Text > Path Options section, and set the Path popup to Mask 1. (If you don't see Mask 1, make sure the mask was applied to the text layer!) The text will now sit on top of your mask path.

Press **Home** to return to 00:00 and study your text; you might want to increase the Tracking Amount value to spread your text out more along its path.

9 The Path options exist outside the Animator and Range Selector. To make the text slide along your path, keyframe one of its Margin parameters:

• Return to 00:00, and scrub Text > Path Options > First Margin until you are happy with where it starts. Enable the animation stopwatch for First Margin.

• Hit **End** to jump to the end of the comp, and scrub First Margin to a different value to make the text travel. RAM Preview, tweak to taste, and enjoy! (Don't forget to save…)

Our version is in **Comps_Finished > 05-Path_final**. We also added Effect > Blur & Sharpen > Radial Shadow, and animated the mask shape over time.

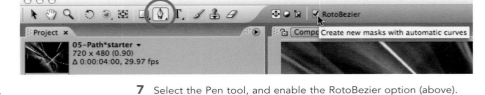

7 Select the Pen tool, and enable the RotoBezier option (above). Then create an open curved path in the Comp panel.

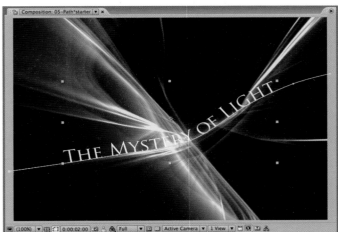

8 To have the text sit on your newly drawn mask shape (above), set the Text > Path Options > Path popup to Mask 1 (below). Then animate the Path Options > First Margin parameter to slide the text along your path. Feel free to animate the Mask Shape as well.

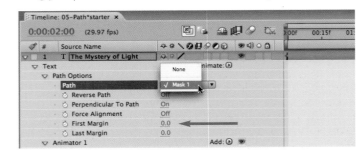

1 To start, we've created a title to suit our penguin footage in the background. Your mission will be to make the title's movement even cuter than that of the penguins. Footage courtesy Artbeats/Penguins.

2 Initially, you will see a "comb teeth" pattern in penguins that are moving – this is known as interlacing (A). When you see this, it is best to separate the fields in this footage (below), which will remove the artifacts and process it properly (B).

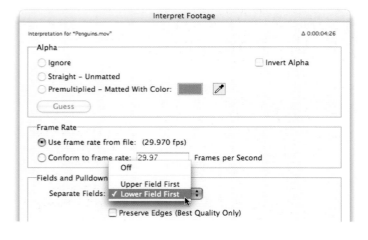

Wiggling Text

Most of your text animations so far have included simple, two-keyframe, "from here to there" movements. For those times when you want to get a little wacky, such as having text jiggle and dance, just add the Wiggly Selector:

1 Open comp **06-Wiggly*starter**, where we've created some basic text using the font Adobe Poplar (installed free with After Effects 7; again, feel free to pick your own). We made the text a pale blue, with a one-pixel Stroke, and added the Drop Shadow effect.

Separating Fields

Before you start wiggling, we need to deal with another issue specific to video. If you are viewing this composition at 100% magnification, you may notice that some of the penguins have a "comb teeth" artifact, where alternating pairs of horizontal lines appear to be drawn offset from each other. This is caused by a video phenomenon known as *interlacing*.

In short, a good deal of video is shot where one set of horizontal lines were captured at one point in time, and every other line was captured at a slightly later time. Video uses this trick to capture and play back smoother motion, as well as to get around a problem with the imperfections in the phosphors that lit up early CRT-style TV sets.

These two different points in time are called *fields*. Two fields are combined (interlaced) together to make a frame. It is best if we work on one field at a time in After Effects, to make sure we don't accidentally scramble together pixels that originally came from two different points in time. Therefore, when you see interlacing in your composition, you should separate the fields of the source in question.

2 Right-click on the **Penguins.mov** source in this comp, and select the menu item Reveal Layer Source in Project. The Sources folder in the Project panel will twirl down to reveal this footage file.

Type ⌘ F (Ctrl F) to reveal its Interpret Footage dialog. In the Fields and Pulldown section, set the Separate Fields popup to Lower Field First, and click OK. The comb teeth will now disappear from the penguin footage in your comp.

The Wiggly Selector

To wiggle text, you need to add at least one parameter to wiggle. Let's wiggle color, then add transform properties:

3 Twirl down the text layer, and select Animate > Fill Color > Hue. Scrub the Fill Hue value to 300 degrees, and the blue text will now appear green.

4 Click Animator 1's Add button, and choose Selector > Wiggly. RAM Preview: Each character now has a random color that varies over time automatically!

5 Select Add > Property > Position. Scrub the Y Position value to around 50 or so. RAM Preview; the characters wiggle a *maximum* of 50 pixels up *or* down.

6 Select Add > Property > Rotation, and set Rotation to around 15 degrees. As with Position, the Wiggly Selector treats this value as a maximum offset; notice that characters rotate clockwise and counterclockwise (ranging from +15 to –15 degrees).

7 Twirl down the Wiggly Selector and set some options:

• To make the title more readable, increase the Correlation value to around 80%. Now adjacent characters behave more alike.

• Try setting Wiggly's Based On popup to Words; now "Penguin" and "Playhouse" will jiggle as words instead of individual characters. Adjust Correlation to 0% to have them be as different as possible, or set to taste.

• To randomize the color and location of the characters without having them animate, set Wiggles/Second to 0.

• To fade out the entire wiggle effect, animate both the Max Amount and Min Amount from their default value down to 0%. Or, fade up or down a single property (say, Position or Rotation) by setting keyframes for that property only.

Our version can be found in **Comps_Finished > 06-Wiggly_final**. We added a couple of touches, such as animating the Amount parameters in the Wiggly Selector. We also faded out the Position and Rotation offsets, leaving just the color variation at the end.

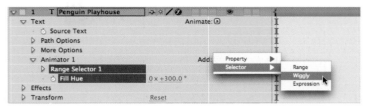

4 Adding a Selector > Wiggly causes the property we are animating – in this case, hue – to automatically randomize per character over time.

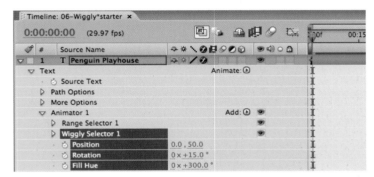

6 By default, the Wiggly Selector randomizes each character by a maximum of the animation properties you set, in either direction (positive or negative).

7 In our final version, we animated the Wiggly Selector's amount and faded down the Position and Rotation leaving just Fill Hue.

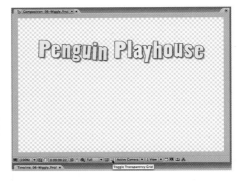

3 Turn off the background layer, and use Toggle Transparency Grid to verify that there are no other layers present (such as a black solid) that are not supposed to render.

5 In the Render Queue, select the Lossless template from the Output Module popup, then click on the underlined "Lossless" to open the Output Module Settings.

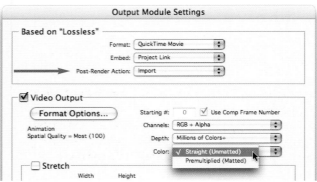

Rendering with an Alpha Channel

Say that after you've finished your penguin title animation in the previous exercise, the editor says he might still change the video behind it – so can he have the title by itself? To do that, you need to render it with an alpha channel.

1 Open or select the **06_Wiggly** comp you created in the previous exercise. If you didn't finish it, open ours: **Comps_Finished > 06-Wiggle_final**.

2 Turn *off* the Video switch (the eyeball icon) for the background layer, **Penguins.mov** – the editor is planning on replacing that.

3 To confirm that you have nothing else behind your type, click the Toggle Transparency Grid button along the bottom of the Comp panel. You should see a checkerboard pattern everywhere the type isn't.

4 Select Composition > Make Movie; the shortcut is ⌘ M (*Ctrl* M). A file dialog will open: Name your movie, and choose a place to save it. Include the word "alpha" in the name to remind you that this movie will have an alpha channel in it. (If you don't get this dialog, you have enabled Preferences > Output > Use Default File Name and Folder. That's okay; in the Render Queue panel, just click on the name next to Output To: to set the name and path.)

5 The Render Queue panel will open, with an entry for your composition. Inside this entry are two lines: Render Settings and Output Module. Next to Output Module, it should say Lossless; this is the default template, and it uses the QuickTime Animation codec which is well-suited for our needs. If it doesn't, click on the arrow and select Lossless from the popup menu that appears.

Click on the underlined "Lossless" text to the right of this arrow to open the Output Module Settings dialog and change these settings:

• In the Video Output section, set the Channels popup to RGB+Alpha. Once you do so, the Depth popup should automatically change to Millions of Colors+ (the "+" stands for alpha).

• Click on the Color popup and change it to Straight: This is the format required by most editing systems to obtain the highest quality.

• Set the Post-Render Action popup to Import. This will bring the finished movie back into After Effects, so you can check it out without having to find it on your hard drive.

Click OK to close the Output Module Settings dialog.

5 *continued* In the Output Module, set Channels to RGB+Alpha, Depth to Millions of Colors+, and Color to Straight.

6 Click the Render button. When After Effects is done, the file will appear in the Project panel.

Double-click your rendered movie to open it in a QuickTime viewer inside After Effects. See that coarse black fringe around your type? That's the result of a Straight Alpha render, where After Effects "oversprays" the color pixels beyond the edges of an alpha, just as you would do when painting through a stencil. You actually *want* to see this; it verifies that you rendered a Straight Alpha. If your editors panic when they see it, tell them it will look fine when it's composited in their editing system, after the alpha channel does its job.

To see what your render really looks like, close the QuickTime viewer, hold down ⌥ (*Alt*) and double-click the movie to display it in its Footage panel. This After Effects viewer factors in the alpha channel. Turn on the Transparency Grid, and you will see clean edges around your type, including any drop shadow effects. Likewise, it will look great if you add this movie to an After Effects composition. Save your project when done.

6 If you view your straight-alpha render in a QuickTime viewer, you will see just the RGB color channels, which includes pixels that extend beyond the alpha (above). View it in the After Effects Footage panel which factors in the alpha channel, and you will see that it is actually clean (below).

▼ Rendering with Fields

When you started working on the **06_Wiggly** comp, we had you separate the fields in the **Penguins.mov** source footage. If your sources have fields, and you are rendering content to be played back on a normal television or monitor, you will want to re-introduce fields on output. This will give you the smoothest possible motion, retain all of the resolution in your sources, and match the feel of the motion between your sources and any elements you added in After Effects.

After you've added a comp to the Render Queue, you should see the word Lossless (the default template) next to Render Settings – if you don't, select Lossless from the popup menu to its right. Then click on the word Lossless to open the Render Settings dialog.

In the Time Sampling section, set the Field Render popup. This will cause After Effects to render each frame twice using slightly different times, creating two fields. It will then *interlace* these fields together to create the final frame. Which field order you choose in this popup depends on the format you are

rendering to: Use Lower Field First for NTSC or PAL DV; NTSC D1 could be either Lower or Upper Field First depending on hardware. Use Upper Field First for HD or PAL D1. Note that if you pick the DV Settings template instead of Lossless, After Effects will set Field Render to Lower Field First for you.

▼ Just Add Sound

✎	#	Source Name						
▷	☐ 1	🎵 Playhouse.aif	⊕	/				🔊
▷	☐ 2	T Penguin Playhouse	⊕ ☀	/ 🎵				
▷	☐ 3	🎬 Penguins.mov	⊕	/			👁	

One of the best things you can do to improve the look of your motion graphics is coordinate them with audio, such as dialog and music. We're not just talking about selecting music which has a mood that suits your visuals, but actually timing your animation to be in sync with the music or words. To do this, you need to "spot" where the important "hit points" are in your soundtrack, and place markers there. These in turn serve as signposts for where to place keyframes and edit points.

Audio Basics

Audio is just another form of footage; you import it the same way as a movie. There are many valid formats for audio, such as AIFF, WAV, and MP3 files; you can also create a QuickTime file that contains just audio. Of course, audio is also often embedded alongside video in the same file.

Like pictures and video, audio's resolution is defined by its *bit depth*, with higher being better. The most common format is 16 bit (the same as CDs); 24 bit is a high-end format. Audio is also defined by its *sample rate*, which is akin to frame rate. Again, higher is better. Consumer DV has an audio rate of 32 kHz (thousands of samples per second); audio CDs have a rate of 44.1 kHz; professional video uses 48 kHz.

Adding Audio to a Comp

Open the finished version of the comp **06-Wiggly** from the previous pages (you can use your version or ours), and press (Home) to return to 00:00. In the Project panel, twirl down the folder **Sources**, and locate the audio file **Playhouse.aif**. Its sample rate and bit depth will appear at the top of the Project

△ Layers with audio (such as **Playhouse.aif** here) have a speaker icon in the A/V Features column of the Timeline panel, akin to the eyeball icon (Video switch) for layers with visual content.

panel. Add this file to your comp just as you would any other footage layer: by dragging it to the Comp or Timeline panels, or pressing ⌘ / ((Ctrl) /).

In the Timeline panel, you will notice that **Playhouse.aif** has a speaker icon under the A/V Features column, just like the eyeball icon (Video switch) that video-only layers have. You can toggle this on and off to mute or unmute an audio layer. Layers that have both audio and video will have both speaker and eyeball icons, which can be toggled independently.

When you RAM Preview a comp, the audio will be played as well (if you don't hear it, toggle the Mute Audio button in the Time Controls panel). To preview just the audio from the current time forward, press ■ (the decimal point key on the numeric keypad). The duration of this audio-only preview is set in Preferences > Previews. In that same dialog you will see popups for Sample Rate and Sample Size; leave these at their defaults, or set them to the same values as the format you eventually plan to render – such as 48 kHz/16 bit for professional DV.

With the audio layer selected, press **L** to reveal its Audio Levels parameter: This is its volume control. You can also adjust this value in Window > Audio. These work like Scale, in that lower values reduce the volume, and higher levels increase it. As with Scale, going over "100%" (0 dB in audio-speak) is generally a bad idea – especially if the red bars along the top of the Audio panel light up

during previews. (If you see this red light, listen for distortion, and if necessary reduce the level.) You can keyframe Audio Levels, but the resulting fades can sound a bit funky; we prefer to use Audio Levels as an overall adjustment, and then use Effect > Audio > Stereo Mixer to keyframe actual volume changes such as fade outs.

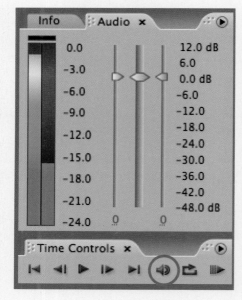

△ The Audio panel can be used to set the Audio Levels for a selected layer. While previewing, the bargraphs to the left will follow the loudness of the audio from frame to frame. If the red "clip" indicators along the top light up, the audio may be too loud. If you can't hear audio during previews, toggle the Mute Audio switch (the speaker icon) in the Time Controls panel.

Just Add Markers

One of the more useful features in After Effects is the ability to place markers on each layer or in the overall composition. You can use these to note special events in the layer or comp, making it easy to synchronize keyframes and other layers to these times.

To place a *layer marker*, select the layer you want to mark, move the current time marker to the desired time, and press the ✳ key on the numeric keypad to create it. (You can also do this while previewing, although it is a challenge to get the timing exactly right!)

To name a layer marker as you create it, hold down ⌥ (*Alt*) when pressing ✳ to open the Marker dialog. You can also double-click an existing marker to open this dialog.

Layer markers are attached to their layer: As you slide the layer in time, its markers will move with it. When you need to mark a time in the composition that doesn't move with the layers, add a *comp marker*. Move the current time marker to the desired place, hold *Shift*, and press **0** – **9** from along the top of the keyboard (not the numeric keypad). A numbered pointer will appear. To jump to that marker, merely type its number. To delete a marker, ⌘+click (*Ctrl*+click) on it. Right+click on a marker for more options.

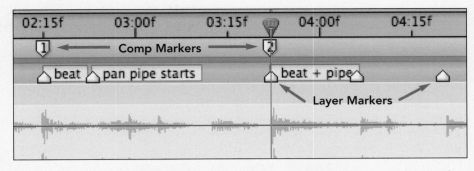

△ Place layer markers on audio layers to denote important beats and events in the sound-track. Add comments to layer markers as needed to remind yourself what they are marking! Comp markers – the numbered icons above the layers – are useful for overall alignment of multiple layers and keyframes. You can drag markers left and right to move them in time.

Penguin Spotting

When we have audio in a project, we place layer markers based on events we spot in its *waveform*. The waveform illustrates how loud the audio is at any given instant. To reveal it, twirl down the layer's Audio > Waveform parameter, or select the audio layer (in this case, **Playhouse.aif**) and press **L** **L**.

The taller the waveform, the louder the sound is at that particular time. Spikes in the waveform indicate percussive events such as drum hits or "plosive" syllables such as "Ps." Those spikes are often great spots to place keyframes or trim a layer to. To gain a feel

for how the waveform relates to what you hear, preview the audio while keeping an eye on the current time marker as it plays through the spikes.

After spotting and marking the musical events in **Playhouse.mov**, twirl up the waveform display to speed up redraws. Then practice moving the keyframes for the **Penguin Playhouse** text layer to line up your markers. You can also mark and slide the **Penguins.mov** video track so the antics of the penguins better align with what's happening in the soundtrack. Our version is in **Comps_Finished > 06-Wiggly_final2**.

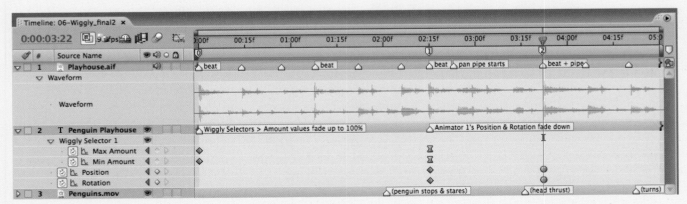

△ Our final timeline. Using our markers as a guide, we moved keyframes and slid the video to better match the timing of the soundtrack.

Text Animation Presets

In Lesson 3, we introduced Animation Presets, which are a great way to save favorite arrangements of effects as well as keyframed animations. In addition to providing a way to save your own creations, Adobe ships After Effects with literally hundreds of already-made Presets that you can explore and use. One of the richest areas to mine is that of Text Presets.

Applying a Text Preset

Make sure the Effects & Presets panel is open and visible. If it isn't, select it under the Window menu, and drag it into a frame that has a lot of height so you can easily see and navigate a long list.

1 Close any previous comps, and open **Comps > 07- Apply Preset**. It contains a text layer and an audio layer. Select the text layer **Jazz It Up!**.

2 Click on the Options arrow in the upper right corner of the Effects & Presets panel, and select Browse Presets. This will open Adobe Bridge (introduced in Lesson 2) and navigate to the Presets folder for you.

3 Double-click the folder **Text**. Inside it will be several sub-folders that represent categories of presets such as Animate In, Blurs, and Rotation. Double-click the **Animate In** folder to open it. You will see a number of thumbnails, representing each preset. Select one by single-clicking it; an animation of it will start playing in the Preview panel. Go ahead and preview a few. If you like, click on the Go Up folder button along the top, and explore some of the other text preset categories.

3 Selecting Browse Presets from the Effects & Presets Options menu opens Adobe Bridge, which makes it easy to preview the Adobe-supplied presets. Double-click one to apply it to a selected layer back in After Effects. If you don't need to see an animated preview, you can also apply presets directly from the Effects & Presets panel.

4 Once you've found a preset you like, double-click it. Bridge will return you to After Effects and apply that preset to your text. (If your text layer was not selected when you applied a preset, you will get a new layer named Adobe After Effects instead. If you see this, Undo, select **Jazz It Up!**, return to Bridge, and try again.) Press **U** to reveal the keyframed properties this preset is using to create its animation.

RAM Preview the comp to see how the animation looks full-size with your text. If you're less than thrilled, no problem; Undo to remove the preset, press **Home** to jump back to 00:00, return to Bridge, and select another preset.

After you've had some fun, undo and apply the preset **Curves and Spins > Counter Rotate.ffx**, as we'll be using it in the next section.

Editing a Preset

Applying an Animation Preset is not the end of the road; you can freely edit the layer afterward. Let's make a couple of customizations to the **Counter Rotate** preset we applied in step 4.

5 While watching the Comp viewer, drag the current time marker until you observe several characters overlapping.

Twirl down the parameters for **Jazz It Up!** until you open the Text > More Options section. Inside there is a popup for Inter-Character Blending. This uses Blending Modes to affect how overlapping characters interact. Try a few, and pick one you like; we thought both Multiply and Add were interesting.

6 Now, tie the text's animation more closely to the music. Select layer 2, **CoolGroove.wav**, and type **L L** to reveal its waveform. RAM Preview this comp, noting how the spikes in the waveform relate to the drum hits, and when the saxophone wail starts and stops. You can add layer markers to remind yourself where these events are.

7 Select **Jazz It Up!** again, and press **U** until you see just its keyframes. Slide them in time to line up with some event in the music. Since these keyframes have had Easy Ease applied to them, they will not seem to "hit" your beats as tightly as they slide out of and back into position again. Feel free to tweak their timing to compensate for this, or to change them to Linear keyframes by **⌘**+clicking (**Ctrl**+clicking) on them. Save your project when you're done. Our final version can be found in **Comps_Finished > 07-Apply Preset_final**.

5 Play with More Options > Inter-Character Blending (top) to create some different looks when characters overlap. Here, we show their normal interaction (A), using Multiply (B), and using Add (C).

7 In our version (below), we keyframed the animation to follow the rise and fall of the saxophone's wail.

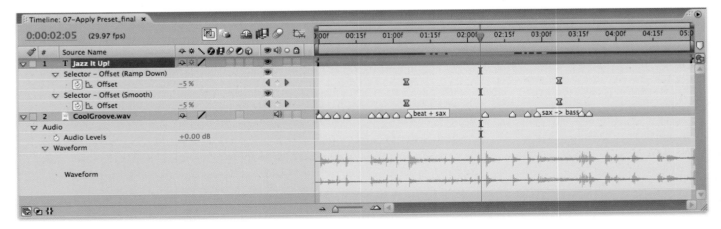

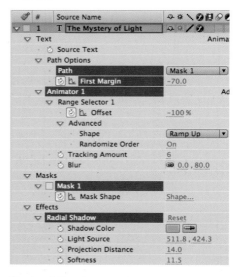

2 Carefully select just the parameters and parameter groups that you want to remember in your Animation Preset. Any keyframes are included automatically for selected items. Note that we did *not* select Source Text.

▽ gotcha

Unaltered Effects

If you apply an effect to a layer, but don't change any of its parameters, After Effects will not reveal this effect when you select a layer and type **U** **U**. Press **Shift** **E** to also reveal Effects in the timeline.

Saving Text Animations

As we've mentioned, you can save your own Animation Presets, including presets you've modified. However, text layers can require a bit of additional thought. If you save everything about a text layer, you will save its Source Text as well – which means that every time you applied it, it would replace any text in the target layer with your old text! So let's get some practice being selective in how we save properties in a preset:

1 Open **Comps > 08-Save Preset**. It contains the Mystery of Light animation you built earlier in this lesson.

2 A great way to remind yourself of what you've done to a layer is select it and type **U** **U** (two **U**s in quick succession) to reveal all of its parameters that have been changed from their defaults. Do this to **The Mystery of Light**. You will see you've made changes to Source Text, parameters inside Path Options and Animator 1, and applied a mask as well as an effect.

• In this case, you don't want to save your Source Text, so don't click on that.

• Click on Path to remember its popup setting, then **⌘**+click (**Ctrl**+click) on First Margin to remember its keyframes.

• **⌘**+click (**Ctrl**+click) on Animator 1; this will by default remember all of the settings indented inside of it, such as Range Selector 1 and the properties you added to the animator.

• **⌘**+click (**Ctrl**+click) Mask 1 (which includes Mask Shape) to remember the path the text is supposed to follow.

• Finally, **⌘**+click (**Ctrl**+click) on Radial Shadow.

3 Select Animation > Save Animation Preset to save your preset. Remember to place it somewhere inside the **Presets** folder, which exists alongside the After Effects application on your computer's drive. You can make your own subfolders inside here if you wish. (Saving animation presets was covered in more detail in Lesson 3.)

▼ Source Text

The Source Text parameter bundles together a bunch of information into one keyframe: your actual text, plus the settings in the Character and Paragraph panels for that text. If you wish, you can keyframe Source Text to change over time, although only Hold keyframes are allowed.

Because you can't save the actual text separately from its style, think carefully whether you want to include Source Text when

saving an Animation Preset. If the essence of the preset is the animation, regardless of the actual text, then don't select Source Text when saving the preset.

On the other hand, if the styling of the text – its size, its color, and the like – are important, then you will need to include it. Just be prepared to replace the underlying text after you apply the preset to your new text layer.

▼ Editing Photoshop Text Layers

Although we have focused on creating and animating text inside After Effects, you may end up working with a Photoshop CS2 file with text already in it. That's okay; you can import the layered Photoshop file as a composition, then convert the Photoshop text to After Effects editable text.

For this final exercise, you'll need the Myriad Pro Condensed and Bold Condensed fonts that are installed free with After Effects 7. (If you don't have these fonts currently installed, open this lesson's **RightWrongPoll.psd** file in Photoshop and replace the fonts to taste.)

1 In the Project panel, select the **PSD Text*starter** folder so that the PSD file will be imported into this folder.

2 Use File > Import and select **RightWrongPoll.psd** from the **05_Sources** folder on your drive. Click Open.

In the options dialog that appears, set the Import Kind popup to Composition, and the Footage Dimensions popup to Layer Size (so that layers are only as big as the content). Click OK, and the folder will now contain a composition and a folder of the individual layers.

2 Import the layered Photoshop file as a composition, using the Layer Size option to automatically trim the layers.

3 Open the **RightWrongPoll** comp that appears inside the **PSD Text*starter** folder. Say that the network graphics department has set up this template with the name of the poll and created dummy text for the date and percentages. It's your job to edit the text and animate the text and bars. Problem is, you can't edit the Photoshop-created text the way it is. Time for a little magic:

3 Select the Photoshop text layer inside After Effects, and under the Layer menu select Convert to Editable Text (top). The result will be an After Effects text layer, noted by the "T" icon next to it (above).

To change the date, select **<month/day>** (layer 2), and choose the menu item Layer > Convert to Editable Text. The layer will now appear with a "T" icon to indicate it's an After Effects text layer. Double-click and type today's date; press *Enter* when done.

To force edited text layers to have the same name as the new text you've typed, select the layer in the Timeline, press *Return*, *Delete*, *Return*.

From here on, think of this as an Idea Corner for you to explore your own design impulses. Convert any other layers you wish to edit or apply an Animation Preset to. For instance, convert the poll's title (layer 3) to editable text, then try out some of the Text Presets you played with earlier in this lesson.

4 The graphic designer created the **dark title bar**, **right bar**, and **wrong bar** in Photoshop using its Shape layers feature. When they were imported into After Effects, they were automatically converted into solid layers with masks.

Select **right bar** and **wrong bar**, and type *M* to reveal their masks. Animate their Mask Shapes to make the bars grow out to their final values. You could also use Effect > Transition > Linear Wipe, as we did in our version **PSD Text_finished > RightWrongPoll_finished**. (Feel free to explore our final comp for some other ideas you can apply or modify for your own comp.)

4 In our final version, we converted some text layers and changed the content to suit our needs, then animated some layers to build on the graphic. Background images courtesy 12 Inch Design/ProductionBlox Units 3 and 8.

Per-Character 3D in CS3

As wonderful as After Effects text is, it does have the limitation (up through version 7) of existing in 2D: Individual characters or words cannot be drawn at different distances from the viewer. You can transform a text layer in 3D space (we cover this in Lesson 8), but it's still a flat layer that you're transforming.

After Effects CS3 introduces Per-character 3D, which addresses this limitation. You can still use all the tricks you've learned up to this point – such as cascading animations, text on a path, the Wiggly Selector, and so on – but now with added dimensionality.

To get the most out of Per-character 3D animation, you need to be working in a composition that also has a 3D camera (and optionally, lights). If you've been following these lessons in order, you haven't encountered 3D cameras and lights yet, as they are introduced in Lesson 8. Therefore, you might want to skim these final exercises for now and return after you've been through Lesson 8. In the meantime, for simplicity's sake, the following exercises take advantage of Custom Views which already have dummy cameras set up for you.

▽ tip

Real 3D

To create dimensional 3D text directly inside After Effects, check out 3D Invigorator Pro and Pro Animator, both from Zaxwerks (www.zaxwerks.com). They allow you to type in your characters, then extrude, bevel, and texture them in a wide variety of ways. Pro Animator also includes a powerful yet quick and easy-to-use animation engine. Plus they can react to After Effects' 3D cameras and lights.

Text Position in Z

To get started, launch After Effects CS3 and open the project file **Lesson_05b_3DText_CS3.aep**. In the Project panel, open **Comps > 01-Position*starter**; a few words have already been typeset for you (feel free to change the words or re-style them if you like).

1 In the Timeline panel, twirl down the text layer, click on the Animate button, and select Position. This will create Animator 1 with a Position property. Position will have two values: X and Y.

2 Here is the magic CS3 feature to enable 3D text: Click either the Animate or Add button and select Property > Enable Per-character 3D from the top of the list. In the Timeline panel, the text's 3D Layer switch will sport two small cubes to show that Per-character 3D is enabled. Study the Comp viewer: The text layer now has a set of red, green, and blue 3D axis arrows that indicate how the layer is oriented in X, Y, and Z respectively. Their origin is where the layer's Anchor Point is located.

2 When you Add > Enable Per-character 3D for a text layer (top), you will see two small boxes appear in its 3D Layer switch (above). The text's XYZ axis arrows will help show how it is oriented in the Comp view (right).

You will also notice that Position has three values: X, Y, and Z. Scrub the Z Position value (the third one) while watching the Comp viewer. Negative values bring the text forward in space (or closer to the front of an imaginary "stage"), while positive values send it farther back in space.

3 To better visualize what you are about to do, change the 3D View popup at the bottom of the Comp panel from Active Camera to Custom View 1. You should now see the text from above and at an angle. (If not, use the menu option View > Reset 3D View.)

Selecting Custom View 1 will give you a perspective view of your comp.

4 You can animate these characters in a fashion similar to the methods you learned earlier. For example:

• Set Position to 0, –75, –350 to position the characters inside the Range Selector higher and forward in Z space compared with where the axis arrows are.

• Twirl down Range Selector 1. At 00:00, enable the stopwatch for Start with a value of 0%.

• Move to 02:00 and change the Start value to 100%. RAM Preview and the characters will animate back to their original position.

• Return the 3D View popup to Active Camera and press **Home** to return to 00:00. Notice how characters that are closer to the camera appear to be larger, even though you haven't changed their scale value. And no matter how close they get to the camera, they will always remain sharp because they are being continuously rasterized (explained near the end of Lesson 6).

4 As the Range Selector's Start animates from 0% to 100%, the characters will move from their offset position in 3D space back to their original plane.

• Click the Add button and select Property > Opacity. Set Opacity to 0% so that the characters will be invisible when they are outside the selector's range.

Our version of this exercise is shown in **Comps_finished > 01-Position_final**.

Note that not all text properties are affected by Per-character 3D. For instance, Opacity, Skew, Fill Color, and Tracking appear the same whether or not it's enabled. However, Anchor Point, Position, Scale, and Rotation all will gain a third parameter: Z. In the case of Rotation, its X, Y, and Z values appear as separately keyframeable parameters for even more control – which we'll play with next.

3D Text Rotation

Still in the same CS3 project, open **Comps > 02-Rotation*starter** and RAM Preview it. To save time, we've already created a basic cascading type-on effect using the same technique you learned earlier in this lesson. Select layer 1 and press **U U** to see the relevant properties; namely, Opacity is set to 0%, the Shape is Ramp Up, and Range Selector 1's Offset is animated.

As a starting point, **02-Rotation*starter** has a basic cascading animation already set up.

1 In the Timeline panel, click the Add button for Animator 1 and select Property > Enable Per-character 3D. Set the 3D View popup in the Comp panel to Custom View 1. You should now see the text from above and at an angle.

2 Click on the Add button for Animator 1 and select Property > Rotation. Parameters for X, Y, and Z Rotation should appear (if not, check that you correctly enabled Per-character 3D in step 1). Let's explore what happens when you rotate on each axis individually:

• Set X Rotation to 1 revolution and RAM Preview. The characters swing around their baseline as they fade up.

• Undo your X Rotation and set Y Rotation to 1 revolution. Now each character swivels around to face the viewer as it fades up. Try other values, such as 60 or –100 degrees for a more subtle effect. Return Y Rotation to 0 when done.

• Set Z Rotation to 1 revolution: This parameter is equivalent to the rotation property when text is animating in 2D.

Explore combinations of X, Y, and Z Rotation. It doesn't take much before your characters are performing complex gymnastics – all with just two Range Selector keyframes!

2 After enabling Per-character 3D, adding Rotation will yield three separate parameters (above). Below: X Rotation swings characters around their baseline; Y Rotation twirls characters around their vertical axis; and Z Rotation behaves the same as rotation in 2D.

Setting the Anchor Point in 3D

By default, characters rotate around their baseline. A lot of fun can be had rotating them around a different point. To do this, manipulate their Anchor Point:

3 Continue with the comp **02-Rotation*starter**. Set X Rotation to 1 revolution, and zero out Y and Z Rotation. Move to a time in the middle of the animation.

4 Click on the Add button and select Property > Anchor Point. You will see three values, again corresponding to X, Y, and Z. These offset the pivot point for the characters. Scrub the third value (Z) and note how the characters move away from their baseline. RAM Preview to observe how they spiral into place.

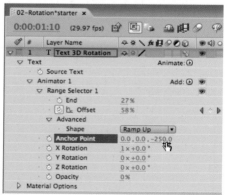

4 Add > Property > Anchor Point and edit the Z value to offset the pivot point.

5 For more fun, try offsetting the X or Y Anchor Point and preview the result.

Note that you don't have to view the text animation from a perspective view: Change the 3D View popup back to Active Camera, and you will still get a sense of dimension.

Per-character 3D can give you interesting results even while working in 2D comps! Our version is shown in **Comps_finished > 02-Rotation_final**.

4 *continued* Offsetting the Z Anchor Point causes the characters to spiral into place.

3D Text in a 3D World

After you work through Lesson 8, you will have a much better understanding of 3D space in After Effects. To whet your appetite for what you'll be able to create with Per-character 3D text layers, open **Comps_finished > 03-3D World** and RAM Preview:

• The floor and wall are a preview of elements you will build in Lesson 12.

• We added a text layer and applied an Animation Preset that ships with After Effects CS3: 3D Flutter In Random Order.

• A camera plus a shadow-casting light were added to the scene, and the text had its Cast Shadows parameter turned On. (All of these are explained in more detail in Lesson 8.)

The real power comes when you set your 3D text into a 3D world and enable it to cast shadows on other objects in that world.

▼ **3D Text Animation Presets**

After Effects CS3 ships with thirty sample text animations that take advantage of Per-character 3D. They can be found in the Effects & Presets panel under **Animation Presets > Text > 3D Text**. You can apply these to any Text layer just as you did earlier in this lesson (see page 126) and use them as is, or as a starting point for your own animation.

For your convenience, we've created sample compositions for each of these presets: They are in the project **05b_Text in 3D_CS3.aep**, inside the **_Adobe Animation Presets** folder. Open each one and RAM Preview, then select the layer and press **U U** to delve into understanding how they were done. Edit them to taste and save your variations as your own animation presets!

Parenting and Nesting

Grouping layers to make them easier to coordinate.

▽ Getting Started

Copied the **Lesson 06-Parent and Nest** folder from this book's disc onto your hard drive, and make note of where it is; it contains the project files and sources you need for this lesson.

Rather than use a single project file, for this lesson we have provided several different project files to make it easier to keep track of all the compositions you will be creating and using.

N o layer or composition is an island – at least, not in complex animations. In this lesson, you will learn how to group layers and build composition hierarchies, making it easier to create and manage complex animations. First up will be parenting, where one layer's animation can influence that of others. After that we'll work with nesting and precomposing compositions: ways to bundle together layers, keyframes, and effects into one comp and treat the result as a single layer in another comp.

Approaches to Grouping

There are three general approaches to grouping inside After Effects: *parenting* layers together, *nesting* and *precomposing* compositions, and applying *expressions* to individual parameters. Here is an overview of their relative strengths, weaknesses, and uses:

Parenting: With this technique, you "parent" (attach) as many *child* layers as you want to a *parent* layer. The children remember their relationships to the parent at the time you attach them. Any changes in the parent's position, scale, or rotation results in the children being dragged along for the ride. The children may have their own animation as well, but these are not passed back to the parent. To better visualize this, image a person walking several dogs. The dogs may be running around their minder, but as their minder walks down the street, all of the dogs move down the street as well.

The advantage of parenting is that all of the layers involved are in the same composition, which makes them easy to keep track of. A disadvantage is that changes in

opacity are not passed along from parent to child, so you can't use parenting to fade out a group of layers together. Effects are also not passed from parent to child.

Nesting: The process of adding a composition to another composition is referred to as *nesting* comps. The nested comp (often referred to as a *precomp*) appears as just another layer in the second comp. You can animate, fade, and apply effects to the nested comp layer as if it were a normal movie file. The primary difference is that it is "live": You can still go back to the first (nested) comp and change it, and those changes will appear immediately in the second (master, or main) comp without the need to first render the precomp.

Another use for nesting is that a single source comp can be nested into more than one master composition. The same source comp may also be nested several times into the same master comp. By doing this, you can easily change the original nested comp, and the change will ripple through to any comp it is nested into. This is ideal for creating repetitive elements such as animated logos that may be used multiple times throughout a project; some animators may refer to this process as creating an "instance."

Precomposing: When building a chain of nested compositions, ideally you're thinking ahead: You use several layers to build an element in one comp, then use the result nested into a second comp. However, the creative process is rarely that orderly and logical. You might build a complex composition, only to later think, "You know, life would be easier if I could just group these layers into their own nested comp..."

Well, you can: The process is known as *precomposing*. You can select one or more layers in the current comp and "send them back" into their own comp (called a "precomp") that automatically becomes a nested layer in the current comp. It's almost as if you planned it that way ahead of time. Once you do this, as far as After Effects is concerned, there is no difference between the resulting precomp and a normal nested comp.

Expressions: After Effects also allows you to connect virtually any parameter to another parameter. This involves creating small pieces of JavaScript code referred to as *expressions*. We cover expressions in the next lesson, but in short, basic expressions could be considered a highly targeted form of parenting, where only individual parameters are connected rather than all transform properties at once. The big advantage is that you can connect any parameter you can keyframe – not just position, scale, and rotation.

In this lesson, you will learn several ways to group together layers to make complex animations easier and to re-use elements multiple times in the same composition.

▽ tip

Effects and Children

Effects applied to a parent are not passed along to its children. To apply the same effect to a group created by parenting, use an Adjustment Layer (Lesson 3), or nest their comp into a new comp and apply the effect to the resulting layer.

▽ factoid

Family Trees

You can create parenting chains where one layer is parented to a second, the second layer is parented to a third, and so on. This makes parenting an essential tool in character animation: For example, you can attach a hand to a forearm, a forearm to an upper arm, and the upper arm to a body.

Use Parenting to make the text and planet scale up as a group, with the text rotating around the planet.

▼ Choosing a Responsible Parent

When grouping together layers using parenting, it is important to think about who should be the parent and who should be the child.

A parent's animation gets passed along to its children. Therefore, the layer that is going to be doing the least animating often makes the best parent – that way, the children are free to run around the parent without their animation being passed onto the parent.

Parenting

In this first parenting exercise, you will be grouping together two layers to make it easier to animate them as a unit. In it, the "child" will keep its animation, which will also be affected by its parent.

1 For these first two exercises, open project **Lesson 06 > 06a-Parenting.aep**. In the Project panel, twirl open the **Comps** folder, then double-click the comp **Parenting1*starter** to open it.

Press **0** on the numeric keypad to RAM Preview this comp. It consists of a movie of a globe rotating, and a Photoshop still image of text on a circular path.

For this animation, let's make the text and planet scale up as a group, with the text rotating around the planet. We'll then try to fade them out as a unit.

2 Select both layers, then press **S** to reveal their Scale followed by **Shift R** to reveal Rotation and **Shift T** to reveal Opacity. If you scrub these values for each layer, they will act independently of the other layer. Undo to get back to their original state.

3 To set up a parenting group, you need to reveal the Parent column in the Timeline panel. If it is not already visible, you can either right-click on any column header in the Timeline panel and select Column > Parent, or use the keyboard shortcut **Shift F4**. We tend to drag the Parent column to reside alongside the layer names, making it easier to read who is connected to whom.

The next step is deciding who the child should be, and "parenting" it to the layer you want it to follow. In our case, we know we want to rotate the text independent of the planet. Therefore, it would be best if the text was the child, so that its rotation will not get passed onto the planet.

4 There are two ways to assign a parent:

• Click on the Parent popup for the prospective child **Text on a circle.psd** and pick its new parent – **planet.mov** – from the list that appears.

• Alternatively, click on the spiral icon (the pick whip tool) in the Parent column for the child and drag it to the name of the layer you wish to be the parent.

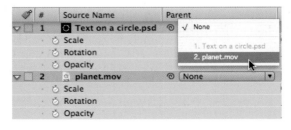

4 There are two ways to attach a child to a parent: Use its Parent pop-up (left), or its pick whip tool to point to its parent (right).

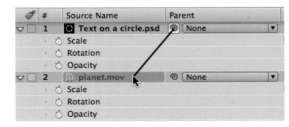

5 Scrub the Scale for **Text on a circle.psd**; only that layer scales. Return it to 100%, then scrub Scale for **planet.mov** – when you scale the parent, both layers scale as a group. Note that the Scale value for **Text on a circle.psd** does not change; its scale value is now shown relative to its parent.

5 As the parent (the planet) scales up, the child (the text) scales up as well, by the same proportional amount.

• Press [Home] to make sure you are at 00:00, then click on the stopwatch for **planet.mov**'s Scale to enable keyframing. Enter a value of 0%; both layers will disappear.

• Move the current time marker to 02:00 and set Scale back to 100%, returning both parent and child to full size. Press [F9] to make this an Easy Ease keyframe.

6 Now let's rotate the child layer:

• Scrub Rotation for **Text on a circle.psd**; it rotates, but its parent does not.

• Press [Home] again, and enable keyframing for **Text on a circle.psd**'s Rotation. Return its value to 0°.

• Press [End], and enter 1 for Revolutions (Rotation's first value). The second keyframe should read 1x+0.0°.

RAM Preview: The text rotates as both scale up together, then continues to rotate without affecting the parent.

6 Nothing applied to the child – for example, rotation or tint effects – are passed along to the parent.

7 Parenting passes scale, position, and rotation from parent to child, but nothing else:

• Move to 10:00, select **planet.mov**, and press [⌥] [Shift] [T] on Mac ([Alt] [Shift] [T] on Windows) to reveal Opacity and enable keyframing.

• Press [End], and set **planet.mov**'s Opacity to 0%: The text will still be visible. You will have to fade out the Text layer separately.

In addition to opacity, effects are also not passed from parent to child. Go ahead and try adding an effect such as blur to **planet.mov**; the text will not be affected. This can be a blessing or a curse, depending on what you are trying to accomplish.

7 Unfortunately, opacity is not passed from the parent to the child so you can't fade out both layers as a group.

1 Play the finished movie. You will use parenting to animate the title layers and the Planet 9 logo together as a group. (You will build the background animation in the next exercise.)

3 The number 9 and the planet form a logo (left), so use parenting to parent the **Nine** layer to the **planet.mov** layer and make a sub-group (right).

4 Null objects appear in the Comp viewer as an outline of a square, with the Anchor Point in its upper left-hand corner. Turn off the background layer to see your new null more clearly.

Parenting with Nulls

Sometimes it is not clear which layer would make the best parent. The solution is to hire a babysitter: a *null object*. Nulls are layers that do not render, but otherwise have normal transform properties such as position, scale, and rotation.

1 Bring the Project panel forward, open the **Finished Movies** folder, and play **Parenting2.mov** to see what you will be building. Close the movie when done.

2 Double-click **Comps > Parenting2*starter** to open it. Then press **Shift F4** to reveal its Parent panel.

Parenting Chain

3 When you start parenting, first build any sub-groups that make sense to handle as one element. In this case, the number 9 and the planet form a logo.

Click on the Parent popup for **Nine**, and select **planet.mov** to be its parent. Now when you move the planet, the number will stay with it.

4 Let's employ a null object to move the rest of the title layers as a group. Still at time 00:00, select Layer > New > Null Object; it will be added to the timeline.

To rename the null, select it, type **⌘ Shift Y** (**Ctrl Shift Y**) to open the Solid Settings dialog, and type a name such as "**Title Parent Null**", and click OK. In the Comp viewer, the null will appear as a square outline. The null may be hard to see, so temporarily turn off the Video switch for **Muybridge_textless.mov**. Note that a null's Anchor Point defaults to its upper left corner.

5 Since scaling and rotation happen around the parent's anchor point, it is important to first move the parent into the desired position *before* attaching the children to it. The center of the planet would make a good center for scaling this group, so let's borrow its Position value:

• Select **planet.mov**, type **P** to reveal its Position, click on the word Position to select it, and use Edit > Copy.

• Then select **Title Parent Null** and Edit > Paste. The top left corner of the null will now appear centered over the planet.

5–6 Copy the planet's position value to the null's position (left). Then select and parent the remaining children to the null (right).

6 Time to parent the other layers. Click **planet.mov** to select it. Then **Shift**+click on **Season Finale** to select layers 3 through 5. (Don't select layer 2, as it is already parented to layer 3.) Then drag the pick whip tool for any of the selected layers to **Title Parent Null**, and they all will become attached to it.

Animating the Null

Now that we have everything set up, we can animate the group. The plan is to have them move forward to make the "9" logo and "Tomorrow" the heroes.

7 Select **Title Parent Null**. Its Position should be visible; type **Shift S** to also reveal Scale. Move to 02:00, then click on the stopwatches for Position and Scale to enable keyframing for these parameters, as well as set their first keyframes.

8 Press **'** (apostrophe) to turn on the Action and Title Safe grids. Make sure you position the text in a legal area of the screen.

9 Move the time marker to 02:15. Increase the scale of **Title Parent Null** to 150%; the entire group grows larger and a second Scale keyframe is created.

Then click inside the null's outline and drag it to the left until the planet is positioned just inside the Title Safe lines. The group will move together, and a second Position keyframe will be created. (If only one layer moves, you accidentally grabbed a layer other than the parent null; undo and try again.)

10 To clean up the title, fade out the words to the left: Keyframe the opacity for **Season Finale** from 100% at 02:00 to 0% at 02:15.

Now that the major structural work is done, you can work with the children without worrying about affecting the parent and the overall move. Animate the **planet**, **Tomorrow**, and **Season Finale** child layers to your personal taste. Turn the Video switch for **Muybridge_textless.mov** back on to see the title in context.

Our version is in **Comps_Finished > Parenting2_final**. We scaled up the planet subgroup, slid in **Season Finale**, and applied a Text Animation Preset to **Tomorrow**, all with staggered timing so that each would get their turn at being the center of attention.

▼ Parenting and Scaling

Scaling a layer past 100% normally reduces its quality. However, the Scale values for a parent and its children are combined before After Effects calculates how to draw the pixels for each layer. Therefore, if a child has already been scaled down, you can get away with scaling up its null object parent without any loss of image quality for the child, as long as the combined scale values amount to 100% or less.

7–9 Keyframe the null object to grow from 100% to 150% (left), and place the planet logo at the edge of the Title Safe area (below) at the second keyframe.

In **Parenting2_final**, we animated each of the children independently, and added a text animation preset to the Tomorrow title. Muybridge images courtesy Dover; background courtesy Artbeats/Digital Web.

The final composite includes multiple copies of the Muybridge "walking man" animation in a nested composition.

2 Create a large composition to hold several copies of the Muybridge sequence.

4 Turn on the Comp panel's rulers and drag a guide down to the top of the viewing area. Placing a guide at Y = 0 will allow you to easily snap layers to the top of the comp.

Nesting a Group of Layers

One of the more powerful features in After Effects is the ability to treat a composition as a layer in another comp. This process is referred to as nesting, and is a great way to group layers together.

Creating the Wide Comp

1 Open the project **Lesson 06 > 06-Nesting1.aep**. Look inside the Project panel's **Finished Movie** folder and play **Human Figure in Motion.mov**: This is what you are going to make. You'll start by building a wide comp that holds multiple copies of the Muybridge human figure sequence. This wide comp will be nested into a second comp that includes all the other layers.

2 In the **Sources** folder, single-click the sequence **Muybridge_ [00-09].tif** to select it. The top of the Project panel informs you that its size is 270×500, with a rate of 10 frames per second (fps). The sequence consists of only 10 unique images, so it was looped 10 times in its Interpret Footage dialog. Your first task will be creating a large composition to hold copies of this sequence.

Select the **Comps** folder so that your new comp will automatically sort into it, and type ⌘ N (Ctrl N) to create a new composition. Enter the following parameters in the Composition Settings dialog:

• Disable Lock Aspect Ratio. Set Width to 2300 pixels (more than eight times the width of the sequence), and Height to 500 pixels (the sequence's height).

• Set the Pixel Aspect Ratio popup to Square Pixels.

• Set the Frame Rate to 10, Start Timecode to 0, and the duration to 10:00.

• Enter a name of "**Figures_group**", and press OK.

Resize your user interface frames to give the Comp panel as much room as you can, and set its Magnification popup to Fit Up To 100%.

3 Drag **Muybridge_[00-09].tif** from the Project panel to the left edge of the Comp viewer – it should snap into place.

4 To help align additional copies of this sequence, let's take advantage of *guides* in the Comp panel:

• Press ⌘ R (Ctrl R) to Show Rulers.

• Click in the top ruler, and drag downward: A blue guide line will appear. Place it even with the top of the comp's viewing area. If you have the Info panel open, drag until it says the guide is at 0.0.

• Verify that View > Snap to Guides is enabled.

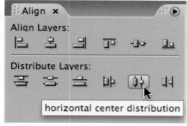

horizontal center distribution

5–6 Create eight copies of the Muybridge layer, with the left and right ones justified to the edges of the comp and the others roughly spaced in-between (top left). Click on the Horizontal Center Distribution button in Align & Distribute (above), and they will be evenly spaced (left).

5 Select **Muybridge_[00-09].tif**, and type ⌘ D (Ctrl D) to duplicate it. Drag it a short distance to the right; your guide will help keep it aligned. (You can also press Shift after you start moving a layer to constrain it to the X or Y axis.)

Make five more duplicates, and drag each just beyond the previous copy; there should be seven layers now. Then create one last duplicate, and while dragging it to the right, add ⌘ Shift (Ctrl Shift) so it will snap to the right side of the comp.

6 Type ⌘ A (Ctrl A) to select all the layers. Open Window > Align & Distribute, and click on the Horizontal Center Distribution button (bottom row, second from the right). Close this panel when you're done, and save your project.

Nesting the Wide Comp

Next, let's create a main comp to nest this group of Muybridge sequences into:

7 In the Project panel, select the **Comps** folder and click the New Comp button. Set the Preset popup to NTSC DV. Change the duration to 06:00, name this comp "**Figures Main**", and click OK. (Feel free to hide the Parent panel.)

8 To nest one comp into another, you can just drag it onto the target comp in the Project panel. It will then appear as a layer with a comp icon in the target comp.

8 To nest a comp, you have two choices: You can drag your first comp into your new comp, just as you would to add any footage item to a comp. Alternatively, in the Project panel you can drag the comp **Figures_group** on top of the icon for the comp **Figures Main** and release the mouse to nest it. After either move, **Figures_group** will appear as a single layer in **Figures Main**.

9 The next step is animating the nested comp to slide from left to right:

• Select the **Figures_group** layer; press S to reveal Scale and Shift P to reveal Position. Set the initial Scale value to 50%.

9 The **Figures_group** comp appears as a single layer when nested so one set of Position keyframes can be used to move the eight layers as a group.

9 *continued* Animate the nested comp to pan from left to right across its new comp. (We changed its label color to gold to make it easier to see its motion path in this figure.)

▽ tip

Opening Precomps

To open a nested comp if its tab is not visible, press ⌥ (*Alt*) and double-click the precomp's layer in the main comp.

11–12 In the precomp, offset the In time of each layer (below) so that they will appear staggered in time (bottom). This edit will automatically show up in the main comp (below right).

• The rulers from step 4 should still be active. Drag down a guide from the top and place it around Position Y = 50. Then press ⌘ R (*Ctrl* R) to hide the rulers.

• Drag the layer so that its right side is aligned with the right side of the comp and its top snaps to the guide.

• Enable the stopwatch for Position to create the first keyframe.

• Press *End* to go to the end of the comp (at 05:29) and drag the layer to the right until its left side is aligned with the left side of the comp. You can use the guide or add the *Shift* key while dragging to keep it at the same height.

RAM Preview. The figures should be marching to the right (if not, check you didn't pan the layer in the other direction!).

Editing the Precomp

It is common to call a nested comp a precomp, as it renders first, with its result included in the master or main comp. Although the main comp appears to get a "flattened" layer to work with, the precomp is still live: Any changes you make to the precomp will ripple through into the main comp.

10 ⌥+double-click (*Alt*+double-click) on **Figures_group** to open this nested comp, or select the **Figures_group** tab in the Timeline panel.

11 Let's stagger the timing of the Muybridge sequences so that the layers are not all in sync:

• In the Timeline panel, right-click on any column header, and select Columns > In.

• For layer 7, click on the In value, enter –1 in the Layer In Time dialog, and click OK. The In time will change to -0:00:00:01.

- Set the In time for layer 6 to –2. Continue to set each layer one frame earlier in time, ending at –7 for layer 1.

Each copy of the sequence will now look different. After sliding the layers earlier, they run out before the end of the comp. In this instance, that's okay because the main comp is much shorter than this precomp.

12 Click on the Timeline panel tab for **Figures Main** to bring it forward, and RAM Preview. Your staggered timing for the sequence has been automatically rippled up to this main comp.

Finishing the Project

Congratulations – you've completed the major steps (save your project…). Here are some ideas for dressing up the final composite; please take artistic liberties and use your own sources to create your own design!

13 Locate **Sources > Digital Web.mov** in the Project panel, and add it as a background layer to **Figures Main**.

14 To better match the background, let's warm up the gray **Figures_group** layer plus give it some dimension:

- Select **Figures_group** and apply Effect > Color Correction > Channel Mixer. Set to taste; we increased Red-Red to 150 and reduced Blue-Blue to 80.

- Add Effect > Perspective > Drop Shadow and set to taste. Effects applied to nested comp layers affect all of the elements in that comp, with the benefit of having only one set of effects to edit.

15 Now let's add a lighting treatment: Select **Sources > Alien Atmospheres.mov**, and this time add it on top of the other layers in **Figures Main**. Press **F4** to toggle to the Modes panel, and set its mode to Vivid Light. This creates a richer look, with a tinge of the new layer's blue color. If you don't like the blue, apply Color Correction > Tint: Its default settings will convert the layer to grayscale. Feel free to try out different modes on both **Alien Atmospheres.mov** and **Figures_group** until you get a blend you like.

13–15 Add a background to your main comp (A), then tint and add a shadow to the nested precomp (B). Add **Alien Atmospheres** on top using Vivid Light blending mode (C); optionally, convert it to grayscale to remove the blue tint (D).

16 If you completed Lesson 5, here's a chance to put your newfound skills to work! Add a title to this composition, such as "**Human Figure in Motion**". Choose whatever font you think works best (we used a condensed font so that it would fit on one line but still be fairly tall), and add Effect > Perspective > Drop Shadow to lift it off the background. Then apply a Text Animation Preset, or create your own design using Text Animators.

Save your project when you're done. If you're curious, our version is **Comps_Finished > Human Main_final**.

16 For a final touch, add a text animation to your composition.

Nested comps are helpful when you have repeated elements, such as the "plate" behind the name of each new city. Map courtesy National Atlas of the United States (www.nationalatlas.gov).

2 The backing badge in the **MyPlate** comp will be re-used in each of the **City** comps.

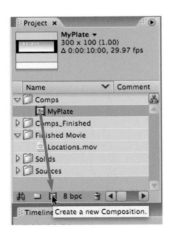

3 Nest **MyPlate** into a new composition with exactly the same vital statistics by dragging it to the New Comp icon (above). Lock this nested layer (right) so you don't accidentally move it.

Nesting a Common Source

In this exercise, you will build a more complex hierarchy of compositions. As part of it, you will see how a single change can update several elements in a project at once – a real time-saver!

The Common Element

1 The idea in this exercise is that your client has three new locations opening in the United States, and they want to highlight this in a five-second animation.

Open the project file **Lesson 06 > 06c-Nesting2.aep**. Twirl open the **Finished Movie** folder in its Project panel and play **Locations.mov**. Notice that the colored backplate and the words "New Location" are common to all three cities. When you have a repetitive element like this, plan your composition hierarchies so that this element can be isolated in a separate precomp, then nest it multiple times. Close the movie when done.

2 In the **Comps** folder, double-click the composition named **MyPlate** to open it. It's only 300×100 pixels, and is twice as long as the client requested. In general, it's a good idea to create precomps that are longer than necessary, as it's a hassle to have to go back through multiple precomps and make each one longer at a later date.

The **MyPlate** comp consists of two layers: the text layer **New Location** and a solid layer, **black solid**. The solid layer has three effects applied: Ramp (adds the color gradient), Stroke (adds the white outline to a mask shape), and a Drop Shadow. Because you will be nesting the **MyPlate** comp into three **City** comps, you will be able to edit the effects settings in this one precomp, and the changes will ripple through to all the **City** comps.

Creating the First City Comp

Now let's create the first of the three **City** comps and add the individual city names on top of this common plate:

3 In the Project panel, drag **MyPlate** to the New Comp icon at the bottom of the Project panel. A new comp will open, with **MyPlate** nested into it perfectly centered. Note that this new comp takes its settings from **MyPlate**, so it is the same size, duration, and frame rate.

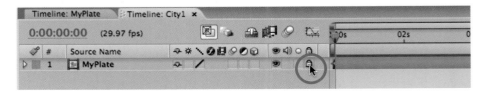

Type ⌘ K (Ctrl K) to open the Composition Settings, rename this comp "**City1**" and click OK. Then in the Timeline panel, click on the Lock switch for the nested **MyPlate** layer so you don't accidentally move it while creating your text.

4 Click on the Workspace popup in the upper right corner of the application window and select Text to open the relevant tools. If you don't see the Character and Paragraph panels after doing this, select Workspace > Reset "Text" and click OK.

Set the Paragraph panel to the Center Text option, then select the Text tool. Click in the Comp panel and type the name of the city you'd like to use (it doesn't have to be the same as ours). Press *Enter* when done, then spend a few moments selecting a font, size, and color; the other cities will be based on the same style.

What Size Should Precomps Be?

Precomps do not need to be the same size as the compositions they are nested into. But what size *should* they be? The answer is more intuition and compromise than certainty.

Rule number one is that you do not want to have to zoom a nested precomp to be larger than 100%, or you will lose image quality. Having some extra size will also give you freedom later to decide how much you want to zoom in or pan around a nested comp (as is the case with the **USA Map** comp in the **Locations** exercise).

Rule number two is that you don't want to make a precomp much larger than it has to be. Larger precomps take more RAM and time to render. If it's just going to be a small button (such as the **Plate** comp in this exercise), there's no need for it to be as large as the final comp.

In general, when you have a complex chain of comps, it is a good idea to first create a test of the comp hierarchy before you spend time finessing the animation in each potentially wrong-sized precomp.

Duplicating Comps

5 Once you're happy with how your text in the **City1** comp looks, select **City1** in the Project panel and press ⌘ D (Ctrl D) to duplicate it. After Effects will automatically increment the number at the end of its name, labeling it **City2**. Duplicate again to create **City3**.

6 Open the **City2** comp. Double-click the text layer to select the text and type the name for your second city. Press *Enter* when done.

7 Open the **City3** comp and edit the text layer to your third city. When you're done, press **V** to return to the Selection tool, and save your project.

Creating the USA Map Comp

Now it's time to place your **City** comps around a map:

8 In the Project panel, locate **Sources > USA map.tif** and drag it to the New Comp icon. A comp called **USA Map** is created that is the same size as the still image map (1480×960). It will be created inside the **Sources** folder; drag it up to the **Comps** folder.

With **USA Map** selected, open the Composition Settings: Verify that its duration is 10 seconds and that the frame rate is 29.97 fps. Click OK when done.

5 Duplicate the **City1** comp twice in the Project panel.

6–7 Enter your desired city names for the **City2** and **City3** comps. The text will be styled the same as in the original **City1** composition.

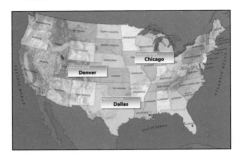

9 Create a new comp for the map graphic and nest the three **City** comps into it, positioning them over their respective states.

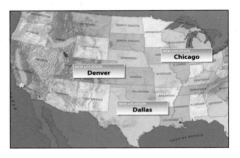

12 Pan and zoom **USA Map** inside **Locations Main** to start with a zoomed-out overview (above), and end up zoomed in on your three cities (below).

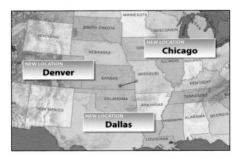

9 Drag in **City1** from the Project panel into the **USA map** Comp panel, and position it over the state where it belongs. Do the same with **City2** and **City3**. Don't worry about animating them right now; let's finish building the comp hierarchy first.

Creating the Main Comp

Now that the cities are placed in position on the map, you can treat the **USA Map** comp as a group. So let's nest it into the final composition and animate it as a group:

10 Select the **Comps** folder, and type ⌘ N (*Ctrl* N) to make a new comp. In the Composition Settings dialog that opens, select NTSC DV from the Preset popup. Enter a duration of 05:00 (shorter than your precomps), change the default name to "**Locations Main**", and click OK.

11 Nest the **USA Map** comp into **Locations Main** by dragging it from the Project panel to the left side of **Locations Main**'s Timeline panel. This will center the map in the composition. Set the Magnification popup in the Comp panel to Fit up to 100%.

12 Now animate the big map inside this smaller comp:

• With **USA Map** layer selected, press **P** to reveal Position, then *Shift* **S** to add Scale.

• Move to 00:10, and enable the keyframing stopwatches for Position and Scale.

• Change Scale to 50% or a little larger, and position the map to what looks like a good starting point.

• Move to 04:20, increase Scale to around 70%, and reposition the map as needed to frame all three of your cities. If your cities are fairly tightly grouped, this simple "push in" animation will suffice. If your cities are more spread out, you might want to do a "pull out" instead (animate from zoomed in on one title to pulling back to include the entire map). In the real world, an animation like this may be driven by a voiceover (narration), in which case you might end up needing to do a more complex "motion control" move (as covered in Lesson 3).

13 This is about the time during a real project that the client calls and says "We changed our mind – it can't say New Locations; it has to say New Cities!" Fortunately, those words are in a single precomp that feeds all of the **City** comps:

• Bring the **MyPlate** comp forward. Double-click the layer **NEW LOCATION**, type "**NEW CITIES**", and press *Enter*.

• Bring the comp **Locations Main** forward again – all of the **City** precomps have been updated to say NEW CITIES.

And that, dear friends, is the power of nested comps and building intelligent hierarchies!

Final Polish

Preview your animation. Once you have the basic move down, bring the **USA Map** comp forward and experiment with animating the three **City** layers so they appear at different times.

In **Comps Finished > Locations_final** we scaled each **City** layer up from 0% to 100% over 20 frames, and staggered them to start at 01:00, 02:00, and 03:00 as we moved from west to east across the country. Of course, you could also have them spin in and slam down with a huge lens flare! (Just kidding...)

13 Through the power of nesting, any changes to **MyPlate** are automatically rippled through to the final comp (above).

In our final version, we zoomed up each city, and staggered when they came on.

▼ Edit This, Look at That

Let's say you need to change the color in the Ramp effect in the **MyPlate** comp and wanted to see what this color looks like against the map layer in **Locations Main**. How can you see both at once?

Open **MyPlate**, select the black solid layer, and press **F3** to open its Effect Controls panel. Lock this panel by clicking the padlock icon at the top left. Then bring the **Locations Main** comp forward. The Effect Controls panel for the solid in **MyPlate** should still be visible. Now you can edit the Ramp color while viewing it against the map colors in a later comp.

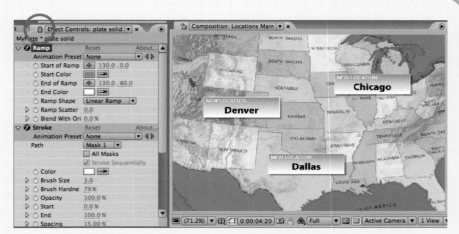

If you lock an Effect Controls panel for a layer in a precomp, it will stay forward even if you display a different comp in the Comp panel.

After you've created a basic design (top), you decide it would be better if the text and logo – but not the background – had a crazy warp effect at the start (above). Background courtesy Artbeats/Alien Atmospheres.

Precomposing a Group

So far, we've demonstrated using nested comps when you can plan ahead and decide what your composition hierarchy should be. As if life always worked out so neatly… More often, you'll be in the middle of a design and discover that you would be better off if some layers already in the main composition were actually in a nested comp of their own. That's where precomposing comes in.

1 Save your current project, and open the project file **Lesson 06 > 06d-Precompose-Move.aep**. In the **Comps** folder is **wiredfruit*starter**; open it by double-clicking.

This comp contains four layers: three that make up the title and logo, plus a background. After building it, you have the sudden brainwave that it would be cool to warp the title and logo as a unit. However, if you applied a warp effect with an adjustment layer, or nested this comp into a master comp and apply a warp effect there, everything – including the background – would get warped.

The solution is simple: Go back in time. Or more practically, select the three layers to be warped and send them back into their own nested comp. Then you can warp the resulting single layer in the current comp. And it's easier than it sounds:

2 Select the layers you want to be in their own nested comp (above left). Use Layer > Pre-compose (below), and they will be replaced with a single layer which is a comp that contains those three layers (above right).

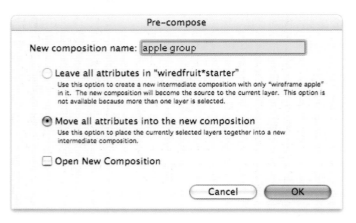

2 In the Timeline panel, click on layer 1, then *Shift*+click on layer 3. The first three layers will be selected. Then choose the menu item Layer > Pre-compose.

The Pre-compose dialog will open. When you select multiple layers, the only option available is "Move all attributes into the new composition." This means a new composition will be created (with the same size and duration as the current comp), and the selected layers – including their current transformation, effects, and any animation – will be moved intact into that new comp.

Disable the Open New Composition checkbox, enter a name that makes sense such as "**apple group**", and click OK. Nothing will appear to change in the Comp panel, but in the Timeline panel, those three layers will now be replaced by a single layer that points to the new nested comp – or precomp, as we like to call it.

3 You can treat this new precomp layer just as you would any other layer: transform it, animate, or apply effects to it.

Select the single nested layer **apple group**, and apply Effect > Distort > Warp. The Effect Controls panel will open. Set the Warp Style popup to Squeeze, and Bend to –100 to get a squished distortion. To animate the effect, click on the stopwatch for Bend to enable keyframing, move a second or two later in the comp, then set Bend to 0 to "come out of" the effect.

And that's the basic technique for precomposing. Bring the Project panel forward and note that your **apple group** precomp appears in the Comps folder. Precomps are still live, like any other nested comp. You can double-click it at any time to open it and any changes you make will ripple up to the top comp where it's nested.

Twirl down the **Comps_finished** folder and take a moment to explore some enhancements we put into our version:

• We added a Fill effect to the **wireframe apple** layer in **apple group_finished** to make it more colorful.

• We also removed the Drop Shadow from the three individual layers in the precomp **apple group_finished** and applied it instead to the nested layer in the main comp **wiredfruit_finished**. Now we have only one effect to tweak (and render), rather than three.

• In the comp **wiredfruit_finished**, select the Bend value for the layer **apple group_finished** and click on the Graph Editor button along the top of the Timeline panel. You'll see how we played with its value graph to overshoot the second keyframe's final value, adding a little bounce when it lands. RAM Preview to see this, then see if you can re-create a similar overshooting in your version.

3 After precomposing, the Warp effect (below) is applied to the precomp group without affecting the background (above).

▽ tip

Anchor Point and Precomps

After you precompose a group of layers, the anchor point defaults to the center of the resulting layer. If you want to scale or rotate this precomp around a different location, use the Pan Behind tool (Lesson 2) to move the anchor point.

In our finished version, we added an overshoot to Bend's value graph to add a little bounce to the end of its animation.

The goal in this exercise is to take this near-finished composition and add a track matte to the apple that animates along with it without having to re-create any of the existing keyframes.

Precomposing a Single Layer

Precomposing is a great way to group together layers. However, it also comes in handy for individual layers. Sometimes, you need to perform a series of treatments on a layer that must happen in a specific order. Precomposing allows you to divide up the chores across more than one comp, making it easier for you to determine what happens when.

1 Open the project file **Lesson 06 > 06e-Precompose-Leave.aep**. In the **Comps** folder is **Red Apple*starter**; open it by double-clicking, then press **O** on the numeric keypad to RAM Preview it.

In this comp, the apple is scaling up and gently bouncing around (thanks to Animation Presets > Behavior > Wigglerama). The gray color in the apple is a little boring though, so the idea struck us to use the apple as an alpha matte (Lesson 4) and fill it with a colorful movie.

The problem with this brilliant idea is trying to match the fill layer to the apple's animation. We would need to also scale up the fill, and possibly wobble it to match. Even if we could do that, we would have another problem with the Drop Shadow effect needing to render after the track matte has been composited.

What you really want is for the track matte effect to be composited in a separate precomp. This precomp would be used as a source in the current comp, where its existing attributes – effects and keyframes – would continue to be applied. Pre-compose to the rescue:

2 Select layer 1 (**wireframe apple**), then Layer > Pre-compose. In the Pre-compose dialog, choose the option Leave All Attributes. This will move just the underlying source layer back into a new comp and keep all of the transforms and effects in the current comp. Enable Open New Composition (since you want to work in it), give your new precomp a clear name such as "**apple+matte**", and click OK. The precomp will open in the Comp and Timeline panels.

2 Select the apple layer (above) and pre-compose, using the Leave All Attributes and Open New Composition options (right).

2 *continued* After you precompose, the result is a new precomp (above left) the same size and duration as the apple layer (above right).

If you open Composition Settings, you will see that the precomp is the same width, height, and duration as the **Apple_loop.mov** layer (not the comp you sent it back from), but the same frame rate as the main comp. Close this dialog when done.

3 Bring the Project panel forward, and twirl down the **Sources** folder. Select the **Light Illusions A.mov** footage and drag it into the **apple+matte** comp *below* the **Apple_loop.mov** layer.

4 This colorful new layer is considerably larger than the comp. There's nothing wrong with leaving it as is. But to create a more intricate pattern for the fill, let's shrink it down to just fit this precomp. With **Light Illusions A.mov** selected, use the menu item Layer > Transform > Fit to Comp.

3–4 In the precomp, add a background movie behind the apple, and use Transform > Fit to Comp to shrink it down. Background courtesy Artbeats/Light Illusions.

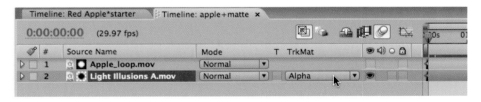

5 Set the background to use the apple above as an Alpha matte (left), resulting in the apple's wireframe being filled with the Light Illusions movie (above).

5 Time to fill the apple's alpha channel with this colorful movie. Press **F4** to reveal the Modes column. Then set the TrkMat popup for **Light Illusions A.mov** to Alpha. Rather than gray, the apple will be filled with the background image.

6 Click on the tab for **Red Apple*starter** and RAM Preview: The colorful apple you created in the precomp appears in this main comp, with its zoom, fade, and wobble intact. Mission accomplished; save your project.

As usual, our version of this exercise is in the Project panel's **Comps_Finished** folder. It includes a few extra touches: We applied Effect > Color Correction > Hue/Saturation to the apple and rotated its Hue 50° to make the apple more red than pink, and enabled motion blur for our animating layers.

6 Our final version includes a hue shift.

Render Order

Sometimes, After Effects will appear to have a mind of its own: You try to treat an image a certain way, but you get an unexpected result. This occurs because After Effects has a very particular order in which it performs operations, which you need to know and understand. Gaining this understanding is the purpose behind the last few exercises in this lesson.

The Order Things Render

Frustration often precedes enlightenment. To help make it clear what's really going on, let's first work through an example in frustration:

1 Open the project file **Lesson 06 > 06f-Render Order.aep**. The **Comps** folder should be twirled down; focus first on the nested folder **Render Example 1**. Inside it is the comp **Basic Order**; double-click it to open it. It contains a single layer: **Digidelic.mov**.

2 Select **Digidelic.mov** and apply Effect > Distort > Wave Warp. The default settings are fine; hit the Spacebar to play, and notice that this effect even self-animates.

3 Select the Rectangular Mask tool and draw a mask around the center of the layer. Rather than cutting a clean rectangular mask, the mask's edges are warped as well!

From the result, you can deduce that the Wave Warp (and for that matter, any effect you apply) is being rendered after the mask – even though you applied the effect before creating the mask.

4 To see how Transform factors into the mix, scrub the Rotation value (if it's not visible, twirl down the Transform parameters). The movie, mask, and wavy pattern are all affected. This suggests that transformations are figured into the mix after masks and effects.

If this is the look you wanted, fine. But perhaps you wanted a straight-edged mask and to have the image wave inside. Or you might want to rotate the underlying image and not have the mask rotate. Who will win this war of wills: the artist or the software?

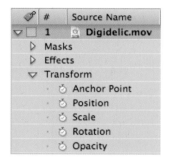

2–4 Take the original movie (A) and apply the Wave Warp effect (B). Then draw a rectangular mask: The mask gets waved (C) even though you applied it "after" the warp effect! Edit the layer's Rotation value, and both the mask and effect are rotated (D). Footage courtesy Artbeats/Digidelic.

First, it is important to grasp that the order in which *you* apply transformations, masks, and effects doesn't matter – After Effects will calculate them in the set order of Masks, Effects, and Transform. And there is very little you can do inside one composition to change this basic rendering order – for example, you can't drag Effects before Masks, or move Masks after Transform.

Two Comps Are Better Than One

There are hundreds of similar render order issues you might encounter, and there's almost always more than one way to solve them. However, the simplest solution is often to use two comps.

Take our **Basic Order** comp as an example. If you were to spread the **Digidelic** layer across two comps, you could then pick and choose the attributes that are rendered in the first comp, and those that are rendered in the second.

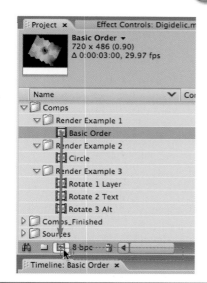

5 In the Project panel, drag the **Basic Order** comp down to the Create New Composition button at the bottom of this panel. This will nest **Basic Order** into a second comp called **Basic Order 2**. This new comp will open automatically. The chain now goes as follows: The **Digidelic.mov** source is in **Basic Order**, and **Basic Order** is nested in **Basic Order 2** (you can see it in the timeline of the comp that just opened).

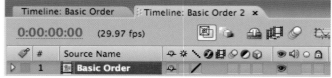

6 The tabs for both comps should be visible. Remember that the **Basic Order 2** comp renders *second*, so if you want the mask to render after Wave Warp and Rotation, you need to move the mask into the second comp:

• Click on the **Basic Order** tab in the Timeline panel to bring this comp forward, and if necessary twirl down Masks. Select Mask 1 and Edit > Cut. The mask will be removed.

• Bring the **Basic Order 2** comp forward, select the nested layer, and Edit > Paste. The mask will be applied, but will have straight edges because the effects and transformations rendered in the first comp and are not affecting it.

5 Drag **Basic Order** to the Project panel's Create New Composition button (top), and **Basic Order** will be nested as a layer in the new comp **Basic Order 2** (above).

6 Select the first comp **Basic Order** (A) and cut the mask from **Digidelic.mov** (B). Then select the second comp **Basic Order 2** and paste the mask onto the nested layer (C). Now the source will be rotated and waved inside a clean rectangular mask.

First comp

Second comp

▼ Pre-compose Options Compared

The Pre-compose dialog offers two options, and the results differ depending on which one you choose. The term "attributes" refers to masks, effects, transformations, blending modes, in and out points, and so on.

Leave All Attributes:

- This option is available for single layers only.
- After you precompose, the precomp will have one layer in it, and the size and duration of the precomp will be the same *as the original layer*.
- Any attributes applied to the layer before you precompose will remain in the *original comp*.
- The precomp will have a fresh render order, and any attributes applied to the layer in the new precomp will render *before* the attributes in the original comp.

Move All Attributes

- This option is available for single layers and multiple layers.
- The precomp created will be the same size and duration *as the original comp*.
- Any attributes applied to the layer(s) before precomposing will be moved to the *precomp*.
- The nested layer in the original comp will have a fresh render order, and any attributes applied to this layer will render *after* the attributes in the precomp.

Open New Composition

Selecting the Open New Composition option has no effect other than if it is selected, the precomp will come forward after you click OK so you can more easily edit it. If it's not selected, the current comp will remain forward.

CIRCLES OF HYPNOSIS

Nice design – too bad the logo isn't actually a circle. Background courtesy CyberMotion.

Using Precomposing to Re-order

In our first example, you fixed the visual problem with the wavy mask by nesting the comp into a second comp, then moving the mask. If the comp you're working in has only one layer, that method works fine.

In the real world, you'll likely come across a rendering order problem in the middle of a project, when there are already multiple layers in the comp. If you were to nest this complex comp, you would be grouping *all* of its layers into the second comp – perhaps not what you had in mind. You need a sharper knife, as it were – and this is where Precomposing becomes your friend.

1 With the Comp or Timeline panel selected, type ⌘ ⌥ W (Ctrl Alt W) to close the previous comps. Bring the Project panel forward, and open **Comps > Render Example 2 > Circle**.

This comp has three layers: **Digidelic.mov** with a circular mask and effects applied, a title, and a background. The client likes the idea, but insists that the result be a clean circle, not a wavy circle.

2 Select layer 1. If the mask and effects aren't visible in the Timeline panel, press **M** to reveal masks, then **Shift E** to reveal the effects. Now let's sit for a second and think this through:

• The Warp effect needs to be applied *before* the mask so that the mask doesn't get warped.

• The Bevel Alpha and Drop Shadow effects need to be applied *after* the mask is calculated (if beforehand, they will apply to the rectangular movie).

• The three color correction effects treat the entire layer, so we don't need to worry about them.

So – how to accomplish this? If you Precompose this layer, you will spread the layer across two comps and can then pick and choose which attributes should render in the first comp (the new precomp) and which should render in the second comp (the current main comp):

3 Select layer 1, **Digidelic.mov**, then Layer > Pre-compose. Select the Leave All Attributes option (you want the attributes to remain in the main comp for now), and enable Open New Composition. Name your new precomp "**Digi_precomp**" and click OK. The precomp will be forward, displaying the source movie in its original form.

4 Click on the tab for **Circle** comp in the Timeline to bring the main comp forward again. The movie in layer 1 has now been replaced with the output of the **Digi_precomp**. (Note that after you precompose, the layer always twirls up.)

• Select layer 1, press **M**, then **Shift E** again. Because you precomposed with the Leave All Attributes option, the mask and effects remained in the **Circle** comp. Let's move the Warp effect back to the precomp, where it will render first:

• Select just the Warp effect and Edit > Cut. The distortion will be removed.

• Click the **Digi_precomp** tab to bring the precomp forward. Select layer 1 and Edit > Paste. The image should twist. Press **E** to twirl down effects and confirm that the Warp effect is now in this comp.

• Click the **Circle** tab again and look at the Comp viewer: The warped movie is now cut out by the mask as a perfect circle.

The precomp (which renders first) is used only to distort the movie; the original comp (which renders second) applies all other effects and the mask.

CIRCLES OF HYPNOSIS

Quick Quizzler: If you were to rotate this layer over time, would it matter which composition you applied the Rotation keyframes in? (Think…what would the consequences be to the light direction in Bevel Alpha and Drop Shadow?)

2 The mask currently renders before all of the effects. What we *need* is for the mask to render after the Warp, but before the Bevel Alpha and Drop Shadow.

4 Cut the Warp effect from the main comp and paste it into the precomp (left), causing the movie to become warped (above).

4 *continued* Back in the main comp, the mask will be applied to the precomp, followed by the other effects (above), giving us the desired result (above left).

▼ Render Order Exceptions

In the latter part of this lesson, we put a lot of emphasis on the order in which After Effects processes layers: Masks are calculated first, followed by Effects, followed by Transforms such as Rotation and Scale.

However, there are exceptions to every rule. The biggest exceptions are layers that are *continuously rasterized*: Their pixels are calculated on the fly, rather than ahead of time. Text layers fall into this category; so does Illustrator artwork and Solids when a special switch is set. In their case, Transforms are calculated first rather than last, followed by Masks and Effects (although the Timeline doesn't tell you so!).

This can have an impact on how masks and effects look. Open the **06f-Render Order** project and turn your attention to the comps inside the **Render Example 3** folder:

• In **Rotate 1-Layer**, the text was created in Photoshop and converted to pixels, so it behaves like a normal pixel-based layer. Scrub through the timeline and pay attention to the direction of the shadow: Unfortunately, it rotates with the text. This is because effects are normally calculated before transforms such as rotation. On the other hand, look at the size of the shadow and the beveled edges relative to the text: As the text scales up, so does the shadow and bevel, which is what you would expect. In this case, transforms occurring after effects is a good thing. Finally, press **End** and look at the quality of the text: Here it is being scaled 150%, where it looks quite fuzzy and aliased as you "blow up" its pixels.

• In **Rotate 2-Text**, the text was created in After Effects and is rasterized into pixels as needed depending on its font size. In addition, transforms such as rotation and scale are applied to the vector text, *before* it is rasterized. Once pixels are created, masks and effects are calculated. Scrub through the timeline and observe: The drop shadow continues to fall in the correct direction even as the text rotates, which is a useful result of effects happening after transforms. On the other hand, as this text scales up, the shadow and bevel stay the same size regardless of the size of the text, with quite unrealistic results – a downside of this rewired rendering order. Finally, press **End** and look at the quality of the text: It is quite sharp, even though it is being scaled 150%. Continuously rasterized layers look sharp at all levels of scale.

You can solve most of these shortcomings using nested compositions or the Distort > Transform effect. We demonstrate the latter solution in this same folder.

To tell if a layer is being continuously rasterized, look for the sunburst icon under the Timeline's Switches column (above). This switch is always on for text layers. It is not offered for movies and most other layers. For solids and Illustrator layers, you will see a hollow box, which means it defaults to off (layer renders normally), but can be switched on (layer behaves like Text layers).

When you have a nested composition, this switch changes roles and becomes a Collapse Transformations toggle: similar to continuous rasterization, but more complex in its implications (so much so that we devote an entire chapter in *Creating Motion Graphics* to it).

△ In **Rotate 1-Layer**, effects are calculated before transformation, so the shadow rotates.

△ In **Rotate 2-Text**, the text is continuously rasterized, so transformations render first.

Quizzler

If you learn how to manipulate the render order, you won't be tempted to compromise the design or change your ideas. That alone will help you realize your full potential as an After Effects designer!

So here are a couple of brainteasers to practice your newfound knowledge of the rendering order. Both may be found in the project **06g-Quizzler.aep**:

Alien Puzzle

Look inside the **Quizzler 1** folder in the Project panel. There are two comps in it: **Alien-1** consists of two layers and is nested into **Alien-2** where it is masked. All in all, not much different from the chain of comps you explored earlier in the Render Order section, except that the first comp has two layers instead of one.

Your mission – should you decide to accept it – is to apply a distortion to the layers in **Alien 1** using Effect > Distort > Warp without affecting the shape of the mask in **Alien 2**. You can apply only one instance of the Warp effect (use any settings you think look good), and you cannot create additional precomps. There are two possible solutions, using features covered in earlier lessons.

Picture in Picture Effect

Now turn your attention to the **Quizzler 2** folder in the Project panel.

 +double-click (+ double-click) the **Quiz 2.mov** to open its Footage panel and play the movie. Focus on the now-familiar **Digidelic.mov** layer panning inside a small "picture in picture" hard-edged shape, floating over the background. A Fast Blur effect animates from very blurry to zero, while a Drop Shadow effect sets this layer off from the background. Looks simple enough?

Leave the Footage panel open for reference, then open the **Quiz 2*starter** comp, which just has the background layer. Create the same result; you'll find the **Digidelic.mov** in the **Sources** folder. There are no restrictions on what you can do, provided the result is essentially the same.

After you've taken a crack at it, check out **Quizzler Solutions > Quiz 2_solution** – we think this is a fairly elegant solution to the problem.

In **Quizzler 1**, your goal is to warp the inset movie (above) without disturbing the square box it resides in (below). Give it your best shot, then look in our **Quizzler Solutions > Quiz 1** folder for the answers.

▽ tip

Transform Cheat

The Effect > Distort > Transform effect has all of the features of the Transformation section and more. Because you can drag the Transform effect before other effects, you can use it to manipulate the render order or even have two sets of, say, Position or Rotation keyframes on one layer.

In **Quizzler 2**, the plan is to blur and pan the inset movie while keeping things as simple as possible.

Expressions and Time Games

Using expressions and playing with time.

▽ Getting Started

Make sure you have copied the **Lesson 07 – Expressions and Time** folder from this book's disc onto your hard drive, and make note of where it is; it contains the project file and sources you need for this lesson.

I n this lesson, you will become acquainted with two admittedly mind-bending areas of After Effects. First we will cover expressions, which can help you save time while animating. After you master those, we will show you how to make time literally stand still – as well as speed up, slow down, and go by more smoothly.

Expressions 101

The geek explanation of expressions is that it's a JavaScript-based programming language that allows you to manipulate time-based streams in After Effects. The artist explanation is that it's an easy way to make any keyframeable parameter react to what another parameter is doing – such as having two layers rotate or scale together without having to copy and paste keyframes between them.

Although expressions can be very deep and powerful, in reality the majority of expressions are very easy to create. Indeed, After Effects does most of the work for you: All you have to do is literally point one parameter to another using the *pick whip* tool. Beyond that, the most common task you will need to do is add little bits of math such as "times two" or "minus 180." We will also show you three simple *functions* (pieces of code) that will come in handy time and again. Not only will expressions save you a lot of time and tedium, they often inspire new animation ideas – something both geeks and artists can get enthused about.

The Problem

1 Open this lesson's project file: **Lesson_07.aep**. In the Project panel, the **Comps** folder should be twirled open (if not, click on its twirly arrow). In this folder, locate and double-click **01-Pick Whip*starter** to open it.

Press **0** on the numeric keypad to RAM Preview this comp. The blue pulley on the left scales and spins; the red pulley on the right just sits there. The client says he wants them both to do the same thing. That's easy enough to do the old-fashioned way:

Your goal is to make these two pulleys perform the same animation. You can copy, paste, and hand-edit keyframes...or let expressions do a lot of the work for you.

2 The Scale and Rotation keyframes for **Blue Pulley** should be visible in the Timeline panel; if they aren't, select this layer and type **U** to reveal its animating properties.

• Click on the word Scale for **Blue Pulley**; all of the Scale keyframes will be selected. Hold down **Shift** and click on Rotation: Its keyframes will be selected as well. Then type **⌘ C** on Mac (**Ctrl C** on Windows) to copy the selected keyframes.

Timeline: 01-Pick Whip*starter ✕								
0:00:00:00 (29.97 fps)		00s	01s	02s	03s	04s	05s	06s

	#	Layer Name			
▽ ☐	1	Blue Pulley		👁	
·		Scale	10.0 , 10.0 %		
·		Rotation	0 x +0.0 °		
▽ ☐	2	Red Pulley		👁	
·		Scale	10.0 , 10.0 %		
·		Rotation	0 x +0.0 °		

• Press **Home** to make sure the current time marker is at 00:00 before pasting. Select **Red Pulley** and type **⌘ V** (**Ctrl V**) to paste. Type **U** to reveal its new keyframes.

• RAM Preview; both pulleys scale and rotate the same.

2 Select the keyframes for **Blue Pulley**, copy, select **Red Pulley**, and paste. Their animations will be identical – for now...

3 Now that the client sees both pulleys together, he decides he wants the rotation to finish before the pulleys scale back down. Okay – move the last Rotation keyframe for both layers back to 04:15.

4 RAM Preview. Now the client thinks the pulleys are spinning too fast, so edit the last Rotation keyframe for both pulleys to be –1 rotation, not –2.

You can quickly see how tedious client changes can become, just with two layers. Now imagine if you had 10 or 100 layers! This is a perfect example of how expressions could make your life easier.

Expressions Guided Tour

In this lesson's **07-Guided Tour** folder is a QuickTime movie that gives a visual overview of creating, deleting, enabling, and disabling expressions. If you have trouble following our instructions on using the pick whip or expression language menu, watch this to become more familiar with what we're talking about.

The Pick Whip

The main tool you will use to create expressions is the pick whip. This tool makes it easy to link one parameter to another.

5 Turn off the stopwatch for **Red Pulley**'s Scale and Rotation to delete their keyframes.

• Hold down the ⌥ (**Alt**) key, and click on the stopwatch for **Red Pulley**'s Scale. This enables expressions for the associated property. Scale will twirl down, revealing a line that says Expression: Scale, with a set of new icons next to it. **Red Pulley**'s Scale value will change from blue to red, indicating it is now controlled by an expression. You will also see some text appear: `transform.scale`. This says **Red Pulley**'s Scale is currently "expressed" to its own Transform property, Scale.

• Click on the spiral icon next to Expression: Scale – this is the pick whip tool. Drag it up to the word Scale for **Blue Pulley**; this word will highlight when you're close. A line will connect the two properties as you drag.

Release the mouse, and the text for **Red Pulley**'s scale will change to say `thisComp.layer("Blue Pulley").transform.scale`. Expression code can look like an alien language, but it's not hard to read: In this comp is a layer called **Blue Pulley**; use its Transform property Scale.

• To accept this new expression, press **Enter** on the numeric keypad (not on the regular keyboard), or click elsewhere in the window.

RAM Preview: **Red Pulley** will now have the exact same scaling as **Blue Pulley** – but not its rotation. Expressions are applied to individual properties,

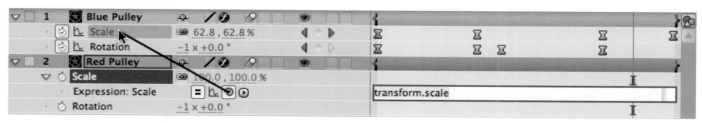

5 ⌥+click (**Alt**+click) on an animation stopwatch to enable expressions. Click on the spiral icon and drag it to the parameter you want to copy (above). Release the mouse and press **Enter**; After Effects will write the expression and the value will be copied (below).

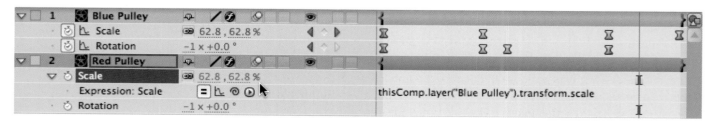

not entire layers. If you want **Red Pulley**'s Rotation to follow **Blue Pulley**, you will need to create an expression for that property as well:

6 Just as you did for Scale, ⌥+click (*Alt*+click) on the stopwatch for **Red Pulley**'s Rotation, and it will twirl down to reveal its expression. Drag its pick whip to **Blue Pulley**'s Rotation property. When it highlights, release the mouse and press *Enter*. RAM Preview; both pulleys will now scale and rotate together.

7 Edit the Scale and Rotation keyframes for **Blue Pulley**, then preview: **Red Pulley** will faithfully follow along. No matter how many changes you make to their values, or whether you move the keyframes earlier or later in time, **Red Pulley** will follow its leader. Compared with copying and pasting, there will be a lot less work when the client wants additional changes.

Simple Math

We know that many may consider the phrase "simple math" to be an oxymoron, but adding or dividing a number here and there will greatly multiply what you can do with expressions.

Continue with the composition you were working with in the previous step, or open **Comps > 02-Simple Math*starter**.

8 Move the current time marker to 02:00. Select **Blue Pulley**, and apply Effect > Perspective > Drop Shadow. Increase Drop Shadow's Distance parameter to make it more obvious.

Preview, and you will notice that the shadow rotates with the pulley. To cancel out the layer's rotation, you need to animate the shadow's Direction to spin the opposite way. Expressions to the rescue:

9 Make sure that **Blue Pulley**'s Rotation property is still exposed in the Timeline panel and that you have some spare room in this panel to see more lines of properties.

• In the Effect Controls panel, ⌥+click (*Alt*+click) on the stopwatch for Drop Shadow's Direction parameter. Drop Shadow's parameters will be exposed in the Timeline panel, with Direction enabled for expressions.

8 Effects (such as Drop Shadow) are calculated before transforms (such as Rotation), resulting in the shadow spinning with the pulley.

9 ⌥+click (*Alt*+click) on the stopwatch for Drop Shadow's Direction parameter.

9 Enable expressions for Shadow's Direction, and use the pick whip to connect it to the layer's Rotation (right/top). Then add the text *** −1** to the end to make Direction spin in the opposite direction as Rotation (right/bottom).

After applying the initial expression, the shadow points straight up at 0°.

▽ try it

Inherent Value

If you want to add a parameter's original value to an expression, type "**+ value**" at the end. Try it yourself: In Step 10, replace **+ 135** with **+ value**. A benefit of this approach is that you can scrub the Direction property to change the angle of the shadow without having to edit the expression.

10 Add an offset to the end of the expression (right), and now it will point at the desired angle (above).

• In the Timeline panel, drag the pick whip for Direction to the word Rotation. Release the mouse, but don't press **Enter** yet!

• To have the shadow rotate in the opposite direction, place the cursor at the end of the expression `transform.rotation`, and type " *** −1**" (multiply by negative one).

Press **Enter** and preview. The shadow now stays in the same place – but it's in the wrong place, pointing straight up. A little math can fix that, as well:

10 Click on the expression text for Direction to activate it for editing.

• To be safe, surround the current expression with parentheses so it looks like `(transform.rotation * −1)`. Everything inside parentheses is calculated as a self-contained unit.

• Press the down cursor arrow to move to the end of the expression. Then type " **+ 135**" to add the original Direction value of 135° to the current calculation. Press **Enter** and preview – now the shadow is where it belongs!

If you got lost, our version is in **Comps_Finished > 02-Simple Math_final**, where we also applied the same correction to **Red Pulley**'s shadow. Save your project before moving on.

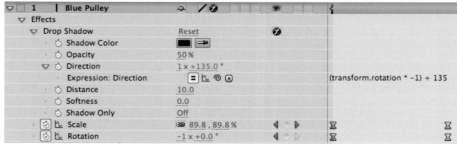

Clockwork

In this next exercise, we'll expand on the skills you've just learned to build a clock. You'll use the pick whip and some simple math, then augment these with the *linear* function, which will make it easier to translate between different parameters.

1 With the Comp or Timeline panel selected, type ⌘ ⌥ W (*Ctrl* *Alt* *W*) to close the old comp panels. In the Project panel, locate and open **Comps > 03-Clockwork*starter**.

This composition contains the pieces needed to make a clock: the face, plus the hour, minute, and second hands. There are also a couple of background layers. We've already arranged the layers and set their anchor points so that everything lines up and spins properly. We've also animated the minute hand's rotation.

Your task is to make the hour and second hands follow the minute hand. You will then create a transition between the two background layers which follows the minute hand as well.

We've already animated the minute hand; now you have to animate the hour and second hands to follow, using expressions instead of keyframes. Background courtesy Artbeats/Alien Atmospheres.

2 Use the pick whip to tie the Rotation values for **hour** and **second** to **minute**'s Rotation. Then modify the expressions as needed with simple math such as / 12 and * 60.

2 Select the **minute**, **hour**, and **second** layers, and press **R** to reveal their Rotation properties. Again, only layer 1 – the minute hand – is keyframed.

Think for a moment about what you need to do: The second hand needs to rotate 60 times as fast as the minute hand, while the hour hand needs to rotate at only one-twelfth the speed.

• ⌥+click (*Alt*+click) on the stopwatch for **hour**'s Rotation to enable expressions for it. Drag its pick whip up to the word Rotation for the **minute** layer. Release the mouse, and type " / **12**" to divide the minute hand's rotation by 12. Press *Enter*.

• ⌥+click (*Alt*+click) on the stopwatch for **second**'s Rotation to enable expressions for it. Drag its pick whip up to the word Rotation for the **minute** layer. Release the mouse, and type " * **60**" to multiply the minute hand's rotation by 60. Press *Enter*.

Press *Page Down* to step through the timeline a frame at a time, watching the Rotation values for these three layers to verify your math. For example, when you move the current time marker to 01:15 where the minute hand has rotated 90° (15 minutes), the second hand should have rotated 15 times, while the hour hand should have rotated only 7.5°.

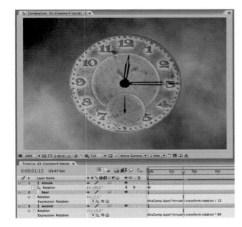

2 *continued* After you have created these expressions, the hour and second hands should now keep their correct relationships to the minute hand.

Translation Services

Now let's have some fun and tie what's happening in the background to the minute hand's animation.

3 Select **Alien Atmospheres.mov** and apply Effect > Transition > Radial Wipe. The Effect Controls panel will open; scrub the Transition Completion to get a feel for how it sweeps away this layer, revealing the layer underneath.

4 ⌥+click (*Alt*+click) Transition Completion to enable expressions for it. In the Timeline panel, drag the pick whip from Transition Completion to the word Rotation for the **minute** layer. Release the mouse, and press *Enter*.

RAM Preview, and you'll see a problem: The transition races ahead of the minute hand. Why? Well, there are 360° in one rotation, but Transition Completion goes from 0 to 100. As a result, it reaches 100% completion after only 100° of rotation.

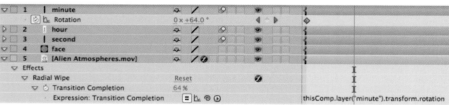

4 If you simply use the pick whip to express Radial Wipe's Transition Completion to follow **minute**'s Rotation (above), the transition will race ahead of the minute hand (top). Second background courtesy Artbeats/Digidelic.

The math to translate between these two isn't so bad (the answer is to divide the Rotation value by 3.6), but there will be numerous other cases where the translation isn't so straightforward. Therefore, we think it's worth the effort to learn an expression function called *linear* that will translate for you:

5 To remember how to use the linear function, memorize this mantra: "As a parameter goes from A to B, I want to go from Y to Z." After Effects will even help us write most of this code:

• Click on the arrow to the right of Transition Completion's pick whip to bring up the expression language menu. Select `Interpolation > linear(t, tMin, tMax, value1, value2)`. Release the mouse, and this text will replace the code created by the pick whip.

• Select `t` (being careful not to select the parenthesis before or the comma after). This is the parameter you want to follow – namely, **minute**'s Rotation. Use the pick whip tool and drag it to the parameter as you did before.

• Select `tMin` (you can double-click it to select it) and type the beginning Rotation value: 0.

• Select `tMax` and type the ending Rotation value: 360.

• Select `value1` and type the desired beginning Transition Completion value: 0.

• Select `value2` and type the ending Transition Completion value you need: 100.

Press *Enter*, and the Radial Wipe will now snap to line up with the minute hand. RAM Preview to verify this, and save your project.

▽ tip

Preset Shadow

We use the trick of having the Drop Shadow effect react to the layer's Rotation quite a bit. Rather than create an expression for its Direction parameter every time you want to use it, set it up once, select Drop Shadow in the Effect Controls panel, then select Animation > Save Animation Preset. You can now apply this preset – with the expression intact – whenever you want.

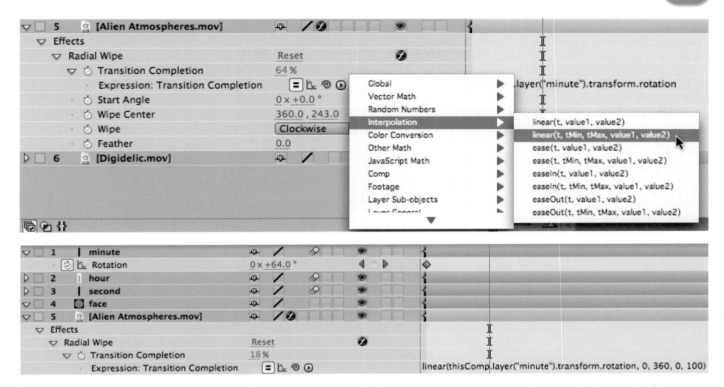

5 You can use the expression language menu (top) to remind you of the format of common expression functions. Replace each of its generic values with the values you need (above). After you're done, the wipe transition will follow the minute hand correctly (below).

If you like, edit the second keyframe value for **minute**'s Rotation, perhaps entering a lower value such as 120°. The hour hand, second hand, and transition will all update to stay in sync with the minute hand's rotation. Hopefully, the beauty of expressions has now become more apparent: Once you set them up, you need to edit only one set of keyframes to update a complex animation.

In the Project panel, locate and open our version: **Comps_Finished > 03-Clockwork_final**. We added a few tricks, such as animating a hue shift of the **Alien Atmospheres.mov** layer using the linear function. We also added drop shadows to the clock pieces, and used expressions to stabilize their positions so that they didn't spin around with the hands.

Our version (**03-Clockwork_final**) includes additional tricks, such as enabling motion blur, varying the hue of the fog during the transition, and adding drop shadows to the clock pieces. Everything that animates is driven by one pair of keyframes: those for the minute hand's rotation.

Going for a Loop

Time to introduce another expression into your repertoire: the ability to repeat a keyframed animation for the duration of a layer.

1 Open **Comps > 04-LoopOut*starter**. Select **watch_widget.tif**, and type **U** to reveal its keyframes: There are two for Rotation, at 00:00 and 01:00. RAM Preview; it rocks in one direction, then stops.

Your task is to make this widget rock back and forth for the duration of the layer. You could create a bunch of additional Rotation keyframes, but that would be a pain to edit later. Or, we could introduce you to the *loopOut* function.

2 +click (**Alt**+click) on the stopwatch for Rotation to enable expressions for this property. Type:

```
loopOut("pingpong")
```

and press **Enter**. This will tell After Effects to follow the animation from the first keyframe to the last keyframe, then animate in reverse back to the first keyframe. It will then repeat this until the Out point of the layer. RAM Preview: The widget now rocks back and forth continually.

▽ **gotcha**

Return versus Enter

When you are finished working on an expression, remember to press the **Enter** key on the numeric keypad, not the normal **Return** or **Enter** key – the latter will add a carriage return to the expression, as if you wanted to write another line.

2 The combination of just a few keyframes and the loopOut expression (top) can create an animation that repeats from the first frame to the layer's Out point (above).

3 There are other options available for the loopOut expression:

• Click on the expression text to select it, and replace the word **pingpong** with the word **cycle** (don't accidentally delete the parenthesis!). Press **Enter** and RAM Preview; the animation will go from the first to the last keyframe, then jump suddenly back to the first.

• Replace the word `cycle` with the word `offset`, press **Enter**, and RAM Preview: The animation will proceed from the first to the last keyframe, and remember the value of the last keyframe. It will then proceed from the first to last keyframe again, but the rotation will be offset by the value of the last keyframe, creating a continuous motion.

4 Slide the last keyframe earlier or later in the timeline, and RAM Preview again: The speed of the animation will change to match and continue for the duration of the layer.

Our version is in **Comps_Finished > LoopOut_final**. We had fun creating several copies of **watch_widget.tif**, then moved their last keyframe to vary their speeds.

Alternate Loops

There are several variations on the loop function:

• `loopOut()` repeats the animation from the last keyframe to the end of the layer; `loopIn()` repeats the animation backward from the first keyframe to the start of the layer.

• If you don't want to loop all of the keyframes, you can say how many to loop. For example, `loopOut("cycle", 3)` repeats just the last three keyframes in an animation.

• You can also define how much time is looped, rather than the number of keyframes. `loopOutDuration("cycle", 1.5)` would repeat just the last 1.5 seconds of the keyframed animation.

▼ Expression Tips

Here are a few shortcuts and pieces of advice that you will find helpful as you use expressions:

• To delete an expression, **⌥**+click (**Alt**+click) on the stopwatch again. Or select the expression text and delete it.

• To temporarily disable an expression without deleting it, click on its = icon; it will change to ≠. To re-enable it, click on the ≠.

• Selecting a layer and typing **U** will reveal the properties that have keyframes *or* expressions. To reveal just the properties with expressions, select the layer and type **E** **E**.

• Expressions use the same characters as your computer's numeric keypad for math functions: * means multiply (don't type an 'x'); / means divide.

• After Effects can convert an expression into normal keyframes: Select the property you want to convert and use the menu item Animation > Keyframe Assistant > Convert Expression to Keyframes.

• Expressions can be applied across multiple comps in the same project. To do this, you need to arrange two sets of Effect Controls or Timeline panels – one for each comp – so you can see both, then use the pick whip to reach across them.

If you accidentally click in the wrong place in the middle of creating an expression, After Effects may think you're done when actually you're not. One of two things will then happen:

• If the expression fragment you wrote makes sense, After Effects will assume that's what you meant and enable the expression.

• If the expression fragment creates an invalid piece of code, After Effects will give you an error message and turn off the expression.

In either case, it is easy to correct the expression. Click in the area where you see the code, and either delete it and start again, or add the missing piece you intended. When you press **Enter**, After Effects will re-enable the updated expression.

▽ tip

Behaviors

If you want to wiggle the position, rotation, or other transformations of a layer, we suggest you apply an Animation Preset (introduced in Lesson 3). Look inside the Behaviors folder for the presets that start with "Wiggle." These handy presets are based on the wiggle expression.

2–3 By adding the wiggle expression to Position and Rotation (right), you can make the gizmo fly drunkenly around the screen without adding keyframes (above). Gizmo courtesy Quiet Earth Design.

4 Duplicate the gizmo several times. Each copy will wiggle differently, automatically. Background courtesy Artbeats/Light Alchemy.

The Wiggle Expression

The third expression function we really feel you should learn is *wiggle*. This simple expression can add random variation to virtually any parameter. To use wiggle, you just need to think about two things: How fast do I want to wiggle, and how much?

1 With the Comp or Timeline panel selected, type ⌘ ⌥ W (**Ctrl Alt W**) to close the old comp panels. In the Project panel, locate and open **Comps > 05-Wiggle*starter**. It contains two layers: a background and a yellow gizmo that opens and closes.

2 Select **Gizmo.mov** and type **P** to reveal its Position. ⌥+click (**Alt**+click) on the stopwatch for Position to enable expressions. In the expression text area, type the following:

• Type "**wiggle(**" to start the expression.

• How fast do you want the object to wander, in wiggles per second? Type that number, followed by a comma – for example, "**1,**" for one wiggle/second.

• How much do you want this value to wiggle by? Enter that number, followed by a closing parenthesis – for example, type "**200)**" for up to 200 pixels of wanderlust.

 Your final expression should be `wiggle(1,200)`. Press **Enter**, then RAM Preview – the gizmo will wander about the comp.

3 Let's have the gizmo rotate as it wanders, as if it's having trouble stabilizing. Say we want it to wiggle only half as fast (0.5 wiggles/second) and rotate by as much as 45°:

• With **Gizmo.mov** still selected, press **Shift R** to also reveal the Rotation parameter.

• Enable expressions for Rotation.

• Type "**wiggle(0.5,45)**" – the values we decided upon – and press **Enter**. RAM Preview, and enjoy the flight of the drunken gizmo!

4 As if that isn't cool enough…wiggle also randomizes its actions based on the layer it is applied to. Select **Gizmo.mov** and duplicate it several times. You will now have a flock of out-of-control gizmos. Our version is saved in **Comps_Finished > 05-Wiggle_final**.

Expressions and Effects

Expressions such as wiggle are great, but it can be a bit of a pain to have to edit the expression text every time you want to tweak their values. The solution is a special set of effects known as Expression Controls. These effects don't change how an image looks; they provide user interface elements that allow you to control expressions.

1 Open **Comps > 06-Effects*starter**. RAM Preview, then select **underwater** and press **E** **E** to reveal the expressions applied to it. We've added the wiggle expression to the Angle parameter of a Twirl effect to animate this text layer.

2 You may find our initial wiggle values a bit manic. What if you wanted to tweak it, or keyframe the amount and speed of the wiggle? The solution is to create your own user interface for the expression:

• With **underwater** selected, apply Effect > Expression Controls > Slider Control. The Effect Controls panel will open. Select the effect name Slider Control, hit Return to highlight it, type in a useful name such as "**Wiggle Speed**" and press *Return* again.

• Then apply Effect > Expression Controls > Angle Control. Rename this effect "**Wiggle Amount**".

• Drag these two new effects above Twirl. Placing your user interface controls at the top makes them easier to find and use. You can also twirl these controls down in the Timeline panel.

3 Back in the Timeline panel, click on the expression text to make it active.

• Carefully select just the **3** inside the parentheses; you want to replace it. Drag Angle's pick whip to the word Slider (not the effect's name) for Wiggle Speed. The expression code `effect("Wiggle Speed")("Slider")` will now appear in the Timeline.

• Select the **60** after the comma, being careful not to select the comma or closing parenthesis. Drag Angle's pick whip to the word Angle for Wiggle Amount to replace it as well. Press *Enter* to accept this new expression.

4 Try keyframing the values for Wiggle Speed and Wiggle Amount, RAM Previewing to check your results. Our version is **Comps_finished > 06-Effects_final**.

Expression controls will make it easier to tweak and keyframe the amount of wiggle applied to this text's distortion. Footage courtesy Artbeats/Under the Sea 1.

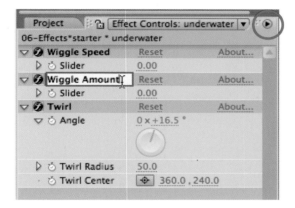

2 Add a Slider and Angle Control, and rename them to reflect the expression parameters you want them to control. (Note: To simplify this figure, we toggled off Show Animation Presets from the Effect Controls Options menu.)

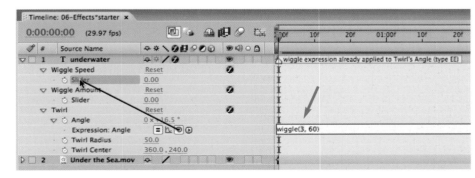

3 Select the first value in the expression, then drag the pick whip to the name of the Wiggle Speed Slider control (not the name of the effect). You can drag either to the Slider control in the Timeline panel or the same parameter in the Effect Controls panel.

Master Controller

Another great use for Expression Controls is to have one master controller for multiple layers – such as to pick colors.

1 Open **Comps > 07-MasterControl*starter**. It contains several lines of text, plus a solid. We created all of these in white. However, the client has requested they be something more colorful. Rather than change the color for each layer individually – every time the client changes her mind – let's set up a master color that controls all of the layers.

2 Select Layer > New > Null Object. Press ⌘ *Shift* Y (*Ctrl* *Shift* Y) to open the Solid Settings dialog, and change its name to "**MASTER CONTROL**" to make it easy to find. Click OK, then turn off its Video switch (the eyeball icon).

3 Select Effect > Expression Controls > Color Control. Press **E** to reveal it in the Timeline panel, and twirl it down to reveal its Color swatch.

4 Use the pick whip to attach the text layer's Fill effect's Color parameter to the Color parameter of your **MASTER CONTROL** layer.

4 Select the first text layer: **REASONS TO UPGRADE**.

• To colorize it, apply Effect > Generate > Fill. The text will change to Fill's default color of red.

• *⌥*+click (*Alt*+click) on the stopwatch next to Fill's Color in the Effect Controls panel; this will reveal it in the timeline and enable it for expressions. (Don't worry about the warning message saying the Comp view is disabled – it's waiting for you to complete the expression.)

• Drag its pick whip to the word Color for the Color Control effect applied to **MASTER CONTROL**. Then press *Enter* to accept the expression.

5 Click on the Color swatch for **MASTER CONTROL** and change it (you can also click and "scrub" it directly in the timeline). Pick a color complementary to the background, such as a golden yellow. The text will change too.

6 After you've "wired" the other layers to be controlled by your master layer, you need to change only the master swatch (above) to change the color of all the layers wired to it (below). Background composite: Artbeats/Digital Aire and Digital Biz.

6 Time to make the other layers follow: In the Timeline, click on the word Fill for **REASONS TO UPGRADE** and type ⌘ **C** (*Ctrl* **C**) to copy the effect. Twirl up the Fill effect to gain more space in the Timeline.

• Click on **dividing line** to select that solid, then *Shift*+click on **24/7 e-commerce** to select all of the remaining text items.

• Type ⌘ **V** (*Ctrl* **V**) to paste the Fill effect – with the expression that points to **MASTER COLOR** – to all of the selected layers. They will all change to yellow to match.

• Alter the Color for **MASTER CONTROL**, and all of the text and solid layers will update as well.

▼ Driven By Sound

Motion graphic designs are often more powerful if the visuals are tied to the audio. The combination of expressions plus a special Keyframe Assistant make this easier to accomplish.

1 Open **Comps > 08-Audio*starter**. It contains a soundtrack, background movie, and still image of a speaker. Our goal is to make the speaker's woofer bounce in and out in time with the music.

2 Expressions cannot directly access sound. However, After Effects has a Keyframe Assistant that can convert the comp's audio into keyframes applied to an Expression Controller.

Select Animation > Keyframe Assistant > Convert Audio to Keyframes. A null object named **Audio Amplitude** will be created at the top of the layer stack. Select it and press **U** to reveal its keyframes.

Drag the current time marker along the timeline while watching the values for Both Channels (an average of the left and right channel amplitude). Some peaks go over 50, although it seems most values are under 30. (You can also use the Graph Editor to more clearly see how the keyframe values change over time; select the Both Channels > Slider parameter in the timeline to see its graph. Toggle off the Graph Editor when done.)

3 Select **speaker.jpg** and press **F3** to open its Effect Controls panel. We've already applied a Bulge effect to it and centered the bulge on the woofer. Scrub the Bulge Height parameter and watch the speaker flex. Get a feel for what would be a good range of values – maybe –1.0 to +1.0.

4 A few exercises ago, we showed you how to use the linear expression to convert between different value ranges. Remember

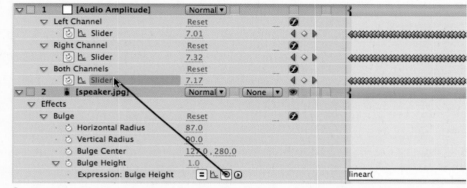

2 Convert Audio to Keyframes creates a null object with three Slider Controls. Their keyframes match the amplitude of the comp's audio.

3 Use the pick whip to help connect Bulge Height to one of the Slider Controls.

3 *complete* Check our version **Comps_finished > 08-Audio_final** if you have trouble.

the mantra: As a parameter goes from A to B, I want to go from Y to Z.

• ⌥+click (**Alt**+click) on the stopwatch next to Bulge Height to enable expressions.

• Type "**linear(**" to start the expression.

• Drag the pick whip to the parameter you want to follow: Both Channels > Slider. Then type a comma to separate it from the numbers that follow.

• As the audio amplitude goes from 0 to 40, you want Bulge Height to go from –1 to +1. So type "**0, 40, –1, 1**" followed by a closing parenthesis, ")".

Press **Enter** and preview – the woofer will now bop along with the music! If you want to have some more fun, duplicate the speaker, and instead of hooking the expression up to Both Channels, hook one speaker up to Left Channel and the other to Right Channel.

This same basic technique can be used to drive virtually any parameter with audio. If you got lost, our version is in **Comps_finished > 08-Audio_final**.

If you find you like this technique, check out the more powerful third-party plug-in Trapcode Sound Keys (www.trapcode.com).

Soft objects – such as clouds and blurry backgrounds – are excellent candidates to frame blend. Footage courtesy Artbeats/Aerial Cloud Backgrounds.

Time Stretch

Stretch

Original Duration: 0:00:10:01

Stretch Factor: 300 %

New Duration: 0:00:30:03 is 0:00:30:03
Base 30non-drop

Hold In Place

◉ Layer In-point
◯ Current Frame
◯ Layer Out-point

Cancel OK

2 In the Time Stretch dialog, change the Stretch Factor to 300% to make the duration three times longer.

Time Games

We're going to change subjects. Now we'll deal with time – how to make it go by more smoothly or chop it up. We'll also look at how to change its speed.

Frame Blending

There will be occasions when you wish the action in footage you receive was happening faster or slower. It's relatively easy to "stretch" the footage, but this can result in staggered motion as frames are repeated or skipped. To help counter this, After Effects offers *frame blending* to smooth out the final motion.

1 Project file **Lesson_07.aep** should still be open. With the Comp or Timeline panel selected, type ⌘ ⌥ W (*Ctrl* *Alt* W) to close the old comp panels. In the Project panel, locate and open **Comps > 09-Frame Blending*starter**, and RAM Preview it. The comp contains one layer, which is footage of flying over clouds.

2 Say you wanted to slow down this clip to one-third of its original speed. In the Timeline panel, right-click on one of the column headers. Select Columns > Stretch to open this additional parameter column. Click on the current value (100%); the Time Stretch dialog will open. Change the Stretch Factor to 300% and notice how the duration is now three times longer. Click OK.

RAM Preview: You'll notice that the clouds move more slowly (each frame now plays for three frames), but are also jerky in their motion. Smoothing this out is something frame blending excels at.

3 In the middle of the Switches column header is an icon that looks like a film strip. This is the Frame Blend switch. Click once in the hollow area underneath this icon for **Aerial Clouds.mov** to enable basic frame blending. A pixelated backslash will appear in this hollow, saying this layer will have frame blending calculated when it renders.

If you want to see the effects of frame blending in the Comp viewer before you render, you also need to enable the master Frame Blending switch along the top of the Timeline panel. To do this, click on the large filmstrip icon. RAM Preview again, and the cloud motion will be much smoother!

Ah, if only every clip worked that well… Unfortunately, you will find many clips that don't blend nearly as smoothly:

3 Enable Frame Blending for both the layer and for the entire composition in order to view the results in the Comp viewer.

4 Open **Comps > 10-Pixel Motion*starter**. This comp contains footage of a man walking past a car. Its Stretch column should be visible; you'll see that it has already been slowed down 300%. RAM Preview it; you will notice considerable staggering in the motion as frames are duplicated.

5 Click on the Frame Blend switch once for **Business on the Go.mov** to get the pixelated backslash. Then enable the large Enable Frame Blending switch.

RAM Preview. The result no longer looks like a stop motion animation, but it is still a bit rough. Stop the preview and press **Page Down** to step through the frames, and you will see echoes around sharp edges such as his jacket. Frame blending just mixes together adjacent frames; you can obviously see this crossfading effect on sharp footage.

Pixel Motion

6 Move to 00:08 where you can see ghosting. Click on the Frame Blend switch one more time, to where it becomes a solid forward-leaning slash. This enhanced frame blending mode is known as Pixel Motion. The ghosts will disappear. Pixel Motion studies the movement of every pixel between frames and calculates where each pixel should be to create a new in-between frame at the requested time.

RAM Preview; it takes longer because Pixel Motion requires a lot of computing power. The movement – particularly at the start and end of the shot – is much smoother now. However, it doesn't always work…

7 Move the current time marker to 01:20, where the man's arm starts to swing away from his body and across the hood of the car. Pixel Motion – and all similar time interpolation algorithms – has more difficulty deciding what to do when one set of pixels crosses another. Press **Page Down** to slowly step through the next several frames, watching what happens around the man's arm – there's a lot of distortion. Pixel Motion is certainly not perfect; you should carefully study every shot you use it on. But when it works, it's great!

5 Normal frame blending creates visible ghosting along sharp edges as it crossfades between layers (right). Footage courtesy Artbeats/Business on the Go.

6 Clicking a layer's Frame Blend switch a second time changes it to a slash, which engaged Pixel Motion. This creates brand new in-between frames, resulting in cleaner images (right).

▽ tip

After Effects Professional comes with the Time > Timewarp effect, which performs a similar task as Pixel Motion but with more user control. There are also third-party solutions available; we often use RE:Vision Effects' Twixtor.

7 Pixel Motion can cause strange distortion when objects are moving across each other. Notice what's happening to the windshield as the man swings his arm (below).

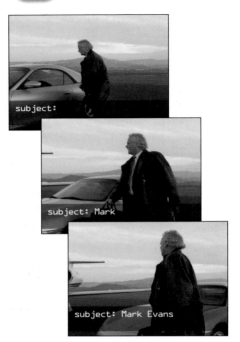

The goal is to make the video look like a series of stills, while keeping the smooth type animation.

4 If you want a lower frame rate in a precomp to be honored throughout a project, enable its Preserve Frame Rate option in Composition Settings > Advanced.

Stop Motion Tricks

There are occasions when you don't want your animations to play back smoothly – for example, if you are trying to simulate a low frame rate "stop motion" look, or if you are trying to slow down an overly nervous effect that randomizes every frame.

Preserve Frame Rate

First, we need to show you how After Effects may try to thwart your attempts to create a stop motion look. Then we'll show you how to thwart After Effects.

1 In the Project panel, locate and open **Comps > 11a-Preserve Rate*starter** and RAM Preview it. It contains the footage of the executive walking to his plane that you saw in the previous exercise. Our plan is to make this footage look like it was a series of still photographs, shot as part of an undercover surveillance.

2 Type ⌘ K (Ctrl K) to open its Composition Settings. You will notice that it (and the footage) is at a film-like rate of 23.976 fps. Change the Frame Rate to 1 fps, and click OK. RAM Preview, and you will see After Effects holds on some frames and skips others to create that stop-motion look.

3 Open **Comps > 11b-Output Rate*starter**. This has the previous comp nested into it. Its frame rate is also set at 23.976 fps, to simulate how your final render might look in the final composite. RAM Preview: Hey, the motion's smooth again! What happened?!?

The frame rate in each composition is actually a preview rate that takes effect just while working in that comp. If you nest it into another comp that has a different frame rate, After Effects will honor this second comp's rate and process any nested sources at this new rate. When you render, After Effects honors the rate in the Render Settings and calculates all the animation at *this* final speed. But there's a way around that…

4 In the Timeline panel, click on the tab for the comp **11a-Preserve Rate*starter** to bring it forward again. Type ⌘ K (Ctrl K) to open its Composition Settings again. Then click on the Advanced tab in this dialog. Check the box next to the text "Preserve frame rate when nested or in render queue" and click OK. This will lock in this comp's frame rate regardless of what you do with it later.

Bring **11b-Output Rate*starter** forward again, and RAM Preview: Now you have your surveillance look again. Notice that the text animation proceeds at the same pace as before; it is obeying the frame rate of the comp it's in – not that of the nested comp.

Calming Down Effects

Now let's use that Preserve Frame Rate trick to alter the behavior of effects:

1 Open **Comps > 12a-Numbers*starter**, and RAM Preview it. This small composition contains a solid with Effect > Text > Numbers applied to it: a very handy effect for creating data readouts and the such.

2 Select the **numbers** layer and press **F3** to open its Effect Controls panel; you will notice that we've checked its Randomize option. RAM Preview: The numbers change every frame, making the result virtually unreadable.

Some effects such as Numbers randomize on every frame. To slow them down, you need to place them in their own precomp with a lower frame rate and enable Composition Settings > Advanced > Preserve Frame Rate.

3 Type **⌘ K** (**Ctrl K**) to open this comp's settings, enter a lower frame rate such as 5 fps, and click OK. RAM Preview, and now you can take in each number before it changes.

4 Open **Comps > 12b-Nested*starter**. Its frame rate is 29.97 fps. The **12a-Numbers*starter** comp is nested into it. RAM Preview, and you'll see the numbers randomize on every frame again. This is the exact same issue as you observed with the footage in the previous exercise.

5 Bring **12a-Numbers*starter** forward again, open its Composition Settings, click on the Advanced tab, enable the Preserve Frame Rate option, and click OK. Now when you RAM Preview **12b-Nested*starter**, your lower frame rate will "stick" for the numbers.

Open our final versions of these two in the **Comps_Finished** folder – there's a neat trick in there. In **12a-Numbers_final**, we kept the full frame rate of 29.97 fps, but enabled the Preserve Frame Rate option to lock it in. In **12b-Nested_final**, we duplicated this precomp several times, then gave each one a different Stretch value to slow them down while maintaining the stop motion look.

▽ tip

Blended Motion

To create an interesting, dream-like look, combine stop motion and frame blending. Render out an intermediate movie of your stop motion animation, import this render, add it to a composition, and enable frame blending for this new movie.

In our final version (left), we duplicated the nested numbers precomp several times, and used Stretch to vary their resulting frame rates (right). This trick works because the precomp's frame rate is locked at 29.97 fps thanks to the Preserve Frame Rate option.

#	Source Name	Stretch
1	12a-Numbers_final	500.0%
2	12a-Numbers_final	700.0%
3	12a-Numbers_final	600.0%
4	12a-Numbers_final	900.0%
5	12a-Numbers_final	450.0%
6	12a-Numbers_final	1000.0%
7	12a-Numbers_final	667.0%
8	12a-Numbers_final	875.0%
9	12a-Numbers_final	525.0%
10	12a-Numbers_final	750.0%

▽ tip

Freeze Frame

If you want to freeze a clip on a single frame
for its entire duration, make sure Time
Remapping is currently disabled, move the
current time marker to the desired source
frame, select the layer, and choose Layer >
Time > Freeze Frame. This will create a single
Time Remap keyframe at the chosen time.
You can scrub its value in the Timeline panel
(under the Switches column) to change it.

Time Remapping

In After Effects, you can keyframe almost anything – including time itself.
The door to this world is Time Remapping. This parameter allows you to define
which frame of a source should be playing at a specific frame of your comp.
After Effects will then speed up or slow down the footage as needed between
keyframes to make this happen.

Adding Handle

Before getting too insane, let's start with a common task: extending the duration
of a shot with a freeze frame.

1 Continue with **Lesson_07.aep**. If you've been following earlier exercises,
close the old comp panels; the shortcut again is to select either the Comp or
Timeline panel, then type ⌘ ⌥ W (Ctrl Alt W).

 In the Project panel, locate and open **Comps > 13-Freeze Frame*starter**,
and RAM Preview it. It contains a pan by the facade of the Supreme Court.
The problem is, the news editor wants the shot to be longer so he can build
and hold a title animation over it.

2 Select **Supreme Court.mov**. Then select the menu item Layer > Time > Enable
Time Remapping. The Time Remap property will appear in the Timeline panel,
with keyframes set at the beginning and end of the original duration of the layer.

2 Select Layer > Time > Enable Time
Remapping, and Time Remap keyframes will
appear for the layer. You can then drag the
layer's Out point later to extend the clip.
Footage courtesy Artbeats/Washington DC.

3 You might also notice that the area past the end of the layer in the timeline
has changed from being empty to having the "ghost" color that indicates there
is more of the clip to reveal. Drag the clip's Out point (the end of its layer bar)
to the end of the comp. Scrub the current time marker around the end of the
timeline; the clip will be frozen on the last frame.

4 What if you need additional handle at the head of the clip as well? Click on
Time Remap in the Timeline to select its keyframes and drag them later in time
(be sure to move them together, keeping the same number of frames between
both keyframes). The clip will freeze on the first frame and start playing when
it crosses the first Time Remap keyframe.

Time Remap Fun

You're almost done with this lesson, so let's get crazy: We're going to use Time Remapping to make a glass of milk dance.

1 Open **Comps > 14-Time Remap*starter**, which contains a super-slo-mo shot of a glass of milk being dropped. RAM Preview it or hold down ⌥ (**Alt**) and double-click it to open it in a QuickTime player. Scrub back and forth through the shot to get a feel for it.

Your task will be to alter the way this clip plays back to make it start playing in real time, slow down to a stop after it hits the table, then dance back and forth from there.

2 Select **Milk Drop.mov**, then select Layer > Time > Enable Time Remapping. Time Remap keyframes will appear in the Timeline panel at the beginning and

end of the clip. Let's set some additional Time Remap keyframes to mark important frames in the original clip:

• Scrub the current time marker while watching the Comp viewer, looking for the frame just before the glass appears (around 02:06). In the Timeline panel, click on the hollow diamond between the keyframe navigator arrows to set a keyframe here. The diamond will turn gold. Note the time readout under the Switches column; this keyframe is remembering the frame number of the source.

• Scrub until the glass hits the table, around 04:13. Add another Time Remap keyframe here.

• Scrub until the splashing milk strikes a nice pose, such as when the lower splash hits the table around 05:15. Set another keyframe.

• Pick one more good pose – such as around 07:05 – and set one more keyframe. These should be enough to have some fun with.

2 Scrub to find interesting points in time in the footage (top) and place Time Remap keyframes at these points (above). The time readout under the Switches column indicates the frame of the source footage. Footage courtesy Artbeats/Ultra Motion.

3 Move the current time marker to around 05:00, and press **N** to end the work area here. Then press **Home**, and zoom in a bit on the timeline. Make sure the Info panel is visible; press ⌘2 (**Ctrl** 2) if it isn't.

4 The time before the glass appears is boring, so delete the first Time Remap keyframe at 00:00. Click on Time Remap to select the remaining keyframes, and drag them back until the first keyframe you created is now at 00:00. (Add the **Shift** key after you start dragging and the keyframe will snap to the current time marker.)

4 Delete the first Time Remap keyframe, and drag the remaining ones back so that the first keyframe you created (around 02:06 in the original clip) is now at 00:00 in the comp.

5 Deselect the first keyframe, and drag the others so that they start at 00:10 in the comp (right). The Info panel will confirm the time as you drag (below). Note that the value of this keyframe is 04:13 – that's the frame of the source footage that will play by this time.

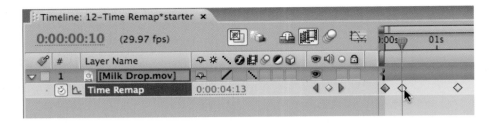

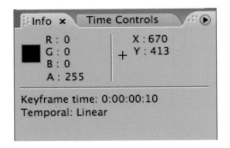

▽ tip

Speed Shift

Although Time Remapping plus Frame Blending can create that play fast/play slow trick you see in commercials and music videos, bear in mind that big budget productions shoot on high-speed film for better quality slow motion.

5 Our next idea is to make this drop appear as if it was happening at normal speed. To speed up playback, you need to reduce the amount of time between Time Remap keyframes.

Make sure all of the remaining Time Remap keyframes are still selected, then **Shift** +click on the first one to deselect just it. Drag your second keyframe to 00:10 in time. The Info panel will confirm where you are dragging it.

RAM Preview; the glass will drop fast, then slow down as soon as it hits the table – in other words, as soon as it crosses your second keyframe. Since you have not changed the spacing between the second keyframe and those after it, the clip will continue to play from here at its unaltered speed.

6 Now we want to slow down the milk splash until it stops, frozen at its first pose:

• **Shift** +click on the second keyframe to deselect it; the other Time Remap keyframes should remain selected.

• Increasing the time between Time Remap keyframes will slow down playback. Drag the remaining keyframes later in time, until the third keyframe is around 02:00 in the overall timeline.

• Deselect the third keyframe, and slide the fourth keyframe later to 05:00. Playback will now be slowed down from the second keyframe onwards.

• Select the third keyframe only, and press **F9** to apply Easy Ease to it. This will cause the playback speed to slow down as it approaches this keyframe, stop while on it, then speed up again as it moves past it.

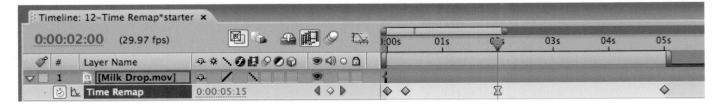

6 Your timeline should look like this after Step 6. By applying Easy Ease to the third keyframe, playback will slow to a stop at this keyframe, then pick up speed again.

RAM Preview to check your progress so far. The milk splash will slow down until it encounters the third keyframe, then resume playing again. (We've already enabled frame blending for you, so playback shouldn't look *too* rough…)

7 Time to make the milk dance by playing backward. To do that, we need to create a Time Remap keyframe that stores an earlier time than that stored by a previous keyframe.

7 By pasting an earlier Time Remap keyframe after a later one, you can re-order time so that playback backs up, then goes forward again.

• Select the second keyframe, which stores a source time of 04:13 when the glass first hit the table. Copy it.

• Move the current time marker to 03:00 (past the keyframe where the milk was splashing), and Paste.

RAM Preview, and absorb for a moment what is going on: Playback is initially fast, slows down to a stop, plays backward (retracing its steps to an earlier Time Remap keyframe), then resumes in the forward direction as playback progresses to the last Time Remap keyframe you created in step 2.

8 To see what's going on in a graphical manner, select Time Remap, and type **Shift F3** to open the Graph Editor. Click on the eyeball icon along the bottom and make sure Show Selected Properties is enabled. Then click on the icon to its right (Choose Graph Type) and make sure either Auto Select Graph Type or Edit Value Graph is selected.

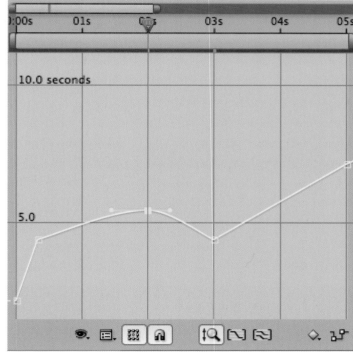

The white graph line indicates how time is progressing during this composition. It starts at just past 2 seconds into the clip (the first keyframe you created in step 2), moves very quickly to just past 4 seconds into the clip, moves more slowly to 05:15 (where it encounters the keyframe with Easy Ease applied), then plays in reverse (arcs downward) to just past 4 seconds. The upward slope after this keyframe indicates playback is going forward again.

Then click on the Choose Graph Type button again and select Show Speed Graph. Move your cursor along the graph and you'll get a reading for the velocity of the layer at that point in time. When viewing either graph type, you can toggle on Graph Type > Show Reference Graph; the gray line that appears will show you the other graph type for comparison.

8 The Graph Editor gives a more pictorial view of what is happening to the clip's playback over time. A steep slope means fast playback; a downward slope means playing in reverse.

This composition, up to this point in time, is saved in **Comps_Finished > 14-Time Remap_so far**. Feel free to continue from here by turning off the Graph Editor and further manipulating the Time Remap keyframes, or have fun applying time remapping to your own footage.

Idea Corner

The single most useful thing you learned in this chapter (aside from the pick whip tool) may well be the wiggle expression. It's something we use all of the time, creating everything from wild automated animations to slight "human" imperfections to our movements.

One of the richest areas to explore is using wiggle to control effect parameters. In the **Idea Corner** folder in this lesson's project file are a few simple examples of combining wiggle with effects:

In **Idea1-Nervous Text**, Directional Blur's Blur Length and Direction are both controlled by wiggle expressions.

Idea1-Nervous Text: We applied a Directional Blur effect to a text layer, then used wiggle to randomize both the blur's Direction and Blur Length parameters, creating a "vibrating with energy" look. We added expression controllers for the wiggle speed as well as the maximum blur length and angle; experiment with them to see the different looks they create.

When you preview this comp, you may notice that about half the time, you see no blur. This is because when you set the wiggle amount for blur length to, say, 100, wiggle is generating numbers between –100 and +100. However, Directional Blur doesn't understand the concept of a negative blur length, so it just calculates no blur when this value is less than 0. You will notice a similar result if you apply wiggle to a layer's Opacity: Since Opacity can't go below 0 or above 100, it will "clip" at these values.

Idea2-Lens Flare: We used a wiggle expression on the Flare Brightness parameter to cause the flare to flicker.

Wiggle's random values are always added to a parameter's underlying value. We keyframed this value – Flare Brightness – to decrease as the time lapse footage behind faded into night.

We then added one more trick by basing wiggle's "how much" parameter (the second number inside the parentheses) on this underlying value, so the number that wiggle adds also fades down over time.

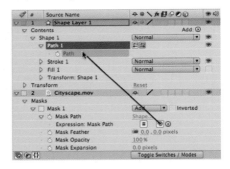

In After Effects CS3, you can link Mask Paths, Paint Strokes (Lesson 10), and Shape Paths created with the Pen tool (Lesson 11). Make sure you enable expressions for and drag the pick whip tool between parameters named "Path."

In **Idea2-Lens Flare**, wiggle causes the lens flare to flicker. Footage courtesy Artbeats/Timelapse Cityscapes.

Idea3-Electric Arcs: We employed the Lightning effect applied to a solid layer. With Lightning, you can define where the bolts start and where they end. We set the start to be the middle of the comp, then let wiggle decide where they should end, resulting in a wandering arc that searches around the frame.

In **Idea3-Electric Arcs**, wiggle is used to randomize the end points of a trio of Lightning effects.

We added Expression Controls for the speed and amount, applied to a null object. We could then duplicate the solid layer that had the lightning effect, and all of the duplicates would point at the same master controller layer. Also remember that wiggle behaves differently for every layer it is applied to – so the result was three independently wandering arcs of electricity.

Quizzler

• Play the movie **Quizzler > Quiz_Gears.mov**. There are three wheels, scaled 100%, 50%, and 25%. Only the largest one has keyframes, but they all stay in perfect sync. How would you make this happen using expressions? Use the comp **Quizzler > Quiz_Gears*starter**; two different solutions are saved in the **Quizzler Solutions** folder.

When wheels touch, they rotate in opposite directions. And their speeds are based on their relative sizes. Can you create the expressions needed to make this work?

• In Lesson 3, you learned how to loop footage. In this lesson, you learned how to loop keyframes. Can you loop an entire composition? Yes, you could nest it and then duplicate it end to end, or render it out, import the resulting movie, and loop that in Interpret Footage. But in this lesson you've also learned a pair of techniques that can be combined to loop a nested composition as a single layer without having to render it first. See if you can figure it out using the **Quiz_Looped Comp*starter** comp. The answer is in **Quizzler Solutions > Looped Comp**.

▼ More on Expressions

There are a number of references available on expressions and the JavaScript language, including an extensive chapter plus a bonus PDF in our *Creating Motion Graphics with After Effects* series. Also well worth checking out are the following resources:

www.motionscript.com

This website teaching expressions and scripting was created by Dan Ebberts, a true expert in these areas. Dan has also written several advanced expression tutorials and actively answers questions on a number of online forums.

www.aenhancers.com

This community web forum includes discussions, tutorials, and a library of After Effects expressions, scripts, and Animation Presets.

JavaScript – A Beginner's Guide
by John Pollock (Osbourne)

Most JavaScript books assume you want to use this language to program advanced web pages. But this book also contains some of the simplest, clearest explanations we've seen of the JavaScript language and how it works.

3D Space

Add a new dimension to your animations.

Getting Started

Make sure you have copied the **Lesson 08-3D Space** folder from this book's disc onto your hard drive, and make note of where it is; it contains the project file and sources you need to execute this lesson.

3D Space is one of the most rewarding areas to explore in After Effects. A simple switch allows each layer to move in the Z dimension – closer to and farther away from the viewer – in addition to left and right. Layers may also be rotated in 3D, which gives the ability to view them from new angles. You can selectively add cameras and lights to a composition, allowing you to cast shadows and move around your imaginary 3D world.

The beauty of 3D in After Effects is that you don't *have* to build an entire world to use it – you can be quite selective, adding a little perspective here, a little lighting there. If you're new to 3D and a little apprehensive, don't worry – we'll go slowly, adding to your skill set a step at a time with useful graphics tricks.

Basic 3D

Any After Effects layer can be placed into 3D space. Even without adding lights or cameras, this allows some neat perspective tricks, plus it permits objects to move more naturally as they animate about your composition.

As soon as you enable the magical 3D Layer switch, some of the rules change with regards to how you move and arrange layers in the Comp and Timeline panels. We'll use this first exercise to get you up to speed on this new reality.

1 Open this lesson's project file **Lesson_08.aep**. In the Project panel, locate and double-click **Comp > 01-Basic 3D*starter** to open it. It contains two overlapping text layers. First, let's reinforce the way you would normally interact with these layers:

• With 2D layers, the stacking order in the timeline determines who renders on top. Swap the order of **Enter a New** and **Dimension** in this comp; the higher one in the Timeline panel is the one drawn the most forward in the Comp viewer.

• With 2D layers, you can move them only in the X (left and right) and Y (up and down) dimensions. To make a layer appear to move closer or farther away, you need to play with its Scale value.

• 2D layers rotate like a pinwheel around their Anchor Point. (We've already centered the Anchor in these text layers to get a nice rotation.)

Mastering 3D space opens the door to natural multiplaning, creating 3D logos, bringing illustrations to life, and adding new dimensions to still photographs.

2 Undo any of your experimenting in step 1 to return to **Enter a New** on top of **Dimension**, both set to 100% scale. Make sure the Switches column is visible in the Timeline panel (press **F4** if it isn't).

Select both layers, then click in the hollow box underneath the three-dimensional cube icon: This is the 3D Layer switch. The layers will not change size or place in the Comp viewer. However, you *will* see red, green, and blue axis arrows sticking out of the Anchor Points of layers that are selected. Press **P** to reveal their Position values: There is now a third value, known as Z. It defaults to 0.0.

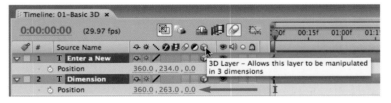

2 When you enable their 3D Layer switch, layers gain a third Position value: Z (top). In the Comp panel, selected 3D layers will have a set of red, green, and blue axis arrows sticking out of their anchor points (above).

▼ Scale, Quality, and 3D

Scaling up beyond 100% usually reduces image quality. But with 3D layers, you can't just look at their Scale value; its size also depends on how close it is to the virtual camera.

To tell if a layer is being scaled larger than 100%, duplicate it, turn off the 3D Layer switch for the duplicate, and set its

Scale to 100%. If the duplicate is still the same size or larger than the 3D version, you're okay. If the duplicate is smaller, you are "blowing up" the 3D version – get a higher resolution source, or move the layer farther away from the camera.

Layers that continuously rasterize (see *Render Order Exceptions* at the end of

Lesson 6) are your friend in 3D space, as After Effects can re-render them as needed so that they stay sharp. This includes all text layers. You can enable an optional Continuous Rasterization switch (the sunburst icon) for Illustrator artwork; we've already done that for you as required throughout this lesson.

🖊	#	Source Name	⬇ ✳ ↖ ⊘ ⊟ ○ ○ ◉	◉ ◀) ○ 🔒
▽ ☐	1	T Enter a New	⬇ ✳ /	▢ ◉
·		⏱ Position	360.0 , 234.0 , 0.0	
▽ ☐	2	T Dimension	⬇ ✳ /	▢ ◉
·		⏱ Position	360.0 , 263.0 , -125.1	

3 As you reduce the Z Position value for a 3D layer (left), it will move toward you, including moving in front of other layers with a higher Z Position value (right), regardless of the stacking order in the Timeline panel.

Axis Arrows Guided Tour

We've created a movie that shows how to manipulate the axis arrows. It is located in this lesson's folder in the **08-Guided Tours** folder.

4 If you see an X, Y, or Z next to the cursor, your dragging will be constrained to this dimension. (X is red, Y is green, and Z is blue.)

🖊	#	Source Name	⬇ ✳ ↖ ⊘ ⊟ ○ ○
▷ ☐	1	T Enter a New	⬇ ✳ / ▢
▽ ☐	2	T Dimension	⬇ ✳ / ▢
·		⏱ Orientation	0.0 ° , 0.0 ° , 0.0 °
·		⏱ X Rotation	0 x +0.0 °
·		⏱ Y Rotation	0 x -45.0 °
·		⏱ Z Rotation	0 x +15.0 °

5 3D layers have four rotation parameters: Orientation, plus Rotation for X, Y, and Z.

3 Press **F2** to deselect the layers. While closely watching the Comp viewer, scrub the third Position value (Z) for **Dimension**. As you scrub to the left to reduce the Z Position value, **Dimension** will appear to grow larger as it comes toward you. As you scrub to the right (increasing Z Position), it will appear to grow smaller as it moves away from you.

Key Concept #1: *The size a 3D layer is drawn is determined by a combination of its Scale value and how close it is to the camera. (If you have not explicitly created a camera, After Effects uses an invisible default camera.)*

There is a second phenomenon you might have noticed: If the Z Position value for **Dimension** is less than the Z Position for **Enter a New**, **Dimension** will appear to pop in front of **Enter a New**, even though **Dimension** is below it in the timeline.

Key Concept #2: *With 3D layers, stacking order in the Timeline panel no longer determines which one draws on top in the Comp viewer. What matters now is how far they are from the camera.*

4 In addition to scrubbing the Position values for 3D layers, you can also drag them around in the Comp panel. However, pay attention to the cursor as you try this:

• If you place the cursor near the layer's Anchor Point and do not see an additional letter at the cursor's tail, you can freely drag a layer in any direction.

• If you see an X, Y, or Z next to the cursor, your dragging will be constrained to that dimension. To ensure you get this special cursor, place it near the desired axis' arrow.

5 Set **Dimension**'s Z Position back to 0. With **Dimension** selected, press **R**: Instead of getting just Rotation, you will see *four* parameters! Here's what they do:

• Orientation is used to "pose" a layer in 3D space – for example, to face up or to the right. This parameter won't animate as you might expect, so don't use it for keyframing.

• Z Rotation is the same as the normal 2D Rotation you're used to.

• Y Rotation spins the layer around its vertical (up/down) axis. Go ahead and scrub it!

- X Rotation spins a layer around its horizontal axis.

You can scrub these Rotation values, or press **W** to select the "Wotate" (Rotate) tool and manipulate them directly in the Comp panel. (Keep an eye out for the axis letters popping up next to the cursor – like Position, they indicate your dragging will be constrained to that one dimension.)

As you play with X and Y Rotation, you should notice that **Dimension** will appear to intersect **Enter a New** as portions of them cross – another cool bonus of 3D space.

6 Scrub **Dimension**'s X or Y Rotation values to 90° while watching the Comp viewer: They will disappear when viewed on-edge.

Key Concept #3: *3D Layers in After Effects do not have any thickness. This is their main limitation and is the primary reason you may need to use a real 3D program to achieve certain looks.*

Press **V** to return to the Selection tool. Continue to experiment with Position and Rotation values for **Enter a New** and **Dimension**, including enabling keyframing for them and trying an animation or two.

If you feel more like watching than doing right now, twirl down the **Comps_Finished** folder in the Project panel and double-click **01-Basic 3D_final** to open it. Press **0** on the numeric keypad to RAM Preview. We've animated Z Position and Y Rotation for the two text layers to make them fly and swivel into position.

Once you've digested this, open **01-Basic 3D_final2** and RAM Preview. In this comp, we removed the Position animation and instead applied a 2D Text Animation Preset to each text layer. (If you have CS3, you can now animate text in 3D on a per-character basis; this is covered at the end of Lesson 5.)

5–6 You can rotate 3D layers in each of its three dimensions as well. Note how **Dimension** intersects **Enter a New** as they cross. When you rotate a layer perfectly on-edge, it will disappear; 3D layers have no thickness.

▼ **Not Intersecting?**

If you are certain 3D layers should be intersecting each other, and they're not, try the following:

- In After Effects 7, open Composition > Composition Settings, click on the Advanced tab, and make sure the Rendering Plug-in popup is set to Advanced 3D.

- If there is a 2D layer between your 3D layers, it will "break the rendering order" and prevent them from intersecting. Re-arrange the layers in the timeline.

In **Comps_Finished > 01-Basic 3D_final 1** we animated Z Position and Y Rotation to fly and swivel the layers into place.

1 In 2D, the relationships between layers do not change when they move as a group. Illustration courtesy Russell Tate/iStockPhoto.

▽ tip

3D View Shortcuts

You can use **F10**, **F11**, and **F12** to quickly switch between alternate 3D Views. To change which view is assigned to which key, select your desired view, hold down the **Shift** key, then press **F10**, **F11**, and **F12**.

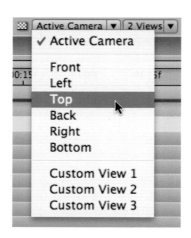

5 The 3D View menu offers six orthographic views and three custom views in addition to the Active Camera view. Only the Active Camera view can be rendered.

Multiplaning

Perspective in 3D is not just placing things closer, farther away, or at an angle to the camera. Another important 3D trick is known as *multiplaning* where objects close to you whiz by quickly, while those farther away appear to move more slowly. This phenomenon can be faked in 2D by animating each object by hand. In 3D space, it happens naturally. While demonstrating this trick, we'll also show you some alternate ways to view your work.

1 In the Project panel's **Comps** folder, double-click **02-Multiplaning*starter** to open it. This composition contains a set of 10 layers, all parented to a Null Object. RAM Preview this comp: All of the buildings drift from right to left, as if locked together.

2 The plan is for you to arrange each of the buildings and trees at different distances from the imaginary camera. Type **⌘ A** on Mac (**Ctrl A** on Windows) to select all of the layers. Enable the 3D Layer switch for any one of them, and it will be enabled for all selected layers. Type **P** until Position is revealed for all of the layers, then press **F2** to deselect them (otherwise, you might accidentally edit all of the layers at the same time!).

It is easy to lose perspective (pardon the pun) when viewing only the result. Therefore, After Effects provides a number of alternate 3D views. You can also see more than one view at the same time, making it easier to understand what is going on.

4 Along the bottom of the Comp panel is the Select View Layout popup menu; it currently says 1 View. Click on it and choose 2 Views – Vertical. The Comp panel will split into two.

5 With the Selection tool active, click in the top half of the Comp panel and look at the 3D View popup to the left of Select View Layout: It should say Active Camera (if it doesn't, set it to this). The Active Camera is what your 3D camera sees and is the view that will ultimately render.

Click in the bottom half of the Comp panel, then on the 3D View popup. The first six choices below Active Camera are called *orthographic* views. These are the standard "drafting" views that observe your 3D scene from a specific side,

with no 3D perspective distortion. Select Top for now; think of this as looking down on your "stage."

Click on a layer in the Comp view; it will be highlighted in the Timeline panel. Scrub the Z Position (the third value) for this layer to a negative value: You will see it move down in the Top view (toward the camera), while the same object comes forward in the Active Camera view.

Select the lower view (there will be yellow triangles in the corners of its Comp panel) and click on the 3D View popup again. The last three choices are temporary camera angles you can use while rearranging layers. Select Custom View 3. Now as you scrub the Z Position for a layer, you get a much better idea of what's going on on your "stage."

6 Move the buildings, trees, and clouds (but not the null!) back and forth in Z to create an arrangement you like. Press **Home** and **End** as needed to see all the layers in the Active Camera view.

7 When you think you're getting close to a good arrangement, RAM Preview: The Active Camera view (the top) will calculate and play back your animation. Now as the buildings drift past, the objects closer to your imaginary camera (lower Z Position values) move faster, and those farther away (higher Z Position values) move more slowly, causing their relationships to change over the course of the animation. Note that you didn't have to create any additional Position keyframes!

Continue to tweak. When you want to see your final animation at full size, set Select View Layout to 1 View and 3D View to Active Camera, and preview again. For comparison, our version is saved in **Comps_Finished > 02-Multiplaning_final**. Save your project before moving on.

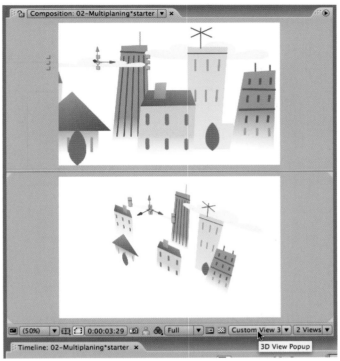

4–6 To better visualize the position of objects in 3D space, it is helpful to set the View Layout to 2 or 4 Views, then pick different 3D Views for each. Here we have set the top view to Active Camera and the bottom to Custom View 3.

7 In 3D, the relationships between layers arranged at different positions in "Z space" drift automatically as they move.

The goal in this exercise is to have the two words arc in and slam down in 3D space. Editing their motion paths will be trickier than working in 2D.

3 Move **Under** toward the upper left, and pull it forward in Z (top). Then drag its keyframe handles to create an arcing motion path (above).

3D Animation

We often tell clients "it's called 3D because it takes three times as long." This is particularly true when it comes to editing motion paths for a 3D layer, as you need to look at the path from multiple angles to fully understand what's happening.

1 With the Comp or Timeline panel forward, type ⌘ ⌥ W (Ctrl Alt W) to close the previous comps. Return to the Project panel and open **Comps > 03-3D Animation*starter**.

This comp contains four small layers with their 3D Layer switches already enabled, and are slightly separated in Z. Your goal is to make the layers **Under** and **Pressure** fly down into their current locations.

2 Since **Under** and **Pressure** are already in their "at rest" positions, this is a good place to set keyframes:

• Move the current time marker to around 01:00.

• Select **Under** and **Pressure**, and press ⌥ Shift P (Alt Shift P) to turn on the stopwatches for Position and reveal this property in the timelines.

3 Think about where you want these layers to fly in from. For example, it may be fun to have **Under** fly in from the upper left, and **Pressure** from the lower right, both starting out closer to the viewer.

• Press Home to return to 00:00.

• Press F2 to deselect the layers.

• Drag **Under** to the upper left of the frame; this moves it in X and Y.

• Hover your cursor over **Under**'s blue axis arrow until you see a Z appear next to it. Click and drag to the right, and you will pull **Under** forward in Z (you can confirm this by watching its Position Z value in the Timeline panel).

• The dotted line in the Comp panel is **Under**'s motion path. Look for the slightly larger dots; these are the handles for the keyframes. Click and drag these dots to create an arcing motion path. If you can't see them, press ⌘ (Ctrl), click on the keyframe icon in the Comp viewer and drag out the handles (you may need to move in time so you can see the icon clearly).

• Repeat the same for **Pressure**, making it arc in from a different location at 00:00, and changing its Position Z value.

Editing in Multiple Views

By working just in the Active Camera view, you've seen only part of the picture of what's really going on with your motion paths.

4 Set the 3D View popup to Left to view the layers edge-on from the side. Select **Under** to see its motion path. Scrub the time marker and you might see that this layer is actually sliding in from above, rather than slamming straight down.

To edit more interactively, set the Select View Layout popup to 4 Views. Click on the upper left view, and set its 3D View popup to Top. Set the upper right view to Front, the lower left view to Left, and the lower right view to Active Camera. This way, you can see your path from all angles as well as the final result.

(You will probably need to reduce the Magnification to 50% for each view to fit everything in. If you still have trouble seeing all the layers, turn the page and read *Using the Camera Tools.*)

5 Select **Under** again to reveal its motion path. Drag the motion path handles in the Left view while watching the result in the other views. Try to arrange a straighter entry into the second keyframe, while keeping the swooping-in motion you had originally. This will require some back-and-forth editing to get it the way you want. Press **0** to RAM Preview, and the Active Camera view will play back your results. After you're happy, click on the word Position for **Pressure** to highlight its motion path, and adjust it.

Feel free to get more creative with the move, such as starting the words completely off-screen. Our version is in **Comps_Finished > 03-3D Animation_final**. Of course, yours does not have to look like ours – just as long as you feel you have a better grasp of editing motion paths in 3D space. Save your project before moving on.

After you have set up your animation, select a layer and choose Layer > Transform > Auto-Orient. Choose the Orient Along Path option and click OK. The layer will now bank and turn as it zooms down into position. We used this trick in our **03-3D Animation_final2** comp.

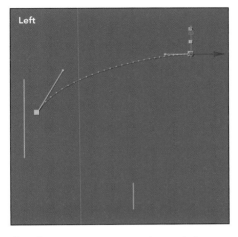

4 When you view your motion path from the Left view, you may find it doesn't arc into its final position quite as you had planned. This is the danger of editing paths only in the Active Camera view.

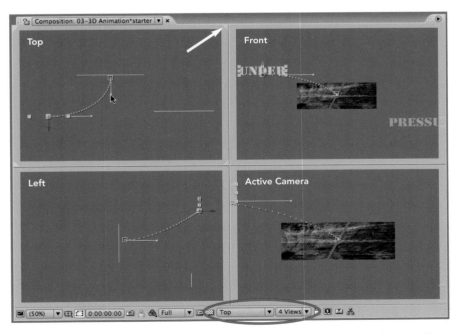

5 Edit in one view while watching the result in the other views (the selected view will have yellow triangles in its corners). It will take a bit of compromise to get a path you're happy with. Remember, what really counts is the result in the Active Camera view!

Cameras in After Effects by default have two points: a Position (the body of the camera) and a Point of Interest (where the cursor is pointing). Its field of view is illustrated by the lines radiating out at angles from the camera's body.

The 3D Camera

Moving layers in 3D space is very useful, but the real fun happens when you move a camera through that space. Once you know how to animate a 3D layer, you have mastered most of what you need to animate a camera. The main differences are:

• Its "anchor point" is called its Point of Interest. Rather than a center point, this is where the camera is being aimed.

• It has an Angle of View or Zoom parameter, which affects the perspective of the layers it is viewing.

• There is a different set of tools used to move and view it. Read about them in *Using the Camera Tools* on the next page.

Adding a Camera

Nothing demystifies a feature like using it, so let's dive in!

1 With the Comp or Timeline panel forward, type ⌘ ⌥ W (Ctrl Alt W) to close the previous comps.

Return to the Project panel and open **Comps > 04-Basic Camera*starter** – it contains an expanded version of the logo from the previous exercise. The layers that make up the logo have already been arranged in 3D space for you. Rather than animate these layers, this time you're going to animate a camera around them. They should have their Position values exposed; we've arrayed them around Z = 0.0, as this will be the center of our "universe."

2 Select Layer > New > Camera; the Camera Settings will open. The Preset popup near the top simulates a number of common lenses. Higher numbers are telephoto lenses, which means the camera will have a large Zoom value and reduced perspective distortion; smaller numbers are wide-angle lenses, which translates to a small Zoom value and exaggerated perspective distortion.

The 50mm preset matches the comp's invisible default camera, so pick it for now. Disable the Enable Depth of Field option and click OK.

3 Make sure your new **Camera** layer is selected. Press **P** to reveal its Position, then **Shift A** to reveal its Point of Interest. Note that the Point of Interest's Z value is 0.0, which places it in the center of our logo layers.

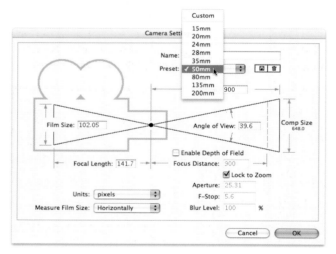

2 Select New > Layer > Camera, and select the 50mm preset (which has a Zoom value of 900).

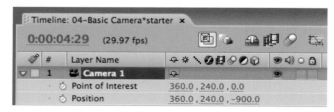

3 Initially, the X and Y values for the camera's Position and Point of Interest are the middle of the comp. Position's Z equals the Zoom value, while Point of Interest's Z is set to 0.0.

▼ Using the Camera Tools

After Effects provides special Orbit and Track Camera tools for moving the 3D camera. These same tools may be used to zoom and pan around the alternate 3D views. They are selected from the Toolbar; you can also press **C** to toggle between them.

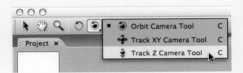

△ The Orbit and Track Camera tools can be used for moving the camera and moving around inside the 3D views. Remember their shortcut key: **C**.

Moving the Camera

To use these tools for manipulating the camera, you need to be in a Camera view (such as Active Camera or Camera 1) and have a camera layer selected.

Orbit Camera Tool: Use this tool to rotate how the camera views the scene. If the camera's Auto Orientation is set to Orient Towards Point of Interest (the default), you will be moving the body of the camera (its Position), and it will pivot about its Point of Interest. If the camera's Auto Orientation is Off, you will be editing the Orientation values for the camera.

Track XY Camera Tool: This tool pans around a scene by moving the camera up, down, left, and right. It edits the X and Y Position and Point of Interest values.

Track Z Camera Tool: Use this tool to push the camera in on a scene or to pull it back. It edits the camera's Z Position and Point of Interest values.

The biggest "gotcha" comes when you create one keyframe for the camera's Position, go to another point in time, and move the camera using the Orbit Camera tool to create a second Position keyframe. Although you may have seen a nice arc while you were moving the camera in the Comp view, the resulting motion path will be a straight line between keyframes. Edit their Bezier handles to create a rounded arc.

Navigating the Views

If you are in any of the Orthographic (Front, Left, Top, Back, Right, Bottom) or Custom views, these tools do not edit the camera's values. Instead, they zoom and pan around these views strictly for preview purposes.

Orbit Camera Tool: This tool works only in the Custom views. You can use it to re-pose these temporary views on your 3D scene.

Track XY Camera Tool: This replaces the Hand tool and pans around your view.

Track Z Camera Tool: This acts as a continuous zoom tool, allowing you to smoothly zoom in and out on your view without having to pick a specific value such as 50%.

Camera Tools Guided Tour

We've created a movie that shows how to use the camera track/orbit tools. It is located in this lesson's folder inside the **08-Guided Tours** folder.

△ The Orbit Camera tool affects the Position of a default 2-point camera (left) or the Orientation of a 1-point camera (right).

△ If you find yourself zoomed in too close in a view (left), use the Track Z Camera tool to zoom out and the Track XY Camera tool to re-center your view (right).

▼ The Camera Settings Dialog

This initially daunting dialog is really just asking you two things: how wide or narrow is the camera's field of view, and how much it should blur out-of-focus layers.

If you are familiar with cameras and lenses, this dialog gives you a number of ways to precisely define your camera, including by Angle of View (a common 3D program parameter), or by focal length and film/sensor size. You can also define your depth of field by aperture or f-stop.

If you are a camera newbie, the parameter you are most interested in is Zoom. The Zoom value is in pixels. When the camera is this many pixels away from a layer, the scale of the layer will not be altered in 3D space. All other layers will appear larger or smaller depending on how close to or far away they are from the camera. The smaller the Zoom value, the more exaggerated this effect will be.

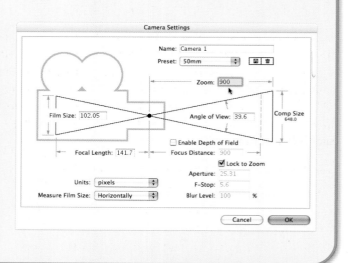

4 Set up 2 Views in the Comp panel: Active Camera (upper) and Top (lower). Use the Camera Track tools to zoom out and pan the Top view until you can see the camera and the layers. Background courtesy Artbeats/ Liquid Abstracts.

4 In the Comp panel, select 2 Views – Vertical. Set the upper view to Active Camera, and the lower view to Top. You will probably need to set the Magnification for both to 50%.

Is the Top view zoomed in too close to see the camera as well as the layers? Hover the cursor over the Comp panel and press **C** until the cursor changes into a two-way arrow (the Track Z Camera tool). In the lower view, drag down or to the left until the camera's field of view outline is about half the width of the viewer. Press **C** twice to change the cursor to a four-way arrow (Track XY Camera tool) and drag upward until the layers and the camera are centered in this view. (These tools are discussed in more detail in *Using the Camera Tools*.)

Moving the Camera

5 As with any 3D layer, you could scrub the camera's values in the Timeline panel or drag it directly in the Comp panel (the same rules for axis constraints apply).

For a more interactive experience, select the Orbit Camera tool: With the cursor over the Comp panel, press **C** until it changes into a ball with an arrow curving around it. Drag around in the Active Camera view (the upper one) and watch how the camera moves in the Top view below. You can also watch the Position values change in the Timeline panel.

Press **V** to switch back to the Selection tool. In the Top view, drag the boxy camera icon (this is its Position); notice how moving it changes the perspective in Active Camera view.

6 Make sure the lower view is selected – there will be yellow triangles in its corners. Set the 3D View popup for it to Front.

In the Front view, carefully click on the crosshair: This is the camera's Point of Interest, which determines what is centered in its sights. Drag it while watching the result in the Active Camera above to get a feel for how it works. Also try dragging it in other views, such as Custom View 3.

7 Time for the payoff: setting up a camera move!

• Press **Home** to make sure you are at 00:00.

• Click on the stopwatches for **Camera**'s Point of Interest and Position to enable keyframing.

• Use whatever combination of tools and views you prefer to set up a camera pose you like.

• Press **End** to move to the end of this comp and set up a new camera pose.

RAM Preview and observe your camera move. Even though you set up the start and end poses, you might not be happy with how it looks in the middle. Rather than adding a third keyframe, try adjusting the motion paths for the camera's Position and Point of Interest. These are common Bezier paths, just like those you edited for 3D layers in the previous exercise. You can switch Select View Layout to 4 Views to get a better picture of your path, or pick one view at a time to work in.

Our version is **Comps_Finished > 04-Basic Camera_final**. We decided to leave the Point of Interest focused on the middle of the logo, and instead created a series of alternating fast and slow Position moves to generate surprise and excitement. We enabled motion blur for the logo layers to further enhance the impression of speed.

5 Use the Orbit Camera tool to pose the camera off-axis to the logo.

6 Use the Selection tool to move the Point of Interest, changing what is centered in the camera.

Motion blur enhances the effect of fast 3D camera moves – but there is a render penalty involved.

Cameras and Auto Orientation

Both 2D and 3D layers can be set to automatically orient themselves along their motion paths. 3D cameras bring a couple of new twists to this idea…

2 In the layout 2 Views – Horizontal, with the Camera layer selected, you can see an overview of the camera path on the left and the result on the right. Initially, the camera always points toward its Point of Interest; a graphical line connects the camera's body to this point.

3 The camera offers several Auto-Orient options (right). When set to Off, the camera faces wherever it is pointed – not toward its Point of Interest (below).

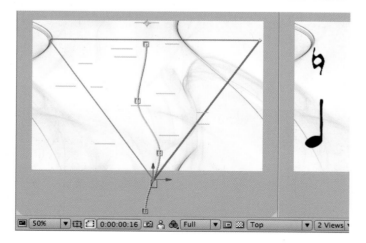

1 In the Project panel's **Comps** folder, double-click **05-Orientation*starter** to open it. This composition contains a number of music symbols hanging in 3D space, a 3D camera, and a 2D background plus soundtrack. RAM Preview; the camera gently weaves through the notes.

2 Set Select View Layout to 2 Views – Horizontal. Verify that the left view is set to Top and the right view is set to Active Camera.

Select the camera and study its path: We have set its Point of Interest to focus on the last symbol and animated its Position (the camera's body). As the camera body moves left and right, it turns to always face its Point of Interest.

Alternate Orientations

Let's say we want a more exciting animation. This default *2 point camera* can be a bit tricky to animate for complex flight paths, as you would have two motion paths to worry about – so let's try some alternatives.

3 Select the camera and open Layer > Transform > Auto-Orient. Select the Off option and click OK. The Point of Interest – and the line that connects it to the camera in the Comp views – will disappear. This is known as a *1 point camera* as now you have only Position to deal with. Drag the current time marker through the timeline while watching the Comp panel; now the camera will always point straight ahead.

If the camera were a car or airplane, it would turn to follow its motion path rather than always face the same direction. You can animate the rotation of the camera to simulate this turning. Or, you can let After Effects do the work for you!

4 With the camera still selected, again open Layer > Transform > Auto-Orient. Select the option Orient Along Path and click OK.

As you drag the current time marker through the timeline, in the Top view you will see the camera automatically

turn to follow its path. In the Active Camera view, the result will be a much more obvious movement as the camera swoops around. This makes it easy to create thrill-ride-style 3D camera animations.

However, be aware that using the Orient Along Path option will often require more work on your part! Make sure there is always something interesting to look at as the camera swings around. You may also need to smooth out kinks in your motion path that will cause sudden camera movements. This is where mastery of the Graph Editor and use of the Roving Keyframes option (both discussed in Lesson 2) come in handy.

Orient Towards Camera

RAM Preview or scrub the current time marker through time. As the camera swings along its path, it occasionally looks at some of the musical symbols from quite a skewed angle. The resulting perspective distortion can often look interesting. Other times, it distorts objects like client logos a bit too much for their taste, and can break the illusion of 3D space as you view layers from their sides. Therefore, there's one more auto-orientation trick you should know about:

5 Click on layer 2 (**repeat**) and ⬚*Shift*+click on layer 14 to select all of the music symbols. Study the Comp panel for a moment, in particular how the axis arrows for the symbols are all pointing in the same direction.

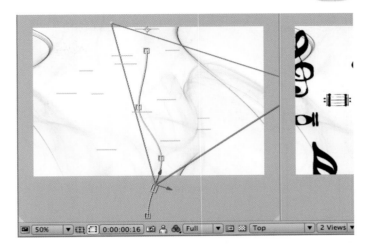

4 Setting the camera to Orient Along Path means it will automatically steer along its motion path, creating more obvious movements during its flight. (However, it does not "bank" the camera to lean into its turns the way an airplane or bike rider might. To simulate this, you will need to manually keyframe the Z Rotation for the camera.)

Open Layer > Transform > Auto-Orient again – this time for the 3D layers, rather than the camera. Select the option Orient Towards Camera, and click OK. Watch what happens in the Comp panel: All of the symbols swivel to face directly toward the camera. You can really see this behavior when you scrub the current time marker. (If you are uncertain whether you followed our directions correctly, compare your result with our **Comps_Finished > 05-Orientation_final**.)

5 Normally, layers point where they're told by their Orientation and Rotation parameter (left). However, 3D layers can be set to automatically orient toward the 3D camera as it moves around (right). (The arrow is pointed at the camera.)

1 If no lights are present, 3D layers are evenly lit. Footage courtesy Artbeats/ Time & Money.

▽ tip

Light Settings

To edit a light's settings, double-click it or select it and type **A** **A** to reveal its parameters in the Timeline panel.

3 You can edit the Light Settings when you make a new light, or any time later during a project. These settings can also be edited in the Timeline panel.

3D Lights

If you don't add a light to a scene, After Effects will automatically illuminate all 3D layers equally so that they are just as bright as they were as 2D layers. However, adding a 3D light can considerably enhance the mood of a scene.

1 Save your project. Click on the Comp Viewer drop-down menu (along the top of the Comp panel) and select Close All to close all open comps. Then open **Comps > 06-Basic Lights*starter**. It contains a single 2D video layer.

2 To see the results of 3D lights, you need at least one 3D layer.

• Enable the 3D layer switch (the cube icon) for **Clock.mov**.

• Then enable the Lock switch for the layer so you don't accidentally move it while playing with your light.

3 Select the menu item Layer > New > Light. The Light Settings dialog will open. Let's go over some of its parameters:

• *Light Type* decides how the light rays are cast. *Ambient* illuminates everything evenly; *Parallel* casts straight rays as if from a distant source. More useful are Spot and Point. *Point* is akin to a bulb hanging in space. *Spot* is the most versatile, as you can control how narrow a cone it casts. Choose Point for now.

• *Intensity* is the brightness of the light. It can be cranked over 100% to blow out a scene or reduced below 0% to create pools of darkness in a complex scene. Set it to 100% for now.

• *Cone Angle* and *Cone Feather* are available only with the Spot light type. They control how wide an area of light is cast and how soft its edges are.

• *Color* is – ta da! – the color of the light. Start with a white light. You can later change it to a pale blue to cool down a scene, or a pale orange to warm it up.

• We'll deal with shadows in the next exercise, so leave them off.

Give your light a useful name such as "**First Light**" and click OK. (If you get a warning dialog, you missed step 2.)

4 The corners of **Clock.mov** will darken a bit as the light falls away, creating a subtle vignette. **First Light** should be selected; press **P** to reveal its Position, then **Shift** **T** to reveal its Intensity.

Timeline: 06-Basic Lights*starter ✕

0:00:00:00 (29.97 fps)

✎	#	Source Name
▽ □	1	💡 **First Light**
		⏱ Position
		⏱ Intensity
▷ □	2	Clock.mov

Position: 295.0 , 149.0 , –37.0

Intensity: 250%

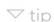

4 Point lights can be used to create simple vignettes and hot spots by playing with their position and increasing their intensity.

• Scrub the Z Position parameter for **First Light**. As the light moves closer to the layer, the illuminated area will shrink; back it away, and the layer will be illuminated more evenly.

• You can also scrub the X and Y Position values or place your light interactively by dragging it around the Comp viewer. The same rules apply as for any other 3D layer: If you click on one of the axis arrows or otherwise see an axis character next to your cursor, your dragging will be constrained to that dimension.

• Scrub Intensity: It controls how brightly the layer is lit. (Return it to 100% when you're done.)

5 Double-click your light layer (**First Light**) to re-open its Light Settings. Set Light Type to Spot, Cone Angle to 60, and Cone Feather to 0. Click OK, and now you will have a sharply defined pool of light, rather than a soft vignette. (If the pool is very small, set the light's Z Position to -400 to back it away from the layer.)

A long list of parameters should twirl open in the Timeline panel. You will see that Spot lights are similar to normal 3D cameras in that they have both a Position and a Point of Interest. Just like a camera, the Point of Interest helps you aim the light. If the light is selected, you will see both the light's body and its anchor-point-like Point of Interest in the Comp panel. Practice dragging these around to develop a feel for how they work.

Now experiment with scrubbing its Cone Angle and Cone Feather parameters. You can quickly achieve a variety of cool looks – especially when you also manipulate its Position and Point of Interest to control the angle the light is cast! In **Comps_Finished > 06-Basic Lights_final**, we had fun animating the light's parameters. Play with your own light and save your project before moving on.

▽ tip

Flickering Lights

Try adding a wiggle expression (Lesson 7) to a light's Intensity to make it flicker. Cone Angle and Cone Feather are fair game as well. Apply wiggle to a spot light's Point of Interest to create an automatic searchlight.

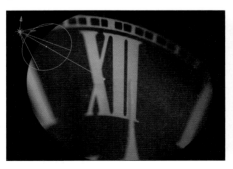

5 You can achieve a variety of interesting looks with Spot lights.

2 Create a new light and make sure you enable Casts Shadows.

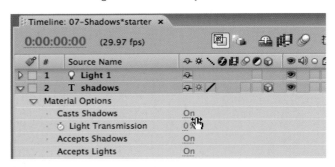

3 Type **A A** (two **A**s in quick succession) to reveal a layer's Material Options, including Casts Shadows.

Casting Shadows

Lights in After Effects also have the ability to cast shadows. For shadows to happen, you need three things:

- A light enabled to cast shadows.
- A 3D layer to cast the shadows.
- A 3D layer to receive shadows that is farther away from the light than the layer casting the shadows.

In this exercise, you will become familiar with setting up shadows, plus how lights, layers, and shadows interact.

1 Return to the Project panel and double-click **Comps > 07-Shadows*starter**. It contains two layers that are already enabled for 3D and spread out in Z space: Layer 1 (**shadows**) is a text layer, and layer 2 (**shadow catcher**) is a white solid.

2 Select Layer > New > Light. In the Light Settings dialog, set the Light Type to Point and Intensity to 100%. Enable the Casts Shadows option, and for now set Shadow Darkness to 50% and Shadow Diffusion to 0 pixels. Click OK, and a new **Light** layer will be added to your comp. The illumination of the layers will change, but no shadows will be visible yet…

By default, layers can receive shadows, but do not cast them. This is because shadows require a lot of computing power, and After Effects does not want to slow you down if you didn't want them. In this case, we do want them:

3 Select the layer **shadows** and type **A A** to reveal its Material Options. The very first parameter is Casts Shadows; as we hinted, it defaults to Off. Click on Off to toggle it to On; the shortcut to toggle shadows on and off is **⌥ Shift C** (**Alt Shift C**). Now you will see some rather large shadows cast from the text!

A

B

C

3 *continued* Casts Shadows can be toggled between Off (A), On (B), and Only (C).

While you're here, let's quickly explore two other useful options:

• Click on the Casts Shadows value one more time, and it will toggle to Only. Now you will see only the shadow, not the original layer.

• Toggle Casts Shadows back to On, then scrub the Light Transmission parameter. At 0%, the shadow is black; at 100%, it is the color of the layer casting the shadow. (By the way, this also applies to multicolored layers, including video…) Set it back to 0% for now. Then press **P** to reveal this layer's Position again, just to remember where it resides in 3D space.

4 Select the **Light** layer to see its axes in the Comp panel and press **P** to reveal its Position. Move the light either by scrubbing its Position values or interactively dragging it in the Comp panel. As you do so, the size and position of the shadow changes. Note that as the light gets closer to the layer casting the shadow, the shadow gets wider. Back the light away in Z space (high negative values), and the shadow will get smaller.

5 Scrub the Z Position values for **shadows** and **shadow catcher**. The closer these two layers are to each other, the tighter the shadow. Return them to their original positions when done (**shadows** at 360, 266, 0; **shadow catcher** at 360, 240, 250).

6 Select **shadow catcher** and press **R** to reveal its Orientation and Rotation properties. Scrub its X or Y Rotation values to tilt it in relation to the layer casting the shadow: The shadow will be angled too. (If you rotate it too far, you will see the edge of this layer; there will be numerous occasions where you need to enlarge layers to avoid this faux pas during 3D animations!)

7 Select **Light** again, and type **A A** (two **A**s in quick succession) to reveal its Light Options. Scrub the Shadow Diffusion parameter: This controls how soft the shadow is at the cost of longer render times. Then scrub Shadow Darkness: It controls how dark ("dense") the shadow is.

Now that you have an idea of how shadows interact, go ahead and put your newfound skills to work by setting up an animation for the light and perhaps the 3D layers.

Shadows enhance the realism of the scene and are a great graphical element. But note how slow they are to render: We'll discuss some ways to deal with that in the next exercise.

▼ **The Comp Viewer**

An odd feature of working with the 3D views is that a portion of the Comp panel will render your layers, while the rest (the pasteboard) will not. The size of this area has no effect on your final render; it merely reflects your current zoom level. Even more disconcerting is that any 2D layers enabled in a comp will draw in this area, again with no relationship to the size or position of the 3D layers you are working with. You can solo the 3D layers we are focusing on in order not to be distracted by this 2D display.

6–7 You can quickly create interesting looks by altering the position and rotation of the 3D layers and the light. Increasing the light's Shadow Diffusion parameter creates soft shadows – at the price of longer render times.

▽ tip
Draft 3D

If you find your computer is particularly slow while working in 3D and setting Fast Previews to OpenGL doesn't help enough, toggle Draft 3D along the top of the Timeline panel: This switch disables lights and camera depth of field. If you can't see shadows and think you should, make sure you didn't accidentally turn this switch on!

OpenGL and Fast Previews

Depending on the speed of your computer (and how much caffeine you've had), you may have noticed things have been slowing down as you worked through the exercises in this lesson – particularly that last one with shadows. In this exercise, we'll push you over the edge – then show you how to speed back up by taking advantage of the OpenGL graphics chip inside your computer. Along the way, you will also gain more useful experience working with lights and shadows.

1 Open **Comps > 08-OpenGL*starter**. We've taken a multilayered illustration, separated its elements in 3D space, and enabled them to cast and receive shadows. We also added a 3D camera to play with.

Select the Orbit Camera tool and drag around in the Comp panel to swivel about the 3D layers. Hopefully, your computer is still pretty responsive while performing this simple task. Undo to return to the original straight-on camera position.

2 Add a Layer > New > Light. In the Light Settings dialog, set the Light Type to Spot, Intensity to 100%, Cone Angle to 120°, and Cone Feather to 20%. Enable Casts Shadows and set Shadow Darkness to 50% plus Shadow Diffusion to 0 pixels. Click OK.

3 Even scenes with just a few layers and shadows can be sluggish to tweak. The blue bar in the lower right indicates After Effects is busy thinking. Illustration courtesy Manik Ratan/iStockPhoto.

3 New lights in After Effects tend to default to being too close to most layers. In this case, the pool of light cast will be fairly small, despite your generous Cone Angle.

With the light selected, press **P** to reveal its Position and scrub the Z Position value to the left to back the light away from the 3D layers. Go until they are better illuminated, and you'll start to see some nice shadowplay between the layers. While doing this, you may notice your computer is rather more sluggish. The blue render progress bar along the bottom right of the Comp panel indicates when After Effects is busy thinking.

4 Look along the bottom right of the Comp panel for an icon of a computer monitor with a lightning bolt through it: This is the Fast Previews switch. Click on it to reveal its menu of choices. We initially set up Fast Previews for this comp to Off, which means After Effects will always be using its highest quality renderer.

Choose OpenGL–Interactive, then try scrubbing the Z Position for your light.

Your computer should be considerably more interactive now! With the Orbit Camera tool still selected, also try swiveling the camera, or press **V** to switch back to the Selection tool and drag around the back of the light. Suddenly, an annoyingly slow experience becomes much more fun.

Depending on the OpenGL chip in your computer, you may have now noticed some compromises in the image quality – for example, crunchy aliased edges around the layers and shadows. When Fast Previews is set to OpenGL–Interactive, you will see these compromises only while editing your scene; as soon as you let go of the mouse, the normal After Effects renderer will kick in and show you a higher quality scene. OpenGL chips continue to improve; look for the quality gap to shrink with each new computer you buy.

By the way, this is a fun comp to play with; go ahead and build an animation with these pieces. Our version is in **Comps_Finished > 08-OpenGL_final**: We animated the various layers as well as the camera, plus added a large dark purple solid behind everything to catch all our shadows. Drag the current time marker; it should be fairly interactive, as we have OpenGL enabled. Then RAM Preview to see how long a high-quality render would take!

4 Set Fast Previews to OpenGL–Interactive (right) to take advantage of OpenGL while tweaking your scene. A yellow lightning bolt in the Fast Previews icon indicates OpenGL is currently engaged (below). A downside is reduced quality in some case (above).

In our final version, we moved the camera, animated the layers, and added a large solid behind to catch the shadows from the layers.

▽ gotcha

OpenGL Issues

If your OpenGL previews are looking bad, open Preferences > Previews, click on the OpenGL Info button, and make sure the Quality popup is set to More Accurate – the improvement is well worth the slight speed penalty. This dialog also shows what your OpenGL card supports; note that the minimum requirements are more stringent in CS3. For more info, visit www.adobe.com/products/aftereffects/opengl.html.

Dimensional Stills

In this final exercise, you will learn how to re-create a look popularized by the film *The Kid Stays in the Picture*. The underlying trick requires editing a still photograph so that some of its elements are on separate layers. These layers are then spread out in Z space in After Effects. Animate a camera around these layers, and they will appear to move in relation to each other. First we'll show you how to set up this comp, then how to prepare your own images to exploit this technique.

1 Save your project. Click on the Comp Viewer drop-down menu (along the top of the Comp panel) and select Close All to close all open comps. You will be building this comp from scratch, starting with the layered still image file. (If you want to see where we're headed, play **Finished Movies > 09-Faux Dimension.mov**.)

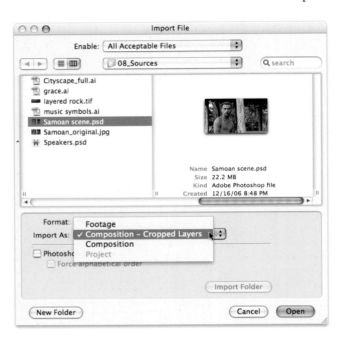

2 Import the already prepared layered Photoshop file as Composition – Cropped Layers. Image courtesy Artbeats/Faces of the World 1.

2 In the Project panel, select the **My Sources** folder. Type ⌘ I (Ctrl I) and navigate to the **08_Sources** folder – it should be in the same place as this lesson's project file. Open it, and single-click **Samoan scene.psd** to select it. This is a layered Photoshop file we already prepared for you. Set the Import As popup to Composition – Cropped Layers and click Open.

3 Your **My Sources** folder will open; inside of it will be a comp and a folder named **Samoan scene**. Drag the comp into the My **Comps** folder. Open this folder, then double-click **Samoan scene** to open it. It will initially be as large as the original image. Set the Magnification to Fit up to 100%.

4 Type ⌘ K (Ctrl K) to open the Composition Settings dialog. Change the Preset popup to the format you are currently working in, such as NTSC DV. Set the Duration to 05:00, edit the comp's name if you like, and click OK.

5 Time to array the layers in 3D space. You can delete layer 6, as it's a copy of the original un-altered image, and you won't be needing it for your move.

• Type ⌘ A (Ctrl A) to Select All. Enable the 3D Layer switch for any one layer, and it will be enabled for all selected layers.

• Type P to reveal Position for the selected layers, then F2 to deselect them (so you don't accidentally edit more than one at a time!). A good starting point is to leave the background at Z = 0 to keep it more or less stable, as this is where a camera's Point of Interest defaults to. Then move the other layers 10 to 50 pixels

4 The initial image is larger than your comp. You can pull back the camera to fix this.

Timeline: Samoan scene ×

0:00:00:00 (29.97 fps)

	#	Layer Name			
▽	1	Camera 1			
		Position	360.0 , 240.0 , -1925.0		
▽	2	man			
		Position	-21.0 , 283.5 , -100.0		
▽	3	foreground pole			
		Position	517.5 , 240.0 , -75.0		
▽	4	pot+wall			
		Position	788.0 , 623.5 , -50.0		
▽	5	left pole			
		Position	-525.5 , 240.0 , -25.0		
▽	6	background			
		Position	360.0 , 240.0 , 0.0		

apart from each other and toward you in Z so they will multiplane as you move the camera. For example, set the Z Position for **left pole** to –25, **pot+wall** to –50, **foreground pole** to –75, and **man** to –100 (you can always edit these later).

6 Add a Layer > New > Camera. Use the 50mm preset for a starting point. To speed up rendering, leave Enable Depth of Field off and click OK. Type **P** to reveal the camera's Position property and scrub its Z value to the left (larger negative numbers to back away from your 3D layers) until you see more of the image – but not so far that you see its edges!

7 Select the Orbit Camera tool and drag around in the Comp panel – you will now see a multiplane effect between the layers of this still image. Don't drag so far that you see the edges of the layers, or doubled-up images from the layers behind (see the sidebar on the next page). If you find this tricky, you may need to reduce the camera's Angle of View: Select the camera, type **Shift A A** to reveal its Camera Options in addition to its Position, increase Zoom, then adjust the camera's Z Position to compensate.

Tweak the spacing between the layers and animate a camera move. Our version is in **Comps_Finished > 09-Faux Dimension_final**. We also animated Tint applied to an Adjustment Layer to transition the background layers from color to grayscale, emphasizing the man as the focal point of the shot.

5–6 The initial image is larger than your comp. Spread out the layers in Z space, add a camera, and back it away to comfortably frame the layers.

7 As you perform a camera move, the layers will appear to move in relation to each other. Be careful not to reveal the edges of the layers (where arrow is pointing).

We took advantage of the image being cut into layers to transition the background to black and white, focusing more attention on the hero.

▼ Cutting Up Stills

To re-create the "Kid Stays in the Picture" technique with your own sources, you need to do some file preparation beforehand:

Source

The best sources have a few clearly defined objects that were originally different distances from the camera. They can overlap each other, but keep in mind that you will need to rebuild any portions of an object that are obscured by another object. Generic backgrounds such as walls and nature are fairly easy to fake. Detailed objects, such as someone's face, are much harder to rebuild convincingly.

Your initial file needs to be larger than your final output format. This will give you more pixels to work with when you perform masking and cloning. The added resolution will also give you more freedom to zoom in on the image without worrying about the quality degrading.

Layers

Decide what program you are most comfortable cutting apart objects in. Many use Paths in Photoshop for this. We're just as comfortable using the mask tools in After Effects.

Start with the original image as your first layer, then make a duplicate layer for each object. For **Samoan scene**, this meant a layer for the man, two for the wooden poles, one for the wall behind the man with a pot on it, and one for the rest of the background.

Use masks or paths to cut out each object on its own layer. Make sure the path is just inside the object's outline; you don't want to see a fringe of what's behind it. When an object is partially obscured, you are going to have to make a guess as to what the shape

△ We used two masks to cut out the man: one for his body and a more softly feathered one for his hair.

of the original object might have been. Feather the edges of your shapes based on how sharp or soft their outlines are. The background layer does not need cutting out.

Our masking efforts are contained in this lesson's project file, in **Comps_Finished > 09-Samoan cut-up**. Solo each layer to see the corresponding shape. For the **man** layer, we used two masks: a hard-edged one for his body, then a softly feathered one for his hair. To continue working on this file in Photoshop, we then used Composition > Save Frame As > Photoshop Layers.

Cloning

Finally, decide which program you are most comfortable cloning in. Again, Photoshop is a popular choice (and what we used for this exercise), but you could also use the paint and clone tools in After Effects.

Your first task is reconstructing any bits of your layers that were obscured by another object. In **Samoan scene**, we had to rebuild the pot, fan, and wall that were obscured by

the pole in front of them. The Lock Transparent Pixels feature in Photoshop's Layers panel (above) came in handy to make sure we didn't accidentally paint outside our masked shapes.

Your second task is cloning the foreground objects out of your background layer. You don't need to clone out every last pixel – just around the edges. The rest will hopefully be obscured behind the foreground layers. The more you plan to move the camera, however, the more you need to clone.

It is not unusual to set up an animation in After Effects, then find you have to go back into Photoshop to perform additional clean-ups.

△ For the background plate, clone away enough of the foreground elements that they will be fully covered by the floating, isolated foreground layers.

Idea Corner

• To keep the **02-Multiplaning** exercise simple, we did not use all of the buildings in Russell Tate's original illustration. In the Project panel, twirl down the **Sources > illustrations** folder; **Cityscape_full** has over twice as many elements for you to play with. In addition to arranging them in a horizontal line, you could also try arranging them as a street to travel down in Z space, akin to the music symbol flythrough in **05-Orientation**.

• Try this lesson's techniques with your own Illustrator artwork. If the individual objects are all on the same layer in the file, you will need to isolate them into their own layers. Make sure that the vectors that make up individual shapes have already been grouped together – such as windows grouped with a house's outline. In the Layers palette in Illustrator, select the master layer, click on the arrow in the upper right corner, and choose Release to Layers (Sequence). Each object will appear in its own layer underneath the original layer. Drag the newly liberated layers out from under the original layer and delete the now-empty original. Rename the layers as appropriate and save the result with a new file name. Then import it into After Effects as a composition.

The source file has many more buildings for you to play with to create your city scene. Duplicate layers to create even more.

▽ tip

Multiple Cameras

You may create multiple cameras in a comp. The top camera in the layer stack is the active camera. You can trim camera layers to edit between the various cameras.

• In the third and fourth exercises (the ones with the Under Pressure logo) we had you either animate the logo pieces or animate the camera around them. Combine these two techniques: Animate the logo pieces into position. Then animate a camera move around them as they come together and hold. This is a technique that is used in many show opening titles. To practice, either use **Comps > 04-Basic Camera** or design your own title. (Our version is in **Idea Corner > 04-Basic Camera_enhanced**, where we added a light for shadows, plus a Bevel Alpha effect on the slabs.) You could also try adding text animation presets to the text, or creating multiple camera layers and editing between them!

• Try your hand at creating your own "dimensional still" animation using the techniques illustrated on the last few pages. This technique was originally used to bring older photos to life, so if you have any older photos of your own family, give it a whirl. You also see this technique used to create interesting static scenes to go into or come out of normal video, with the advantage that you continue the motion – just in a surreal, "bullet time" fashion.

For added excitement, try animating both the logo layers *and* the camera.

▽ tip

Edit Original Source

If you need to make changes to a Photoshop layer, with the layer selected in After Effects, use Edit > Edit Original. The layer will open in Photoshop. Make the changes, Save, and return to After Effects – the layer will be updated. It's best to work on one layer at a time to ensure layers update correctly. If not, select them in the Project window and use File > Reload Footage.

Track and Key

Tackling several essential skills for creating special effects.

▽ Getting Started

Make sure you have copied the **Lesson 09-Track and Key** folder from this book's disc onto your hard drive, and make note of where it is; it contains the project file and sources you need to execute this lesson.

Note: This lesson requires After Effects Professional and the Keylight plug-in (requires separate installation in After Effects 7). Keylight is not included with the Trial version of After Effects.

L ife is easy when you can capture everything to tape or film exactly the way you want it. But reality often intervenes: Maybe the camera shook too much. Or maybe it wasn't possible to have the actors perform in front of the exact background required. Maybe you couldn't get a license to blow up that building in real life, or shoot arcs of electricity across a canyon.

Therefore, if you are interested in a career creating visual effects, you need to learn how to *stabilize* footage, *motion track* objects in footage, and *key* (create an alpha channel for) footage shot against a blue or green background so that you can place it over a new background. In this lesson, you will get a chance to practice all three – plus work with some high-definition footage as well.

Overview

The basic concept behind Motion Tracking and Stabilization ("tracking" for short) is to follow an object as it moves around from frame to frame in a piece of footage. Once you can do that, you can perform some pretty fun tricks:

• Stabilize the footage: If you know this object was supposed to be in the same place from frame to frame, but it actually moves (maybe because the camera was held by hand rather than mounted on a tripod), After Effects can track the object's movements, then animate it to move in exactly the opposite direction so it appears to be steady.

• Make one object follow another: If you know how an object is moving through a scene, you can then make another object of your choosing follow the exact same path. For example, you can replace an image such as a

poster with a different poster. You can also create some fun composites such as having a piece of text follow a person or object around the screen.

To make this magic happen, you need to show After Effects a "feature region" in the footage for it to track. The best features have clearly defined, consistent shapes with distinct edges. They also have contrasting color or brightness compared with the pixels around them. After Effects has the ability to adapt what it is looking for from frame to frame, but the less the feature changes size or shape the better.

Once After Effects has this initial idea of what to look for, it looks inside a user-defined "search region" for the same feature in the next frame of footage. Once it finds it, it resets the location of these regions and looks at the next frame. The tighter you can define these regions, the faster and more accurate the track.

Often, tracking one feature is enough. However, sometimes it is useful to track multiple features. If you track two features, After Effects can look at the angle between them, which allows it to add rotation to its tracking and stabilization tricks. It can also measure the distance between features, allowing it to factor size changes (scale) into the equation. And if you track four features – such as the four corners of a poster – then After Effects can take perspective distortion into account and "corner pin" a new object over the object you are tracking.

Basic Stabilization

We'll start with one of the easiest but most useful tasks: stabilizing footage where the camera wasn't entirely steady.

1 Open this lesson's project file: **Lesson_11.aep**. In the Project panel, the **Comps** folder should be twirled open (if not, do so now). In this folder, locate and double-click **01-Stabilization*starter** to open it.

2 This comp contains one layer: **Wildebeests.mov**. Press **0** on the numeric keypad to RAM Preview the clip and watch it closely: The image bobs up and down slightly. If this movement isn't obvious, place your cursor near the ground; you will see the ground shift as the clip plays.

While previewing the footage, look for items that might make good features to base your stabilization off of: something that has good contrast, that keeps roughly the same shape and position throughout the shot, and that isn't obscured by another object.

3 In the upper right corner of the application window, click on the Workspace popup and select Motion Tracking. This will open the Tracker Controls panel. Note that it currently says Motion Source is set to None.

In one of the exercises in this lesson, you will make text follow this wildebeest to help it express its thoughts. Play the movie **TrackingExample.mov** in the **Lesson 11 > 11_Finished Movies** folder to see this in action. Footage courtesy Artbeats/Animal Safari.

▽ tip

Docked Layer Panel

In some of the earlier lessons, we had you undock the Layer panel to make it easier to position alongside the Comp panel. In this lesson, it is fine to have the Layer panel docked into the same frame as the Comp panel, as most of the time you will be switching between the two rather than viewing both at once.

Tracker Guided Tour

A guided tour of how to set up the Tracker Controls is included in this lesson's **Guided Tour** folder. Watch it before starting this lesson; it contains tips you will use in virtually all of these exercises.

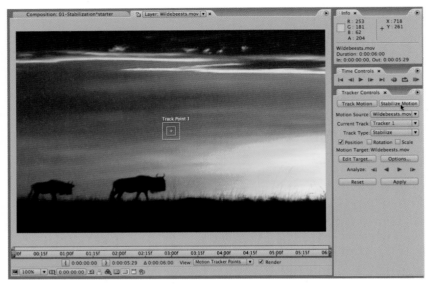

3–4 Select the Motion Tracking Workspace, double-click the clip to open its Layer panel, and click Stabilize Motion in the Tracker Controls. A track point will be created.

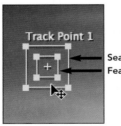

5 When you see a cursor with four arrows at its tail, you can then move the track point as a group (left). While you're dragging the track point, it turns into a magnifier (right).

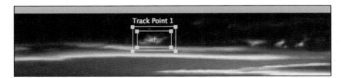

6 Drag the inner feature region large enough to just enclose your feature; drag the search region a little larger than the feature region. Note that dragging a corner of the feature or search regions will move all corners symmetrically around its center. To move just one corner, press ⌘ on Mac (*Ctrl* on Windows) while dragging.

Tracking and stabilization need to take place in the Layer panel so you can focus on just that clip. Double-click **Wildebeests.mov** to open its Layer panel; you will notice in the Tracker Controls panel that Motion Source automatically changes to this layer's name.

Track Points

4 Click the Stabilize Motion button in Tracker Controls. This will create a *track point*, which consists of two boxes and a crosshair:

- The inner box is the *feature region*, which you will use to enclose the feature you wish to follow.

- The outer box is the *search region*, which tells After Effects how far to search in the next frame for a group of pixels that matches what was in the feature region in the previous frame.

- The crosshair in the middle of these boxes is the *attach point*. It is the center for any stabilization that takes place. When tracking, it defines where the Anchor Point for the new layer will be placed.

5 You need to set up your track point at the time you plan to start the track, so press **Home** to return to 00:00. Hover over the track point until the cursor changes to a black pointer with four arrows at its tail, which indicates you can move the entire track point together as a unit.

Drag the track point to a feature you identified in step 2. The bright cloud fragments make good candidates; we're going to pick the one on the left. Center the track point over your desired feature. While you're dragging, you'll notice that the track point turns into a magnifier, making this easier.

6 The feature we picked out is larger than the default size of the feature region. Drag out the feature region's corners until it is just big enough to enclose the entire cloud fragment, including a little fringe around it. Also make sure the search region is bigger than the feature region, taking into account how much the feature moves from frame to frame. Zoom into the Comp panel if you need to.

Performing the Track

7 In the Tracker Controls, click on Options. To not waste time on a bogus track, you should always verify these are set correctly before performing any track:

• The most important section is Channel. Set this based on how your feature stands out from the pixels around it. In this case, the clouds are all the same basic hue, but the bright bits have considerably different luminance than their surroundings – so check Luminance.

• You can usually leave Process Before Match disabled; use it only if you have trouble tracking. If the footage is out of focus, enable it and try Enhance; if it is noisy, try Blur.

• You always want to leave Subpixel Positioning on, and most of the time you want to leave Track Fields off (see the sidebar *When Tracks Go Wrong*). We usually leave Adapt Feature On Every Frame off; enable this switch if your feature constantly changes shape or size every frame. We often set the popup below to Adapt Feature and leave Confidence at 80% – this tells After Effects to keep looking for the same feature unless it thinks it has changed too much.

 Click OK when you're done.

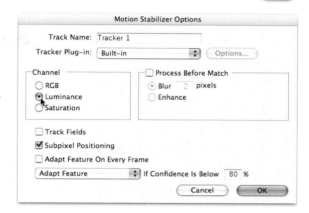

7 Always check the tracker's Options before performing a track. Most important is to set Channel based on what's unique about your selected feature.

8 Click on the Analyze Forward button in the Tracker Controls. After Effects will search each frame for the feature you've defined.

 When it is finished, you will see a motion path created for Track Point 1. In this case, its individual points will be all bunched together, as the feature doesn't move that much. Press **U**, and in the Timeline panel you will see a large number of keyframes applied to Track Point 1.

 It's a good idea to save your project after performing a successful track so that you can revert back to it if something goes wrong afterward. After that, the next step is taking these keyframes and doing something useful with them!

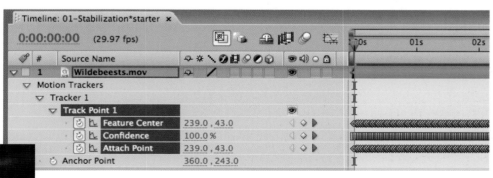

8 Click Analyze Forward (top). After Effects will then chase your feature around the shot from frame to frame. When done, you will see a motion path for your track point in the Layer panel (left) and a large number of keyframes in the Timeline panel (above).

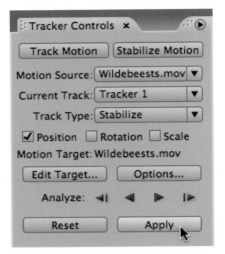

9 Verify the Tracker Controls settings, click Apply (above), and keep the default of applying to both X and Y dimensions (right). Keyframes will then be created for the layer's Anchor Point to stabilize the clip (below).

Applying Stabilization

9 In the Tracker Controls, make sure Track Type is set to Stabilize and Motion Target is set to **Wildebeests.mov** (if it isn't, click on Edit Target). Then click Apply. A Motion Tracker Apply Dimensions dialog will open; leave it at its default of X and Y Dimensions and click OK.

After Effects will bring the Comp panel forward and add a set of Anchor Point keyframes in the Timeline panel. These Anchor Point keyframes offset the movement detected for your feature region, causing the footage to be stabilized.

To verify that your stabilization worked, RAM Preview. You might want to place your cursor over a feature in the Comp viewer to verify that the footage is no longer bobbing as much as before. It may still wander very slightly; it is hard to get a perfect track – especially on your first try!

Congratulations: You now have the basic skills required to perform most motion tracking and stabilization chores.

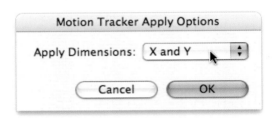

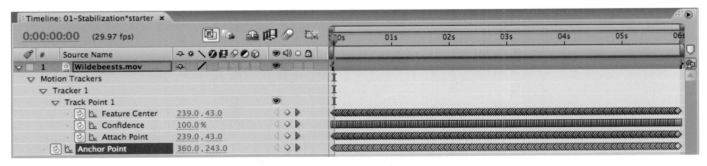

Cleaning Up

Now for the bad news: Scrub the current time marker along the timeline and watch the top edge of the Comp viewer. That pink area you see is the comp's background color peeking through (we made it an obnoxious color to make it more noticeable). As a result of the layer being moved to make it appear stable, it is no longer centered, and therefore doesn't cover the entire frame.

Let's try a few ways to compensate for this. The best solution will vary from job to job, depending on how much the layer moves and what looks best.

10 Select **Wildebeests.mov** and press **S** to reveal its Scale. Scale up the footage slightly until it covers the entire frame throughout the entire timeline. The cost of this is a slight softening of the image as you scale over 100%.

▽ tip

Matching Blur

When tracking one object and applying that motion to another, it's a good idea to enable motion blur for the new object to better match the original shot – especially if the object is moving fast. On the other hand, shots with a lot of motion blur are not good candidates to stabilize; they look weird if they're rock-steady, but blurred…

11 Return the layer's Scale to 100%, and press ⏺ (the apostrophe key) to reveal the Action and Title Safe grids. If the offending area is well outside the Action Safe area, you may be able to rely on the television's bezel cutting it off. However, you should fill these areas with *something*, just in case. Here are a couple of ideas:

• Cover the background with a solid. Select Layer > New > Solid. Click on the Make Comp Size button, and eye-dropper a color from around the edges of the footage. Click OK and drag this new solid down the layer stack to sit behind your tracked footage. You will now have a solid color border to fill in the revealed areas.

• Select **Wildebeests.mov** and type ⌘ D on Mac (Ctrl D on Windows) to duplicate it. Select the copy on the bottom (layer 2), press Home, then press A to reveal its Anchor Point; its value should read 360,243 (its initial location at the center of the comp). Click on Anchor Point's stopwatch to delete the keyframes created by applying the stabilization. You will now have an echo of the footage in the revealed areas. This is the approach we took in our version, **Comps_Finished > 01-Stabilization_final**.

10–11 After stabilizing, you may see some of the Background Color (pink, in this case) around the edges of the Comp viewer. You should fill it with something, either by scaling up the footage, or using a carefully colored solid or a copy of the original footage.

▼ When Tracks Go Wrong

Not all footage can be tracked accurately; be prepared for some disappointment and compromise. If you notice the track point wandering away from the feature it is supposed to be tracking during the Analyze step, press any key to stop the track, then try these corrective actions:

• Scrub the time marker in the Layer panel back until the track point looks correct, then click Analyze Forward again.

• If that doesn't work, return to the start and modify your track point, try different Options, or try tracking a different feature.

• If the feature grows larger over time, you might need to delete this track, press End, set up your track points there, then click Analyze Backward instead of Forward.

• If there is no one good feature to track over the entire shot, track one feature until After Effects loses its way, hold down ⌥ Shift (Alt Shift), and drag the track point to a new feature while leaving the attach point where it was (this is essential; otherwise, the resulting track will jump suddenly at this point).

• If the feature you want to track goes off screen, you may need to create a manual off-screen keyframe and let After Effects interpolate between this and the last good tracker keyframe.

Tracking Interlaced Footage

Usually, you want to separate fields (enabling Preserve Edges) plus remove pulldown, if present. Then you can disable Track Fields in the Motion Tracker Options for most footage. However, if there are sudden changes in the movement of the tracked feature where one field is very different from another, you may need to enable Track Fields to more accurately follow this motion. If you are having trouble locking onto a feature to track and there is very little motion in the feature you are tracking, try turning off field separation just while you are tracking.

2 As you drag the track point, it will magnify what's inside the feature region. Center this region over the horns of the smaller wildebeest.

Basic Tracking

Now that you know your way around the Tracker Controls, let's put your new-found skills to work with a typical motion tracking exercise.

1 To simplify things, bring the Comp or Timeline panel forward and type ⌘ ⌥ W (Ctrl Alt W) to close your previous comp. In the Project panel, double-click **Comps > 02-Tracking Objects*starter** to open it. It contains three layers: the wildebeest footage from the previous exercise, a text layer, and a small pointer. The plan is to make the text and pointer follow the head of one of the wildebeests, as if we could read its thoughts.

2 After making sure the Tracker Controls panel is visible, press Home. Select the **Wildebeests.mov** layer, then click Track Motion in the Tracker Controls. This will open your clip in its Layer panel and create a tracking point.

Click inside the track point somewhere that you see the black cursor with the four-arrow tail, and drag the track point until it is centered over the horns of the wildebeest at the left. As it so happens, the default size of the feature region nicely fits the horns, so there's no need to resize these boxes.

3 Click on the Options button in the Tracker Controls and position the Motion Tracker Options dialog where you can still see the wildebeest.

First is setting Channel. What sort of contrast is there between the wildebeest's horns and the sky behind? Luminance – so select that option.

Next comes the Adapt Feature settings. The feature you want to track – the horns – changes over the course of the shot as the wildebeest turns his head back and forth. In this case, enable the Adapt Feature on Every Frame option. Set the popup below to Stop Tracking so it will be obvious if After Effects can't follow this feature any longer. Then click OK.

Click the Analyze Forward button in the Tracker Controls. After it is finished, After Effects will display the motion path for the track in the Layer panel.

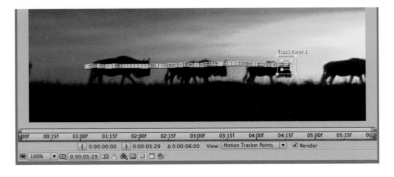

3 Since the horns change during the shot, enable Adapt Feature on Every Frame (top left). To know if After Effects loses the scent, set the popup below to Stop Tracking. Click Analyze Forward; when done, you will see the track's motion path (left).

Applying the Track

Time to apply the results of your motion tracking. There's a quick and dirty way to do this, and a more clever way…

4 To decide which layer will receive your motion track, click the Edit Target button in the Tracker Controls. In the Motion Target dialog that opens, there will be a popup for Layer. Hmm…two layers want to get the track, and you can select only one. You could apply the track twice, or you could use a trick you picked up back in Lesson 7: using parenting and null objects.

5 Click Cancel in the Motion Target dialog. Instead, create a dummy layer to receive the track to which you can later attach as many other layers as you want.

Select Layer > New > Null Object; it will appear in the Timeline panel. Back in Tracker Controls, click on Edit Target again, and this time select your null. Click OK and verify that the name of the null appears next to Motion Target.

Click on Apply and click OK in the Motion Tracker Apply Options dialog that appears. The Comp panel will come forward with your null object selected showing its new motion path.

Type **F2** to deselect all and clean up the display. Scrub the current time marker and note how the upper left corner of the null follows the head of the wildebeest.

6 Time to parent your other layers to this null:

• Select the text layer **I have no idea where**, then **Shift**+click the **pointer** layer to select it as well. Drag them into your desired position in relation to the second wildebeest's head.

• Press **Shift F4** to reveal the Parent panel (if it's not already visible). With your two layers still selected, click on the Parent popup for either one of them and choose your null. (You can turn off the eyeball for the null; it will still work as a parent.)

RAM Preview: The text and pointer will follow the wildebeest across the comp. Our version is in **Comps_Finished > 02-Tracking Objects_final** – we added a second line of text to make the shot more interesting. And don't forget to save your project…

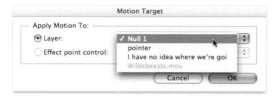

5 Create a new null and choose it in the Tracker Controls' Motion Target dialog (above). Click Apply and the null will now follow the head of the second wildebeest (below).

6 Use parenting to attach your additional graphical layers to the null (above); now they will all follow the wildebeest's travels (top).

In this exercise, you will track a mountain peak as we fly past it and apply an effect that will make it seem like radio signals are being broadcast from it. Footage courtesy Artbeats/Mountain Peaks 2.

2 The Radio Waves effect creates a series of shapes that appear to be "born" from a moveable Producer Point. These shapes can change size and opacity over time.

Tracking for Effects

In addition to making a layer follow an object in another layer, you can also use motion tracking to have effects follow a feature around a layer by assigning the tracked motion to an effect point. In this exercise, you will track a mountain peak and use results to send out radio waves from that peak.

1 In the Project panel, double-click **Comps > 03-Effect Track*starter** to open it. It contains one layer, which is an aerial pullback over a range of mountain peaks. RAM Preview it, thinking about which peaks might be candidates for tracking.

2 Select **Mountain Peaks 2.mov**. Then apply Effect > Generate > Radio Waves. (If needed, dock the Effect Controls panel into the Project frame.) RAM Preview. The mountain footage will be replaced by a series of concentric blue circles emanating from the center. Press *End* for now, so you can see several waves on screen and become familiar with the Radio Waves controls:

• In the Effect Controls panel, twirl down the Wave Motion section and increase Frequency to increase the number of waves. Alternatively, you can reduce the Expansion value to slow down how fast the waves fly off screen. Then try decreasing the Lifespan: You will notice that the waves start to die away as they get older.

• Twirl down the Stroke section. Decrease the Start Width and decrease the End Width; you will now see the waves start skinny and grow thicker with age.

• Press *Home* and click on the stopwatch next to Producer Point (near the top of the Effect Controls) to enable keyframing. Move the current time marker a few seconds later, click on the crosshair icon next to Producer Point, then click somewhere in the Comp viewer. Do this a couple more times until you reach the end of the comp. RAM Preview: You will notice that the waves remember where they were born, creating an interesting trail over time.

3 Make sure the Tracker Controls panel is visible; if not, select the Motion Tracking Workspace or open Window > Tracker Controls. Make sure **Mountain Peaks 2.mov** is still selected, then click Track Motion in the Tracker Controls.

The Layer panel will open. The original footage should now be visible again, even though the Radio Waves effect is still applied. This is controlled by the View popup along the bottom of the Layer panel: Switch it to Radio Waves (the motion path for Producer Point will be visible), then back to Motion Tracker Points.

<div style="float:right">

▽ tip

What Channel to Track?

If you are having difficulty deciding whether to use Luminance, RGB, or Saturation to track, make sure the Info panel is open and move the cursor inside and outside your feature region while watching its values. Click on Info's Options arrow in the upper right corner and switch to HSB to get a more direct reading of Hue (color), Saturation, or Brightness (luminance).

</div>

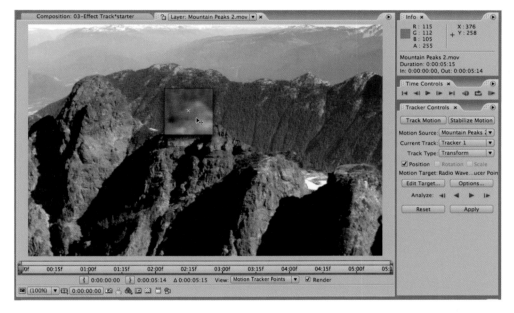

4 Place the track point over one of the peaks, looking for an area with clean edges and good contrast.

4 Press **Home** to make sure you are at the start of the clip. Hover the cursor over the track point until the now-familiar black pointer with the four-arrow tail appears. Click and drag the track point over one of the peaks. We chose the pointy peak near the middle of the frame, as it remains visible for the entire shot and keeps good contrast with its background during the shot. Be sure to enlarge the track and search regions to enclose a good part of the peak.

5 Click on Options in the Tracker Controls. The foreground peaks are about the same brightness as the mountains behind but are a different color; therefore, set Channel to RGB. The mountain peaks do not change shape much during the shot, so go ahead and disable Adapt Feature on Every Frame and set the popup below to Adapt Feature (meaning it will adjust its search only when the feature has changed quite a bit). Finally, give your track point a name at the top of the dialog, such as "**foreground peak**." Click OK.

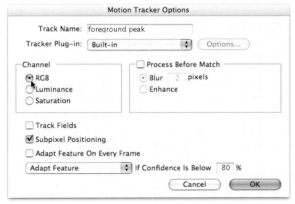

5 In the Motion Tracker Options, set Channel to RGB, disable Adapt Feature On Every Frame, and set the bottom popup to Adapt Feature.

Motion Target

Apply Motion To:

○ Layer: Mountain Peaks 2.mov

● Effect point control: Radio Waves/Producer Point

Cancel OK

6 After the track is finished, verify that the Motion Target is the effect's Producer Point before trying to apply the track.

7 After you apply the track, the Radio Waves will animate across the screen (above left). To composite the waves over the mountains, duplicate the layer, delete the effect from the copy underneath, and use a Blending Mode on the top layer to mix (above right and right).

▽ tip

Storing Multiple Tracks

If you have a track or stabilization that you think might work, but want to try another, click on Track Motion or Stabilize Motion again. Your previous and new tracks will be saved as keyframes for the same layer, and you can apply either one later. Rename tracks in the Options dialog to keep straight which track is which.

6 Click Analyze Forward in the Tracker Controls. When After Effects finishes, click Edit Target to open the Motion Target dialog. Make sure that Effect Point Control option is selected instead of Layer and that Radio Waves/Producer Point is selected in the adjacent popup. Click OK.

Back in the Tracker Controls click Apply, then OK when the Motion Tracker Apply Options dialog appears. This will replace your trial animation in step 2 with the motion tracker's data.

7 RAM Preview, and Radio Waves will create a nice set of moving circles for you. But where are the mountains? Radio Waves does not have any "composite" options that allow you to see it and the underlying layer. No problem – just duplicate the layer and use that:

• Twirl up the open parameters in the Timeline panel to reduce the clutter. Select **Mountain Peaks 2.mov** and use Edit > Duplicate.

• Select the bottom copy of **Mountain Peaks 2.mov** and select Effect > Remove All.

Have some fun tweaking the Radio Waves effect on the top layer. Press **F4** to reveal the Modes column and try compositing the waves with modes such as Add or Overlay. Our version is saved in **Comps_Finished > 03-Effect Track_final**.

Make sure you save your project. In an Idea Corner at the end of this lesson, we'll also challenge you to continue working with this composition and track a second peak, applying the results to an effect with two effect points: Lightning.

Applying tracks to effect points is a skill that is useful in both motion graphics and visual effects. For example, you can apply the track to the center of a radial blur effect to create an interesting selective focus look. It is also quite common to track light sources in real scenes or 3D renders and apply them to lens flare centers.

Next, you'll move up to a more challenging task that requires tracking four effect points.

The plan is to take a handheld shot with a computer monitor (left) and to replace its display with a new one (center). We then applied the "instant sex" treatment to tie them together (right). Footage courtesy Artbeats/Medical Montage and Control Panels 1.

Corner Pin Tracking

One of the greatest uses of motion tracking is to replace one object with another. For a replacement to be convincing, not only must it be in the correct position; it must also exhibit the same perspective as the original.

This is where *corner pin* tracking comes in. With this method, you typically track the four corners of a rectangular shape and distort your new layer so that its corners match the original object's corners. It's like motion tracking, times four – and more…

Four Track Points

1 In the Project panel, double-click **Comps > 04-Corner Pin*starter** to open it. RAM Preview it, paying particular attention to the computer monitor. Your task in this exercise will be to replace its display.

2 In the Project panel, twirl down the **Sources** folder. Select **Heart Monitor.mov** and type ⌘ **/** (*Ctrl* **/**) to add it to your composition. Initially, it covers the entire frame; After Effects will shrink it down once you've completed the track.

3 Press **Home** to return to 00:00. Make sure the Tracker Controls panel is open (if it isn't, select the Motion Tracking workspace). Click on the Motion Source popup and select **MRI Computer.mov**. This will open its Layer panel, but no track points will be visible yet.

Click Track Motion: One track point will appear in the Layer panel. Then click on the Track Type popup and select Perspective Corner Pin. Now you will see four track points in the Layer panel – one for each corner.

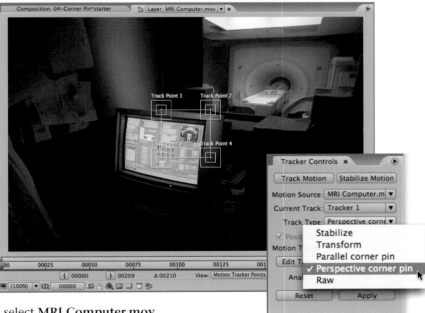

3 After selecting **MRI Computer.mov** and clicking Track Motion, select Perspective Corner Pin for Track Type. This will create a set of four track points in the Layer panel.

5 Place the first track point around one corner of the old display. Then zoom in and carefully place the attach point just beyond the edge of the old display.

6–7 Place all four track points in their respective corners of the display, make sure Channel is set to Luminance under Options, and click Analyze Forward to perform the track.

▽ tip

Panning and Zooming

To zoom into and out of a display such as the Layer panel, you can use the 🔳 and ➖ keys above the normal keyboard, or the scroll wheel on a mouse. Press and hold **Z** to temporarily switch to the Zoom tool, then click to zoom in. To pan around the display, hold either the spacebar or **H**, then click and drag inside the display.

4 Hover the cursor over Track Point 1 until you see the black cursor with the four-pointed arrow at its tail. Drag this track point over the upper left corner of the computer monitor. The contrast between the blue of the old display screen and the black around it makes it a great feature to track. The feature region is a bit larger than necessary to enclose this feature; to help increase the accuracy and speed of the track, reduce the size of this region. Zooming into the Layer panel display will make both sizing and placing it easier.

The Attach Point

5 After you have positioned the feature region, you need to pay extra attention to the attach point: the + symbol that defaults to the center of the feature region. The attach point is where a corner of your new layer will be placed. If the attach point was placed inside the glowing area of the old display, this fringe would peek out from behind your new layer. Therefore, make sure the attach point is just beyond the bright blue area. Zoom further into the Layer panel to make it easier to move this point.

6 Repeat steps 4 and 5 for the remaining three track points. Then press **Shift** **/** to recenter the viewer and return to normal magnification.

7 Click on the Options button. Our features have strong contrast, so select Luminance under Channel. The other default settings (Adapt Feature On Every Frame off; the popup below set to Adapt Feature) are fine. Click OK.

Click Analyze Forward. If you've made your feature and search regions reasonably small, the track should proceed very quickly even though there are four points to track.

Applying and Improving

8 Make sure Motion Target is set to **Heart Monitor.mov**; if it isn't, click on Edit Target and set it. Then click Apply. Take a moment to examine the layers in the Timeline panel:

• **MRI Computer.mov** has a set of keyframes for each of its four Track Points.

• **Heart Monitor.mov** has had the Corner Pin effect applied, with a set of keyframes for each of its corners.

• **Heart Monitor.mov** also has a set of Position keyframes, which reflect how the center of the new display moves to match the movements in the computer monitor.

After applying a corner pin track, both layers might be selected; press **F2** to deselect all. RAM Preview; the new display will now track the computer monitor. However, there is still some blue peeking out around the corners of the display,

#	Source Name		
1	Heart Monitor.mov		
	Effects		
	Corner Pin	Reset	
	Upper Left	286.1 , 176.3	
	Upper Right	443.3 , 193.5	
	Lower Left	280.9 , 283.5	
	Lower Right	428.3 , 318.0	
	Transform	Reset	
	Position	315.0 , 274.0	
2	MRI Computer.mov		
	Motion Trackers		
	Tracker 1		
	Track Point 1		
	Track Point 2		
	Track Point 3		
	Track Point 4		

8 After applying the perspective corner pin track, the new display is fitted onto the computer monitor (above). In the Timeline panel, the Corner Pin effect is applied to layer 1, along with a set of Position keyframes (top).

even though you were careful in how you placed the attach points. You are seeing the results of the monitor's CRT being bowed out (it was manufactured before the era of flat-panel displays). Therefore, this composite will require a little more work to make the result convincing:

9 Select **Heart Monitor.mov** and choose Effect > Distort > Bezier Warp. This effect allows you to use the familiar Bezier handles (from mask shapes and motion paths) to gently warp a layer.

Look at the Comp panel: After applying this effect, your new screen went flying off into space! This was caused by the order in which the effects are being applied. In the Effect Controls panel, drag Corner Pin to below Bezier Warp; now things will look normal.

10 Bezier Warp needs to be edited in the Layer panel. However, you need to watch the results in the Comp panel while working. Double-click **Heart Monitor.mov** to open its Layer panel. Then either undock this panel or otherwise arrange it so that you can see it and the Comp panel at the same time.

In the Layer panel, set the View popup to Bezier Warp. You will notice a series of 12 crosshairs around its outline. Leave the ones in the corners – the warp vertices – alone. Slowly drag the handles ("tangents") along the left outward, watching the result in the Comp panel. Move them just enough until the blue fringe has been covered up in the final composite. Do the same for the handles along the bottom. The handles along the top don't need adjusting; if anything, the handles on the right may need to be pulled in slightly to compensate for the perspective and bow of the computer monitor.

When you're happy with the warp, re-dock the Layer panel, bring the Comp panel forward, and RAM Preview. Congratulations – you just finished a fairly challenging track assignment! (Save your project…) Our version is **Comps_Finished > 04-Corner Pin_final**; we added the "instant sex" trick you learned back in Lesson 3 to spiff up the final composite and better blend the results.

10 Adjust the Bezier Warp handles in the Layer panel until the blue fringes around the old display just disappear.

The source shot was provided by the Pixel Corps (www.pixelcorps.com) and is from the production of its film *Europa*. Pixel Corps shot most of the action on a greenscreen stage with the intention of later placing the actors in a 3D environment.

1 Since the HD frame is so large, set the Comp panel to 50% Magnification and Half Resolution (or smaller, if needed).

2 Select the movie, click Stabilize Motion in the Tracker Controls, then enable Position, Rotation, and Scale.

Background Replacement

In this final exercise, you will take a handheld shot of a pair of actors on a green-screen stage, stabilize the shot, remove ("key out") the green, and place the result over a new background to make it appear the shot originally took place outdoors.

For an added challenge, this composition is created at the high-definition resolution of 1920×1080 pixels. Note that we have saved this source footage using the common HDV frame size of 1440×1080 pixels. These pixels are "anamorphic" in that they are supposed to be displayed wider than that, yielding the same result as a normal HD 1920x1080 frame. It will look normal in the Comp panel; in the Layer or Footage panels, you will see the original, squeezed image. Read the *Tech Corner* later in this lesson for more on high-def issues.

Stabilizing Position, Rotation, and Scale

This will be your most challenging track in this lesson, as you will need to stabilize not just position but also rotation and scale. The good news is the greenscreen stage already has nice tracking dots placed on it. The bad news is one of the actors walks in front of the dots you need…

1 Close your previous comps. In the Project panel, double-click **Comps > 05-Keying*starter** to open it. If you can, arrange your panels so you can view the Comp panel at 50% Magnification and Half Resolution; if not, set Magnification to 33% and Resolution to Third.

RAM Preview this shot, paying particular attention to the tracking dots. Any dots that go off screen during the shot are of less use. Note that the camera moves in closer during the shot and rotates a bit. The new background you will be placing this action over does not move. Therefore, you will need to stabilize position, rotation, *and* scale!

2 Select **PXC_Europa.mov** and press `Home`. Make sure Window > Tracker Controls is visible and click Stabilize Motion. The movie will open in the Layer panel with a default track point.

In the Tracker Controls, enable the checkboxes for Rotation and Scale in addition to the default Position. This will create a second track point. In order to stabilize rotation and scale, After Effects needs to measure distance between two points over time, as well as the angle between them.

3 Still at 00:00, start with Track Point 1 on the left. Drag Track Point 1 over the upper left tracking dot, because it remains visible throughout the entire shot. Drag a corner of its feature region (the inner box) to make it just larger than the green square on the background. In the process, bump the search region (the outer box) to be about twice the size of the feature region.

For Track Point 2, think for a moment about which dot to track. It should be as far away from Track Point 1 as possible: The greater the distance between track points, the more accurate the scale and rotation tracks. It would hopefully remain visible throughout the shot as well. The second actor walks in front of all of the dots on the right; the middle dot in the upper row is obscured the least – so place Track Point 2 over it.

Resize Track Point 2. Again, do not make the track point larger than necessary; if you do, it will slow down the track, and After Effects will have more trouble when the actor walks in front of the dot.

4 In Tracker Controls, click on Options. The dots are the same color as the background but lighter, so pick Luminance for Channel. Further down, Adapt Feature On Every Frame should be off. Click on the popup underneath; since we know one of the features we will be tracking will be obscured during part of the track, select the option to Extrapolate Motion. This tells After Effects that if it cannot find the feature it's tracking, keep going in the same direction and hope it reappears. Click OK.

5 Time for some trial and error. Click Analyze Forward and keep your eye on Track Point 2, especially when the actor walks in front of its dot:

• If you set up a good track point, it will wander temporarily when the actor walks in front, but will find its dot again a few frames after he passes.

• If the track point follows or appears to "bounce off" the actor when he passes in front of the dot, the track point was too large. First Undo to remove the old track, tighten up the feature region, and analyze again.

• If the track point finds the dot after the actor passes but then loses the dot again later, the search region is too small. Undo, increase the outer rectangle very slightly, and try again.

If you tried several times and still can't get a good track, open **Comps > 05-Keying*starter2** *and continue with this comp instead. Double-click layer 1 to open its Layer panel and set View to Motion Tracker Points.*

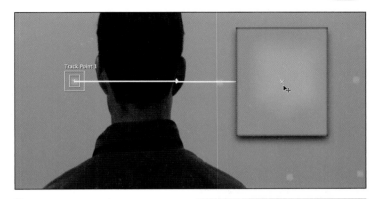

3 Enlarge the track points just enough to fit around the bright square dots. Place them over a pair of dots that are far apart but aren't too obscured during the course of the shot (above). For best results, make sure Track Point 2 in particular is a fairly tight fit around the dot (right).

4 In the Motion Stabilization Options, set the Confidence popup to Extrapolate Motion. This tells After Effects what to do when the actor walks in front of one of the dots we're tracking.

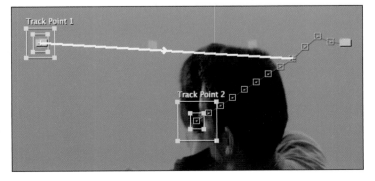

5 If Track Point 2's search region (the outer rectangle) is too large, it will follow the actor rather than re-find its dot.

▽ □ 1	⚙ [PXC_Europa.mov]		⊕	╱		👁	
▽ Motion Trackers							
▽ Tracker 1							
▽ Track Point 1						👁	
· ⏱ ⌐ Feature Center	259.6 , 447.4	◄ ◇ ►					◇◇◇◇◇◇◇◇◇◇◇◇◇◇◇◇◇◇◇◇◇◇◇◇◇
· ⏱ ⌐ Confidence	95.3 %	◄ ◇ ►					
· ⏱ ⌐ Attach Point	259.6 , 447.4	◄ ◇ ►					◇◇◇◇◇◇◇◇◇◇◇◇◇◇◇◇◇◇◇◇◇◇◇◇◇
▽ Track Point 2						👁	
· ⏱ ⌐ Feature Center	1053.0 , 465.9	◄ ◇ ►					◇◇◇◇◇◇◇◇◇◇◇◇◇◇◇◇◇◇◇◇
· ⏱ ⌐ Confidence	90.1 %	◄ ◇ ►					
· ⏱ ⌐ Attach Point	1053.0 , 465.9	◄ ◇ ►					◇◇◇◇◇◇◇◇◇◇◇◇◇◇◇◇◇◇◇ ◇ ◇◇
▷ □ 2	🖻 [Big Morongo.jpg]		⊕	╱		👁	

Add or remove keyframe at current time

6 When the attach point at the Center of Track Point 2 begins to wander (above), that's a bad keyframe. Delete it (top) and any other rogue keyframes (the lonely keyframe in the middle of the gap is probably the only other bad one).

7 After stabilization, the layer will be smaller at the end of the comp, as After Effects had to reduce its scale to remove the camera move. Disable keyframing for Position and move the layer to the bottom of the screen.

6 With **PXC_Europa.mov** selected, type **U** to see all of the tracker's keyframes. There will be a noticeable gap in Track Point 2's Attach Point keyframes when the actor passed in front of the dot. Let's make sure After Effects interpolated the motion correctly through that area.

Slowly scrub the current time marker in the Timeline panel while watching the Layer panel. When the actor's chin crosses into Track Point 2 at 01:11, you will see it snap away from the dot it was tracking. Stop at this frame, and delete the corresponding Attach Point keyframe.

Scrub later in time until you see Track Point 2 snap back into its correct position over the dot – that's a good keyframe. Delete any keyframes between this one and the keyframe you deleted above (there's probably just one, in the middle of the gap). Now as you scrub through this area, Track Point 2's boxes will still wander, but the attach point (at the end of the line connecting Track Point 1 and 2) will stay on course. Save your project.

7 Whew! That was a lot of work. Now for the payoff and some final tweaks before moving onto the greenscreen:

• Make sure Motion Target is still set to **PXC_Europa.mov** and click Apply, then OK. After Effects will bring the Comp panel forward.

• RAM Preview; the actors will now be stable. However, their layer will get smaller as After Effects compensates for the camera movement, leaving a gap at the bottom of the composition. Press **End**, where the gap is at its largest.

• Press **F2** to Deselect All and twirl up the Motion Trackers section in the Timeline panel to save space. Still at time 03:23, disable keyframing for Position, then reposition **PXC_Europa.mov** to where it just sits on the bottom of the composition (around Y = 482).

The term *keying* is short for keyhole: creating a cutout so you can see through one object to view another. Your next task is to "key out" the green in the **PXC_Europa.mov** layer so you can see a new background layer behind it.

▼ Tech Corner: Working with High-Definition Footage

In the final exercise in this lesson, you worked with high-definition (HD) footage. An HD frame can contain up to six times as many pixels as a DV frame, so you will need a lot of RAM, a fast computer, and hopefully a large monitor – even then, you'll need to employ a few tricks to make things manageable.

△ HD formats such as HDV and DVCPRO-HD use non-square pixels to save on data. Make sure the Pixel Aspect Ratio popup is set correctly for these footage items.

Work Smarter, Not Harder

In most lessons in this book, you've been working at Full Resolution and up to 100% Magnification so that you could see every pixel of your result. This would be terribly slow with HD. Therefore, it is quite common to work in a composition at 50% Magnification and Half Resolution. This is the way we've set up the comps in this exercise. If you have a small screen or a slow computer, you may need to go smaller than this (such as 33.3% Magnification and Third Resolution). On a real job, you would always go back to 100% Magnification and Full Resolution for a final confidence check; always render your final at this size as well.

Additionally, this shot touches on two additional technical issues that you will often have to deal with when working in HD: non-square pixels and 3:2 pulldown.

Pixel Aspect Ratio

True HD comes in two frame sizes: 1920x1080 pixels ("1080"), and 1280x720 pixels ("720"). This is a lot of pixels to record to videotape. Therefore, some HD video formats – such as HDV and DVCPRO HD – use fewer pixels and expect software or hardware to stretch the final images back out to full size later.

One of the most common formats is the "1080" flavor of HDV. On tape, this frame actually contains only 1440x1080 pixels.

As a result, the pixels are not square, and unprocessed footage would look skinny on a computer monitor. To compensate for this, After Effects needs to know its pixel aspect ratio so that it can perform the required stretch for you. This is set in the Interpret Footage dialog for each clip. We've already set this popup correctly for you; always check it for any HD footage you receive.

(Note: Since we cannot be sure that you have an HDV codec installed on your computer, we saved this file using a more commonly available QuickTime codec.)

3:2 Pulldown

Video in North America is normally shot at 29.97 fps. By contrast, most film is shot at 24 fps. Some people want their video to look more like film. To accommodate this, some video cameras can shoot at "24" fps. However, many still need to record a tape at 29.97 fps.

To make the math work, they first capture images at the almost-24 rate of 23.976 fps. They then spread one frame across three video fields (remember, there are two fields in each video frame), then the next source frame across two fields. This process is

△ If an HD shot was recorded with 3:2 pulldown, set Separate Fields to Upper Field First and try the Guess Pulldown buttons in the Interpret Footage dialog – most of the time, they will remove pulldown automatically for you.

known as 3:2 Pulldown; the result has an effective frame rate of 29.97 fps.

If you need to work with video that has 3:2 pulldown, you can remove the pulldown to get back to the originally captured frames. This results in fewer, cleaner frames to process. If you need to remove pulldown on HD footage, open the Interpret Footage dialog, set Separate Fields to Upper, then click on Guess 3:2 Pulldown. (We have saved this exercise's clip at its original, non-pulldown rate of 23.976 fps.)

3:2 Pulldown is covered in more detail in the Appendix.

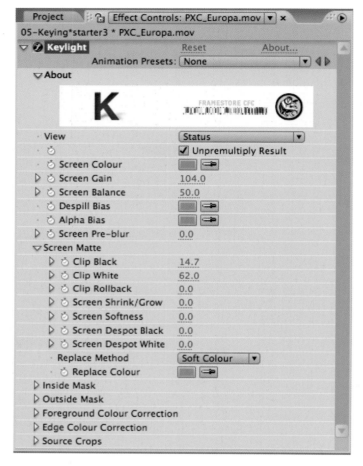

Keylight

Continue to use the comp you built in the prior section, or start with our version **05-Keying*starter3**.

8 Press (Home) and apply Effect > Keying > Keylight. This is a high-end keying plug-in that comes bundled with After Effects Professional. Then follow these steps to perfect your key. This is an interactive process, so have patience and be prepared to repeat some of these steps to balance the desired results:

• In the Effect Controls panel, click on the eyedropper for Screen Colour and click in a green area near the actor. This is your initial key. Not bad! However, if you look at the right side of the actor's neck, it's partially transparent and the background layer is showing through. For now, turn off layer 2 so you can concentrate on your key. If not already enabled, toggle on the Transparency Grid to better check the transparency of your key.

• Back in the Effect Controls panel, change the View popup to Status. This produces an exaggerated display of the key's transparency.

• Twirl down the Screen Matte section. Slowly increase Clip Black until most of the gray outside the actor disappears. Press ⌘ (Ctrl) to scrub in finer increments. You may leave the gray squares in the background (otherwise you'll start cutting into his head).

8 Eyedropper the green area near the first actor to get an initial key (A). Change Keylight's View popup to status (B). Carefully increase Clip Black and Screen Gain until the area outside the actor turns black (C). Decrease Clip White to maintain the solid areas in the actor, keeping a gray fringe in the semitransparent areas (D). Our initial set of numbers is shown (top); there is more than one valid combination.

• Slowly increase Screen Gain until the rest of the gray just disappears. Balance these two values against each other until you've made the smallest total increase while eliminating the gray.

• Slowly decrease Clip White until the gray in the actor's head turns white or light green. Don't push this too far; you want to keep some gray (which denotes transparency) around his hair's edge, as well as in the motion blurred areas as he moves.

• Scrub the current time marker through the timeline, checking that the black areas stay black and the light areas stay light.

• Change Keylight's View back to Final Result and preview your work. If the edges around the actors are too hard-edged, increase Clip White slightly.

9 Turn on the Video switch for layer 2 again so you can see your key in the context of its new background. Not too bad! But there are a couple of areas where it could be improved:

• Move to around 02:18. See the dark fringe on the first actor's arm? That's the result of decreasing Clip White too much. However, if you increase Clip White, you may start to see the background through the second actor's head. Tweak this parameter to reach a compromise.

• The edges around the actors are a little hard, especially when they are moving fast. Slightly increase Screen Softness to blend them better into the scene. If too much fringe starts to appear, you can balance this by decreasing Screen Shrink/Grow. (These two adjustments will also help the dark fringe problem.)

10 The final step consists of a bit of color correction to better match the actors to their new environments. While still at frame 02:18 (where you can see the actor's skin), click on the eyedropper for Despill Bias, then click on a pinkish skin area such as the left actor's forehead. This will remove some of the green cast or "spill" caused by shooting on a greenscreen stage.

It would be customary at this point to then spend time color correcting the foreground and/or background to better match each other, to help sell the illusion that the actors really were in this new room when the footage was shot. At a minimum, try using Levels to adjust the gamma and Hue/Saturation to adjust the hue. For more advanced color correction work, learn Synthetic Aperture's Color Finesse, which comes bundled with After Effects Professional.

RAM Preview; not bad, eh? Save your project, and have a nice cup of tea.

9 The composite looks pretty good (top). However, decreasing Clip White too much can result in hard edges, such as the black fringe on the actor's arm while moving (above left). Increasing Screen Softness and decreasing Screen Shrink/Grow can help this problem, as well as the overall composite (above right).

 tip

Keylight Documentation

For more documentation on Keylight, go to www.thefoundry.co.uk and select Products > After Effects > Keylight. Look for the header Support & Training; under it will be links for the Keylight manual, plus some example files you can practice with.

 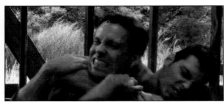 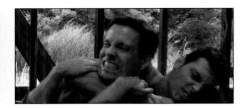

10 The original footage has a green cast (left). Using the Despill Bias eyedropper on their flesh tones helps remove this (center). In our final version, we brightened the actors using Levels and tweaked their color using Hue/Saturation (right).

 tip

Finer Control

Hold down ⌘ (*Ctrl*) as you scrub values such as Clip Black, Clip White, and Screen Gain for finer control.

Our version is in **Comps_Finished > 05_Keying_final**. In it, we also key-framed Screen Softness to start out sharp when the actor is closest and getting softer later in the shot. Of course, you can spend a lot more time further finessing this shot – and those who do are the ones who earn the big bucks!

These basic keying instructions can be applied to most shots. The overall goal is to do the least amount of damage to the outlines of the objects you want to keep. This comes with practice as well as compromise. If you have a series of shots taken with the same actors, lighting, and set, you may be able to reuse your keying settings, but most of the time you will have to approach each shot fresh.

It takes a lot of patience and attention to detail to be a good visual effects artist, so it's not for everybody – but films are relying on visual effects work more and more, so it's a good skill to have.

▼ Creating a Garbage Matte

When working with greenscreen footage, there may be extraneous objects that you don't wish to see in the final composite such as mic booms, light stands, props, the edge of the stage, and so on. If they're not also painted green, you will need to create a *garbage matte* to mask them out.

Another reason to create a garbage matte is simply to reduce the area you need to key. For example, perhaps the corners of the frame are not as well lit as the center where your foreground is, making your keying job more difficult.

A garbage matte could be as simple as creating a loose rectangular mask shape around your foreground; the mask does not need to follow the edges closely as the key will take care of that. If necessary, animate the mask throughout the clip by setting keyframes for Mask Shape.

For more intricate shapes, create a loose mask with the Pen tool. When there are multiple actors involved, you could even create one mask for each actor.

Masking and animated masks were covered in Lesson 4.

△ Creating an animated "garbage mask" (the yellow outline) that loosely encloses the actors will remove extraneous details and reduce the area you need to key.

If you plan on doing more keying, we recommend the Composite Toolkit from dvGarage (www.dvgarage.com). It contains excellent training on how to make better composites, plus the dvMatte plug-in which works great with normally problematic DV footage.

Idea Corner

• If you have access to a camera, shoot your own footage of people walking across campus or down the street. Then practice tracking them and placing text or other objects over their heads and the like.

• Take a handheld camera and shoot footage of objects with four clear corners – such as a poster, sign, painting on a wall, or a license plate or billboard on a bus going by. Use the Perspective Corner Pin track skills you learned in **04-Corner Pin** to replace it with your own source.

• Open the **Lightning*starter** comp in the **Idea Corner** folder and track another mountain peak, but this time from the mountain range in the background. Then apply Effect > Generate > Lightning and apply your tracks to Lightning's two effect points. Our version is the **Lightning_finished** comp.

Alternately, add a soundtrack to your project and use Generate > Audio Spectrum or > Audio Waveform in place of Lightning.

Track two peaks in the Mountain Peaks 2 shot and use this to make the Generate > Lightning effect jump from peak to peak.

Quizzler

• In the **Quizzler > Quizzler 1** folder, open the **Mask problem*starter** comp and RAM Preview. The wildebeests footage has an added rectangular mask. However, even though the footage has been stabilized, the mask is wobbling. Your mission is to make the stabilized animals play inside a static mask so it looks like **Mask_fixed.mov** in the same folder. Give it your best shot, then check it against the solution in **Quizzler Solutions > Quizzler 1**.

• In the first exercise, you learned how to stabilize the **Wildebeests.mov** shot; in the second exercise, you learned how to track it and make other layers follow one of the animals. How would you stabilize *and* track this shot? Use the comp **Quizzler 2 > Stable+Track*starter** as a starting point. A movie of the final shot is in the same **Quizzler 2** folder; one potential answer is in **Quizzler Solutions** – but don't peek until you try to solve it first.

• In the final exercise, you stabilized the greenscreen shot to match the new background, which didn't move. The result is a locked-down shot, which can lack the energy of a handheld shot. So, rather than stabilize the foreground shot **PXC_Europa.mov**, how would you make the new background take on the same camera movement as was in the foreground? Again, we've provided a movie of the result for you to study in the **Quizzler 3** folder and a starter comp. One potential solution is in **Quizzler 3_solution**.

How do you both track *and* stabilize the same shot, and still get the new layers to match the resulting motion? Try to find a solution with Quizzler 2.

Paint and Clone

Using Paint and Vector Paint to make your mark.

▽ In This Lesson

▽ Getting Started

Copy the **Lesson 10-Paint and Clone** folder from this book's disc onto your hard drive, and make note of where it is; it contains the project files and sources you need for this lesson.

The Vector Paint plug-in is not available in After Effects 7 Standard. The Vector Paint exercises have their own project file.

After Effects features two different ways to paint non-destructively onto a layer: by using the Vector Paint plug-in or its own Paint animation engine. Both allow you to create your own visible paint strokes on a layer and to reveal or erase parts of an underlying image; Paint can also clone from one area of an image to another.

After Effects Paint is based on Adobe Photoshop's paint tool with the addition of ani-mation. It works in the Layer panel, allowing you to focus on the whole, unmolested source layer as you work. Every single stroke is exposed in the Timeline panel, allowing you to retime, edit, and animate the brush settings and location of the stroke after the fact. In CS3, you can also use expressions to link its strokes to masks and Shape layer paths that have been created with the Pen tool. On the downside, it does not have the stroke wiggling capabilities of Vector Paint.

Vector Paint works both in the Layer and Comp panels, the latter allowing you to see your layer after it has been transformed and effected, as well as in context with other layers around it. Unlike After Effects Paint, Vector Paint has an "onion skin" option that lets you see strokes from previ-ous and future frames as you make new strokes. It can also wiggle paint strokes to create fun effects. On the downside, the individual strokes are hard to precisely time and move after you've created them. It also does not have a "clone" option.

Paint Basics

We'll start by becoming familiar with After Effects Paint. It contains three tools: Brush, Clone Stamp, and Erase. In this exercise, we will practice using all three.

1 Open the project file **Lesson_10a-Paint.aep**.
In the Project panel, make sure the **Comps** folder is twirled down, then double-click the comp **01-Paint Basics*starter** to open it. This comp consists of a still image of a fanciful mask that has an alpha channel.

There are three main Paint tools: Brush, Clone Stamp, and Erase.

2 Select Window > Workspace > Paint. This will open the Paint and Brush Tips panels which allow you to control and customize the Paint tools. It will also

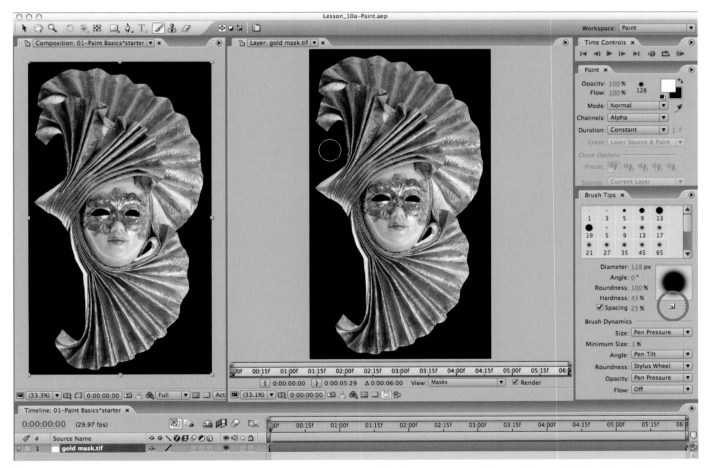

2 Open or create a Workspace that includes the Paint and Brush Tips panels. These are essential for working with After Effects Paint. You can choose to Save Current Settings as New Brush by clicking the icon circled in red.

▽ tip

Quick Size

To interactively resize the brush tip for either After Effects or Vector Paint, press ⌘ on Mac (**Ctrl** on Windows) and drag to set the diameter; release the modifier key and continue to drag to set the feather amount (Hardness).

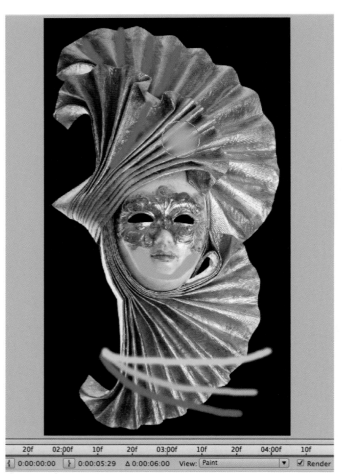

4 In the Layer panel, make a few practice strokes with the Brush tool, trying different Brush Tips and paint colors. Image courtesy **José Luis Gutiérrez/iStockPhoto**.

re-arrange your viewers so that the Comp panel takes the place of your Project panel and the Layer panel takes center focus. This is because After Effects Paint must be used in the Layer panel. If you use this layout, be sure to select Window > Project and dock the Project panel into the left side with the Comp; otherwise, you won't be able to open other comps when instructed. Of course, you can also make your own custom workspace that includes the Paint, Brush Tips, and Layer panels.

3 Double-click **gold mask.tif** to open it in the Layer panel. Then select the Brush tool. The shortcut is ⌘ **B** on Mac (**Ctrl** **B** on Windows); this will toggle through the three Paint tools. Note that the Paint panel will be grayed out unless one of the three paint tools is selected.

Each tool has its own set of Paint panel settings. When you change the brush size for the Brush tool, for example, this does not affect the size of the Eraser. The Erase popup is active only when the Eraser tool is selected. The Clone Options in the lower half of the Paint panel will be grayed out unless the Clone Stamp tool is selected.

If this is the first time you are using Paint, the defaults are fine for now. Feel free to pick a foreground color other than bright red plus a different size brush. However, make sure that the Paint panel's Mode popup is set to Normal, Channels is set to RGBA, and Duration to Constant. Opacity should also be set to 100%.

4 Check the bottom of the Layer panel: The View popup should be set to Paint and the Render switch should be enabled. Then draw a few strokes on the gold mask image in the Layer panel to get the hang of things. Try a few different Brush Tip sizes and foreground colors.

Key concept: Changing the settings in the Paint panel affects new strokes only, not existing strokes. But every stroke you draw will appear in the Timeline panel, where you can edit and even animate them. Press **P** **P** to reveal the Paint parameters in the Timeline.

Paint is an "effect" as far as After Effects is concerned. However, if you open the Effect Controls panel, the only option is Paint on Transparent, which is also available in the Timeline.

▼ Erasing Strokes

If you made a mistake while painting, you might be inclined to reach for the Eraser tool. Be aware that this tool also creates vector-based Eraser strokes in the Timeline, resulting in more items for you to manage.

However, if you set the Erase popup in the Paint panel to Last Stroke Only and pick a small brush tip, you can erase portions of the last brush stroke *without* creating a new Eraser stroke. Try out both methods so you can compare the results.

You can invoke the Erase Last Stroke Only mode *while the Brush tool is selected* by pressing ⌘ Shift (Ctrl Shift) and then erasing. Note that when you do this, the Brush Tip size used for erasing is defined by the Eraser tool's last brush size, *not* the Brush tool's current size! If you want to use this handy shortcut, we recommend you *first* set the Eraser to a smaller brush size with a similar Hardness value as the Brush tool *before* starting to paint. Then you'll be able to quickly switch modes and erase pixels as you paint.

△ The Last Stroke Only option in the Erase menu allows you to erase portions of the last stroke without creating Eraser strokes in the Timeline.

Painting the Eyes

Now that you've had time to play, let's work through some exercises and explore the various options available. To quickly delete all your strokes, use the menu command Effect > Remove All. Press Home to ensure the current time marker is at 00:00. Set the Layer panel's Magnification to 100% to better see what you are doing; remember you can hold down the spacebar and drag the image in the Layer panel to reposition it.

5 Let's start by adding some eye shadow to the eyelids of our mask. Make sure the Brush tool is selected. Select any color you like in the Paint panel. In the Brush Tips panel, pick a soft brush around 20 to 30 pixels in size.

Paint around the eyelid on the left side, making sure you slightly overlap the empty eye socket. Notice how the paint draws inside the eye socket? This is because the Channel popup in the Paint panel defaults to RGBA: the RGB color channels, plus the Alpha transparency channel. As a result, your paint stroke's alpha channel is *added* to the underlying layer's alpha.

Undo to remove the first stroke, change the Channels popup in the Paint panel to RGB, and paint the left eyelid again. Now the stroke is confined to the RGB channels only.

5 Painting with Channels set to RGBA results in your strokes going outside a layer's original alpha channel (left).

5 *continued* Set Channel to RGB (left), and your strokes will be confined to the underlying layer's alpha (right).

6–7 Set the Brush's mode to Overlay, and your stroke will be blended into the underlying image (above). Many of the Paint and Brush Tip parameters for each brush stroke appear in the Timeline panel for later editing and animation (right).

▼ **Brush Duration Bar**

Because the Duration popup in the Paint panel was set to Constant, both Brush strokes will appear for the entire duration of the layer. However, you can drag these gray duration bars to move them earlier or later in time, and trim them – just as you can with ordinary layer bars. By animating the Opacity parameter in Stroke Options, you can also make individual strokes fade up and down.

▽ tip

Painting Order

Because Paint is an effect, you can apply multiple instances of Paint to the same layer and combine it with other effects. You can determine the order in which the effects render by dragging them up and down in the Effect Controls or Timeline panels.

6 Press **P P** to reveal Brush 1 in the Timeline panel. To the right of Brush 1 is a Blending Mode popup for the individual stroke (not to be confused with the Mode popup for the entire layer). To better blend the stroke with the underlying image, select Overlay or Color mode, or another one that suits your fancy. By selecting the Brush, you will also see a thin line appear in the Layer panel that illustrates the middle of your stroke.

While you're here, twirl down Brush 1, then its Stroke Options. Notice that you can change the size, color, opacity, and much more of any stroke *after* you've created it!

7 Before painting the right eyelid, set the Mode popup in the Paint panel to the same mode as you just chose for Brush 1. Channels should still be set to RGB.

Important! *Press **F2** to deselect Brush 1* – otherwise, you will replace it with your new stroke! Now paint over the right eyelid; your new settings will be used. When you're done, Brush 2 will appear in the timeline with its Mode already set.

Painting the Lips

8 In the Paint panel, pick a nice red color for the lips and set the Mode popup to Color. In the Brush Tips panel, again select a smallish brush (we used Soft Round 21 pixels).

Press **Home** to make sure you are at 00:00. Check that no existing Brush strokes are selected (press **F2** if so). Using one continuous stroke, paint the top lip and continue around painting the bottom lip until the lips are completely covered. When you release the mouse, Brush 3 will be added to the Timeline panel.

9 As you are finished creating paint strokes for now, press **V** to return to the Selection tool; it's best not to edit with the Brush tool active as it's too easy to replace a selected stroke. Click on the Comp panel to bring it forward again. (Indeed, if both are open, After Effects will give priority to updating the Comp panel over the Layer panel.)

• In the Timeline panel, twirl up Brush 1 if it is still open. Then twirl down Brush 3 > Stroke Options.

• Scrub the Stroke Options > Start parameter: Your stroke will wipe off as the value increases. Return Start to 0%.

• Now scrub the Stroke Options > End parameter; reducing the value wipes the stroke off in reverse.

• Set End to 0% and enable its animation stopwatch to set the first keyframe at 00:00.

• Move later in time to 01:00 and set End to 100%.

Press **0** on the numeric keypad to RAM Preview: The "lipstick" will now animate on over one second, following the same path you used to paint it.

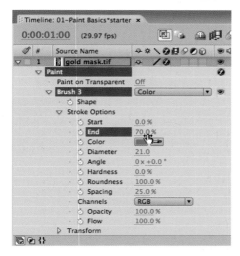

9 As you scrub either Start or End under a Brush's Stroke Options (above), your brush stroke will animate (left).

10 Feel free to also animate Brush 1 and 2 to draw on the eye shadow over time. Your strokes are already done; all that's left is to animate the End parameter:

• Click on the word End for Brush 3 to select both keyframes and Edit > Copy.

• Press **Home** (as keyframes are pasted starting at the current time).

• Select Brush 1, then **Shift**+click Brush 2 to select it as well.

• Paste, and both of these brushes will also get your End keyframes.

RAM Preview, and all three brush strokes will animate in sync. To offset them in time, simply drag the stroke bars in the timeline so that they are staggered in time. A handy shortcut is to move the current time marker to where you want the stroke to start. Start dragging the stroke bar, then press **Shift** as you get close; it will snap to this time.

10 After you twirl up a Brush in the Timeline panel, dots along its bar will indicate where its underlying keyframes are located.

The goal in this exercise is to use Paint to reveal a series of shapes during this colorful animation.

2 To quickly view just the alpha channel, ⌥-click (*Alt*+click) in the Show Channel switch along the bottom of a viewer. The alpha of our bird shows the rough paper texture used.

Painting to Reveal

Quite often, you will not use Paint to directly create visible strokes; instead, you will use Paint to reveal other layers you've already created. This can give the impression that you are "painting on" more complex imagery. This trick will be the focus of our next exercise.

1 In the Comp panel, select Close All from its top menu. Type ⌘ O (*Ctrl* O) to re-open the Project panel. Assuming you are still using the Paint workspace, dock the Project panel into the Comp panel's frame to save space. Double-click **Comps > 02-Write On*starter** to open it and RAM Preview. (It's large and therefore will take a little while to render; if it is too slow, reduce the comp to 50% Magnification and Half Resolution.)

Select any layer in this gritty but colorful composition and press **U** to see its keyframes; also feel free to solo layers to see them in isolation. The individual layers were created by hand (see the sidebar *Creating Textures*), then combined using techniques you've learned in earlier lessons including Blending Modes, Track Matte, Frame Blending, and wiggle expressions.

To add even more interest to this composition, you're going to "paint on" the first few layers using animated paint strokes. If you want to see where you're heading before diving in, play **Finished Movies > 02-Write On.mov**.

2 To reveal an image, its layer has to start off invisible, then gradually be revealed over time. Painting on an invisible layer isn't very easy, though – so you'll make the layer transparent in a later step. Start by painting in its new alpha channel:

• Double-click layer 1 – **auto-bird.tif** – to open it in its Layer panel. Make sure your comp is at Full Resolution by pressing ⌘ J (*Ctrl* J).

• ⌥+click (*Alt*+click) on the Show Channel icon along the bottom of the Layer panel to view just the Alpha. You will see a textured white shape against a black background.

• Select the Brush tool. In the Paint panel, check that Opacity and Flow are both set to 100%. Set the Foreground color to white.

• For Paint's popups, set Mode to Normal and Channels to Alpha. It's important to paint these strokes *only* in the layer's alpha channel; painting in the RGB channels will obliterate the original color of the layer.

• Set the Duration popup to Write On. The Write On option automatically sets the keyframes for the stroke's End parameter.

• In the Brush Tips panel, select a round brush with a diameter of around 50 pixels. Change its Hardness value to around 80%.

▼ Creating Textures

For this exercise, we created a variety of fun sources using inexpensive art supplies. After they dried, we scanned them into the computer. They are contained in the **Sources > CyberMotion** folder. Here is how some of them were made:

• **ink texture** was created by smearing printing ink on paper with a putty knife.

• **waxpaper matte** was created by rolling printing ink on wax paper then pressing it onto paper.

• The four sources beginning with the word "**auto**" were created with India ink and a calligraphy tool known as an automatic pen. They were all scribbled in one pass in just a few seconds – it's best not to think too hard to get this look! Once scanned, these black-and-white images were inverted in Photoshop and moved to an alpha channel so their backgrounds would be transparent in After Effects.

• The "**rough**" icons were created loading India ink into a folded pen – another calligraphy tool. Drawing on rough watercolor paper gives the edge texture, which is more organic than the otherwise beloved Stylize > Roughen Edges plug-in.

• **sunprint sequence** contains a series of ten images cropped out of a blurred abstract watercolor. This sequence was slowed down and looped in its Interpret Footage settings, then Frame Blended in the comp to create crossfades.

• We also created some of our own stamps by heating special foam and pressing found objects into them.

Have fun creating some of your own textures and marks. Check out your local library for art books such as *Art Effects* by Jean Drysdale Green. The Web is also full of ideas from the arts and crafts world, including instructions for how to make a folded pen from a soda can!

• Press **Home** to make sure you are starting at 00:00. In the Layer panel, paint from the bottom up in one continuous stroke over the course of a few seconds, moving your brush as necessary to eventually cover the entire bird.

When you release the mouse, the paint stroke will disappear. This is because Write On automatically created keyframes for End, starting at End = 0%. Press **U** to see these keyframes in the Timeline panel, then scrub the time marker to see the stroke animate. If you're not happy with the stroke, Undo and try again.

(Note: If you took longer than 10 seconds to draw your stroke, the second End keyframe may not be visible. In the Timeline panel, drag the Brush 1 bar to the left until you can see the second keyframe, and move it earlier in time. Then return the Brush 1 bar to start at 00:00.)

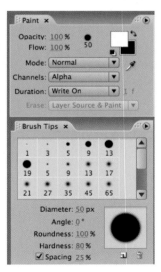

◁ Feel free to drag the top of the Brush Tips panel to cover the Clone Options.

2 *continued* Configure a roughly 50-pixel brush to paint on just the Alpha channel, using Write On for its Duration, and paint over the image from the bottom up.

 A
 B
 C

3 When the RGB channels are viewed, you'll initially see paint blobs plus your bird (A). Toggle the Paint on Transparent option On, and you'll see just your strokes (B). Apply Effect > Channel > Set Matte, and the bird's original alpha channel will cut through your strokes, yielding the desired effect (C).

3 Press **V** to return to the Selection tool. Return the Layer panel Channels popup to RGB mode and scrub the timeline. Hmm…a black blob on a black bird – not our intention. Time to finish the illusion:

• With **auto-bird** still selected, press **F3** to open its Effect Controls panel, which will show the Paint effect. Toggle Paint on Transparent option to On. Now the layer will start off transparent.

• The remaining problem is that the original alpha has been replaced with the paint stroke. To retrieve it, apply Effect > Channels > Set Matte. The default options reapply the alpha from the layer's source.

RAM Preview and adjust the timing of the Stroke Options > End keyframe to taste. Bring the Comp panel forward and preview your reveal in the context of the other layers.

Our version is in **Comps_finished > 02-Write On_final** if you'd like to check it out.

Don't stop here! Repeat the above steps with the **rough-triangle** layer (you may need to keyframe the brush diameter for this one as it starts skinny and gets thicker as it unwinds), the **stairs** layer (adjust Brush Tip Roundness to create a flatter brush to get more of a wiping effect), and the **zigzag** layer (experiment with adjusting the Brush Tip Angle parameter).

Our version is in **Comps_finished > 02-Write On_final**, where we've also staggered the timing of the layers, scaled and rotated **rough-triangle**, and added some wiggle expressions to heighten the craziness.

▼ Tablet Settings

A pressure sensitive tablet such as a Wacom is a great companion for Paint. The Brush Dynamics section at the bottom of the Brush Tips panel allows you to set how the pen's pressure, tilt, or stylus wheel affects the brush as you paint. Click on the Save Current Settings As New Brush button to remember your favorite configurations.

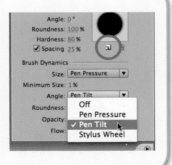

Using the Clone Stamp Tool

If you are familiar with cloning in Photoshop, the Clone Stamp tool in After Effects works in a similar fashion: It samples pixels from one part of a layer and copies them to another part. You can use it to repeat parts of an image or to repair flaws.

1 Still in project **Lesson_10a-Paint.aep**, close all previous comps and open **Comps > 03-Cloning*starter**. For this exercise, we suggest you continue using Workspace > Paint so you can view the Comp and Layer panels side by side.

Spend a few moments getting familiar with the various layers, then focus on the **misc splats.tif** layer. A variety of "ink splats" are scattered around this footage. You'll use the Clone Stamp tool to add a few more, then transform them.

2 Just like the other Paint tools, you can use the Clone Stamp tool only in the Layer panel. Press **Home** to return to 00:00, then double-click **misc splats.tif** to open its Layer panel. Verify that the Channels popup at the bottom of this panel has been set back to RGB.

3 Select the Clone Stamp tool. The Paint panel will update to show the last settings used for this tool. Opacity and Flow should be at 100%; set Mode to Normal, Channels to RGBA, and Duration to Constant.

Verify that the Clone Options are visible at the bottom of the Paint panel. The Aligned switch should be disabled; this will allow you to clone multiple copies without having to reset the origin point.

Set your Brush size to a largish Diameter such as 80 so you can clone the splats easily. Increase the Hardness value to reduce the possibility of picking up stray pixels.

In this exercise, you will clone some of these ink splats (left) to create a busier layer, and animate them to appear at different times.

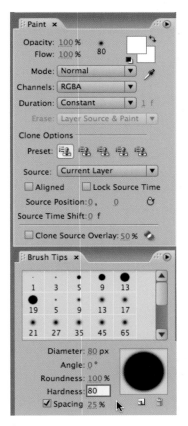

3 Select the Clone Stamp tool (left). The Clone Options will become active in the Paint panel; make sure they are revealed (above). Use these settings for Paint and Brush Tips.

 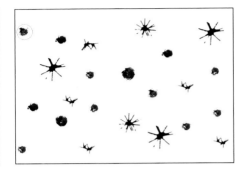

4 Press ⌥ (*Alt*) and click on the splotch you wish to clone; you will see a crosshair icon as you do so (left). Release ⌥ (*Alt*) and copies of it elsewhere on the layer (center). Clone various spots until you are happy with how full the layer looks (right).

▽ gotcha

Replacing Strokes

Be warned that if a Brush stroke is already selected in the Timeline panel, and you draw a new stroke, the selected stroke will be replaced. Press *F2* to deselect all strokes before drawing new strokes.

4 Finally, you are ready to start cloning:

• Press the ⌥ (*Alt*) key; the cursor will change to a crosshair icon. Click on the first splat you want to copy. The Source Position will update in the Paint panel.

• Release the ⌥ (*Alt*) key. Then paint where you'd like to drop a new splat. Because the Aligned switch is off, you can click again in a new location to repeat the same item elsewhere on the layer.

• As soon as you create one stroke, the Paint effect is applied. (If the Effect Controls panel comes forward, dock it with the Comp panel and bring the Comp panel forward again.)

Have fun cloning other spots until your layer is nicely populated with splotches.

5 Press **P P** to reveal the Paint effect in the Timeline; you may need to resize its frame to see all of your individual Clone stroke bars. You can then edit parameters of the individual strokes:

• Press **V** to return to the Selection tool. To move a cloned object after the fact, select one of your Clone strokes in the Timeline panel, and its anchor point (plus the center line of any "brushing" you did) will appear in the Layer panel. Drag it to a new position; when you release the mouse, the Comp panel will update to show its new location in context.

• To create variations on the cloned originals, twirl down one of your Clone strokes in the Timeline, then twirl down its Transform settings. Scrub the Rotation and Scale settings while watching the Comp panel. Go ahead and keyframe these parameters to animate the clone.

• Try offsetting some of the Clone strokes in the Timeline panel so that they start at different points in time. That way, they will appear to "pop" on. To fade them on, animate their Stroke Options > Opacity parameter.

5 In the Timeline panel, you can slide the Clone stroke bars in time and transform how each stroke is drawn. Transform properties can also be animated.

- To remove a cloned stroke, select it (in the Layer panel or the Timeline) and press **Delete**.

- To remove a splat on the original layer, use the Eraser tool: Set the Channels to RGB and the background color to white, then you can erase without creating a "hole." The render order of the strokes goes from bottom to top in the Timeline, so make sure After Effects gets a chance to render the clone before you erase its source!

- You can also clone a clone, just like you can in Photoshop. And if you clone an animated Clone stroke, the second clone will also animate!

Continue cloning, erasing, and transforming until you have a nice balance and arrangement of ink splats. If you want to compare results, open Window > Project (it's near the bottom of the list) and view our version **Comps_Finished > 03_Cloning_final**.

Paint Idea Corner

In the **Sources > CyberMotion** folder you'll find additional textures, images, and icons to play with. Craft your own design combining Paint with these elements plus your own textures. If you have After Effects 7 Professional or CS3, read the following section on the Vector Paint effect to learn how to create some "wiggly" strokes for more fun animation ideas.

Screening Room

Once you create some cool imagery, have fun putting them to work in another composition! For example, play **Finished Movies > Screening Room.mov**. The comps that created this are in this project's **Idea Corner** folder. Return to Workspace > Standard and explore:

- The first comp, **assembly-1/montage**, includes our finished **02-Write On** and **03-Cloning** comps sequenced together.

- The second comp, **assembly-2/composite**, scales down the montage to fit the screen in the conference room.

- The third comp, **Screening Room**, performs a final "push in" on the entire composite.

Try compositing your comps into a similar environment: windows, billboards, and so on are all good candidates.

If you are using an image where the "screen" is not a perfect rectangle, distort your layer to fit using Effect > Distort > Corner Pin (included with After Effects 7 Professional or CS3). If you have just the Standard edition and have installed the Cycore Effects, you can use Distort > CC Power Pin in its place.

▽ tip

What's in a Stroke

In After Effects, Mask Shapes and Brush Shapes are both vector paths, and you can copy and paste between them. You can also copy paths from Illustrator (see Lesson 12). Before you Paste, though, be sure to click on the existing property name (such as Brush 1 > Shape) to "target" it.

▽ tip

Dynamic Pin

Using the Corner Pin effect is a simple technique for fitting an animation into a window in a still image. If the window is moving, use the Perspective Corner Pin mode for the Motion Tracker, which was demonstrated in the previous lesson.

The **Idea Corner** folder contains a series of comps which put our fanciful Paint animations to work. Room image courtesy Jami Garrison/iStockPhoto.

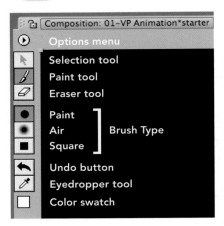

When the Vector Paint effect is selected, a set of buttons dedicated to it appears along the left edge of the Comp panel. Right-clicking in the Comp panel will also produce a menu of additional options.

3 Vector Paint contains a wealth of Composite Paint modes; setting to Only will show only your strokes, not the underlying layer.

Vector Paint

Vector Paint is an oldie-but-goodie effect that was created before After Effects gained its own paint tools. (Vector Paint is available only in the Professional edition of After Effects, not After Effects 7 Standard.) It is a bit idiosyncratic in that its user interface appears around the edges of the Comp panel, there is no cloning mode, and the user does not have direct access to the individual paint strokes in the Timeline panel. On the other hand, it has a wealth of compositing modes, the ability to see other frames as you work, and a really fun "wiggle" option.

In these final two exercises, we'll give you a taste for what Vector Paint can do. If you're intrigued and want to learn more, the After Effects online help file contains extensive documentation on Vector Paint: Press **F1** from inside After Effects and search for the words "vector paint."

Animated Strokes

In this first exercise, you will use Vector Paint to draw some crazy squiggles coming out of a mannequin's head.

1 If you have After Effects 7 Professional or After Effects CS3, open the project file **Lesson_10b-Vector.aep**. Make sure the Workspace is set to Standard; you don't need the special Paint workspace when working with the Vector Paint effect.

In the Project panel, open **Comps > 01-VP Animation*starter**. This comp contains an image of a mannequin's head that has an alpha channel.

Vector Paint cannot paint beyond a layer's boundaries, and the **mannequin.tif** layer does not come close to filling up the comp's frame. Therefore, you will create a full-frame solid to paint onto:

2 Select Layer > New > Solid. In the Solid Settings dialog that opens, click Make Comp Size, enter the name "**Vector Paint squiggles**" and click OK. The solid will temporarily obscure the mannequin.

3 With **Vector Paint squiggles** selected, apply Effect > Paint > Vector Paint. The Effect Controls panel will open; in it, set the Composite Paint popup to Only. The solid will disappear, and only your paint strokes will render for this layer.

As long as Vector Paint is selected in the Effect Controls panel, an additional set of buttons will appear along the left side of the Comp panel. These define the type of brush you will be using and its color. Numeric parameters for these controls are echoed in the Effect Controls panel.

4 Time to paint some strokes:
• Click on the color swatch at the bottom of Vector Paint's Comp panel buttons and pick any color you like.

• You can set the Radius and Feather for your brush in the Effect Controls or you can size your brush interactively. To interactively size your brush, hold down the ⌘ (*Ctrl*) key and click and drag in the Comp viewer. A circle will show you how big your brush is. With the mouse button still held down, release the ⌘ (*Ctrl*) key and drag some more: A second circle inside the original circle will show you how big your feather is. Now release the mouse button.

4 You can interactively size your brush in the Comp panel by holding then releasing the ⌘ (*Ctrl*) key while you drag (left). Paint a series of fun strokes around the mannequin (above). Mannequin courtesy Bernd Klumpp/iStockPhoto.

• Click and draw a stroke leading away from the mannequin's head (or from her mouth…or draw her some eyebrows, or a mustache…just have fun!). Draw several strokes, feeling free to change the brush size and color between strokes if you like.

5 Scrub the current time marker in the Timeline panel. Oops – the strokes disappear after the first frame. No problem! In the Effect Controls panel, change the Playback Mode popup to Hold Strokes: They will stay on for the entire duration of the comp.

Press **Home** to return to 00:00, then change the Playback Mode popup to Animate Strokes. Scrub the current time marker or RAM Preview; your strokes will each animate on at the speed with which you originally drew them. If you want to change that speed, use the Playback Speed parameter in Vector Paint's Effect Controls panel.

5 By setting Playback Mode to Animate Strokes, your strokes will draw on at the pace you originally drew them.

Wiggle Strokes

One endearing feature that sets Vector Paint apart from the normal After Effects Paint tool is its ability to easily wiggle your strokes, resulting in some really wild animations:

6 In the Effect Controls panel, twirl down Vector Paint's Wiggle Control section. Click on the box for Enable Wiggling and RAM Preview again: Each of your strokes will now jiggle on its own!

6 Check the Enable Wiggling option, and your strokes will wriggle automatically.

7 Increase Displacement Variation to make them loop around on themselves (above); increase Pressure Variation to vary them in width, including breaking up into small blobs. In our version (below), we pushed these to extremes and composited the Vector Paint solid using the Color Burn blending mode.

7 Take some time to explore the other parameters in the Wiggle Control section. For example:

• Wiggles/sec defaults to a very fast speed; try slowing it down to 10 or less.

• Increase Displacement Variation to get more curls in your strokes. At extreme settings, your strokes will loop back over themselves, creating an animated graffiti effect.

• Increase Pressure Variation to vary the width of the strokes along their lengths. At higher settings, your strokes will break up into individual segments.

We had fun taking these to extremes in our version, **Comps_Finished > 01-VP Animation_final**.

Onion Skin

Another nice feature of Vector Paint is the ability to see what you've done in adjacent frames. This makes it easier to animate strokes with continuity of motion.

1 Bring the Project panel back forward and open **Comps > 02-VP Onion Skin*starter**. It contains an image of a microphone; your goal is to draw fanciful sound waves traveling along its cord.

2 Select **microphone.jpg** and apply Effect > Paint > Vector Paint. Select a color you think will complement the microphone and table, then set the brush size and feather to taste.

3 We're going to animate a series of strokes "on twos" (every two frames). It will be easier to draw the next stroke if we can see where the prior stroke ended and perhaps the stroke before that to check continuity. This requires two adjustments:

• In the Effect Controls panel, click Options (to the right of the Vector Paint effect's name). In the Onion Skinning Section, set both Backwards and Forward Frames to 4 so you can see two adjacent strokes. Feel free to change the color of the ghost strokes, adjust the Skin Opacity to 50%, then click OK.

• Set the Playback Mode popup to Onion Skin.

3 Open Vector Paint's Options (above) to control how the strokes that are adjacent in time will be drawn while in Onion Skin mode (right).

4 Press **Home** to make sure the current time marker is at 00:00, limber up your wrist, and get ready to do some drawing:

• Draw a short stroke, starting at the jack that plugs into the base of the microphone. You can try to precisely trace the cable, draw fanciful squiggles that roughly follow it, or do anything in-between. If you don't like it, undo and draw it again.

• Press **Page Down** twice to advance two frames. A ghost of the previous stroke will be visible.

• Draw a new stroke that starts on top of where the old stroke ended and continues its motion.

• Press **Page Down** twice more, and continue this rhythm until you complete the length of the cable.

5 Once you reach the end of the cable, press **Page Down** two more times, then press **N** to end the work area here. Now let's try out a few different Playback Modes, RAM Previewing each one to see if we like it:

• Remaining in Onion Skin mode gives you a real-time playback of what you saw while you were drawing.

• Setting Playback Mode to Hold Strokes holds a stroke until a new stroke was drawn. This results in each of your strokes being visible for two frames.

• Past Strokes keeps older strokes on screen as each new stroke is drawn, eventually filling in your path along the cable. This one is particularly fun when combined with Wiggling!

Double-click the work area bar to return it to the full length of the comp and have fun "finishing" this animation any way you like: Make more waves travel down the cable, animate waves entering the microphone's grill, or do whatever strikes your fancy. Our version is in **Comps_Finished > 02-VP Onion Skin_final**; we're sure you can surpass it with a little patience and creativity.

Paint in After Effects is not as developed as it is in some other programs. However, it is still underused considering what you can do with it; practice it, and you will have a skill that not many other After Effects artists do.

4 In Onion Skin mode, you will be able to see your prior strokes in the Comp panel, making it easier to continue their motion. Image courtesy Mike Manzano/iStockPhoto.

Experiment with Playmode modes such as Hold Strokes and Past Strokes.

In our final version, we used three copies of the Vector Paint effect to create independent animations for different strokes, then duplicated this layer so we could using Blending Modes to mix the result back on top of the original photo.

New Features in CS3

Exploring Brainstorm, the Puppet tool, and Shape layers.

▽ Getting Started

Make sure you have copied the **Lesson 11-CS3 Features** folder from this book's disc onto your hard drive, and make note of where it is; it contains the project file and sources you need to execute this lesson.

All of the exercises in this lesson require After Effects CS3 Professional. This lesson's project file will not open in After Effects 7.

After Effects CS3 Professional (also known as Version 8) introduces several new features aimed specifically at animators and motion graphics artists. You'll play with three of them here: Brainstorm, the Puppet tool, and Shape layers.

Brainstorm produces variations on selected properties, keyframes, or effects. You can have Brainstorm keep generating ideas until you find one you like, or have it save new compositions with variations that you found promising and might like to explore later.

The **Puppet** tool provides an alternate way to warp layers. Imagine your image being printed on a sheet of rubber, which is automatically trimmed to the outline of your layer. Then imagine pushing pins through areas of that layer, such as where feet and hands are. Then imagine dragging some of those pins around…

Shape layers are one of the most comprehensive, exciting new features added to After Effects in some time. Many of the drawing tools you are familiar with in Adobe Illustrator have now been brought into After Effects to be animated, including several of the more interesting path effects. This opens up an endless well of graphical shapes you can create and animate inside After Effects without having to involve another program.

Brainstorm

A large portion of graphic design is playing "What If?" The game can be as simple as deciding how far or how fast to animate a layer, or as complex as trying to learn an effect that has a seemingly endless list of sliders and values. As much fun as this game is, it tends to take a while to play.

This is where Brainstorm comes in. You select as many or as few parameters, keyframes, or effects as you like on a layer and let Brainstorm try out different combinations of values for you. It presents nine alternatives at a time; you can toss them all away and start over, or select ones that are close and have Brainstorm generate new ideas based on the ones you liked. You can apply one of Brainstorm's results to the layer you are working on, or have it save off intermediate variations in their own new compositions.

Let's work through a few common scenarios where Brainstorm would be useful:

Effect Variations

Open this lesson's project file **Lesson_11_CS3.aep**. In the Project panel, locate and double-click **Comps > 01a-Brainstorm 101** to open it. It contains a single text layer. Let's use Brainstorm to help us try out an effect treatment on this layer:

1 Select the text layer **eroded** and apply Effect > Stylize > Roughen Edges. This is one of our favorite effects to distress a layer. Not familiar with what this effect can do? Brainstorm can help…

2 Press **E** to reveal the effect in the Timeline panel and make sure the effect Roughen Edges is selected in either the Effect Controls or Timeline panels. Then click on the Brainstorm icon along the top of the Timeline panel. A floating window with nine copies of your comp will appear, each showing a variation on your original layer.

3 Brainstorm defaults to a relatively mild degree of randomness: 25%. Scrub this value up to 100% and click on the Brainstorm button at the bottom of this window. You will get nine more choices, with more variations. Keep clicking the Brainstorm button until you see one or more variations you like.

▽ tip

Preset Variations

Brainstorm works particularly well with Animation Presets to generate variations on their themes. In particular, try Brainstorm on presets in the Backgrounds, Behaviors, and Synthetics folders by selecting the effects they apply to a layer. In the case of Behaviors, select only the first "controller" effect; don't select the effects whose names are in parentheses.

2 Select the effect you applied and click the Brainstorm icon in the Timeline panel (above). A window with nine variations will appear (below).

If you want to try something other than our text, open comp **01b-Map Edges*starter** and work with the layer **Indian Territory_sml.jpg** instead.

Randomness: 25 % 0:00:00:06

Brainstorm

4 When you see a variation you like, hover your cursor over this image to see what your options are (below).

Maximize Tile

Apply to Current Comp

Save as New Composition

Include in Next Brainstorm

4 Hover your cursor over a preferred variation, and a series of four buttons will appear floating on top of it. Click on the Include in Next Brainstorm button to tell After Effects "more like these." Reduce Randomness to back around 25% and click Brainstorm again.

5 If you see a variation that you would like to explore later but are not quite sure if it is "The One," click the Save as New Composition button. It will be saved in the same folder as the comp you are currently working on, with its ending number incremented automatically.

6 Keep going, clicking Brainstorm and checking different variations you like, until you find one you'd like to continue with. (If you feel you went past a set of variations that in retrospect you decided you rather liked, click on the Back button to the left of Brainstorm.) Move your cursor over your chosen variation so that its buttons appear and click Apply to Current Composition. The Brainstorm window will close, and these parameters will be applied to your selected effect.

Brainstorm is great for exploring unfamiliar effects. For example, open **02a-Fractal Noise*starter** or **02b-Cell Pattern*starter**. Select the **Solid** layer in these comps and press ⏹ to see their applied effects – they have a long list of parameters! Select the name of the effect and use Brainstorm to give you an idea of the variety of looks you can achieve with these effects. We've added the new-in-CS3 Tritone effect to colorize the results; if you like, select this effect as well when you Brainstorm. Remember to increase Randomness to get a wider range of variations.

Brainstorm is great for seeing the range of possibilities available with complex effects such as Fractal Noise (left) or Cell Pattern (right).

Brainstormed Keyframes

By selecting specific properties or keyframes before activating Brainstorm, you can restrict what values it works on. This is handy for testing alternate animations or avoiding results you know you aren't interested in.

1 Bring the Project panel back forward and open **Comps > 03-Keyframe Brain*starter**. RAM Preview; it's a simple animation of a word moving across the screen. Say you want to spice this up but don't know how just yet.

2 Select **Next**, and press **U** to reveal its transform keyframes. Drag a marquee around the keyframes at 00:00 and 00:10 to select them.

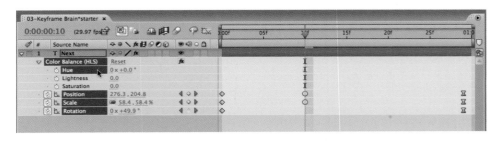

Then press **Shift E** to reveal the Color Balance (HLS) effect also applied to **Next**. Twirl down its parameters and **Shift**+click on Hue to select just that property in addition to the keyframes.

2 Select just the keyframes and parameters you want Brainstorm to randomize.

3 Click Brainstorm. It will automatically start calculating a RAM Preview for all nine variations; there are Play/Pause plus Rewind to Start buttons underneath the viewers.

Note that you are getting variations in starting Rotation and Scale, in the path the word takes (as the middle Position keyframe is getting randomized as well), plus in the color of the word thanks to the Hue parameter. Increase the Randomness value to around 35% (or higher) and try some more variations. If you see one or more you like, hover your mouse over them, enable their Include buttons, reduce the Randomness value, and click Brainstorm again to get variations more closely related to these choices.

We had some fun with this by saving multiple comps with intermediate Brainstorm variations. We then took the resulting layers in those comps and copied them all back into the same comp. Finally, we used Blending Modes to combine these multiple variations, creating a swarming effect. The result can be found in the Project panel's **Comps_finished** folder as **03-Keyframe Brain_final**; we also rendered a copy and placed it in the **Finished Movies** folder.

3 In addition to randomizing effects, Brainstorm provides a way to generate variations on animation moves.

Three Puppet tools give you new possibilities in warping layers.

The Puppet Tool

Also new in After Effects CS3 is a set of three tools collectively known as the Puppet tool. These provide an alternate way to warp layers. As you might guess from the name, they are particularly well suited for character animation, although they can also be used for entertaining effects on other types of layers.

The core element of the Puppet tool is the idea of a *pin*. Pins serve two purposes:

• They stabilize elements that you don't want to move, such as feet that are supposed to stay on the ground.

• They act as handles to drag elements that you *do* want to move, such as a hand reaching or waving.

After the pins are placed, the Puppet tool then warps the layer between the stationary pins and the moving handles. It also includes other useful options, such as a Starch tool that reduces how much an area warps, and an Overlap tool that ensures that the part of the layer you are dragging will cross over in front or behind another part of the same layer.

Puppet Pin Tool

1 Click on the Composition panel's view menu and select Close All to close your previous comps. In the Project panel, locate and open **Comps > 04-Puppet*starter**. Select **MiroMan.psd**: a fanciful character with a few appendages to play with.

2 Select the Puppet Pin tool in the toolbar. A set of options will appear to the right in the Toolbar. Enable the Mesh: Show switch and leave the others at their defaults for now.

Press `Home` to make sure you are at 00:00 – this is important because unlike most other parameters inside After Effects, the Puppet tool enables animation and creates a keyframe as soon as you create a pin.

3 Click on one of MiroMan's ankles to pin it in place. A yellow pin will appear where you clicked. **MiroMan.psd** will also be overlaid with a mesh of triangles, which indicate how the layer has been divided for warping. Click on the other ankle to pin both into place.

2–3 Select the Puppet Pin tool and enable Mesh: Show (left, top). Clicking on the layer with this tool places a yellow pin (left, where red arrow is pointing), plus reveals the mesh of triangles the Puppet tool will use to break up and warp your layer. Credit: We drew this character in Adobe Illustrator while referring to an image in the Dover book of public domain art *Treasury of Fantastic and Mythological Creatures*. He is based on a character in the Joan Miró painting *The Harlequin's Carnival (Le carnaval d'Arlequin)* 1924/25.

4 Click on the arm on the left, just before the point where it meets the pencil. This is a handle we want to move.

Now for the fun bit: Click on the yellow dot for the pin you just created (the cursor will turn white, with a four-way arrow at its tail) and drag it around the Comp panel. **MiroMan** will warp to follow your dragging, with the ankles remaining pinned in place.

Notice how the feet beyond the ankles counter-rotate slightly as you drag, helping give the impression of the character stretching on his tippy-toes. If you don't want the toes to move, undo to a pre-stretched pose, pin the toes as well, then get back to dragging and stretching the arm with the pencil.

5 Click on the top of the pencil to add another pin. Hover the cursor over this new pin; it will change to the four-arrow pointer. Drag this new pin, and the pencil will bend.

Animating Pins

6 Now let's animate your arm and pencil:

• Hold **Shift** and press **Page Down** to move forward ten frames. Move the tip of the pencil into a new position.

• Press **End** to move to the end of the comp. Select the pins for both the pencil tip and where the arm meets the pencil. You can drag a marquee around them, or **Shift**+click them. Drag this pair together into a new position.

Press **0** on the numeric keypad to RAM Preview and watch your simple animation. Remember, After Effects enabled keyframing for you automatically to save you from having to dive into the Timeline panel chasing after every single pin. With the layer selected, press **U** and you will see your keyframes.

We've animated a few more pins in our version **Comps_Finished > 04a-Puppet_final**; select Puppet in the Timeline to see these pins.

4 Dragging one of your pins warps the entire character, pivoting around the pins you're not moving.

6 After Effects automatically enables every Puppet Pin for keyframing (above). When you select a pin, its motion path is displayed in the Comp panel (left).

▼ Puppet Part Stacking Order

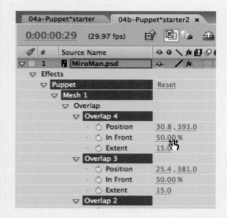

04a-Puppet*starter	04b-Puppet*starter2 ×

0:00:00:29 (29.97 fps)

🖉	#	Source Name	♣ ✳ ◥ fx 🗐 ⚲
▽	1	🖪 MiroMan.psd	♣ ╱ fx
▽ Effects			
▽ Puppet		Reset	
▽ Mesh 1			
▽ Overlap			
▽ Overlap 4			
○ Position		30.8 , 393.0	
○ In Front		50.00 %	
○ Extent		15.0	
▽ Overlap 3			
○ Position		25.4 , 381.0	
○ In Front		50.00 %	
○ Extent		15.0	
▽ Overlap 2			

You have control over which layer pieces will pass in front of or behind other layer pieces. With the Puppet Overlap tool selected, *Shift* +click on the blue Overlap pins to select all that relate to a specific section of the body. Press *S* *S* (*S* twice, for Solo Selected) to reveal these Overlap pins in the Timeline panel. Twirl them down: The In Front parameter determines stacking priority for a pin's area; Extend determines how wide an area that pin has influence over.

Puppet Overlap Tool

An important feature of the Puppet tool is the ability to control how your character behaves when you drag one piece to overlap another.

1 Open **Comps > 04b-Puppet*starter2**. This is the same character you've been working with.

2 Select **MiroMan.psd**. If Puppet isn't visible in the Timeline panel, press *E* to reveal effects. Select the word Puppet in the Timeline panel, and you will see three yellow circles in the Comp panel that show where we've already placed pins for you: on the two ankles and on the wrist on the left (the one holding the pencil). We've disabled the mesh to make it easier to see what's going on.

3 Drag the pin on the wrist so that it moves across his left hip: The warped element will go *behind* the body. Now drag the pin up and over this shoulder: The pencil will move in *front of* the body. You can control what element passes in front of or behind another:

• Select the Puppet Overlap Tool. Pressing ⌘ *P* on Mac (*Ctrl* *P* on Windows) will also toggle to this next tool. If the character is still warped, a gray outline of the unwarped body will appear.

• Inside this gray outline, click on what would be the top of the pencil. A blue dot will appear, and its outline will be shaded in white, following the mesh triangles.

• Continue clicking inside this outline until the pencil and left arm are filled in (if you select too much of the body, Undo or move the blue pins down the arm).

• Press *V* to return to the Selection tool. Drag the pin on the wrist over the character's hip – now the arm and pencil will pass in front of his body!

3 Normally, the arm will pass behind the body when you drag it behind his hips (A).

Use the Puppet Overlap tool to click and fill in the area of the pencil and arm you wish to treat differently (B); now it will pass in front of the body (C).

A

B

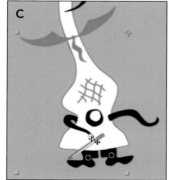
C

Recording Puppet Animation

The Puppet tool has a version of Motion Sketch (discussed in Lesson 2) to make it easier to animate pins. Continuing on with **04b-Puppet*starter2** above:

4 Make sure the Puppet effect is still selected in the Timeline panel. Press the ⌘ (*Ctrl*) key and hover the cursor over the yellow pin on the left arm: The cursor will look like a stopwatch.

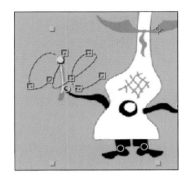

While still holding ⌘ (*Ctrl*), click on this pin and start dragging it around. After Effects will start recording your animation as you drag and will stop either when you release the mouse or time runs out in the comp.

In the Comp panel, you will see a motion path for the pin you dragged. Press **U**, and its keyframes will be revealed in the Timeline panel. Press **0** on the numeric keypad to RAM Preview.

If you don't like the results of your puppetry, you can always undo and try again, or refine your animation using the Graph Editor (Lesson 2). If you have trouble drawing a path you like in real time, select the Puppet tool and click on the Record Options in the Toolbar. This will allow you to record at a different speed than it will play back at, as well as to control the display and how much automatic smoothing will take place. In addition, you can edit the motion path in the Layer panel; set the View popup to the Puppet effect, select an animated pin, and its path will appear for editing.

Puppet Starch Tool

Sometimes, portions of your layer may be more flexible than you wish, or other kinks may appear. One solution is to increase the number of triangles for a layer. Another is to use the Puppet Starch tool.

1 Open **Comps > 04c-Puppet*starter3**. Make sure the Puppet Pin tool is selected, then select the layer **MiroMan.psd**. In the Comp viewer, look for the yellow circles: We've added pins to his feet, plus three for his big red tie.

2 Click on one of the pins at the ends of his tie and drag it around. As you move to more extreme positions, you might notice some strange kinks in the neck.

3 To fix these kinks, select the Puppet Starch Tool. A gray outline will illustrate the shape of the original unwarped layer. Click in this gray area in the middle of the neck where the tie would cross it – this will add a red starch pin to your layer. Wait a second while After Effects calculates; the neck will straighten out. Return to the Selection tool and try dragging the tips of the tie again to compare.

◁ **4** Hold ⌘ (*Ctrl*) while dragging a pin, and its animation will be recorded automatically (left).

▽ In our comp, **04b-Puppet_final** (below), we animated the wrist and pencil, then copied the keyframes for Pin 4 (the pencil tip). These keyframes were pasted to the Brush Position of the Write On effect on a solid layer. A little tweaking, and our MiroMan is "write on"!

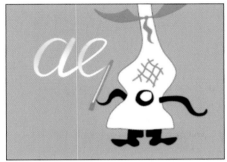

3 When warping a layer, kinks may appear, such as in the neck here (above). Clicking in the problem area with the Puppet Starch tool selected will "stiffen" the neck (below), helping to straighten out the kinks.

Shapes Guided Tour

Included in this lesson's folder is a QuickTime movie that gives you a quick tour of how to create and edit shapes. We suggest you watch it before diving in, especially if you don't have time to work through this first Shape exercise.

▽ tip

Reshape as You Draw

You can use the up/down arrow keys or mouse scroll wheel while you drag a shape to change the roundness of its corners (Rounded Rectangle) or the number of points it has (Polygon or Star).

2 The old "mask" tool can now be used to create masks or shapes, with more basic shapes available.

3 When you select a Shape tool, Fill and Stroke options will appear along the right of the Toolbar. Click on the words Fill or Stroke to open an options dialog; click on the swatches to select a color.

Shape Layers

One of the most exciting new features in After Effects CS3 is Shape layers. These vector-based layers are heavily inspired by Adobe Illustrator, including many of its familiar tools and effects. Their advantage over using Illustrator artwork is that they can be created and – more importantly – animated inside After Effects.

You can draw standard shapes including a rectangle, rounded rectangle, ellipse (circle), polygon, or star. It is easy to modify these shapes after the fact, including parameters such as rounding or how many points a star has. You can also draw your own free-form shapes. Each shape can have its own stroke and fill. You can also apply Shape Effects such as Wiggle and Twist to modify and animate the shapes. A Shape layer may have multiple shapes, and you have many options for how these shapes may be grouped and combined.

Shapes can be used to create anything from simple abstract objects to entire cartoons. Our focus here will be on graphical elements. We'll start by leading you through a grand tour of what you can do with the basic tools. We'll then show you how to create a few useful objects, and end by employing a Shape layer for a common task: creating an animated map path.

1 We assume you have this lesson's project file **Lesson_11-CS3.aep** open. Click on the Composition panel's view menu and select Close All to close your previous comps. In the Project panel, locate and double-click **Comp > 05a-Shape Play*starter** to open it. It is currently empty.

Make a Shape

2 Click on the Rectangle tool in the Toolbar section along the top of the application window and keep the mouse button held down until a menu pops open. In After Effects 7, this tool was used to create Rectangular or Elliptical mask shapes. In After Effects CS3, it is used to create both masks plus Shape layers. There are also several new options available under this menu, including Rounded Rectangle, Polygon, and Star.

3 Select the Rounded Rectangle tool. When you select one of these tools, Fill, Stroke, and Stroke Width options will appear in the Toolbar to the right. You can use these to change the color of your shapes before or after you create them.

- Click on the word Fill to open the Fill Options dialog. Here you may select between fill mode buttons: None, Solid, Linear Gradient, and Radial Gradient. You can also set the Blend Mode popup and Opacity for the fill. Choose Solid Color and Normal mode. Set Opacity to 50% and click OK.

3 *continued* Clicking on Fill or Stroke will open an options dialog where you can set the desired type, opacity, and mode.

▼ Mask or Shape?

The Shape and Pen tools are context sensitive:

• If any layer other than a Shape layer is selected, After Effects assumes you want to draw a mask on the selected layer.

• If no layer is selected, After Effects assumes you want to create a new Shape layer.

• If a Shape layer is selected, an additional pair of buttons in the Toolbar let you choose whether you want to draw a new shape in the currently selected Shape layer, or you want to draw a mask on the Shape layer.

Shape Tool Tool Creates Shape

Pen Tool Tool Creates Mask

• To the right of Fill is its color swatch. Click on it to select your color (choose what you like; we'll use red). You can also ⌥+click (**Alt**+click) this button to toggle between the fill modes.

• Next is Stroke Options; it has the same choices as Fill Options. Choose a Solid Color fill with the Blending Mode set to Normal and Opacity = 100%.

• Next is Stroke Color, which has the same choices as Fill Color. Choose whatever color you like; we'll go with white.

• The last option is Stroke Width, with a scrubbable value. Start with 6 pixels.

4 Click and drag in the Comp panel, and your shape will appear. A Shape Layer will also be added to the Timeline panel, twirled open to reveal your first shape group: Rectangle 1 in this case.

Edit a Shape

5 Twirl down Rectangle 1 to reveal what makes up your initial shape group: Path, Stroke, Fill, and Transform.

Temporarily twirl down Stroke 1 and Fill 1 – you will see the same parameters as in the Toolbar, and more. We'll experiment with them later; twirl them up for now.

The default arrangement is Stroke over Fill. Click on Fill 1 in the Timeline panel and drag it just above Stroke 1 until a black line appears above it. When you release the mouse, the fill will now be over the stroke (you will see some of the stroke's line because you set the Fill to 50% in step 3). Undo to get back to stroke over fill.

4 Click and drag directly in the Comp panel to create a new Shape.

5 Twirl down Rectangle 1.

▼ Shape Positions

There are three different types of Position values (and for that matter, Transform properties) in a Shape layer, each of which may be edited and animated:

• Each shape path – such as Rectangle Path 1 – has its own Position inside its shape group.

• Each shape group – such as Rectangle 1 – has its own Transform > Position. Its initial value is based on where you drew the first shape path and is shown as an offset from the layer's Position in the comp.

• An overall Shape layer (including all of its groups) also has a normal Transform section, which includes Position.

8 With your Shape Layer selected, click and drag a new shape in the Comp panel (right). A new shape group will be added in the Timeline (above). Delete Ellipse 1 when done.

6 Twirl down Rectangle Path 1 and explore its parameters:

• Size is akin to a shape path's scale. Scrub its values, trying it with the Constrain Proportions switch (the chain link) turned on, then off. Set it to 200, 200 when you're done.

• Position offsets this path (Rectangle Path 1) inside its group (Rectangle 1). Leave it at 0, 0.

• Roundness controls how rounded your rectangle is, ranging from square-edged to a circle. Set to taste.

Unless you were very careful with how you dragged your shape, it is probably not centered in the Comp panel – even though the shape's Position value is 0,0. This is where the shape group's Transform properties come in:

7 Twirl down Transform: Rectangle 1. These parameters are for an entire shape group. Currently, you have only one shape in your group, but these come in really handy as you create more complex composite shapes.

Play with these parameters to become familiar with them. Then set Transform: Rectangle 1 > Position to 0, 0 to center your rectangle in the Comp panel.

Multiple Shapes

A Shape layer can contain more than one shape path.

8 Click on the Rounded Rectangle tool until its popup menu appears, then select the Ellipse tool. Tweak the Fill and Stroke settings if you like.

Make sure your **Shape Layer** is still selected (otherwise, you'll create a new layer!). Drag out your new shape in the Comp panel.

When you release the mouse, a new shape group called Ellipse 1 will be added to **Shape Layer** in the Timeline panel. Twirl Ellipse 1 down, and you will see it has its own Path, Stroke, Fill, and Transform. You can play with these parameters if you want.

When done, select Ellipse 1 and delete it.

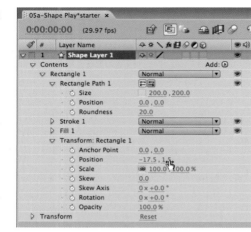

6,7 Each shape path has its own Size and Position, plus parameters (such as Roundness) that control the shape. In addition, a shape group has its own set of Transform properties.

9 Instead of creating a new shape group, you can add a new shape path to the group you're already working on. To do this, select its name in the Timeline (in this case, Rectangle 1) or a member of its group (such as Rectangle Path 1). Then click on the Add button either in the Timeline (to the right of Contents) or in the Toolbar (to the right of Stroke Width). Just for something different, select Polystar. It will share the same Fill and Stroke settings as Rectangle Path 1, as they belong to the same shape group.

10 Twirl down Polystar Path 1 and experiment with its parameters. This is one of the most versatile shape paths: It has a popup to turn it into a Star or a Polygon, plus you have a lot of control over how many points or sides it has and how rounded its corners are.

To create interesting looping shapes, try setting Inner and Outer Roundness to very large positive or negative values. After you've had some fun playing, set up a shape where the Polystar's outline forms interwoven or overlapping lines, either within the Polystar's own shape or intersecting the Rectangle.

11 Twirl down Fill 1. Set its Fill Rule popup to Even-Odd. Now alternating sections of the overlapping shapes, rather than the entire shape, will be filled.

There is a lot more that can be done with combining shapes, which we'll explore in later exercises. For now, either delete Polystar Path 1 or twirl it up and click on the eyeball next to it to turn it off.

Save your project before continuing. If you've fallen off the path, you can open **Comps_Finished > 05a-Shape Play_final1** to pick up this exercise at this step so you can jump into playing with Shape Effects.

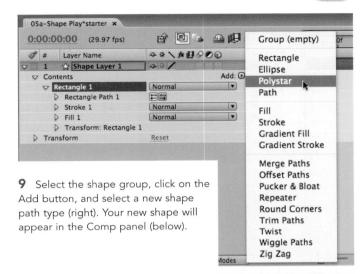

9 Select the shape group, click on the Add button, and select a new shape path type (right). Your new shape will appear in the Comp panel (below).

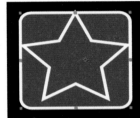

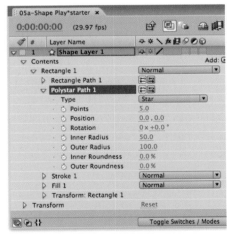

10–11 The Polystar is one of the most versatile shape paths (left). Adjust it until it partially overlaps the rectangle underneath (A), then change Fill > Fill Rule to Even-Odd to create a pattern of filled areas and holes (B).

Twist

Pucker

Bloat

Zig Zag

Shape Effects

In addition to creating shape paths, there is a wide variety of Shape Effects that can be employed to modify those shapes. Let's have fun briefly exploring a handful of them, one at a time:

12 Click on Add, then select Trim Paths. Twirl down Trim Paths in the Timeline panel and scrub Start and End while watching the Comp viewer: Only a portion of your shape will be drawn. Set one or both to a value between 0 and 100%, then scrub Offset: The shape will appear to rotate or chase itself. This attribute is particularly useful when you don't have a fill, as it allows you to create animated stroke effects. When you're done, twirl up Trim Paths and turn off its eyeball to disable it.

Trim Paths

13 Select Add > Twist, twirl it open, and scrub its Angle parameter: This adds a nice, organic distortion to stiff shapes. Twirl it up and disable it when done.

14 Select Add > Pucker & Bloat; your rectangle will take on an overstuffed appearance. This attribute bends the path segments between the shape path vertices: In this case, the lines between the corners and the rounded corners themselves. Twirl down Pucker & Bloat and scrub its Amount (try positive and negative value): You can create some really wild shapes this way. When you're done, twirl it up and turn off its eyeball.

15 Select Add > Zig Zag. This can be thought of a spiky version of Pucker & Bloat. Twirl it down and scrub its Size and Ridges parameters: You can quickly create anything from mad scrawls to cool, angular, geometric figures. Change the Points popup from Corner to Smooth to create a more freehand-drawn look. When you're done, twirl it up and turn off its eyeball.

16 Select Add > Wiggle Paths. Initially, it will look like static has been added to your shape's path! Twirl it down and experiment initially with its Size and Detail parameters, along with the Points popup.

This effect is special in that it self-animates: Press **0** on the numeric keypad to RAM Preview, and your shape will dance for you! Play with Wiggles/Second and Correlation to change the dance speed and pattern. Our version is shown in **Comps Finished > 05a-Shape Play_final2.**

Wiggle Paths

The Repeater

As if that wasn't enough fun, we'll wrap up this whirlwind shape tour with one of the most useful effects: the Repeater. Open comp **05b-Repeater*starter**.

To see what is happening more clearly, we've turned off the eyeball for Fill 1 in the Timeline panel. You will see just the stroked outline in the Comp panel.

17 Select Add > Repeater. Additional echoes will appear to its right.

18 ⌘+click (**Ctrl**+click) on the arrow next to Repeater in the Timeline to twirl down all of its parameters. Go ahead and experiment with their values; they're a lot of fun to play with. For now, focus on Copies, Position, Scale, Rotation, Start Opacity, and End Opacity. If your repeats are going off-screen, reduce the Repeater's Position offset to bring them back into the picture.

19 After you've had your fun, set Copies to 5, Offset to 0, both Anchor Point and Position values to 0, Scale to 75%, Rotation to 30°, Start Opacity to 100%, and End Opacity to 0%. At this point you should have a nice geometric outline in the Comp panel.

Now press ⌘ (**Ctrl**) and slowly scrub the Offset parameter. This offsets where the chain of repeated shapes starts. In this example, if you set Offset to a negative number, the "first" repeat will be larger than the original as it will be scaled up instead of down.

20 You can keyframe any numeric parameter in Shape layers – including the Repeater:

• Press **Home** to return to 00:00. Slowly scrub Offset until the shapes grow off the edges of the Comp viewer. Click on the stopwatch next to Offset to enable keyframing.

• Press **End** to move to the end of the comp. Scrub Offset until the shapes become very small. RAM Preview, and enjoy the time-tunnel style animation!

Our version is **Comps_Finished > 05b-Repeater_final**. We added a background layer, thickened and colorized the stroke, and used a Blending Mode to make the shape interact with the background. For more complex shapes, toggle some of our other effects (such as Zig Zag or Twist) on and off in the Timeline panel. Save your project; we'll move on to creating some additional shapes.

▽ try it

Fill and Stroke are Live

When a shape is selected, the Fill and Stroke parameters in the Toolbar are still "live" – edit them, and your shape will update.

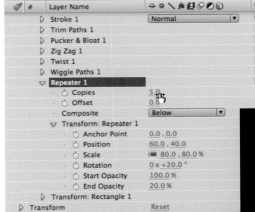

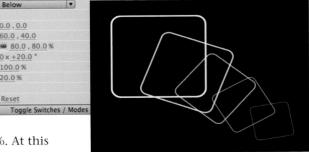

18 The Repeater attribute takes your shape path and copies it. Each successive copy is modified by the parameters in Transform: Repeater.

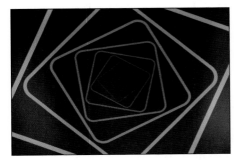

20 Animating the Repeater's Offset and Rotation with Scale set to less than 100% creates a fun time-tunnel animation. Background courtesy Artbeats/Nature Abstracts.

▼ Compound Paths

One of the more useful Shape Effects is Merge Paths. This effect helps you make "compound" shapes – for example, the cutout in the middle of letters like O. We'll employ them in this exercise to create a gear.

1 Click on the Comp panel's view menu and select Close All to close your previous comps. In the Project panel, double-click **Comps > 06-Gear*starter** to open it. It is currently blank.

2 We'll start by making the teeth of the gear:

• **Q** is the shortcut key to toggle through the shape tools. Type **Q** until you see a star shape in the Toolbar.

• Click on the word Fill in the Toolbar, make sure Solid Color is selected, set Opacity to 100%, and click OK.

• Click on the word Stroke. Set it to Solid Color and 100% Opacity.

• Set Fill Color, Stroke Color, and Stroke Width to taste.

• Click in the middle of the Comp panel and drag outward to create roughly the size of gear you want; add the **Shift** key while dragging to prevent the shape from rotating. Release the mouse and a new Shape layer containing the Polystar 1 group will be created in the Timeline.

• Since you'll be adding shapes to this group, let's rename it: Select Polystar 1, press **Return**, type "**Gear Group**" and press **Return** again.

3 Next, let's tweak the default star into something that more resembles a gear:

• First, center the shape in the comp. Twirl down Gear Group in the Timeline, then twirl

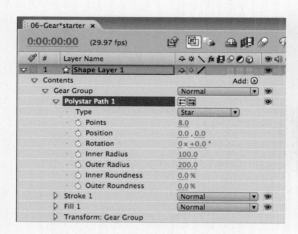

3 Tweak Polystar Path's parameters to set up the number, size, and slope of your gear teeth.

down Transform: Gear Group. Set Position to 0, 0 and twirl up Transform: Gear Group.

• Twirl down Polystar Path 1. Set Points to the number of teeth you want in your gear.

• Tweak Inner and Outer Radius to set up what will be the angle of your gear teeth. We find that making Outer Radius about twice the value of Inner Radius works well for gears.

• Zero out the Roundness values; we want sharp teeth for our gear. Twirl up Polystar Path 1 when done.

4 Next, trim off the spikes on your teeth:

• Make sure Gear Group is selected (not just the Shape layer), click the Add button, and select Ellipse.

• Twirl down Ellipse Path 1. Scrub Size until your circle is just inside the star's points.

5 At this point, the circle is being filled and stroked as well, when you really want to use it just to chop off the star's points. Time to combine them into a compound path:

• Make sure Gear Group is selected. Select Add > Merge Paths.

• Twirl down Merge Paths 1 and set its Mode popup to Intersect. (Feel free to try out the other options, of course.)

4 Add an Ellipse shape path.

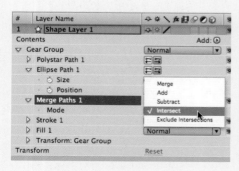

5 Add Merge Paths set to Intersect.

5 *continued* When you set Merge Paths to Intersect, the ellipse chops off the star's points.

• Further tweak Ellipse Path 1's Size to taste and twirl up Ellipse Path 1 plus Merge Paths 1 when done.

6 Now, let's fill in the bottom of your teeth. Making sure Gear Group is selected (so that you don't accidentally start a new group):

• Select Add > Ellipse again. Drag Ellipse Path 2 underneath Merge Paths 1.

• Twirl Ellipse Path 2 down, increase its Size to fill in the bottom of the teeth, and twirl it up. This new ellipse will also be stroked; Merge Paths can fix that as well.

• Select Add > Merge Paths again. Drag Merge Paths 2 below Ellipse Path 2.

• Twirl down Merge Paths 2 and verify that its Mode is set to Add. The ellipse will be added to the result of the first Merge Paths attribute to make one shape.

7 The last step is adding a third Ellipse Path and Merge Paths pair to cut the hole out of the middle (above).

6 Add a second Ellipse path after the initial Merge Paths to fill in the bottom of the gear teeth (above).

6 *continued* Add a second Merge Paths and drag it after your new Ellipse (above right). Now the stroke will follow the result of the compound path, instead of the individual shapes (right).

7 The last step is the hole in the middle:

• Make sure Gear Group is still selected. Then select Add > Ellipse and drag Ellipse Path 3 underneath Merge Paths 2. Tweak its Size to taste and twirl it up.

• Select Add > Merge Paths. Drag Merge Paths 3 below Ellipse Path 3.

• Twirl down Merge Paths 3 and set its Mode to Subtract to have the final ellipse cut out from the composite shape.

If you got lost along the way, feel free to open our version: **Comps_Finished > 06-Gear_final2**. In it, we used polygons instead of ellipses to file down and fill in the gear teeth to get a chunkier look.

We created a crosshair with shapes in **Comps_Finished > 07-Display_final**, then used it to track a subject in **Display_final2**. Footage courtesy Artbeats/Business on the Go.

▽ try it

Crosshair Shape

The Rounded Rectangle is the basis of our crosshair shape; it can be easily made into a square, circle, or shapes in-between. In this exercise, twirl down Rectangle 1 > Rectangle Path 1 and play with Roundness.

2 The Gradient Editor allows you to set the color and transparency of your gradient.

Crosshairs

Dials, crosshairs, and other objects that can help you build fake informational displays are often useful. While building a sample crosshair, we'll employ a few additional Shape layer tricks: gradients, pen paths, and groups.

Gradient Editor

1 Open **Comps > 07-Display*starter**. Since this is an element to be used in a later composite, we made this comp a smaller square rather than full-frame video size. We also set the background color to a grayish tint, which helps us better see what's happening with our transparency and colors.

We've also made a starter rounded rectangle for you. Rectangle 1 should be twirled open in the Timeline panel; if it isn't, twirl down **Shape Layer 1**, then Contents, then Rectangle 1.

2 Rather than use solid colors, let's fill the center of our crosshair with a partially transparent gradient:

- Select **Shape Layer 1** (the highest level of the layer).

- Hold down the ⌥ (*Alt*) key and click on the Fill Color swatch in the toolbar. It should change from a solid to a gradient.

- Release ⌥ (*Alt*) and click on the Fill Color swatch again. The Gradient Editor will open. Position it so that you can also see the Comp panel while editing your gradient.

- Select Radial Gradient by clicking on the second of the two icons in the upper left corner.

- Click on the pointer at the upper left corner of the gradient bar: This Opacity Stop sets the opacity of the center of the gradient. We want to see through the center of our crosshair, so set its Opacity to something low, such as 15% or less.

- Click on the Opacity Stop along the right; this is for the outer edge of the gradient. We want to keep some transparency in the corners, so set it roughly around 50%.

- Click on the pointer in the lower right corner of the gradient bar: This is the Color Stop for the outer edge of the gradient. Set it to black.

- Finally, click on the Color Stop to the left: This is the center color. Pick a color to taste, and note how it tints the center of the gradient in the Comp viewer. Click OK when finished.

• Press **V** to make sure the Selection tool is active and verify that Gradient Fill 1 is selected for your Shape layer in the Timeline panel. In the Comp panel, you should see a pair of solid dots with a line between them: These define where the gradient starts and ends. Drag the outer dot until you are happy with the way the gradient "falls off" in your display.

2 *continued* In the Comp panel, you can graphically edit where the gradient starts and stops.

Pen Tool

Next, we'll use the Pen tool to create our crosshairs:

3 To help precisely draw our lines, make sure the Window > Info panel is open and visible. Also make sure your Shape Layer is selected.

4 Press **G** to select the Pen tool. In the Toolbar, make sure Tool Creates Shape is enabled.

We want to draw a vertical line centered in our 400-pixel-wide comp, so move the cursor over the Comp panel until Info says X = 200 and Y = 20, then click. Move the cursor downward to X = 200 and Y = 380, and click again: Your line will appear.

5 In the Timeline panel, a new group called Shape 1 will appear. Twirl it down; it will contain your new Path, plus its own Stroke, Gradient Fill, and Transform.

You still need to create the horizontal crosshair; best to place it in the same group as the vertical one. Select Shape 1, then Add > Path. Path 2 will appear.

In the Comp panel, with the Pen tool still selected, place the cursor at X = 20 and Y = 200, and click to start your new path. Then place the cursor at X = 380 and Y = 200, and click again to finish your horizontal crosshair. Press **V** to return to the Selection tool.

6 The advantage of having a separate group for the crosshairs is that you can make them a different color and width. Twirl down Shape 1 > Stroke 1 (under Path 2) and change the Color, Opacity, Stroke Width, and Line Cap to taste. You now have your crosshair!

Our crosshair shape is in **Comps_Finished > 07-Display_final**; we then used it to track a "person of interest" in **07-Display_final2**.

4 Select the Pen tool and enable Tool Creates Shape (left). With the help of the Info panel, create a vertical line (above).

6 By placing the crosshair paths in their own group, they can also have their own Stroke settings (above and left).

Stroked Paths

We'll finish our exploration of Shape layers by tackling another common task: Drawing a path on a map or underscoring other elements in a composition, then stroking that path. Shape layers are particularly well suited to this job as you can design interesting dashed patterns to stroke your path.

1 Save your project and close your previous comps. Then open **Comps > 08-Map Path*starter**.

This large comp contains a scan of a map of Indian Territories in the 1890s. Resize your Comp panel's frame to view it at 50% Magnification.

2 Select the Pen tool, enable RotoBezier mode, set Fill to None, and set the Stroke to taste (you can always edit its color and width later).

2 Make sure **Indian Territory.jpg** is *not* selected – otherwise, you will draw a mask on this layer, when you actually want to create a new Shape layer. Press **G** to select the Pen tool, then enter the following settings using the Toolbar:

• Enable the RotoBezier option to make it easy to create a fluid path.

• Since you're drawing a line, your shape will not need to be filled. Press **⌥** (**Alt**) and click on the Fill Color swatch until it is a gray box with a red line through it.

• Click on Stroke, make sure it is in Solid Color mode, and set its Opacity to 100%. Click OK.

• Set the Stroke Color to taste, thinking of what might provide a good complement to the map's colors. We choose a dark turquoise green.

• You want a thick stroke to outline your path, so increase the Stroke Width to around 16 pixels.

3 Visualize a path you want to create across this map, perhaps telling a story of an expedition from east to west. Click on the dark line along the right edge of the map to start your path. Then click several additional points across the map until you reach the left hand border. There is no need to click and drag; RotoBezier automatically calculates the curve between the points you create. If you are unhappy with your path, you can hold **⌘** (**Ctrl**) and drag existing points to new locations.

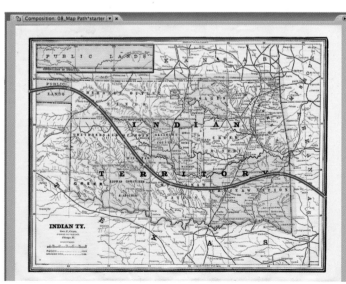

3 Click several points to define a path across the map.

Press **V** to switch back to the Selection tool when done. A line indicating the stroke's path will be drawn down the middle of your stroke. (If you like, toggle off Mask and Shape Path Visibility to see your stroke more clearly.)

3 *continued* You can click on Toggle Mask and Shape Path Visibility at the bottom of the Comp panel to hide the yellow path.

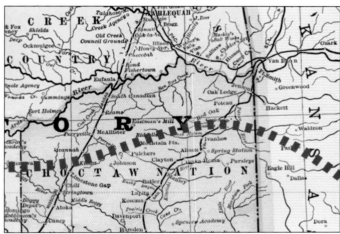

4 The default stroke is a solid line, but it's possible to design your own pattern along the stroke. In the Timeline panel, twirl down Shape Layer 1 > Contents, then Shape 1, then Stroke 1 to reveal the Stroke's parameters.

The last Stroke parameter is Dashes. Twirl it down; it does not contain any segments yet. Click on the + button; the stroke will now be a dashed line.

4 Click on the + switch next to Stroke 1 > Dashes to convert the line from solid to dashed.

5 Let's get a better look at that stroke. Increase the Comp panel's Magnification to 100%. While pressing the space-bar, click and drag in the Comp panel to recenter the display so that you can see the starting point of your stroke.

The default stroke has squared-off edges. Click on the popup for Stroke 1 > Line Cap and set it to Rounded Cap. Then scrub the Dash value for Stroke 1 > Dashes to spread out the segments.

As you increase Dash, you might have noticed that the length of the dashes and the space between them grow at the same time. If you want independent control over these, click on the + button again. A new parameter called Gap will appear. Tweak Dash and Gap to get a segment/space pattern you like.

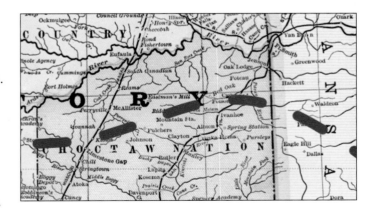

5 To create more elegant dashes, set Stroke 1's Line Cap popup to Rounded Cap. Tweak the Dash and Gap values to taste.

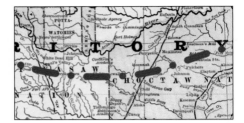

6 Add two pairs of Dash and Gap values to your stroke to alternate line segments with dots.

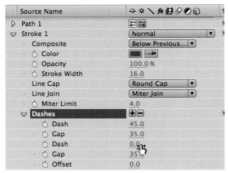

6 Say you want alternating dots and dashes. Click on + twice more to add another Dash and Gap. Set the value of the second Dash to 0 to create dots between segments. Set the two Gap values the same to have even spaces on either side of the dots.

7 Type **Shift /** to see the entire map in the Comp panel again. Scrub Offset and watch your stroke travel along its path. (Think of the uses you would have for animating this…) Tweak the Dashes settings – and the other parameters in Stroke 1 – until you are happy with your line, then twirl up Stroke 1.

Animating the Stroke

A line tells you what to look at; an animated line tells you a story. Think back to the first shape exercise, where you took a whirlwind tour of some of the available shape attributes: Which one trimmed a shape's path? That's right: Trim Paths.

8 Select Shape 1, then Add > Trim Paths. Twirl down Trim Paths 1 and scrub the End parameter: The path will shorten and lengthen as you do so.

• Press **Home** to make sure you are at 00:00, set End to 0%, and click on its stopwatch to enable keyframing for it.

• Press **End** and set Trim Paths 1 > End to 100%.

• This is a big map to load into RAM for a preview, and you probably are already looking at it at 50% Magnification or smaller – so why render more pixels than you're seeing? Click on the Resolution popup along the bottom of the Comp panel (it should say Full) and select Half. Then press **0** on the numeric keypad to RAM Preview your animation or press **Shift 0** to preview every other frame.

The flat dashed line can be a little hard to read against the flat map. Since Shape layers are indeed their own layers, you can apply effects to them to help them stand out from the other layers in your comp.

9 Make sure Shape Layer 1 is still selected, then apply Effect > Perspective > Drop Shadow. Increase the Distance and Shadow parameters until the line starts to "lift off" of the map.

If you had any trouble following this exercise, go ahead and peruse our version, **Comps_Finished > 08-Map Path_final**. We added one more touch: a Perspective > Bevel Alpha effect, which renders before the Drop Shadow.

▼ The Public Domain

This map of Indian Territories was scanned from *Cram's Unrivaled Family Atlas of the World*, printed in the 1890s. It is old enough that its copyright has finally expired, and therefore it is in the public domain.

Many people misunderstand what really is and isn't in the public domain (call it wishful thinking). We recommend reading *The Public Domain* from Nolo Press: It contains sound legal advice on what can and can't be used, as well as numerous sources for public domain materials.

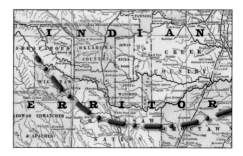

9 Our final map, with animated dash illustrating our journey. Shown with Bevel Alpha and Drop Shadow effects added.

The Shape of Things to Come

For the motion graphics artist, Shape layers are one of the most significant new features added to After Effects in recent years. It takes a little while to get your head wrapped around them – especially features such as grouping, Merge Paths, and complex gradients – but they're fun to play with, so dive in and experiment in your spare time. It will be time well spent.

Idea Corner

Brainstorm, the Puppet tool, and Shape layers all introduce a large number of new design possibilities. Make sure you set aside some time to experiment with them. Here are a few ideas you might try:

• In the last exercise in the Shape layers section, you created a stroke that traced along a map. The map itself is much larger than a video frame, giving you plenty

 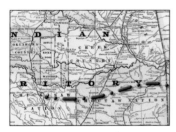 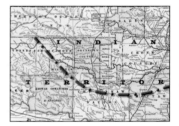 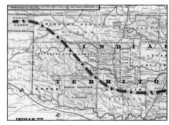

of room to zoom and pan around it. So take **08-Map Path**, nest it into a new video-sized comp, and move around it using the "motion control" techniques you learned in Lesson 2 using the Anchor Point.

• Create a *parametric* shape (any shape other than those made with pen paths), apply a Shape Effect or two, and use Brainstorm to come up with variations for you.

• A lot of "high tech" background images and stock footage consist of taking an abstract or otherwise non-specific piece of background footage, then adding graphical elements such as circles, lines, blocks, and other sprites on top. They don't have to have any meaning; they just have to look cool!

Practice this yourself. In the **Sources** folder inside this lesson's project is a good starter clip: **Nature Abstracts.mov**. Create a series of graphical elements using Shape layers to dress it up. Remember you can use Blending Modes (introduced in Lesson 3) to make their colors interact with the background in more interesting ways. For bonus points, use the Numbers effect we used in the **12a-Numbers** exercise at the end of Lesson 7 to add counting random numeric elements.

▽ tip

Shape Presets

After Effects ships with dozens of presets that contain Shape layers, ranging from simple elements and sprites to complex backgrounds and animations. These can be found in the Effects & Presets panel in the Animation Presets > Shapes folder. Spend some time applying them to a blank composition and explore the results. Remember that you can also save your own shapes as Animation Presets!

Create a motion control camera move on the finished Map Path comp.

▽ factoid

Open Parent Composition

New in CS3: If the current comp is nested in another comp, click the Open Parent Composition button along the top of the Timeline panel to open it. If it's nested in more than one comp, a popup menu will appear for you to choose from.

Final Project

Putting your newfound skills to work in a fun project.

▽ Getting Started

The project file and sources are contained in the **Lesson 12-Final Project** folder on this book's disc; copy this folder to your hard drive. Make sure you have Cycore Effects. This set is installed with After Effects CS3; in After Effects 7, you must run a separate installer on the original program disc. Some steps will also benefit from having Adobe Illustrator on your computer.

Throughout this book, you've been learning features in After Effects through a series of short exercises. In this final lesson, you will create a complex single project containing multiple elements and compositions: You will animate a character, and then set him in a 3D world.

Along the way, you will get a chance to pull together and expand upon many of the skills and techniques you've learned such as importing layered files, adjusting anchor points, applying behaviors, using expressions, employing multiple effects, parenting, nesting, and animating a pair of cameras in 3D space. Working through this project will also uncover a few gotchas, just like the real world. This is not a paint-by-numbers project; we'll be expecting you to remember and know how to use some of what you've already learned. We will also encourage you to take artistic liberties – including using your own elements.

To get started, open the project **Lesson_12.aep** from this lesson's folder. To get a sense of what you'll be creating first, open the **Finished Movies** folder in the Project panel and play the movie **MiroMan.mov**: This is the character you will be animating. Then play **MiroWorld.mov** to get an idea for the world you will be creating around him.

In this final lesson, you will animate a Miró-inspired character and set him into a virtual 3D world.

Part 1: Creating the MiroMan Character

The first steps of this project will involve importing a layered Illustrator file of a "MiroMan" character, then animating him using a variety of techniques.

1 In the Project panel, select the **MySources** folder to make sure your new footage items will sort into it. Press ⌘ **I** on Mac (**Ctrl I** on Windows) to open the Import File dialog. Navigate to the **Lesson 12 > 12-Sources** folder and select **MiroMan.ai**. Set the Import As popup to Composition – Cropped Layers and click Open.

A composition and folder will appear in your **MySources** folder, both named **MiroMan**. Drag the comp to the **MyComps** folder and twirl this folder open.

1 Import **MiroMan.ai** as a composition, using the Cropped Layers option so that each element will be pre-trimmed to size.

2 Double-click **MyMiroMan** to open it. Its pieces are black and white, which makes it hard to see against a black or white comp background. Type ⌘ **Shift B** (**Ctrl Shift B**) to open the Background Color dialog and set it to something more interesting, like purple. Then set the Magnification popup in the lower left corner of the Comp panel to Fit up to 100%.

3 The comp After Effects created for you is the same size as the source, but does not necessarily have the frame rate and duration you want. Type ⌘ **K** (**Ctrl K**) to open the Composition Settings. Change the Duration to 10:00 (more than you will need), verify the frame rate is 29.97 frames per second (fps), rename this comp "**MyMiroMan**" and click OK.

If the comp was shorter than 10 seconds, press ➖ (minus key on the keyboard) to zoom out the timeline. If the layers are shorter in duration than 10 seconds, extend them: Press **End** to jump to 09:29, type ⌘ **A** (**Ctrl A**) to Select All, and press ⌥ **]** (**Alt]**) to trim all selected layers to the current time. Then press **Home** to return to 00:00.

Familiarize yourself with the layers in this comp by turning their Solo buttons on and off – they are located in the Timeline panel's A/V Features column. As you do so, think about how you might like to colorize and animate some of these elements. For example, we like the idea of wiggling the rotation for the **moustache**, **tie**, and **arm** layers. Then think about how you might need to prepare those layers before you start animating.

3 Open **MyMiroMan** and explore its component layers by soloing them. We drew this character in Adobe Illustrator while referring to an image in the Dover book of public domain art *Treasury of Fantastic and Mythological Creatures*. He is based on a character in the Joan Miró painting *The Harlequin's Carnival (Le carnaval d'Arlequin)* 1924/25.

Setting the Anchor Points

As you learned in Lesson 2, any transformations applied to a layer – such as rotation or scale – are centered around a layer's Anchor Point. Therefore, it is important to set up these anchors before starting an animation. We'll walk you through setting it for one layer, then you can do the rest on your own.

4 Solo **moustache right** (above) to see it in isolation, press **Y** to change to the Pan Behind tool, and move its Anchor Point to the start of the moustache (right).

▽ **tip**

Solo Trick

To solo just one layer at a time, ⌥+click (**Alt**+click) on a Solo switch to disable solo for the other layers.

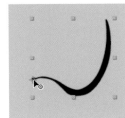

4 Select layer 1, **moustache right**. Press **S** then **Shift R** to reveal its Scale and Rotation. Scrub these parameters, and you will see that by default the moustache does not move around where it connects to the face. Return these values to 100% and 0° respectively, and let's fix that.

⌥+click (**Alt**+click) **moustache right**'s Solo switch to see it in isolation. Press **Y** to select the Pan Behind tool and drag the Anchor Point – the crosshair icon – to the start of the moustache. Press **.** (period key) to zoom in as needed. When done, scrub Scale and Rotation; now it behaves as you would expect. Then twirl up this layer and turn off this layer's Solo switch so you can see the rest of the layers as well.

Continue going through each layer one by one, setting an appropriate anchor point for each. Some layers may not need to animate later, but it doesn't hurt to adjust their anchors now rather than panic later.

When you're done, press **V** to switch back to the Selection tool, turn off all the Solo switches, and save your project.

Parenting Chain

Objects that contain multiple individual elements are easier to animate if you group elements that should move together. This technique is known as Parenting and was covered in Lesson 6.

The first step is deciding which layer should be the parent. In this case, the **MyMiroMan** comp will be nested as a layer in a second composition, so its comp will by default group all of its elements together. That means you need to focus only on creating smaller animation subgroups inside this comp.

5 Attach the **pencil** to the left arm by choosing **left arm** as its parent. Now the pencil will move when the arm moves.

5 Let's say you plan to move the arm on the left. If the arm moves, so should the pencil it's holding:

• If the Parent column is not already visible in the Timeline panel, press **Shift F4** to open it.

• Click on the Parent popup for **pencil** and select **left arm**. Now the pencil will move with the arm.

6 If you decide that the **head** layer should wiggle, then the **moustache left** and **right**, **eyes**, **hat pieces**, and **tassel** layers should follow it:

- Select these five layers. Hold ⌘ (*Ctrl*) as you click to select multiple layers.
- Drag the Parent pick whip for any one of the selected layers to the **head** layer or use the Parent popup. Then press *F2* to Deselect All.

If you want to double-check that you correctly set up the Anchor Points and Parents, you can compare your work so far with our version **Comps_Finished > MiroMan-Step 06**.

Coloring the Layers

The next step is adding a little color to the character. The artist Joan Miró was fond of using red, yellow, and blue, so we thought we'd use this color palette as well. Feel free to use different colors.

There are three effects we will use to color layers: Fill, Tint, and Ramp.

7 Fill works great for flooding any shape with an even color. Select the **tie** layer and apply Effect > Generate > Fill. It will turn red; click on the color swatch in the Effect Controls window to change it if you wish.

7 Effect > Generate > Fill fills a layer with a flat even color.

8 Tints works best to colorize layers that contain black and white (as well as shadings of gray in-between):

- Select the **pencil** layer and apply Effect > Color Correction > Tint. To make the dark outlines the same color as the tie, click the eyedropper icon next to Map Black To, then click on the **tie** layer in the Comp viewer.
- Apply the Tint effect to the **head** layer. Click the color swatch for Map White To and pick a bright yellow. Leave the Map Black To color as black so that the stroke will remain black.
- Apply Tint to **eyes** and choose a cyan blue for Map White To.

8 Effect > Color Correction > Tint (left) is useful for colorizing layers that have both black and white areas, such as the **head** and **eyes** (right).

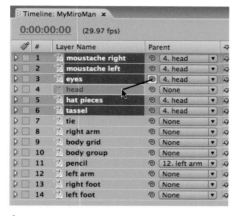

6 Decide which layers need to move when the **head** moves, then use the popup or pick whip in the Parent column to connect these layers to layer 4, **head**.

Compositing the Ramp Effect

We want to add a blue-to-white gradient ramp to the neck area at the top of the **body group** layer. The Ramp effect replaces the original colors in a layer, so we will need to apply it using a blending mode to keep the original layer's black outline.

9 You can drag the Start and End of Ramp's crosshairs (see red arrows, right) where you like, or click on the crosshair icon in the Effect Controls panel (above) then click where you want to place it in the Comp panel (right).

10–11 Use CC Composite (above) to blend the original image on top of your effected version of the image (right). The result of our colorizations is shown far right.

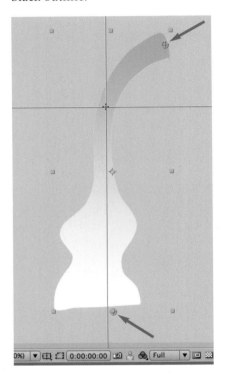

9 Select **body group** and enable its Solo switch.

• Apply Effect > Generate > Ramp. The default creates a black-to-white gradient.

• Change Ramp's Start Color to cyan blue.

• With the Ramp effect selected in the Effect Controls panel, you will see crosshairs at the top and bottom of the layer. The top crosshair is the position of the Start of Ramp; drag it to the top of the neck area.

• Now set End of Ramp using a different technique: Click on the crosshair icon next to End of Ramp in the Effect Controls panel. Move your mouse over to the Comp panel and click about halfway down the neck. The ramp should now go from blue at the top of the neck, fading to white as it moves down.

10 The Ramp effect replaced the original image, obscuring the layer's stroke plus the belly button. To composite any effect on top of the source layer, make sure Cycore Effects is installed, then employ its CC Composite effect:

• With **body group** still selected, apply Effect > Channel > CC Composite.

• In the Effect Controls panel, click the Composite Original popup and select Multiply. Now, the original image will be blended on top of the result of any effects applied to this layer before the CC Composite effect.

11 Turn off the Solo switch for **body group** to view all layers again and save your project!

To execute this next section, you will need a recent copy of Illustrator installed on the same computer as After Effects. If you don't, we've pre-built an intermediate composition that you can pick up and continue with after step 17.

Animated Lines

For our next trick, we want the line art in the **tassel** and **body grid** layers to wipe on over time. The Stroke effect is suited for this job, but it works only with Mask Shapes (Paths). Illustrator artwork starts life as paths, but After Effects rasterizes those paths into pixels before you can get to them. Not all is lost, however: You can copy paths from Illustrator and paste them into After Effects masks.

12 Select the **tassel** layer and enable its Solo switch. Then choose Edit > Edit Original. This will launch Illustrator and automatically load the underlying source file **MiroMan.ai**.

The series of gray brackets in Illustrator is the Crop Area. When you import a layered Illustrator file as a composition into After Effects, the size of the comp created is determined by the document's Crop Area (or *bounding box*). Creating the Crop Area is covered in the *Bounding Illustrator Artwork* sidebar on page 285.

13 In order to copy and paste paths from Illustrator to After Effects, you need to set a special preference. In Illustrator, open Preferences > File Handling & Clipboard, enable Copy As > AICB, and select the Preserve Paths option. Leave Copy As > PDF enabled, then click OK.

14 Make sure Window > Layers is visible. Twirl down the **tassel** layer and notice that it consists of seven sublayers (which we already renamed for you from their default of <Path>). Click on the button to the right of the word **tassel**, and all of these sublayers will be selected. Then use File > Copy.

13 In Illustrator, enable Preferences > File Handling & Clipboard > Copy as AICB and select the Preserve Paths option.

14 Click on the target button for the **tassel** layer, and all of its sublayers will be selected. Copy these.

✐	#	Layer Name	Parent	⊕ ✦ ＼ ∅ 🗄 ♀ ∅ ∅
▽	6	☐ tassel	◎ 4. head ▾	⊕ ／
		▽ ☐ Mask 1		
		· ⊙ Mask Shape		Shape...
		▽ ☐ Mask 2		
		· ⊙ Mask Shape		Shape...
		▽ ☐ Mask 3		
		· ⊙ Mask Shape		Shape...
		▽ ☐ Mask 4		
		· ⊙ Mask Shape		Shape...
		▽ ☐ Mask 5		
		· ⊙ Mask Shape		Shape...
		▽ ☐ Mask 6		
		· ⊙ Mask Shape		Shape...
		▽ ☐ Mask 7		
		· ⊙ Mask Shape		Shape...
▷	☐ 7	☐ tie	◎ None ▾	⊕ ／ ∅

15 When you paste the Illustrator layers onto a layer in After Effects, it will create a Mask for each sublayer.

Project | ⊞ ⊟ | Effect Controls: body grid ▾ | × | ⊙ ▶
MyMiroMan * body grid

▽ ∅ **Stroke**	Reset	About...	▲
Animation Presets:	None	▾ ◁ ▷	
· Path	Mask 1 ▾		
·	☑ All Masks		
·	☑ Stroke Sequentially		
· ⊙ Color	▢ ▭		
▷ ⊙ Brush Size	2.0		
▷ ⊙ Brush Hardness	79%		
▷ ⊙ Opacity	100.0%		
▷ ⊙ Start	0.0%		
▷ ⊡ End	70.0%		
▷ ⊙ Spacing	15.00%		
· ⊙ Paint Style	On Transparent ▾		

17 Use the Stroke effect to draw on the tassel and body grid layers (shown below partway through their animation).

15 Bring After Effects back forward. Select the **tassel** layer and use File > Paste. With **tassel** still selected, press **M**: Masks 1 through 7, corresponding to the seven sublayers, will be revealed in the Timeline panel. If you can't see the yellow mask paths in the Comp viewer, click the Toggle View Masks option at the bottom of this panel. When done, press **M** again to twirl up the layer and toggle off the View Masks option.

16 With **tassel** still selected, apply Effect > Generate > Stroke.

• In Stroke's Effect Controls panel, enable the All Masks option. You will now see white strokes on top of each tassel piece.

• Set the Stroke's Color to a Miró-like red.

• By default, the strokes render over the top of the original artwork. To replace the artwork with the strokes, set Stroke's Paint Style popup to On Transparent.

• At time 00:00, enable the animation stopwatch for the End parameter and set it to 0%. This will make the stroke invisible at the start of the animation.

• Move to 01:00 and set End to 100%. This will cause the stroke to wipe on over time. The Stroke Sequentially option is on by default; this means each mask shape (and therefore, each tassel piece) will be painted on one at a time.

Now that you've finished with **tassel**, turn off the solo switch for **tassel** and RAM Preview the animation.

17 Use what you've just learned in steps 12 through 16 to also stroke on the **body grid** layer: Select its sublayers in Illustrator, paste them as mask shapes in After Effects, and use the Stroke effect to animate them on (don't forget to enable All Masks and to set Paint Style to On Transparent!). Save your project when you're done.

*If you don't have Illustrator, locate our version **Comps_Finished > MiroMan-Step 17** in the Project panel. Duplicate it, rename it to make it your own, move it to the **MyComps** folder, and use that from here on.*

Revealing Lines

The **tassel** and **body grid** pieces were created in Illustrator with simple stroked paths; that's why it was easy to re-draw them along their center line using Stroke in After Effects. By contrast, when an Illustrator shape is an area contained inside a closed path, you need to use other techniques. For simple rectangular shapes, an animated mask shape works well (see page 86). Animating a mask

shape around a curvy object (such as our character's moustache) is trickier, so let's use a different recipe:

Using the Pen tool, create a mask path in After Effects that is centered along the moustache. Have the Stroke effect create an animated thick stroke following the moustache, covering the original artwork. Then use an option in the Stroke effect to reveal the original artwork, giving the impression that it is being drawn on. Let's try it:

18 Select layer 1 – **moustache right** – and solo it so you can see it clearly.

• Press **G** to select the Pen tool, and enable the RotoBezier option in the Toolbar.

• Click on the leftmost point of the moustache, then click a few more times along the center of the moustache shape until you reach the tip. RotoBezier will create the curves automatically. The mask does not have to follow the center of the shape exactly.

19 Press **V** to return to the Selection tool. With **moustache right** still selected, apply Effect > Generate > Stroke. It will default to Mask 1. Edit as follows:

• Change the Brush Size to around 10, or whatever size completely obscures the original artwork.

• Move to 01:00 and click on the stopwatch for End (which should be at 100%) to enable keyframing.

• Press **Home** to jump to time 00:00 and set End to 0%. The stroke will now be invisible at the start of the animation. Scrub the current time marker; the stroke will wipe on over time.

• Set Paint Style popup to Reveal Original Image. With this setting, the white stroke will act as an animated matte, wiping on the original black artwork.

Turn off the **moustache right**'s Solo switch and RAM Preview the animation.

20 One down, one to go: Repeat steps 18 and 19 for **moustache left**. We suggest you place your first mask point at its rightmost tip; otherwise, you will have to animate Stroke's Start instead of its End.

When done, turn off Toggle View Masks, turn off any Solo switches, twirl up all layers, and save your project.

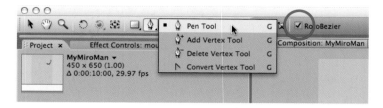

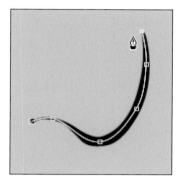

18 Select the Pen tool and enable RotoBezier (above), then click at a few points along the moustache to create a mask path (left).

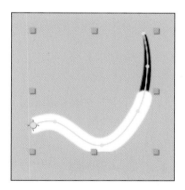

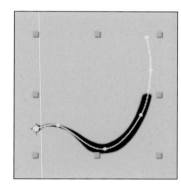

18–19 By default, Stroke covers the underlying artwork (above left). By setting its Paint Style popup to reveal Original Image (left), it will uncover the original artwork (above right).

21 The Behavior Animation Presets contain a set of useful wiggle presets which give layers some fun animation – without having to keyframe the moves yourself.

Wiggling the Body Parts

Now it's time for the fun stuff: adding animation to individual elements of your character. Continuing with your **MyMiroMan** composition, you'll practice adding Wiggle behaviors (Lesson 3) to some layers and hand-creating wiggle expressions (Lesson 7) for layers that are parents. Then you will finish off your character by animating and re-timing layers to taste.

Feel free to set the work area as needed in this section to RAM Preview as much or as little of the comp as you like. RAM Preview as often as you like to see the wiggle results.

Wiggle Behaviors

21 Select the layer **moustache right**. Make sure the Effects & Presets panel is visible; if not, open Window > Effects & Presets and dock it into a frame where you can open it fairly tall.

• Twirl down Animation Presets > Behaviors. (If you don't see the Animation Presets folder, click on the Options menu arrow in its upper right corner and enable Show Animation Presets.)

• Double-click Behaviors > Wiggle–rotation to apply it to the selected layer.

• In the Effect Controls panel, you will see that a custom controller named Wiggle–rotation has been applied, which uses a set of pre-written expressions to control the Transform effect underneath. RAM Preview and adjust the Wiggle Speed and Amount to taste.

22 Select **moustache left**, open the menu item Animation > Recent Animation Presets, and choose Wiggle–rotation: Since you just applied it, it will be right at the top of the list. Set its parameters to match **moustache right**.

23 Select layer 5 – **hat pieces** – and this time apply Behaviors > Wigglerama from the Effects & Presets panel. This preset can wiggle Position, Scale, and Rotation all in one pass; adjust these settings to taste (you may need to dial them back from their defaults).

24 Select the layer **tie**, apply Wigglerama again, and tweak it to taste: For example, set Wiggle Position to 0 to keep the tie firmly pinned in place as it rotates and scales.

RAM Preview. That's a lot of animation, and you didn't have to create any keyframes! Behaviors can be very useful that way.

24 The moustache, hat and tie pieces should now be wiggling on their own thanks to Behaviors.

25 Since **head** is a parent for other layers – and effects are not passed along to a parent's children – we manually added a wiggle expression for its rotation.

Wiggle Expression

To wiggle the rotation of the **head** layer, you will have to use the wiggle expression rather than the more convenient wiggle behaviors. The reason is that **head** is a parent to four other layers. The wiggle behaviors are created by manipulating the Transform effect, and effects are not passed from parent to child. Instead, you will employ a simple but very useful expression you learned back in Lesson 7:

25 Select layer 4 – **head** – and press **R** to reveal the Rotation property in the Timeline panel. To enable expressions for it, press ⌥ (**Alt**) and click on the stopwatch for Rotation; the expressions field will appear with the default expression transform.rotation selected.

Replace this default expression by typing "**wiggle(1,5)**" (no quotes) and press **Enter** on the keypad to accept it. Remember that the first value – 1 – is the number of times per second to wiggle, while the second value – 5 – is the amount of rotation.

RAM Preview and note that the child layers follow the **head** around as it wiggles. If you are unhappy with the speed or amount of the wiggle, select the numbers and change them.

26 Select layer 12 – **left arm** – which is the parent to the **pencil** layer, and repeat the last step to wiggle its rotation as well. We chose to wiggle it by 10° instead of the 5° we used for the head. After you're happy, twirl up all layers and save your project!

Abnormal Behavior

The Behavior Animation Presets do not work with parent layers, because effects – which these presets are built around – are not passed onto children. We have also found that they can have unexpected results when applied to layers which have been collapsed or continuously rasterized, such as text layers. For these reasons, it's good to remember how to use the wiggle expression shown in Lesson 7 and apply it manually to each property you wish to wiggle.

Since we do not expect to need to scale up our Illustrator artwork much beyond its original size, we have not turned on the continuous rasterization switches for these layers, so you are safe to use behaviors on them. (Continuous rasterization is discussed in more detail in the *Render Order Exceptions* sidebar near the end of Lesson 6.)

Edit Original

If you want to make any changes to the original Illustrator artwork in this exercise, select the layer you want to change, then choose Edit > Edit Original to open the file in Illustrator. Make the desired changes, save your file, and return to After Effects. The layer will be updated automatically. This same process also works for Photoshop files. Be sure to Save the file before returning to After Effects, as it refers to the last modified date on disk when determining whether the file needs to be reloaded.

We find it best to update one layer at a time so that After Effects will know what we changed. If you update multiple layers at once and they don't all update automatically when you save and return to After Effects, select these layers in the Project panel and use File > Reload Footage.

Creating new layers is more problematic. We usually just import the entire file again as a second composition, which will then also import the new elements. Copy and paste any new layers from this new comp into the original comp. Also be sure to move the new source layers from the newly created folder to the original footage folder so that you don't delete them by accident. You can then delete the duplicate sources and comp.

MiroMan Final Tweaks

We have just a few more tweaks to perform to MiroMan's animation before we place him into a 3D world. Most of them have to do with offsetting the timing of animations we already created in order to maintain visual interest as the animation plays out.

27 RAM Preview again and size up your animation. Most of the body parts are either drawing on over time or wiggling their hearts out. But there are still more ways you can add to the fun:

27 Edit the Bezier handle for **tie**'s second Scale keyframe to give a little "bounce" to the animation.

• Try scaling up the **tie** layer from 0% to 100% over one second, starting at 00:00. Add an overshoot to the second keyframe to give it a little bounce. To do this, you will need to select the second keyframe, press **Shift F3** to open the Graph Editor, set the Graph Type to Edit Value Graph, and tweak the incoming

Timeline: MiroMan_final

0:00:00:00 (29.97 fps)

#	Layer Name	Parent		
1	moustache right	4. head		Stroke reveals layer — wiggle rotation behavior
2	moustache left	4. head		Stroke reveals layer — wiggle rotation behavior
3	eyes	4. head		
4	head	None		wiggle expression (it's a parent) – press EE to see expression
5	hat pieces	4. head		Wigglerama behavior+ animated Scale
6	tassel	4. head		Stroke draws paths
7	tie	None		overshoot on 2nd Scale keyframe (see Graph Editor)
8	right arm	None		wiggle rotation behavior — scale animates
9	body grid	None		Stroke draws paths
10	body group	None		
11	pencil	12. left arm		child of left arm
12	left arm	None		wiggle expression (it's a parent) — Scale animates
13	right foot	None		Position and Scale animates
14	left foot	None		Position and Scale animates

Bezier handle for that keyframe. (We demonstrated this technique in one of our finished comps in Lesson 6 – refer to page 149 for a refresher.)

• Try a similar scale up and bounce on the **hat pieces** layer so that it pops out of the top of the head.

• Press *Shift F3* when you're done to return to the normal layer bar view.

28 Finally, re-time the animations so that they don't all start at 00:00. You can do this by simply dragging their layer bars to the right in the Timeline panel. Experiment with their timings until you're pleased with the order that elements pop on. You can tweak them again later after you set up your camera move.

If you want to compare ideas, our version is **Comps_finished > MiroMan_final**. Feel free to embellish your character as much as you like, then go make a nice cup of tea – you deserve it! (But don't forget to save your project.)

28 We offset the layer bars of some of the pieces to stagger their timing. The character animation is now finished; time to place him into a 3D world.

▽ tip

Set In Point

To move a layer to the current time, select it and press **[** (the left square bracket).

In the second half of this lesson, you will construct a 3D world, place your character in it, and move the camera around it.

▽ tip

Preview on 2s

To save time, you can preview every second frame by pressing **Shift** **0**. You can also set the number of frames skipped in the Time Controls panel under the **Shift** +RAM Preview Options (below).

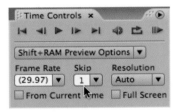

Part 2: Assembling the 3D World

Now that you've finished your hero, it's time to build a world for him to reside in. As this is a major new section, we'll restart the step numbers from 1. To remind yourself where we're going with this, play back **Finished Movies > MiroWorld.mov**.

1 Bring the Project panel forward and select the **MyComps** folder.

Type **⌘** **N** (**Ctrl** **N**) to create a new comp. Choose the NTSC DV preset, change the duration to 06:00, enter a name such as "**MyMiroWorld**" and click OK. If the Parent panel is open, press **Shift** **F4** to close it.

As this comp has a different aspect ratio than **MyMiroMan**, resize your user interface panels as needed to view the Comp panel at 100% or close to it. If you like, type **⌘** **Shift** **B** (**Ctrl** **Shift** **B**) and select a different Background Color.

Creating a Floor and Wall

Let's start by creating a skeleton of a 3D room: a floor and a wall.

Building Materials

To get some realism into our floor and wall surfaces, we're using stills from a pair of stock footage "texture" libraries. These contain images of common surfaces that have been finessed so that they form *seamless tiles*. This means they can be placed end to end to make as large a surface as we need.

You can replace our floor and wall textures with your own photos or images. Make them at least 1024×1024 pixels so that you have enough resolution; twice that size is fine also.

For our floor and wall, we're using seamless textures from the Artbeats City Surfaces (left) and Exteriors (right) libraries.

2 In the Project panel, twirl open the **Sources > wall materials** folder. Inside it, select **Pink Granite 2.tif** and type ⌘ **/** (**Ctrl** **/**) to add it to your comp.

Select its name in the Timeline panel (*the Timeline panel should be outlined in yellow*), press **Return** to highlight it, type in "**Floor**" and press **Return** again. (If the Comp panel was forward instead of the Timeline, the Layer panel will open instead; close this panel and make sure the Timeline panel is selected before trying to rename a layer.)

3 We want this image to serve as our floor. This will require tilting it down in 3D:

• Enable the 3D Layer switch for **Floor**.

• Press **R** to reveal its rotation parameters.

• Visualize what you need to do: Rotate the layer on its horizontal axis until it flattens out. Scrub X Orientation (the first Orientation value) to verify this is what you intended, then set it to 270°. The layer will temporarily disappear because you are now viewing it on edge.

4 Now let's add a wall:

• Select **Sources > wall materials > Concrete Panels 2.tif** and type ⌘ **/** (**Ctrl** **/**) to add it to your comp.

• Select its name in the Timeline panel (this panel should be outlined in yellow), press **Return** to highlight it, type in "**Wall**" and press **Return** again.

• Enable its 3D Layer switch as well.

5 To get a perspective on your 3D set, choose one of the Custom Views from the 3D View popup along the bottom of the Comp panel. If the layers extend beyond the Comp panel's viewing area, press **C** to toggle between the Camera Track tools and drag in the Comp panel as needed to zoom back and re-position your view. (If you need a refresher course on how these work, re-read the *Using the Camera Tools* sidebar on page 191 in Lesson 8.)

To help us arrange the **Floor** and **Wall**, we will take advantage of their Anchor Points (the center around which they rotate and scale) and where their Position value is located in the comp.

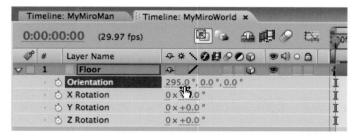

3 As you scrub the layer's X Orientation (top), it will lay down horizontally to become a floor (above).

5 To see your 3D layers in perspective without creating a camera, select a Custom View from the Comp panel's 3D View popup.

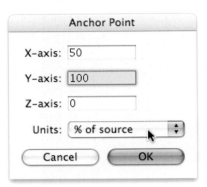

6 In the Anchor Point dialog, setting the Y-axis to 100% of the layer's size places it at its bottom edge. This means the layer's Position value will now describe where its bottom edge is located.

6 Select the **Wall** layer and press **A** to reveal its Anchor Point. Right-click on one of Anchor Point's values, then click on the text Edit Value that appears.

In the Anchor Point dialog that opens, set Units to % of Source – by doing so, we don't have to deal with counting pixels. We want to place the anchor where the wall should meet the floor, so set the Y-axis to 100%. Click OK.

7 By setting the anchor points for the layers to the edges where they are supposed to meet, all you have to do to align them is set their Position values the same.

7 Select **Floor** and press **A** to reveal its Anchor Point values. You want to set its anchor at its back edge, where it should meet the wall. However, since you've tilted this floor down in 3D, it's not as obvious which axis you should be modifying. Scrub its Anchor Point values while watching the Comp viewer to get an idea of how it moves: It looks like reducing its Y value should do the trick.

Right-click on one of its Anchor Point values, select Edit Value, and verify that the Units popup is still set to % of Source. Set X-axis to 50% and Y-axis to 0%. Click OK, and you will see the **Wall** and **Floor** meet up as desired.

(If you like, press **C** and use the Camera Track and Zoom tools to improve your view in the Comp panel, then press **V** when done.)

To verify what's going on, select both layers and press **Shift P** to also reveal their Position values: They are the same. Now that their anchors have been set to the edges where the walls meet, you can keep the corner they form intact merely by setting their Positions to the same value.

Nesting MiroMan

You've already built the Miró-inspired character in his own comp, using a lot of layers. Rather than copy and paste all of those layers into your 3D world, it is much easier to just nest the entire comp into **MiroWorld**, yielding one already-grouped layer.

8 Bring the Project panel forward again. In the **MyComps** folder, select your **MyMiroMan** comp and drag him into **MiroWorld**. He defaults to being a 2D layer; enable his 3D Layer switch, and he will sit back into the world – sticking through the floor…

9 We can also take advantage of the relationship between Anchor Point and Position to set our character on the floor:

• Double-click **MyMiroMan** to open him in a Layer panel. Drag the Anchor Point (the crosshair icon) level with the bottom of his feet.

• Close the Layer panel and press **P** to reveal his Position. It should be the same as the **Wall** and **Floor** layers. He will now be standing on the floor with his back pressed against the wall. To move him away from the wall, scrub his Z Position in the Timeline panel or drag his Z axis arrow forward in the Comp panel. Save your project before moving on.

9 After adding **MyMiroMan** to your 3D world, place his Anchor Point even with the bottom of his feet (left) so that he will stand on the floor, and drag him away from the wall (right).

▽ cheating

Prefab Character

If you jumped into this lesson in the middle and started by building the 3D world, you can use **Comps_Finished > MiroMan_final** in place of your own **MyMiroMan** comp.

▽ tip

Camera Always On

The camera wireframes show only when
that layer is selected. To always see them
displayed, select View Options from the
Comp panel's Options menu, enable and set
the Camera Wireframes popup to On. When
setting Select View Layout to more than 1
View, also enable Share View Options from
the bottom of this menu.

Creating a Camera Move

You have an actor and a set; time to add a camera and move it around them!

10 Change the Comp panel's Select View Layout popup to 4 Views. Pick an array of 3D View settings that will help you view your camera move from several angles. We used Top, Front, Active Camera, and Custom View 2, but feel free to set them to your personal taste provided you have one view set to Active Camera. Make sure the Magnification for each view is set to Fit up to 100% and try to resize the Comp panel large enough to see all four views at 50% or more.

11 Press **Home** to return to 00:00 and add Layer > New > Camera. We suggest using the 35mm preset for this animation: Using a "shorter lens" will give you an exaggerated sense of 3D perspective, plus it won't require you to move the camera as far back from your layers.

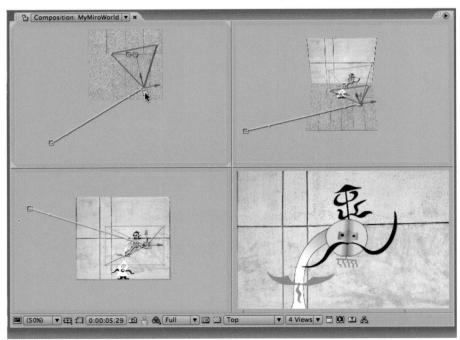

With the Camera layer selected, press **C** to toggle through the Camera Track and Zoom tools and adjust your 3D views as needed to see both the camera and the layers. Remember that only when you use these tools in the Active Camera view are you actually changing the camera's value; in all other views, you are only adjusting the display. When done, press **V** to return to the Selection tool.

12 With your new camera selected, press **A** then **Shift P** to reveal the Point of Interest and the Position properties in the Timeline panel. Enable the animation stopwatch for both. Then create a camera pose you like – perhaps pulled back somewhat from the character and stage. Use the camera tools to adjust your views as needed to still see the camera icon; you might also find either Left or Right view more useful than Front.

12+13 Set up an initial camera move that swoops in to get a closer look at your character.

13 Press **End** to jump to 05:29 and create a second pose for the camera: perhaps pushed in tighter on the character's face, but not so tight that he starts to look fuzzy from being scaled up too much. Press ⌘ (**Ctrl**) when dragging any of the camera's axis arrows to move its Position without affecting the Point of Interest.

Press **Shift** **0** (on the keypad) to RAM Preview every second frame of your camera move, but don't spend too much time on these poses; you'll be tweaking them later after you add more pieces to your 3D world. The goal here is just to sketch out your overall move.

Widening the Stage

While setting up this camera move, we realized there was a lot of blank space around the **Wall** and **Floor** layers. Since we used seamless, tileable textures for the wall and floor, we can repeat them as often as needed to fill out our space.

14 Turn your attention to the Effects & Presets panel (if it's not already open, select it from the Window menu) and type "**tile**" into its Search box. If you have Cycore Effects installed, three effects (plus an Animation Preset) with "tile" in their names will appear. The one you want is CC RepeTile, as it will repeat your layer for you.

• Move the current time marker to a point where your camera is pulled back the farthest from your set.

• Select **Wall**, then double-click CC RepeTile.

• While watching the Comp panel, scrub the Expand Right, Expand Left, and optionally Expand Up values to increase the wall size to help fill in the gaps. To create a tighter pattern, reduce the layer's Scale and increase these Expand values (keeping in mind that the larger you make the wall, the slower your renders will be).

• Feel free to try different Tiling options to create different patterns.

15 Do the same for the **Floor** layer: Apply CC RepeTile and expand it as desired.

What Are You Looking At?

Since the character is the hero that we want to focus on, one approach to moving the camera is to place the camera's Point of Interest right on the character. We dragged **MyMiroMan** out to Z Position = –400; for our first camera move, that's where we placed the Point of Interest's Z as well. This way, we know our camera move will pivot around our character.

Another approach: To quickly snap a camera's Position and Point of Interest to look at a selected 3D layer, type ⌘ ⌥ **Shift** \ (**Ctrl** **Alt** **Shift** \) (the backslash key).

But feel free to set up a dramatic move however you like.

14 The CC RepeTile effect (left) will repeat the layer it is applied to, allowing you to easily create a larger wall using the same source (top). Try different tiling options, and set to taste.

Effect Controls panel showing:

MyMiroWorld * Wall

4-Color Gradient 2 — Reset — About...
Animation Presets: None

Positions & Colors
- Point 1 — 297.8 , 778.6
- Color 1
- Point 2 — 132.3 , 92.9
- Color 2
- Point 3 — 553.8 , 396.7
- Color 3
- Point 4 — 896.4 , 746.3
- Color 4
- Blend — 100.0
- Jitter — 0.0 %
- Opacity — 100.0 %
- Blending Mode — None

CC Composite — Reset — About...
Animation Presets: None
- Opacity — 100.0 %
- Composite Original — Multiply
- ☑ RGB Only

CC RepeTile — Reset — About...
Animation Presets: None
- Expand Right — 1024
- Expand Left — 512
- Expand Down — 0
- Expand Up — 0
- Tiling — Checker Flip H
- Blend Borders — 0.0 %

16 We used 4-Color Gradient plus CC Composite to colorize the back wall. Drag CC RepeTile after these effects so that the colored and textured wall is what gets repeated.

17 The black-and-white Harlequin title initially appears in 2D space, centered in the comp. Title created with P22 Miró font (updated as P22 Catalan).

A Little Paint...

16 Let's make the back wall a little more colorful, using a trick you've already learned in this lesson:

• Select **Wall** and apply Effect > Generate > 4-Color Gradient. The concrete texture will be replaced with a wash of color.

• Assuming you have Cycore Effects installed, apply Effect > Channel > CC Composite. Set its Composite Original popup to Multiply.

• CC Composite is looking at the layer before CC RepeTile has extended it, meaning only part of the wall is getting both the color and texture. To cure this, drag CC RepeTile after CC Composite and optionally set CC RepeTile's Tiling popup to Checker Flip H.

• In 4-Color Gradient, twirl down Positions & Colors and tweak the colors to your taste. We chose variations of the red, blue, and yellow colors we used when building our character.

Adding The Title

In the next few steps, we'll populate our 3D set with a title plus other Miró-inspired elements.

17 Press **Home** to return to 00:00. Bring the Project panel forward and locate the footage item **Sources > Harlequin.ai**. Select it and press ⌘ **/** (**Ctrl /**) to add it to your 3D comp.

Illustrator Crop Area

When you import a layered Illustrator file as a composition into After Effects, the size of the comp created is determined by the document's *bounding box*. By default, the bounding box is defined by an area that just barely fits all the objects. However, some fonts have bits that extend beyond this internally defined box. Also, if you were to change the font or characters in a layer later, the size of the bounding box would change as well. The same rule applies even for single Illustrator layers imported as footage; their size is determined by this bounding box.

△ The Crop Area is seen as a series of gray brackets in Illustrator.

Therefore, sometimes it is useful to create your own bounding box in Illustrator, as we did for **Harlequin.ai**. You can do this by setting the *crop area*. There are two approaches: If you want the size of the document (as set under File > Document Setup) to determine the size of the bounding box, make sure nothing is selected; otherwise, use the Rectangle tool to draw a box loosely around your objects. Then choose Object > Crop Area > Make. Special crop mark brackets will be drawn in Illustrator to show you the corners of your box. To delete the crop marks, select Object > Crop Area > Release.

When you define a rectangle to be your bounding box, avoid making it an odd number of pixels wide or tall – this will cause the layer's center to fall on a half pixel in After Effects, and it may look softer due to antialiasing. In Illustrator's Transform palette, check the size of your box, and if necessary round it up or down to an even number of pixels.

18 This title was created in Illustrator as white text with a black stroke, giving us maximum flexibility to colorize it in After Effects. Apply Effect > Color Correction > Tint and change Map White to a bright compatible color such as the yellow in **MyMiroMan**'s face.

19 Enable the 3D Layer switch for **Harlequin.ai**; it will initially intersect the floor.

Press **P** to reveal its Position. Position **Harlequin.ai** around 360, 50, –800; this will place it in front of **MyMiroMan**'s torso and forward on the stage.

19 Tint the Harlequin title yellow, enable its 3D Layer switch, and place it in front of your character's torso.

20–21 Populate your set with additional shapes and fill them with color. Make sure the arrangement looks good at the start (above) and end (right) of your camera move; if necessary, tweak the camera to help out. Elements converted from the P22 Miró Ornaments font.

Adding More Layers

20 At this point, you can add more layers into your world. The **Sources > Miró Elements** folder contains several related elements, such as **eye**, **flower**, **grid**, **target**, and **wheel**. These are all black artwork with alpha channels.

Add these sources one at a time, remembering to turn on their 3D Layer switch as you do. Size them, then position them around your 3D set as you see fit. Scrub the current time marker through your timeline to make sure you have an interesting arrangement throughout the length of your composition. If you're having trouble making it work, don't be afraid to tweak the position of **MyMiroMan** and **Harlequin.ai** or to edit your camera move!

21 Colorize each of your new elements using Effect > Generate > Fill. You can eyedropper colors from the gradient in the wall, but try to pick colors that help these elements stand out. White and black are also good choices.

You might notice that the degree of contrast with the rest of the scene may influence how large you need to make an object. For instance, black makes a stronger statement than some other colors, so black layers may need to be reduced in size. Save your project before moving on.

Lighting the Set

To emphasize the dimensionality of this world, let's add a light and have the objects cast shadows onto the floor and wall.

22 Press **Home** and add a Layer > New > Light. In the Light Settings dialog that opens, set it to Light Type = Spot, Intensity = 100%, Cone Angle = 120°, Cone Feather = 20%, and Color = white. The reason we're creating it is to cast some nice soft shadows, so set Cast Shadows to On, Shadow Darkness to 50%, and Shadow Diffusion to 10 pixels. Then click OK.

23 Your scene will become very dark! This is because the light defaults too close to the back wall. In a Comp view such as Top, click on the back of the light and pull it away from the wall until your set is better illuminated. The floor will still be dark, since the light is on the same level. In another view (such as Front or Left) drag the light upward until the floor receives some illumination as well.

24 By default, layers receive shadows, but do not cast them. Select all of your elements other than **Wall** and **Floor**; remember you can ⌘+click (*Ctrl*+click) to select multiple items. Then type ⌥ *Shift* *C* (*Alt* *Shift* *C*) to enable their ability to cast shadows.

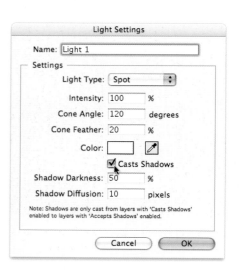

22 Create a new Spot light and enable it to cast shadows.

25 Press **F2** to deselect your layers. Drag the light around to create a shadow pattern you like, using different views to help you position it. We personally raised the light until **Harlequin**'s shadow hit the floor between the title and **MyMiroMan**.

Don't fall into the trap of trying to fix every problem by editing just one item! If you're not happy with your pattern of shadows, also try moving the individual layers to new positions, including closer to or farther away from the light.

26 Time to tweak the light's settings. To see your final image in detail, set Select View Layout back to 1 View and set the 3D View to Active Camera. Select the light and press **A A** to reveal the Light Options in the Timeline panel. Then play around with the following adjustments:

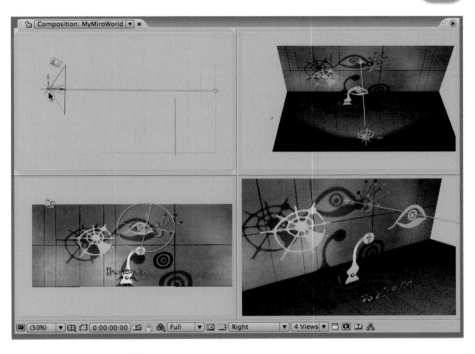

25 Enable your layers to receive shadows and move the light until you get a nice pattern of shadows falling on the floor and wall.

• Increase the Intensity until the scene is as bright as it was before you added a light. (You can toggle the light on and off to test this.)

• To make the shadow subtler, decrease the Shadow Darkness and possibly increase the Shadow Diffusion.

• If you would like to create a vignette effect, decrease the Cone Angle and optionally increase the Cone Feather until the corners of the stage are darkened slightly.

When you're happy with your lighting, twirl up the Light layer and save your project. RAM Preview and enjoy what you've created so far!

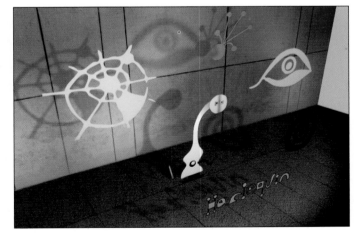

26 Tweak the Light Options to get a nicely illuminated set, perhaps with a bit of vignette (darkened corners) and subtle shadows.

(In the *Finishing Touches* section on page 290, we'll show you an option for brightening up the title layer if it still appears too dark for your taste.)

▽ try it

Editing in an Editor

If you have access to a non-linear editing system, do your camera edits in there, not in After Effects. Render your composition multiple times, turning on a different camera for each render while turning off the others. Import these renders into your NLE and have fun cutting and crossfading between them there.

27–28 Create a second camera (right) and then turn off its Point of Interest in Layer > Transform > Auto-Orient (above).

29 Use the new camera to frame the middle letters in the middle of the title. Unfortunately, they are very fuzzy when viewed this close.

Multiple Cameras

A nice feature in After Effects is the ability to cut between multiple cameras in a composition. The rules are similar to those for cutting between full frame video: The layer on top takes priority. Before you continue, move **Camera 1** and **Light 1** to the top of layer stack.

27 Press **Home** and add a New > Layer Camera. Pick the 50mm preset for the sake of variety and click OK. **Camera 2** will be created at the top of the layer stack. Your initial view will be of **MyMiroMan**'s feet.

28 We're going to create a simple pull-back with this camera, so to make it easier to control, turn off its Point of Interest: Select Layer > Transform > Auto-Orient, choose Off, and click OK.

29 Let's start with an interesting close-up of some of the letters in the title:

• Press **P** to reveal the camera's Position.

• Reduce the **Y** Position until the "e" is somewhat centered in the Comp viewer.

• Back the camera away (decrease the Z Position) until you see, oh, three letters.

• Press **'** (apostrophe) to turn on the Action and Title Safe grids. Then tweak all three Position values until you have your chosen letters nicely centered in the Title Safe area.

Houston, we have a problem: When we're zoomed in this close on the **Harlequin.ai** title, it looks really fuzzy.

That's why we created it in Illustrator: to take advantage of a feature in After Effects known as *continuous rasterization*. This takes vector-based artwork – such as Illustrator sources – and renders them into pixels on the fly to give you the resolution you need. We use this feature sparingly, as it can do funny things to the render order (see the sidebar *Render Order Exceptions* at the end of Lesson 6). But when it works, it's magic.

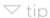

30 Enable the Continuous Rasterization switch for the Illustrator-based title (left), and it will render cleanly (above).

30 Scroll down the Timeline panel until you find **Harlequin.ai**. Click on the second switch from the left (a hollow box) to enable Continuous Rasterization for this layer. Look at the Comp viewer: The title will now become perfectly sharp. Toggle this switch off and on again to compare the difference.

31 Returning to your new **Camera 2** (layer 1), enable the animation stopwatch for Position. Move the current time marker to around 02:00, and move the camera back in Z until the entire title is inside the Title Safe area. (Add the **Shift** key while scrubbing the Position Z value to move in larger increments.) While you're at it, tweak the camera's Y Position so that you can fit the entire MiroMan into the frame as well. You can set his feet on the Action Safe line; get as much of his hat in as you can without making the title too small.

Press **N** to end the Work Area here and press **Shift O** (on the keypad) to RAM Preview every second frame of your second camera move – pretty cool, eh?

32 Now, for that promised camera edit: Move to your last keyframe for your second camera, and press **]** to trim the layer to end here. Press **Page Down**: After Effects will now cut to your original camera!

Double-click the Work Area bar to reset it to the full length of your comp and RAM Preview the multiple camera views and animation.

When done, Save your project and render to disk if you like.

▽ tip

DV Render

To render **MyMiroWorld** to DV, type ⌘ **M** (**Ctrl M**) to add it to the Render Queue and choose the DV Settings template for Render Settings and QuickTime DV NTSC 48 kHz for the Output Module.

31–32 Animate the second camera to frame the title and our hero by 02:00 (left). Trim the second camera to end here, and on the next frame, After Effects will cut back to your original camera (right).

Finishing Touches

We hope you enjoyed building and flying around this 3D world! We're going to wrap up by suggesting a set of refinements, including some ideas of how you can take the animation even further on your own. Most of these have been incorporated into our version **MiroWorld_final** inside the **Comps_Finished** folder.

• One small problem with the camera edit you created is that you're cutting off the beginning of your original camera's animation. Select Camera 1 and press **U** to reveal its keyframes. Drag your first pair of keyframes to start where the earlier camera move ends.

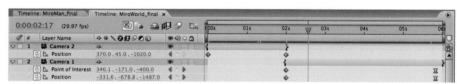

We trimmed the two camera layers so that After Effects would cut between them, and refined their animation including easing into the final keyframes. If you like, re-time your animations in **MyMiroMan** to work better with your camera movements.

If you like, further refine your camera animations. For example, we moved the final keyframes a little earlier and applied Animation > Keyframe Assistant > Easy Ease to them so that the camera move would glide to a stop.

• If you find the cut between the pull-back of the first camera move and the push-in of the second to be a touch jarring, select the earlier camera's keyframes and apply Animation > Keyframe Assistant > Time-Reverse Keyframes.

• You might have noticed a trace of the comp's Background Color peeking through the seam where the Floor and Wall layers meet. This is a side effect of how edges are antialiased. Slightly tweak the Y values of their Anchor Points so that they overlap by a pixel or two.

• Do you still see the comp's background color beyond the edges of the **Floor** and **Wall** layers? Is it annoying you? Change it to a more pleasing color or add a 2D layer behind it as we have in our final version.

• The light is bouncing off your layers at different angles, occasionally causing some to look duller or brighter than normal. For example, **Harlequin.ai** is a little under-lit when viewed at an angle, while the face of **MyMiroMan** is a little blown out when viewed head on. You can remove the effect of lighting on a 3D layer by selecting it, typing **A A** to reveal its Material Options, and toggling Accepts Lights from On to Off.

Notice that this does not turn off your shadows! After Effects is very flexible in that way.

To ensure your 3D layers remain evenly lit, turn their Accepts Lights parameter Off (right). This is especially noticeable in the title and body (left). This does not affect their ability to cast and receive shadows!

 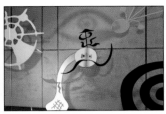

• Under some circumstances, you might notice the **Floor** layer "shimmering" slightly during the camera moves. This is because it contains details that are too fine to be displayed by the limited resolution of a DV video frame. It will be even more pronounced on playback through an interlaced video monitor.

To cure this, select **Floor** and apply Effect > Blur & Sharpen > Fast Blur. Enable Repeat Edge Pixels and very slightly increase its Blurriness parameter until the problem goes away.

• Animate the additional items you added to the set. For example, try rotating **wheel.psd** and **target.psd**, as well as perhaps wiggling the scale and rotation of **eye.psd** and **flower.psd**. Remember to set their Anchor Points to spots that would make good rotational centers!

• Add a soundtrack or sound effects! Time them to your animation. Or edit the animation keyframes to match your sounds. We used **FinalEye.mov** from the **Sources** folder.

• If you added any other Illustrator objects or Solid layers that are now so close to your cameras that they're looking a little fuzzy, enable Continuous Rasterization for them as well. But don't do it for the **MyMiroMan** precomp: This will "collapse" its transformations and cause some of its body parts to shift.

• If you have After Effects CS3, replace our title with your own animated text created inside After Effects using Per-character 3D Animators (as covered at the end of Lesson 5).

• If you have particularly fast camera moves, enable Motion Blur (Lesson 2) for the layers that appear to move the most quickly.

• Finally, we end with a Quizzler: The additional layers might be looking a touch flat compared with the textured wall and floor. Without starting over from scratch, how can you add some texture to them, using materials you already have in this project? Play our **Quizzler > MiroWorld_Quizzler.mov** for one look. Hint: Part of the answer is in Lesson 4 and part in Lesson 6… Check our **Quizzler Solution** folder for our version.

Our final animation is contained in the **Comps_finished** folder and includes many of the final touches described here.

▽ tip

Zaxwerks

If you have Zaxwerks 3D Invigorator or Pro Animator (www.zaxwerks.com), create the title by loading **Harlequin**.ai into one of these plug-ins to give it some thickness. Remember to set up the plug-in to use the comp's camera so that all the movements will be integrated.

Quizzler: How can you add a concrete texture to some of the elements you've already brought into your 3D world?

▼ Real 3D

You can do a lot with 3D in After Effects, but there will come a time when you wish your objects had actual depth and more sophisticated surfaces. There are a few plug-ins that integrate 3D objects into After Effects; in particular, we strongly recommend 3D Invigorator and Pro Animator from Zaxwerks (www.zaxwerks.com). However, eventually you may need to include a full-blown 3D modeling and animation program in your workflow.

Here is an overview of how you can go about integrating a 3D program with After Effects:

3D Integration Basics

Your first step is to create your world in a 3D program, including your camera move. You then need to transfer several elements from that program into After Effects:

• A render of your 3D scene.

• Your camera move. By doing so, any 3D layers you add in After Effects will be viewed in the same way as your original 3D scene. Some programs can also transfer their lights. Each program has a different way to get this data across; many forget the camera's Angle of View, so write that down as well. Maxon Cinema 4D – the 3D program that provides the tightest integration with After Effects to date – exports a special .aec project file, which can then be opened in After Effects with a Maxon-supplied plug-in.

• An "object buffer" for select items in your 3D world. These special renders are used to cut holes into new layers in After Effects so that they don't accidentally obscure elements that were in your original 3D world.

• The coordinates for where in your 3D world you might want to insert a new item

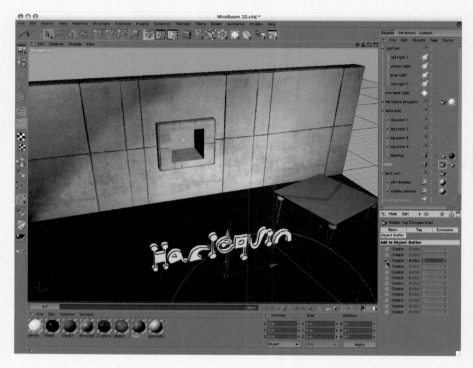

△ With some planning, you can integrate dedicated 3D programs such as Maxon Cinema 4D with After Effects.

in After Effects, such as video on the face of a 3D monitor. Some programs allow you to transfer the locations of null objects or lights into After Effects, which can act as stand-ins for your new layers.

A Case Study

This lesson's project file includes an example of integrating a 3D scene from Cinema 4D with After Effects: **Comps_Integration > MiroWorld_3D+AE**. We've added numerous layer comments in this comp to explain who is doing what; we've also included "before and after" movies in **Lesson_12.aep**'s **Finished Movies > Real 3D** folder for you to study. Here is a short summary:

• The camera and all of the lights – with their animation – were transferred from Cinema to After Effects through the .aec file it creates. We used these to make sure the shadows for the elements we added in After Effects would behave the same as those in the 3D render.

• We used the same **MiroMan** precomp and additional Miro-inspired elements you employed in **MyMiroWorld**. We took advantage of an object buffer rendered from Cinema 4D to cut out **MiroMan** where the 3D title would pass in front of him.

• The 3D render from Cinema must remain a 2D layer in After Effects; otherwise, it will calculate the effects of the camera move and lights twice. However, 2D layers cannot receive shadows from the new 3D layers that were added in After Effects. Therefore, we created some simple white solids to catch just these shadows and blended them on

Cinema 4D render

+ After Effects layers

Timeline: MiroWorld 3D+AE × Timeline: MiroWorld_DV render

0:00:05:29 (30.00 fps)

#	Layer Name	Mode	T	TrkMat			
1	[eye.psd]	Normal					△ top 4 layers are 2D elements placed in 3D in After Effects
2	[target.psd]	Normal		None			
3	[flower.psd]	Normal		None			
4	[wheel-A.psd]	Normal		None			
5	[MiroMultiPass_object_1.mov]	Normal		None			△ "object buffer" cuts out MiroMan when titles passes in front
6	[MiroMan_final]	Normal		L.Inv			△ 2D MiroMan precomp w/ 3D Layer switch enabled
7	[MiroMultiPass_object_2.mov]	Normal		None			△ object buffer from Cinema 4D defines wall cutouts
8	[wall shadow catcher]	Multiply		Luma			△ white solid in After Effects catches new shadows
9	[MiroMultiPass_object_3.mov]	Normal		None			△ (same as above, for floor)
10	[floor shadow catcher]	Multiply		Luma			△ (same as above, for floor)
11	Cinema Camera						△ camera move exported from Cinema 4D
12	red light 1						△ all lights exported from Cinema 4D to match original scene
13	yellow light						△
14	blue light						
15	red light 2						
16	overhead light						△ (we adjusted lights' Shadow parameters to get a nice look)
17	[MiroCinema.mov]	Normal					△ 3D scene render from Cinema 4D

top of the original render. We set them to match the size and 3D location of the wall and floor in the Cinema scene; additional object buffers from Cinema cut out sections as needed (such as the hole in the window).

Output to Video

Most 3D programs have trouble with video's idiosyncrasies such as odd frame rates and non-square pixels. Therefore, we rendered our 3D scene at an even 30 fps and at a square-pixel size larger than a video frame.

We built **MiroWorld_3D+AE** at this size and rate, then nested it into **MiroWorld_DV** to render. There we scaled it down to fit and stretched its duration by 100.1% to slow it down to 29.97 fps.

Yes, all of this requires a lot more work than just staying inside After Effects – but the results match the effort. Remember: The best motion graphics and visual effects artists don't restrict themselves to one program; they use whatever they need to achieve what they see in their mind's eye.

△ After you've rendered your scene from your 3D program (top left), you can add additional elements in After Effects (top right) using the same camera and lights you used in 3D. Examine the layers in our final Timeline panel for **MiroWorld3D+AE** (above). Note that the 3D render (layer 17) plus the object buffers must remain 2D layers in After Effects; otherwise, they will calculate the effects of the camera move and lights twice.

Appendix - Rendering

Unleashing your creations on the world.

▽ tip

Online Help

More information on rendering and file formats is contained in the Adobe Help Center: Press **F1** from inside After Effects and use the Search function.

Render Queue Guided Tour

We have created a QuickTime movie that will give you a tour of the parameters in both the Render Settings and Output Module. It is in the **Appendix > Guided Tour** folder on this book's DVD.

After you finish creating your masterpiece in After Effects, you need to render it out to a file so it can be edited into a film or video, or posted to a website. We covered basic rendering at the end of Lesson 1, and we discussed the issues of fields (interlacing) and alpha channels in Lesson 5. Here we will give you additional advice for other situations that commonly arise.

Whenever possible, you should determine your output format *before* starting a project. Then you can build your compositions – or at least, your final composition – with this size and frame rate in mind. This will ultimately lead to fewer headaches than if you later try to conform your work to a different format.

Rendering: Under the Hood

When you are ready to render a composition, make sure that it is open with its Comp or Timeline panel selected, or select it in the Project panel. Then choose Composition > Make Movie; the shortcut is ⌘ M on Mac (*Ctrl* M on Windows). The comp will be added to the Window > Render Queue panel: This is where you manage your renders. You can then edit the parameters used to render a comp in the Render Queue's Render Settings and Output Module dialogs.

When After Effects renders a composition, two distinct steps take place:

• A frame is rendered based on the Render Settings and is temporarily stored in RAM.

• This frame is then saved to disk using the Output Module settings.

This system means you can have multiple Output Modules per composition, saving the same render to different files during a single render pass – a great time saver.

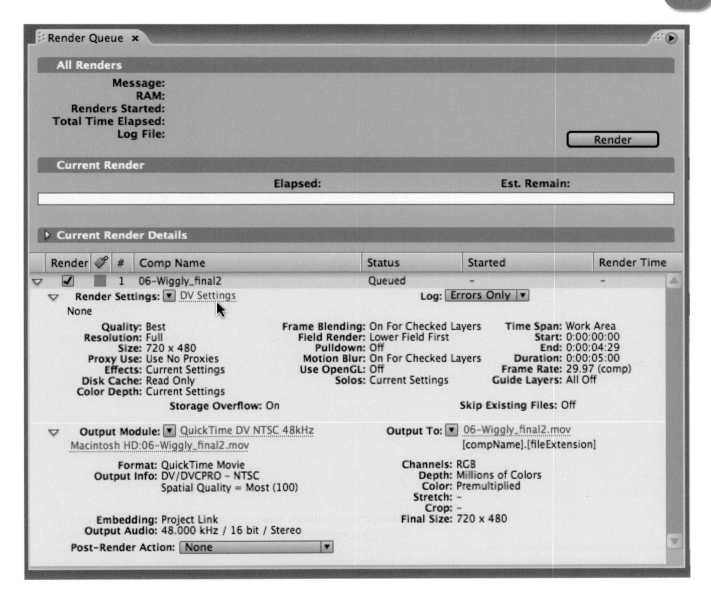

Templates

The parameters that make up Render Settings and the Output Module can be saved as templates, making it easy to render other compositions using the same parameters. These templates can be selected from popups in the Render Queue; they may also be accessed under the Edit > Templates menu. Default templates may be assigned in that menu or by holding ⌘ (*Ctrl*) as you select a template in the Render Queue.

The Render Queue panel, with the Render Settings and Output Module twirled down to reveal their parameters. To edit these parameters, click on the template name (in blue) to the right of the words Render Settings and Output Module; to change the name of the rendered file and the location where it will be saved, click on the blue file name to the right of Output To.

▽ tip

Trillions of Colors

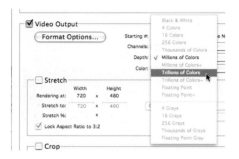

To verify if a codec or file format will support 16 bpc color depth, set Color Depth in Render Settings to 16 bits per channel, then see if Trillions is offered as a choice for Depth in the Video Output section of the Output Module.

▽ factoid

Scaling Interlaced Renders

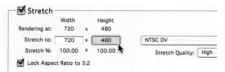

If you have enabled Field Rendering in the Render Settings, be careful when using the Stretch section in the Output Module: Stretching the Height will destroy your fields. Altering the Width is okay.

Which Format Should I Render To?

This is one of the most common questions among After Effects users. There is no simple answer, but we can give you some guidelines.

Your first choice is always to give the clients what they want (keeping in mind that *you* may be your client). Ask what format they would prefer; chances are good that After Effects supports it. This may include a QuickTime or AVI movie, or an image sequence.

Movies

QuickTime and AVI come with a set of standard *codecs* (compressor/decompressors or coder/decoders). If you or your client will be using a specific video card, chances are it requires its own non-standard codec. The installation software that comes with the card will install the necessary codec. If you need to render for a specific card you don't have installed, the manufacturer's website will probably let you download the codec: Look in the Support, Downloads, or Drivers section of their site. Otherwise, borrow the installer from the client.

If instead you are rendering an element that will be re-used inside a project or composited with other footage (or if you want to future-proof your archives), you will want to save it using the highest quality format available. A common solution is QuickTime using the Animation codec with its Quality set to 100. This combination is *lossless* (in other words, it won't change any pixels), is fairly space-efficient, and can support an alpha channel (set to Millions of Colors+). If you can accept some image compression and don't need an alpha channel, a good alternative is QuickTime Photo-JPEG with Quality set around 75 to 99. Both have the shortcoming that they support only 8 bits per channel of color resolution; high-end work is better off with 16 bits per channel.

Sequences

QuickTime or AVI movies are handy because they wrap up all of the individual frames of a movie into a single file. However, there are occasions when an image sequence is the better choice. Some 3D software packages and high-end video systems (such as the Autodesk Flame) prefer sequences. Several options – such as TIFF, SGI, or PNG sequences – are lossless, contain data compression to reduce the file size, offer alpha channels, and support 16-bit per channel color information.

To render a sequence, select the desired file type from the Format popup at the top of the Output Settings dialog; the word "Sequence" will follow the file

Image sequences are a common alternative to movie files. The image number is inserted into the [####] at the end of the file's name when it is saved to disk.

type's name. Create or select a folder for the frames to be rendered into. Each frame will get its own number; how many digits used is determined by the letters [####] attached to the end of the file's name, where each # is a digit.

Web

There are entire books and training DVDs dedicated to creating animation for the web. Our modest goal here is to show you how to get this content out of After Effects, which you can then later integrate into your web pages.

Rendering content for a web page requires significant image compression. Technology changes; when this book was written, QuickTime H.264, Windows Media, and Flash Video (.FLV) were the preferred formats for web video. If your project consists of just vector-based files with no effects applied, the Flash (.SWF) format is very efficient (see the Adobe Help file for details).

Flash Video

Flash Video is one of the most popular formats for adding video content to a website. More recent versions (Flash 8 and later, using the On2 VP6 codec) also support alpha channels, so you can composite your video on top of other elements on your web page.

To render FLV files from After Effects 7, you do not use the Render Queue – instead, select the comp you need to render and use File > Export > Flash Video (FLV). A separate dialog will open with a popup along the top featuring several useful presets. Remember that if you want an alpha channel, you must use one of the Flash 8 choices. If you want to tweak the presets, click on Advanced Settings, where you can fine-tune the parameters used to save the file.

After Effects CS3 allows you to render FLV files directly from the Render Queue: Just select Adobe Flash Video from the Format popup along the top of the Output Module. CS3 provides many additional presets, including ones optimized to convert from specific standard video formats to Flash Video.

Even though After Effects has FLV export capability built in, it is a little limited. As you get more serious about Flash Video, you may want to get a dedicated Flash Video encoder such as Sorenson Squeeze and On2 Flix. In these cases, render a high-quality movie from After Effects (perhaps using the QuickTime Animation or Photo-JPEG codecs) to then feed into one of these dedicated encoding programs to create your FLV file.

Creating FLV files is only part of the equation: You will also need a user interface to present the movie. This is typically added inside a web authoring application (such as Adobe Dreamweaver), linking to your rendered FLV. If you want to test your FLV files before adding them to a web page, there are a number of Flash Video players out there; one is the free cross-platform Wimpy player.

The Export > Flash Video dialog in After Effects 7 contains several useful presets, plus an Advanced section to tweak them.

After Effects CS3 offers Adobe Flash Video as a Format option in the Output Module. It includes more presets, plus tabbed access to its internal parameters.

▼ Converting Between D1 and DV

These two standard definition video formats are similar, but just different enough to cause trouble. Problems arise when you have full-frame interlaced sources that need to be added to a composition which is then going out to a different format: You will need to move these clips up or down to ensure maximum sharpness. Moving by an even number of lines preserves the field order; moving by an odd number reverses it.

When starting a project, you should first determine what format you need to render to, then build your compositions based on that format. However, there will be occasions when you need to render to a different format later. If you are field rendering the result, you have to be careful with how you translate between formats, or you may end up with softened images or staggered motion.

Note that these problems do *not* arise if you are working with graphics or progressive scan video, or if you are altering interlaced footage by scaling, rotating, or otherwise not using it full-frame. You need to follow these recipes only when working with unmolested, full-frame interlaced footage and renders.

NTSC

In the NTSC format, the professional D1 standard is 720×486 pixels. The DV format is 720×480 pixels – essentially D1 with six lines cut off. Adding to the complications, DV is lower field first, where NTSC D1 can be either upper field (UF) or lower field (LF) depending on the video card used.

Table 1 shows how to mix and match these different formats in a composition. **Table 2** shows how to take a composition built for one format and render it to a

different format. The second table takes advantage of the Crop section in the Output Settings to add or subtract lines.

△ The Crop section in the Output Module allows you to add or subtract lines of video. Here we are adding six lines (cropping by negative numbers) to convert a DV comp to a D1 render.

		SOURCE		
		DV	**D1 Upper Field**	**D1 Lower Field**
COMPOSITION	**DV**	Center Position = 360, 240	Center Position = 360, 240	Move Up 1 Position = 360, 239
	D1 UF	Center Position = 360, 243	Center Position = 360, 243	Move Up 1 Position = 360, 242
	D1 LF	Move Down 1 Position = 360, 244	Move Down 1 Position = 360, 244	Center Position = 360, 243

△ Position settings when mixing full-frame NTSC footage with different formats in a comp.

		COMPOSITION		
		DV	**D1 Upper Field**	**D1 Lower Field**
RENDER	**DV**	Render Lower No Crop	Render Upper Crop Top 3, Bottom 3	Render Lower Crop Top 4, Bottom 2
	D1 UF	Render Lower Crop Top –3, Bottom –3	Render Upper No Crop	Render Lower Crop Top 1, Bottom –1
	D1 LF	Render Lower Crop Top –4 Bottom –2	Render Upper Crop Top –1 Bottom 1	Render Lower No Crop

△ Render Settings/Field Render and Output Module/Crop settings when translating a comp to different NTSC output formats.

3:2 Pulldown

3:2 Pulldown is the process used to convert between film – which normally runs at 24 fps (frames per second) – and NTSC video, which runs at 29.97 fps.

To make this conversion work, film is slowed down from 24 to 23.976 fps: the same ratio as between 30 and 29.97. Frames of film are then repeated for either two or three successive video fields (there are two fields per video frame) in a pattern that eventually leads to four frames of film being spread across five frames of video.

There are several different patterns in use; After Effects supports two on input: classic 3:2 Pulldown and 24Pa ("advanced" pulldown). Each version can then have several different "phases" – namely, where you started in the pattern.

In the Interpret Footage dialog, there is a Guess button for each that helps determine the correct phase. After Effects often guesses right, but not always; verify its guess by holding 🔑 (*Alt*) and double-clicking the footage item to open it in its Footage panel, then step through the resulting frames using *Page Up* and *Page Down*. If you see the "comb teeth" pattern of interlacing on any frame, After Effects guessed wrong; use the Remove Pulldown popup in the Interpret Footage panel and manually try different phases until all signs of inter-lacing disappear.

When it comes time to render, you can re-introduce the classic 3:2 Pulldown pattern by following these steps:

• Build your final composition at 23.976 fps.

• In Render Settings, set Field Render to the choice required by your output format (for example, Lower Field First for DV).

• Below Field Render, pick a phase in the 3:2 Pulldown popup. If this render is going to video or DVD, any phase will do. You need to worry about phase only if your render is part of an offline film edit; if so, then make sure the clip lines up with the comp's start point and use the same phase for rendering as you used in the clip's Interpret Footage dialog.

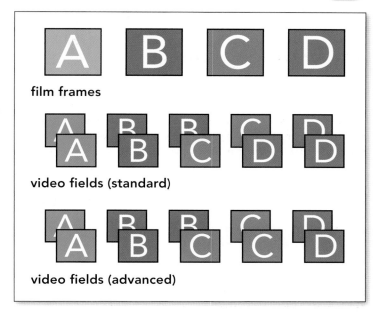

film frames

video fields (standard)

video fields (advanced)

Pulldown is a technique used to spread four frames of film across ten fields (five frames) of video.

▽ tip

Big Windows

The Render Queue panel normally opens in the same frame as the Timeline, which can be a bit cramped. With Render Queue selected, press ` to temporarily expand it to take up the entire application window. This trick works with any panel, too!

To introduce pulldown during rendering, build the comp at 23.976 fps, field render, and pick any phase. The result will be a 29.97 fps interlaced video file that will render faster than field rendering a 29.97 fps comp.

Credits

Senior Acquisitions Editor
Paul Temme

Assistant Editor
Chris Simpson

Publishing Services Manager
George Morrison

Senior Project Manager
Brandy Lilly

Assistant Editor
Dennis McGonagle

Marketing Manager
Christine Degon Veroulis

Production Credits

Cover & Interior Design
Trish Meyer

Cover Calligraphy
Denis Brown (QuillSkill.com)

Page Layout
Stacey Kam, Trish Meyer

Copy Editor
Mandy Erickson

Proofreader
John Bregoli

Indexer
Ken DellaPenta

Media Credits

We'd like to thank Phil Bates and Julie Hill of Artbeats, who provided the majority of the footage used in this book as well as the 3D textures. Additional footage was provided by 12 Inch Design, Pixel Corps, and CyberMotion. Still images and illustrations were arranged by Megan Ironside at iStockPhoto, supplemented by our own images.

Resources

Some of our favorites places to learn more about motion graphics and After Effects.

Our own website is full of information about what we write and where we speak. Key pages to visit include:

articles.cybmotion.com

books.cybmotion.com

training.cybmotion.com

In particular, we write regular articles for DV magazine (www.dv.com) and Artbeats (www.artbeats.com/community/tips.php).

These are some of our favorite forums, web sites, and user groups when we need to find answers to questions on After Effects:

media-motion.tv/ae-list.html

www.adobeforums.com

www.motionscript.com

www.aenhancers.com

www.mgla.org

When you need to feed the other side of your brain, also visit

www.motionographer.com

Here are good sources for software and plug-ins (including freebies):

guide: www.layerlab.com/pluginguide.aspx

distributors: www.toolfarm.com, www.redgiantsoftware.com

And if you are curious about what we do while the computers are busy rendering:

www.wildscaping.com

Index

CREATING MOTION GRAPHICS WITH AFTER EFFECTS
4th Edition • Due Winter 2007–08

Ready for the Advanced Course?

Once you finish *After Effects Apprentice*, you will have a good grounding in using Adobe After Effects for a number of tasks. However, After Effects is a much deeper program and has many more secrets than can be revealed in this book alone.

For those who plan to use After Effects in their career – or those who just want a more thorough understanding of this vital program – we suggest *Creating Motion Graphics with After Effects*. This reference book dives deep into the features, explaining how they work under the hood plus how you would use them in real-world situations through a combination of clear text and numerous hands-on examples.

Creating Motion Graphics includes details on:

▶ Advanced animation tricks and advice, including keyframe assistants and comprehensive sections on how to best exploit expressions.

▶ Building and managing more complex layer and project hierarchies, including the use of guide layers, advanced parenting, collapsing transformations, and comp proxies.

▶ Refined techniques for combining images, including the Smart Mask Interpolation assistant, thorough explanations of each blending mode, plus more on stencils, track mattes, and the Preserve Transparency switch.

▶ A deeper exploration of 3D Space, including using lights to project other images, refining a layer's Material Options to achieve custom looks, integrating After Effects with dedicated 3D programs, and how to best combine 2D and 3D layers in the same composition.

▶ An in-depth exploration of the text animation engine in After Effects, including the various shapes and ease settings, mastering the Wiggly Selector plus learning the Expression Selector.

▶ Tips on color management and color correction, including video monitoring and making sure your colors are broadcast-safe plus working in the new floating point and linear blending modes.

▶ A massive effects round-up including how to use compound effects such as Displacement Maps, and the extended support for Photoshop Layer Styles in CS3.

▶ How to read audio waveforms, spot important hit points, and control audio levels.

The 4th Edition also includes new sections on the Graph Editor, Shape layers, the Puppet tool, Per-Characater 3D, Brainstorm, Pixel Motion, advanced frame blending, and much, much more. See why *Creating Motion Graphics with After Effects* has become known as the bible in the industry.

"I can't think of anyone more qualified to show you how to get the most out of After Effects than Trish and Chris Meyer." – Steve Kilisky, Senior Product Manager, Adobe After Effects.

The third edition of *Creating Motion Graphics* (written for After Effects 6.5) comes in two volumes: *Essentials* and *Advanced Techniques*. The fourth edition (for CS3, due winter 2007/8) combines most of the content of these two volumes into one massive tome, plus adds sections on the major new features – and numerous smaller refinements – in After Effects 7 and CS3.